National Gallery of Scotland

SHORTER CATALOGUE

Colin Thompson and
Hugh Brigstocke

A complete list of the collection
and concise details of 408 principal
works and works on extended loan

2nd (Revised) Edition

EDINBURGH/1978

ISBN 0 903148 14 5

CONTENTS

FOREWORD

The Shorter Catalogue, first published in 1970 with a Supplement in 1976, is designed to give all the information that most visitors to the Gallery will need about several hundred of the more important pictures in the collection, including all those normally shown in the main exhibition rooms. To this is added a handlist of the complete collection. This is the second edition, and incorporates information about works acquired up to March 1978.

The text of the catalogue of PRINCIPAL WORKS *has been revised and brought up to date; the entries on recently acquired British paintings, and some revisions, are by Lindsay Errington, Research Assistant in the Gallery since 1972.*

The Shorter Catalogue differs from the Gallery's earlier publications in including a number of important paintings held on loan for an extended period. We are most grateful to the owners whose generosity has for so long allowed the public to enjoy these paintings for also allowing descriptions of them to appear as entries in this catalogue. We are especially grateful to Her Majesty the Queen for having graciously continued the loan of the Trinity College Altarpiece by Hugo van der Goes.

The earliest loans to the Gallery are the works in the Torrie collection referred to on p. viii. In 1946 the present Duke of Sutherland (then Earl of Ellesmere) lent the 30 paintings from the Bridgewater House collection the presence of which does so much to give the Gallery its present stature; a general note on this collection is given on p. viii. An additional loan is the Ruisdael landscape lent by the Earl of Wemyss and March in 1957.

The donors of many outstanding individual pictures are recorded in the entries describing them, but one disadvantage of a catalogue such as this is that important groups of paintings given or bequeathed by the same donor are inevitably split into separate entries. The following group gifts may therefore be mentioned as having specially enriched the collection: Lady Murray of Henderland's bequest of 15 paintings in 1861; Mrs Nisbet Hamilton Ogilvy of Biel's bequest of 28 paintings in 1921; the 11th Marquess of Lothian's bequest of 18 paintings in 1941; and, the most valuable gift the Gallery has yet received, Sir Alexander Maitland's gift in memory of his wife Rosalind in 1960 of 21 French paintings of the 19th and 20th centuries, which raised the Gallery's representation of this great period of French painting to a level it could never have reached by relying on its own purchasing power.

Of several bequests of money for establishing a purchase fund, the earliest and greatest was the James Cowan Smith bequest in 1919 of £55,000. Substantial bequests of money from Sir D. Y. Cameron and John Stewart Michie were also received in 1945 and 1954.

COLIN THOMPSON
(Director)

INTRODUCTION

The purpose of the present SHORTER CATALOGUE is to make available all the information that is likely to be needed by the great majority of visitors. The section devoted to PRINCIPAL WORKS contains entries for all pictures (mainly) of major importance or of fairly general interest. The sculpture from the Torrie collection (nos. 136, 137 and 165b) and the Duke of Hamilton's Mytens portrait, which were among the loans recorded in the first edition, have since been returned.

In compiling the entries we have relied extensively on the work of our predecessors in the Gallery, particularly Sir Ellis Waterhouse, who initiated the serious study of pre-19th century paintings in the collection. The Director and staff of the National Gallery London have given us, as always, invaluable advice and information on all questions, technical as well as historical; Miss Eyres has greatly facilitated the consultation of books in their library. The auction houses and dealers through whose hands our pictures have passed have given us a great deal of help over their earlier history. We also acknowledge gratefully the unfailing helpfulness of our colleagues in the Portrait Gallery and Print Room in Edinburgh.

The beginnings of the permanent collection

The Royal Institution, Edinburgh, began in 1819 as the Institution for the Encouragement of the Fine Arts in Scotland. By 1827 or before they were buying pictures from living Scottish artists. In 1830/31, using an accumulation of funds recently released for the purpose, they bought 38 'ancient pictures' in Italy, including the big van Dycks, and these formed the nucleus of their collection of old paintings. At much the same time the Royal Scottish Academy, founded in 1826, began a collection of British art with its purchase of the large paintings by Etty in 1829/31. (With the notable exception of Bassano's *Adoration of the Kings*, they bought virtually no old masters.) These two collections, enriched by gifts from private individuals which included Tiepolo's *Finding of Moses*, formed the permanent exhibition when the present gallery was opened in 1859, together with the collection of Sir James Erskine of Torrie (1772–1825), which was deposited on loan by Edinburgh University in 1845.

The Duke of Sutherland loan

Most of the 30 pictures on loan from the Bridgewater House collection were acquired by the 3rd Duke of Bridgewater (1736–1803). Eighteen of them came from the collection of the Duc d'Orléans, and three of these had belonged to Queen Christina of Sweden (sold by her heir in 1692 to Prince Livio Odescalchi, and by his heir in 1721 to the Duc d'Orléans). In 1791 Louis Philippe Joseph, Duc d'Orléans (Philippe Egalité), sold his Italian and French pictures to Viscount Walchiers of Brussels. They were bought from him by François de Laborde de Méréville, who hoped to save them for the French nation but was forced to send them to England. They were sold in London in 1797/8 to Mr Bryan, who was acting for the Earl of Carlisle, the Duke of Bridgewater and his nephew Earl Gower. All the pictures were exhibited for sale at Bryan's Gallery and the Lyceum Gallery from 26 December 1798, but the majority were reserved for this syndicate of three.

At his death in 1803 the Duke of Bridgewater bequeathed most of his pictures, including his share of the Orléans collection, and Bridgewater House, where most of them hung, to Earl Gower, who then became Marquess of Stafford and later Duke of Sutherland. Both the Bridgewater and Stafford collections were housed in the Stafford Gallery until his death in 1833. The second son Lord Francis Egerton, who became Earl of Ellesmere in 1846, then inherited a great part of the collection, including the Bridgewater pictures which were entailed to him. The pictures passed by descent to the 5th Earl, the present Duke of Sutherland, by whose generosity the present loan was arranged with the Gallery in 1946.

Explanations

Measurements are given in inches, with centimetres in brackets, height preceding width.

Titles in inverted commas are traditional titles that are probably not original and that may be misleading.

Literary references given in abbreviated form will be found in full under *Lit:* in the entry where the reference occurs or, in the case of works cited several times, under *Abbreviated references* on pp.167–69. Articles in periodicals are referred to by their first page only. No attempt has been made (i) to give complete bibliographies, (ii) to give all intermediate owners of works whose earlier provenance is established or (iii) to cite exhibitions, unless useful information (including previous ownership) is given in the catalogue.

The last date of cleaning is given for paintings in the permanent collection, if it is known. The word *restored* is substituted for *cleaned* to indicate the cases, common with older pictures, in which areas of the paint surface were missing or damaged and were made good.

X-ray and infra-red photographs existing at the time of going to press are also noted. These and other photographic records and, for example, copies of MS inventories that have been consulted are normally available for study on request.

Works excluded since the 1957 catalogue:
(1) 20th century paintings and sculpture, which now form part of the collection of the Scottish National Gallery of Modern Art. In practice, the oldest artists whose work has been transferred include D. Y. Cameron and Hornel and most of their contemporaries born in the 1860s.
(2) Water-colours by J. M. W. Turner in the Vaughan bequest. These will be catalogued in due course with other English drawings and water-colours in the collection.
(3) A few other works on long loan to the Scottish National Portrait Gallery and the Royal Scottish Museum.

Attributions changed since the 1957 catalogue are cross-referenced in the COMPLETE LIST (pp. 120–58). Entries included in the PRINCIPAL WORKS are given under the new attribution only.

PRINCIPAL WORKS

AIKMAN, William 1682–1732
Scottish, born at Cairney, Forfarshire; pupil of Medina; went to
Rome 1707; in Edinburgh 1712–23; thereafter in London.

167 **Self-portrait**
Canvas: 29 × 24½ (73·6 × 62·2). Other self-portraits by Aikman are
in the SNPG, the Uffizi, Florence, and at Penicuik House. *Coll:*
Probably the portrait of this design owned by the painter's daughter
Mrs Forbes (engraved in *The Bee* Edinburgh, 1793).
James T. Gibson-Craig gift to the RSA 1859; transferred 1910.

ALEXANDER, Cosmo 1724–1772
Scottish, son of John Alexander; with him in Rome from 1745 to
1749 or later. Probably in Scotland 1754; Holland 1763–4; London
1765; United States 1768–72, where he was the first teacher of
Gilbert Stuart.

1882 **Adrian Hope of Amsterdam** (1709–1781)
Adrian and his brother Thomas founded c 1730 a prosperous
banking house in Amsterdam.
 Canvas: 29½ × 24½ (74·9 × 62·2) cleaned 1961. Signed: *CAlex*
pingebat/AD 1763 (*CA* in monogram). Painted in Holland with other
portraits of the family. *Lit:* G. L. M. Goodfellow in *Oud Holland*
1964 pp. 85–7. *Coll:* Hope of Deepdene sale Christie's 20 July 1917
(45).
 Bought at Lord Aldenham sale, Sotheby's 24 Feb 1937 (no. 95).

ALEXANDER, John c 1690—after 1757
Scottish; in London in 1710; in Rome 1714–19; in Edinburgh in 1720.

1784 **Rape of Proserpine**
Pluto's chariot is preceded by a figure of Love holding Cerberus on a
leash. At the corners, the four seasons; shields on the painted frame-
work are inscribed: AMOR OMNIA VINCIT/NAM NEC TEMPORI/AUT
(*sic*) MORTI CEDIT.
 Canvas: 28 × 31¾ (71·1 × 80·7) cleaned 1947. Signed: *JAlex* *in*
& *pinx* *AD 1720* (*JA* in monogram). The model for a canvas of
22 × 20 ft in the staircase ceiling at Gordon Castle, Morayshire (now

no longer there), described in a printed letter from the painter of 29
Apr 1721 and listed in the artist's account dated 8 Dec 1725 in the
Gordon papers at Register House, Edinburgh. The figure of *Summer*
is based on the Sappho in Raphael's *Parnassus*. *Lit:* Waterhouse
1953 p. 240.

Bought at Dowell's, Edinburgh, anon sale of 5 July 1932.

ALLAN, David 1744–1796

Scottish, born at Alloa; apprenticed in 1755 to the Foulis Academy,
Glasgow; in Rome, where he studied under Gavin Hamilton,
1764–77; in London 1777–80; thereafter in Edinburgh.

415 Mrs Tassie, wife of James Tassie

Canvas: 30 × 25 (76·2 × 63·5) cleaned 1954. Companion to the
portrait of James Tassie (1735–99), the gem-engraver and modeller,
in the Scottish National Portrait Gallery. Probably painted in
1778–9.

Bequest of the sitter's nephew, William Tassie, who died in 1860.

612 The Origin of Painting *(The Maid of Corinth)*

Wood (oval): 15 × 12 (38·1 × 30·5) cleaned 1959. Signed on the
back: *D. A. Pint./1775*. Engraved by D. Cunego 1776; it has been
mistakenly associated with the Concorso Balestra medal, which
Allan won with a different picture in 1773. The subject is taken from
Pliny's *Natural History* xxxv 151. *Lit:* R. Rosenblum in *Art
Bulletin* Dec 1957 p. 279. *Coll:* James Byres, Scottish antiquarian
and dealer in Rome, 1776.

Gift of Mrs Byres, widow of General Byres of Tonley, 1874.

2157 Sir John Halkett of Pitfirrane Bart, his wife and family

Sir John Halkett, 4th Bart (1720–93) with his daughter by his first
wife, his second wife Mary daughter of the Hon John Hamilton and
her thirteen children. Pitfirrane House is on the right, Dunfermline
Abbey on the horizon.

Canvas: 60¼ × 94 (153 × 239) cleaned 1952. Signed: *D. Allan pxt.
1781*. The key to the identity of the children is on the back. *Coll:*
Passed by descent.

Miss Madeline Halkett of Pitfirrane bequest 1951.

2260 The connoisseurs

Canvas: 34 × 38½ (86·4 × 97·8). Probably painted after 1780. The
sitters are numbered, including the portrait on the wall. Allan
commonly painted a key to such numbers on the back of his canvas
but our picture had been re-lined before it was acquired. In a letter

of 1974 B. Skinner suggested the sitters might be Charles Hope Weir, Henry Hope and Abbé Peter Grant.
Bought at the Hon Mrs Nellie Ionides sale, Sotheby's 29 May 1963 (no. 86).

ALLAN, Sir William PRSA, RA 1782–1850
Scottish, born in Edinburgh; studied with Wilkie at the Trustees' Academy there and later at the RA Schools, London; abroad 1805–14, mainly in Russia and round the Black Sea; in Edinburgh from 1814; Master of the Trustees' Academy 1826–44.

172 The Black Dwarf
An illustration to Scott's novel of 1816.
Wood: 13 × 17½ (33 × 44·5) cleaned 1933. Catalogued in 1899 as indistinctly signed, but there is no trace of this now.
Commissioned by the Royal Institution, Edinburgh, 1827.

AMEDEI, Giuliano died 1496

attributed to Amedei

1528 The death of St Ephraim
Wood: irregular fragment made up to 13½ × 17½ (34·3 × 43·5) restored 1960. The death of St Ephraim (AD 373) was frequently incorporated into schemes illustrating the lives of the Hermits, as in Uffizi no. 447. Our picture is one of the 20 fragments from such a panel, whose original appearance is reconstructed by Callmann, who also publishes two similar entire panels. Berenson (1963), as Unidentified Florentine c 1420–65 between Giovanni di Francesco and Neri di Bicci; Byam Shaw as by the same hand as the predella of Piero della Francesca's *Misericordia* altarpiece at Borgo S. Sepolcro; F. Zeri as by Giuliano Amedei, for whom see M. Salmi (*Rivista d'Arte* 1942 p. 26). *Lit:* M. Salmi in *Commentari* Jan 1950 p. 28; E. Callmann in *Burl. Mag.* May 1957 p. 149; J. Byam Shaw: *Paintings at Christ Church Oxford* London 1967 p. 40. *Coll:* The original panel was evidently cut up in Italy by 1836 when nine fragments belonging to Walter Savage Landor were put up for sale at Christie's on 25 June (105). Our fragment also belonged to Landor (died 1864) who sold it to William Bell Scott (1811–90).
Bought from James R. Saunders 1921.

APOLLONIO DI GIOVANNI 1415/17–1465
Florentine; kept a joint workshop with Marco del Buono Giamberti (1403–89).

follower of Apollonio di Giovanni

3

1940 **Cassone panel: Triumphs of Love and Chastity**
An illustration of two of Petrarch's six *Trionfi*.
Wood: painted surface 15⅞ × 55¾ (40·5 × 141·6). Assuming the keyhole
was originally central, a piece c 27 cm. wide has been cut from the
right-hand side. The missing piece presumably illustrated a third
triumph, probably the *Triumph of Death*. Probably part of the front
panel of a cassone. In style, our panel shows the influence of
Apollonio di Giovanni. E. Callmann (*Apollonio di Giovanni* Oxford
1974 p. 60 no. 11) attributes it to a painter who had, at some
earlier date, been an assistant in Apollonio di Giovanni's shop, but
who had already left it. *Lit:* P. Schubring: *Cassoni* Leipzig 1915
no. 204 as by the 'Cassone Master'. *Coll:* Bought in Florence as
by Dello Delli by the 8th Marquess of Lothian 1861.
11th Marquess of Lothian bequest 1941.

AVERCAMP, Hendrick 1585–1634
Dutch; trained in Amsterdam; settled in Kampen by 1613.

647 **Winter landscape**
The walled town of Kampen is seen in the background.
Copper: 11¼ × 16⅝ (28·6 × 42·2). Signed: *H A* in monogram.
A mature work, perhaps from the early 1620s. *Lit:* C. J. Welcker:
H. Avercamp . . . Zwolle 1933 (no. S46). *Coll:* Thomas Sivright
sale by C. B. Tait, Edinburgh 17.2.1836 (2840), bt David Laing, 7 gns.
David Laing LLD bequest 1879.

BACCHIACCA (Francesco Ubertini Verdi) 1494–1557
Florentine; pupil of Perugino and friend of Andrea del Sarto;
visited Rome c 1525.

2291 **Moses striking the rock**
In the top right the Israelites are seen complaining to Moses.
Exodus XVII 2–7.
Wood: 39 × 31½ (100 × 80) cleaned before purchase. Closely
related to *The Gathering of Manna* (NG Washington). The two
paintings are perhaps elaborated versions of the scenes from the life
of Moses which, according to Vasari (VI p. 451), were painted by
Bacchiacca for the Triumphal Arch of the Compagnia dell' Orciuolo
(a fraternity of jug-makers or vendors?) at the Festa di S. Felice of
1525. Stylistically our picture appears to date from soon after 1525.
The landscape and many of the figures are derived from engravings
of Lucas van Leyden and Marcantonio, and from Uffizi drawing 599E,
associated with Michelangelo. *Lit:* G. Morelli: *Critical Studies of
Italian Painters* London 1900 p. 108; N. Barbantini in *Emporium*

1908 p. 183; A. McComb in *Art Bulletin* 1926 p. 141. *Coll:* Prince Giovanelli, Venice: 1723 inventory as by Andrea del Sarto, and later as Dürer; sold between 1925 and 1939.
Bought from Colnaghi's 1967.

BACKHUYZEN, Ludolf 1631–1708
Worked in Amsterdam; influenced by W. van de Velde the younger.

2 **A squall: a lugger running into harbour**
Canvas: $18\frac{1}{4}$ × 24 (46·4 × 61) cleaned 1938. Signed: *L. Backhuyzen.*
Lit: H d G no. 199. *Coll:* Lent to Edinburgh Institution 1819 (3) by Sir James Erskine.
 Sir James Erskine of Torrie bequest to Edinburgh University 1835; deposited on loan 1845.

BASSANO, Jacopo (Jacopo da Ponte) c 1510/18–1592
Venetian school; the most important painter from the da Ponte family of Bassano.

3 **Portrait of a gentleman**
Canvas: 50 × $38\frac{3}{4}$ (127 × 98) restored 1959. Acquired as by J. Bassano, and published as a J. Bassano of the later 1560s by Arslan (1931 p. 120). Pallucchini, reviewing the *Bassano Exh.* Venice 1957, attributed it to Tintoretto, following a verbal suggestion by R. Longhi. Arslan (1960 p. 167) admits room for doubt. *Lit:* R. Pallucchini in *Arte Veneta* 1957 p. 116. *Coll:* Grimaldi family Genoa, possibly the *Portrait d'un Viellard du Tintoret* seen in the Palazzo Grimaldi by Brusco (1788 ed. p. 61); thence by inheritance.
 Bought from the Marchesa Pallavicini for the Royal Institution 1830.

100 **Adoration of the Kings**
Canvas: 72 × $92\frac{1}{2}$ (183 × 235). Restored 1964: there are numerous small damages which are not serious except round the side and bottom edge of the canvas. Painted in the early 1540s. The design is a development from a large painting of c 1539 at Burghley House. The landscape, which is like those in the *Trinity* at Angarano and other pictures, may be an idealised rendering of Bassano and Monte Grappa. *Lit:* W. R. Roerick in *Arte Veneta* 1958 p. 197; Arslan 1960 pp. 62/3 and 167. *Coll:* As Roerick explains, the Burghley picture is more likely than ours to be the one noticed by Ridolfi (I p. 400) in Venice in 1648. Ratti (p. 167) described our picture as by Titian when he saw it in 1766 in the Palazzo of Francesco Maria Balbi, Genoa; bought there by Andrew Wilson in 1805; Royal Institution Exh: 1826 (74) lent by Lord Eldin: Lord Eldin sale by Winstanley, Edinburgh, 15 Mar 1833 (113) as by Titian from the Balbi Palace Genoa, bought by Neil.
 Bought from Mr Neil by the RSA 1856; transferred 1910.

studio of Jacopo Bassano

1635 **Madonna and Child with St John and a donor**
Canvas: 30 × 30½ (76·2 × 77). Based on the design (without the
donor) of a signed painting of c 1565–70 by Jacopo Bassano (Arslan
1960, p. 167; now in the Art Institute, Chicago). Our picture is
attributed to Gerolamo Bassano, youngest son and pupil of Jacopo,
by Arslan (1960 p. 288).
Sir Claude Phillips bequest 1924.

BASTIEN-LEPAGE, Julien 1848–1884
French; trained under Cabanel. His peasant scenes influenced the
Glasgow school.

1133 **Pas mèche**
The title means roughly 'No luck'.
Canvas: 52 × 35¼ (132·1 × 89·5). Signed: *J. Bastien-Lepage/
Damvillers/'82. Lit:* G. Clausen in *Scottish Art Review* I 1889
repr facing p. 112. *Coll:* Painted for Tooth, London;
A. Tooth & Sons sale, Christie's 28 Feb 1885 (119); H. J. Turner.
Bought through Wallis & Sons 1913.

BELLOTTO, Bernardo 1720–1780
Trained in Venice in the studio of his uncle Canaletto.

View of Verona with the Ponte delle Navi, looking downstream
Canvas: 52 × 90 (132 × 233·7). The picture in Edinburgh, for which
there is a preparatory drawing in the National Museum, Warsaw
(Rys. Pol. 2041), may probably be dated, on the basis of its style,
to c 1745 when Bellotto was breaking free from the dominating
influence of Canaletto. Another picture of the same design (except
for minor changes in the figures), which was provided by Bellotto
for the royal collection in Dresden and which is now in the Dresden
Gallery, probably dates from after 1747 when the artist settled there.
A companion picture in Dresden, representing a *View of Verona
from the Ponte Nuovo* also appears to be a repetition by Bellotto of an
earlier version which is now at Powis Castle, Montgomeryshire, and
which had been sent to Britain by 1771 (according to a family inventory
it was bought by Lord Clive in 1771; a drawing, apparently by
Bellotto, now in the museum at Darmstadt, no. HZ 160, which
was evidently made as a record of the Powis Castle picture, is
inscribed *per ingiltera* (sic). There is no firm evidence as to when
the Edinburgh picture arrived in Britain, and it was not necessarily
commissioned or conceived as a companion to the Powis Castle

picture. The two pictures are however of exactly the same size, and they might arguably be identified as the two companion views of Verona, measuring 53 × 90 in. and attributed to Canaletto, which were offered for sale at Christie's on 30 March 1771 (54 and 55). However a complication arises from the fact that at about the date of this sale William Marlow made a full size copy (canvas $54\frac{1}{4}$ × $92\frac{7}{8}$ in.) of at least one of Bellotto's Verona views; his *View of Verona from the Ponte Nuovo* is now in the Courtauld Institute Galleries, London. *Lit:* S. Kozakiewicz: *Bernardo Bellotto* London 1972 p. 80 no. 101. *Coll:* Possibly anonymous sale Christie's 30 March 1771 (55) bought Fleming (*sic*) and Gilbert Flemming sale Christie's 21 March 1777 (48) bought Lord Cadogan for £215.5.0d; but the first certain reference to the picture in Edinburgh dates from 4 October 1821 when George James Welbore Agar-Ellis (Lord Dover) describes it (in his diary, preserved at Northamptonshire Record Office) in the collection of his father, the 2nd Viscount Clifden (1761–1836). By descent until sold at Robinson and Fisher 25 May 1895 (784) as Canaletto, bought Agnew's for W. H. Burns of North Mymms Park, Hertfordshire. Sold by Major-General Sir George Burns at Christie's 26 November 1971 (30).
Lent anonymously.

BENSON, Ambrosius working 1519—died 1550
Native of Lombardy; settled in Bruges. He followed the style of Gerard David.

2024 Madonna and Child with St Anne
The apple symbolises the world and original sin; in the background is the Fountain of Life.
Wood (ogee top): $31\frac{3}{4}$ × $23\frac{1}{4}$ (80·7 × 59·1) photographed by infra-red. Dated by Marlier c 1527. The figures recur, enthroned, in a larger panel in the Prado, Madrid (1933 cat. no. 1933). *Lit:* G. Marlier *Ambrosius Benson* . . . 1957 (pp. 119–21 and 296). *Coll:* Said to have belonged to Count Oliver Walshaw Wallis (1600–67), who moved from Scotland to Bohemia. (A Dürer monogram and date 1505 on the back suggests that it was at one time called Dürer.) Arthur Maier, Karlsbad, 1933.
Bought through Reid and Lefevre 1945.

BONINGTON, Richard Parkes 1802–1828
English, born near Nottingham; from 1817/8 he lived mainly in France, where he knew Delacroix.

1017 Landscape with mountains
Millboard: $9\frac{7}{8}$ × 13 (25·1 × 33). According to Shirley, painted in Italy in 1826. (Bonington travelled to Italy via Switzerland in April

1826.) *Lit:* A. Shirley: *Bonington* London 1940 p. 103; M. Spencer: *Bonington Exh.* Nottingham 1965 (270). *Coll:* Probably R. P. Bonington sale Sotheby's 29 June 1829 (160) *Environs of Genoa,* bought by Sir Thomas Lawrence, who sold it at Christie's, 17 June 1830 (28) *Italian View with Mountains,* bought by Moon; James Keyden (by 1888).
Bought from Alexander Reid, Glasgow, 1910.

2164 Venice: Grand Canal
Paper laid on canvas: $8\frac{7}{8} \times 11\frac{7}{8}$ (22·5 × 30·1). Study used as the basis for a larger (now damaged) canvas. *Lit:* M. Spencer: *Bonington Exh.* Nottingham 1965: (274) our picture, (281) the large version. *Coll:* International Exh. 1862 (179) lent by H. A. J. Munro of Novar; H. Butler Johnstone (of Novar) sale 19 Mar 1880 (223), bought Quilter; Sir Cuthbert Quilter sale 9 July 1909 (48); George Salting (1910); thence by inheritance.
Lady Binning bequest 1952.

2165 Estuary with a sailing boat
Board: 9 × 14 (22·8 × 35·5). *Coll:* By inheritance from George Salting collection.
Lady Binning bequest 1952.

BONNARD, Pierre 1867–1947
French; born near Paris, worked mainly there and in the South of France; with Vuillard, a member of the Nabis.

2223 Landscape
Canvas: 19 × 18 (48·3 × 45·7). Signed: *Bonnard.* Probably painted around 1930. A larger square landscape of similar subject and design in the Art Institute Chicago is described as *The Seine at Vernon* c 1930. *Coll:* H. Messeca-Fara, Paris; bought by Mr and Mrs Maitland from Rowland, Browse and Delbanco 1957.
Sir Alexander Maitland gift 1960.

2245 Lane at Vernonnet
Canvas: $29\frac{1}{4} \times 24\frac{3}{4}$ (74 × 62·9). Signed: *Bonnard.* Bonnard bought a house at Vernonnet in the Seine valley in 1912. In 1914 our picture was bought from the painter by Bernheim-Jeune, Paris, who handled his work. Bonnard later made minor adjustments to the colour. *Lit:* J. and H. Dauberville: *Bonnard* Paris 1968 vol II no. 790. *Coll:* Bought back by Bernheim-Jeune from de Freune in 1937 and sold to Reid and Lefevre; lent to NG London 1956–61 by Sir Chester Beatty.
Bought, with money given by Mrs Charles Montagu Douglas Scott, in 1961.

BORCH, Gerard ter 1617–1681
Dutch; portrait and genre painter; worked principally at Deventer.

A singing practice
Canvas: $29\frac{1}{8} \times 31\frac{3}{8}$ (74 × 79·7). The principal version of this design,
which is in the Rijksmuseum, Amsterdam, was painted before 1655.
The subject has been called *Paternal advice,* following an engraving
by Wille of 1765. The meaning of some of the versions is made clear
by a gold coin which the young officer holds in his raised hand.
The sheet of music held by the girl occurs only in the Bridgewater
House version. *Lit:* S. J. Gudlaugsson: *Katalog der Gemälde
G. Ter Borchs* The Hague 1960 no. 110a. *Coll:* A. de la Hante sale by
Phillips, London 2/3 June 1814 (42); sold by Lord Wharncliffe to
J. Smith 1841, who sold it to Lord Francis Egerton (HdG no. 188);
thence by descent. Bridgewater House no. 198.
Duke of Sutherland loan 1946.

BORDON, Paris 1500–1571
Mainly active in Venice; influenced by Giorgione and Titian;
visited Paris and Augsburg 1538–40.

10 Venetian woman at her toilet
Canvas: $38\frac{1}{4} \times 55\frac{1}{4}$ (97·2 × 140·4). Signed: . . ./*RIS B.* (The signature
shows the canvas has been trimmed, but the reduction is probably
very slight.) Probably a relatively late work. *Coll:* G. Canova (*Paris
Bordon,* Venice 1964, pp. 77–8) suggests that it may be the picture owned
by Conte Widmann, Venice, as noticed by Ridolfi (I p. 234).
Grimaldi family, Genoa by 1788 (Brusco p. 61); thence by inheritance.
Bought from the Marchesa Pallavicini for the Royal Institution
1830.

BORGIANNI, Orazio 1578–1616
Born and worked in Rome; in Spain from c 1598 to 1602 and in
1604–5; influenced by Caravaggio.

48 St Christopher
Canvas: $41 \times 30\frac{3}{4}$ (104·1 × 78·1) restored 1957. One of several versions
of this subject by Borgianni. Our picture was probably painted c 1615.
A variant was engraved between c 1609–16 (Bartsch XVII no. 53).
Lit: H. E. Wethey in *Dizionario Biografico degli Italiani* XII p. 746;
A. Moir: *The Italian Followers of Caravaggio* Harvard 1967 p. 48;
O. Osti in *Quaderni di Emblema* II Bergamo 1973 p. 98.
Sir John Watson gift to the RSA 1850; transferred 1910.

BOTTICELLI, Sandro c 1445–1510
Florentine; pupil of Filippo Lippi.

workshop of Botticelli

1536 Virgin and St John adoring the Infant Christ
Wood: 18⅜ × 16⅜ (46·5 × 41·5) restored 1942. Cut down on all
four sides; it undoubtedly began as a tondo, c 28 (71 cm) in diameter.
The design is similar to that of a tondo in Seymour Maynard sale
Christie's 29 Jan. 1954 (72) ascribed to Sellaio. Berenson (1932 and
1963) as in greater part by Botticelli; van Marle (xii p. 234) as by an
ill-defined artistic personality close to Botticelli; described as a studio
production by J. A. Crowe and G. B. Cavalcaselle (*A History of
Painting in Italy* ed. R. Langton Douglas, London 1911 iv p. 267)
and by J. Mesnil (*Botticelli* Paris 1938 p. 223). *Coll:* Lent by
W. Fuller Maitland to British Institution 1852 (96).
Bought from the Fuller Maitland collection 1921.

BOUCHER, François 1703–1770
French, born and worked in Paris; in Rome 1727–31.

studio of Boucher

429 Madame de Pompadour
Jeanne-Antoine Poisson (1721–64) was created Marquise de
Pompadour by Louis xv and installed at Versailles in 1745.
Canvas: 14¼ × 17⅜ (36·2 × 44·1). Cleaned 1960: traces of
squaring up for transfer are visible; the canvas has not been cut down
since it was painted. Boucher's earliest known portrait of the
Marquise in this pose is in the V&A London (28½ × 22½ in, dated
1756). From this he developed a life-size, full-length portrait dated
1758 (Rothschild coll. Paris, lent RA 1932 no. 227). Our picture is a
reduced and simplified version of the Rothschild picture. These
circumstances, and comparison with the V&A portrait, leave
little doubt that ours was painted by a member of Boucher's studio.
Coll: By descent from General Ramsay, son of the painter Allan
Ramsay.
Lady Murray of Henderland bequest 1861.

BOUDIN, Louis-Eugène 1824–1898
French; lived in Le Havre and painted principally on the coast of
Normandy and Brittany.

1072 Port of Bordeaux
Canvas: 15¾ × 25¾ (40 × 65·4) restored 1953. Signed and dated:
E. Boudin, 74 Bordeaux. Lit: Schmit no. 995. *Coll:* Miss Grace
Griggs, New York.
George R. MacDougall, New York, gift 1912.

2349 **Washerwomen on the banks of the Touques**
Panel: 10½ × 16⅛ (26·7 × 41). Signed and dated: *84. E. Boudin.*
Lit: Schmit no. 1888.
Alastair Russell MacWilliam bequest 1977.

2350 **Kerhor: fisherwomen resting**
Panel: 9 × 16 (22·9 × 40·6). Signed and dated: *E. Boudin. 71.*
Lit: Schmit no. 693. *Coll:* Beugniet et Bonjean, Paris; H. Pasquier,
sale Galerie Georges Petit, Paris 2 May 1905 (6).
Robert A. Lillie bequest 1977.

2351 **Fishing boat, Trouville**
Panel: 10⅜ × 8⅜ (27·1 × 21·3). Signed: *E. Boudin. Lit:* Schmit
no. 3022 (c 1892–96). *Coll:* Watelin (Paris); Muller (Paris).
Sold Hôtel Drouot, Paris 3 Dec 1925 (68). J. Grimond.
Robert A. Lillie bequest 1977.

BOUGH, Samuel RSA 1822–1878
Born in Carlisle; began in London, later in Manchester and Glasgow;
settled in Edinburgh 1855. Landscape painter.

2121 **Berwick-on-Tweed**
View from the north bank of the river.
 Wood: 8¼ × 11⅝ (21 × 29·5). Signed: *Sam Bough.* Inscribed on the
back: *from a sketch made in 1837 by Sam Bough painted for J. C.
Bell, Esq, 1863. Coll:* Undoubtedly John Charles Bell (1816–97)
of Dundee, a well known collector of contemporary paintings, but
not traced in his collections.
Miss Ida M. Hayward bequest 1950.

BRAY, Jan de c 1627–1697
Dutch; born and worked in Haarlem, where he was the Civic Painter
in the 1660s.

1500 **A Dutch gentleman**
Wood (oval): 8¾ × 6¼ (22·2 × 15·8). Inscribed: *1662/out 47 jaer.*

1501 **His wife**
Wood (oval): 9 × 6½ (22·8 × 16·5). Inscribed: *1663/out 47 jaer.*

1502 **His younger son**
Wood (oval): 7¾ × 5½ (19·7 × 14). Signed: *J D Bray (J D B* in
monogram)*/1663/out 7 jaer.*

1503 **His elder son**
Wood (oval): 7¾ × 5½ (19·7 × 14). Signed: *J D Bray/1662/out 11 jaer.*

Four companion portraits of a Dutch family, in their original frames carved in the Lutma style. The panels were cleaned in 1957. *Coll:* Lent to Edinburgh Exh: 1883 (nos. 247 and 252) as by F. Hals, by Miss Nisbet Hamilton.

Mrs Nisbet Hamilton Ogilvy of Biel bequest 1921.

BRIL, Paul 1554–1626
Flemish, born in Antwerp, where he trained; settled in Rome by 1582.

1492 **Fantastic landscape**
Copper: 8⅜ × 11½ (21·3 × 29·2). Signed: *PA. BRIL. ROMAE. 1598.*
A repetition with minor variations was in the Dresden Gallery until the war, with a companion picture, *Landscape with Roman Ruins,* signed and dated 1600 (Dresden no. 858). *Coll:* J. Fenton, Norton Hall, Glos. sale Christie's 27 Feb 1880 (224).

Mrs Nisbet Hamilton Ogilvy of Biel bequest 1921.

BURNET, John 1784–1868
Scottish, born in Musselburgh; in Edinburgh, apprenticed to Robert Scott and studied, with Wilkie, at the Trustees' Academy; settled in London 1806. Engraver and writer on art.

1759 **An oyster-cellar in Leith**
Wood: 11½ × 14 (29·2 × 35·5). An uncharacteristic work, whose author, subject and date *in or about the year 1819* are attested by a label on the back written by the artist's brother Thomas, dated 1859, when he gave the picture to John Whitehead.

Bought from J. Kent Richardson 1931.

BURR, Alexander Hohenlohe 1835–1899
Scottish; began at the Trustees' Academy, Edinburgh, in 1850; settled in London 1861.

1000 **The night stall**
Canvas: 20½ × 18½ (52·1 × 47). Signed in monogram: *A H B '60.*
Bought at T. D. Pearson (and others) sale Dowell's Edinburgh 5 Feb 1910 (no. 63).

BURR, John 1831–1893
Scottish; brother of A. H. Burr (q v), and with a similar career.

1001 **Grandfather's return**
Canvas: $9\frac{3}{4} \times 11\frac{1}{4}$ (24·8 × 28·6).
Bought at T. D. Pearson (and others) sale Dowell's Edinburgh
5 Feb 1910 (no. 109).

BUTINONE, Bernardino active 1484–1507
Lombard; working in Treviglio and Milan. Influenced by Mantegna
and Foppa.

1746 **The Christ Child disputing with the doctors**
Wood: $9\frac{7}{8} \times 8\frac{3}{4}$ (25·1 × 22·3) restored 1951. Christ's throne is in the
form of an oriental ziggurat, but reduced in scale and placed in a
Renaissance room. The ziggurat, an oriental symbol of darkness and
confusion, may be intended as an allusion to the tower of Babel which
had a similar form. The disunity of language and understanding
associated with the tower of Babel is conquered by the divine wisdom
of Christ, who sits astride it. A spider and spider's web on the left
wall probably allude to God's divine providence, while the cracked
structure of the walls suggests the crumbling of the old order. One of
fifteen known panels of about the same size from the Life of Christ
(Detroit Institute of Arts no. 64.81; the Keir panel with Hallsborough
1965; the others as listed by Davies 1961 p. 132). They were
perhaps all from a single ensemble, like the triptych with thirteen
panels by Butinone in the Castello Sforzesco, Milan (no. 342).
According to Salmi, an early work of c 1480. *Lit:* M. Salmi in
Dedalo Nov/Dec 1929 p. 344; F. Zeri in *Burl. Mag.* 1955 p. 77.
H. Ost in *Zeitschrift fur Kunstgeschichte* 30 1967 p. 133.
Bought from Knoedler's 1930.

CAMBIASO, Luca 1527–1585
Genoese; his works were a major formative influence in the
development of the seventeenth-century Genoese school.

18 **Holy Family**
Canvas: $56\frac{5}{8} \times 42\frac{1}{4}$ (143·8 × 107). Probably painted shortly before
1570. *Lit:* B. Suida Manning and W. Suida: *Luca Cambiaso*
Milan 1958 p. 155.
Bought from the Cambiaso family, Genoa, for the Royal
Institution 1830.

CAMERON, Hugh RSA 1835–1918
Scottish, born in Edinburgh; began at the Trustees' Academy under
Scott Lauder in 1852; in London 1876–88.

652 **Going to the hay**
Canvas: $22\frac{1}{2} \times 16\frac{3}{4}$ (57·2 × 42·5). Signed: *H. Cameron 1858–9.*
Exhibited RSA 1859 (478) lent by Charles Hargitt.
James T. Gibson-Craig gift 1879.

CARDUCHO, Vicente 1576–1638
Born in Florence; went to Spain 1585 where he became Court
Painter in 1609.

459 Dream of St Hugh, Bishop of Grenoble
The Bishop's dream was followed by the arrival of St Bruno to ask
for a site for what was later to be known as the Grande Chartreuse.
Canvas: 22¾ × 18 (57·8 × 45·7). A small model for the canvas now
in the School of Fine Art, La Coruña, Spain, which was one of the 54
large canvases illustrating the life of St Bruno, painted by Carducho
1626–32 for the cloister of the Carthusian monastery of El Paular
(near Segovia). *Lit:* B. Cuartero y Huerta in *Boletín de la Real
Academia de la Historia* CXXVI (1950) p.362. *Coll:* Sir John Pringle
sale Christie's 18 June 1859 (82) as Velázquez.
Andrew Coventry gift 1863.

CARSE, Alexander working c 1780–1843
Scottish, born in Edinburgh; worked under Robert Scott, engraver;
in London 1813–20; thereafter in Scotland. His early genre scenes
followed David Allan and influenced Wilkie.

780 The new web
Canvas: 18⅝ × 24⅝ (47·3 × 62·5). Shown at the Associated Artists
Exhibition, Edinburgh, 1813 (60) with this title. Later called *The
village tailor*.
Gift of J. R. Findlay, who founded the Scottish National Portrait
Gallery, 1885.

CASTAGNO, Andrea del c 1419–1457
Mainly active in Florence.

by a follower of Andrea del Castagno

1210 The Last Supper
Wood: 11¾ × 14¼ (29·9 × 36·2) not painted up to the left or
bottom edges; the top and right edges gilded. Cleaned 1952: the
paint is very badly worn. A panel probably from the same predella
as the *Crucifixion* (NG London no. 1138) and the *Resurrection*
(Frick collection, New York), though inferior in quality to them.
Berenson (1932 and 1963) as Giovanni di Francesco; Fahy and
Bellosi as Francesco Botticini. If by Francesco Botticini, it would
have to be an early work c 1465, when he was still influenced by
Castagno's late style. *Lit:* Davies 1961 pp. 138–9; E. Fahy in
Burl. Mag. 1967 p. 137; L. Bellosi in *Paragone* Sept 1967 pp. 10–11.
Coll: Probably acquired in Italy by Sir William Fettes Douglas
(1822–91).
Bought at Lady Fettes Douglas sale, Dowell's 17 Mar 1917 (no. 3).

CÉZANNE, Paul 1839–1906
French, born at Aix-en-Provence; worked mainly in the region of
Paris and, especially in later years, Aix.

2236 **La Montagne Sainte-Victoire**
Canvas: 21½ × 25½ (54·6 × 64·8). Dated 1890–95 by L. Venturi
(*Cézanne* Paris 1936, no. 661). *Coll:* Ambroise Vollard; lent by
Captain S. W. Sykes to Fitzwilliam Museum, Cambridge 1938–57;
bought from Tooth's by Mr and Mrs Maitland 1959.
Sir Alexander Maitland gift 1960.

CHALMERS, George Paul RSA 1833–1878
Scottish, born at Montrose; began at the Trustees' Academy,
Edinburgh under Scott Lauder in 1853; worked in Edinburgh.

657 **The legend**
The scene is based on a cottage interior in Glen Esk.
Canvas: 40½ × 60¾ (102·9 × 154·3). Said to have been begun
c 1864–7 and left aside, later much re-worked and never considered
finished. A study belonged to J. M. Gow, Edinburgh, in 1880; a water
colour sketch is in Aberdeen City Art Gallery and an early sketch is
in the Orchar collection, Broughty Ferry. An oil study of the interior
without the figures was in Sotheby's Belgravia sale 30 Aug 1977 (354).
Lit: A. Gibson and J. F. White: *G. P. Chalmers* Edinburgh 1879
pp. 9/10, 35.
Bought by the Royal Association for the Promotion of the Fine
Arts in 1878, and given by them in 1897.

CHARDIN, Jean-Baptiste Siméon 1699–1779
French, born and worked in Paris.

959 **Still-life: the kitchen table**
Canvas: 16 × 12¾ (40·6 × 32·4). Signed: *j. s. chardin.* Restored 1955:
the canvas has an extensive tear, but most of the paint lost is from the
dark background. Comparable with Chardin still-lives dated in the
years 1731–34. *Lit:* Wildenstein 1963, no. 50. *Coll:* Lent to
Galerie Georges Petit, Paris 1907 (67) by Alexis, son of the painter
Antoine Vollon.
Bought from W. B. Paterson, London, 1908.

1883 **Vase of flowers**
Canvas: 17¼ × 14¼ (43·8 × 36·2) cleaned 1937 (X-rayed).
Wildenstein (1963 no. 313) suggests a date of c 1760–63. Chardin
seems to have painted at least three vases of flowers. He showed two
at the Paris Salon: 1761 (under no. 46) and 1763 (58 or 59). There are
difficulties in identifying either of these with our picture, which is the

only Chardin flower piece now known. *Coll:* J. A. J. Aved, painter
and friend of Chardin; Aved sale by Remy, Paris 27 Nov 1766 (136);
Camille Marcille sale Paris 6–9 Mar 1876 (18) bought Marquis de
Charly; David Weill c 1922–32.
Bought from Wildenstein and Co. 1937.

CHURCH, Frederick Edwin 1826–1900
American, born in Hartford; Hudson River School painter of romantic
landscapes.

799 **Niagara Falls**
Canvas: 102½ × 91 (260 × 231) cleaned 1977. Signed: *F. E. Church/1867.*
C. Viele (letter June 1965) suggests that it was painted from sketches
made at Niagara in 1858. Another view of the falls, dated 1857,
exhibited in London the same year and in Paris in 1867, is in the
Corcoran Gallery of Art, Washington D.C.
John S. Kennedy gift 1887.

CIMA da CONEGLIANO, Giovanni Battista c 1459–c 1517
Venetian; influenced by Giovanni Bellini.

1190 **Virgin and Child with St Andrew and St Peter**
Wood: 22 × 18¼ (55·9 × 46·4); painted area 18¾ × 15⅝ (47·8 × 39·5).
The painting is unfinished. In places, especially on the right,
the gesso ground has only a monochrome brush drawing on it. Some
paint may be a later addition (*eg* in the sky, left). The most closely
related designs, in the Accademia, Venice (*Madonna dell' Arancia*)
and in Lisbon are generally dated around 1500. The erect, frontal
pose of the head does not recur in Cima's known Madonnas. Probably
a relatively early work. *Lit:* T. Borenius in *Burl. Mag.* 1916 p. 164;
L. Coletti: *Cima* Venice 1959 p. 77 fig 36; *Cima Exh Catalogue:*
Treviso 1962 no. 25. *Coll:* Allegedly sold by Prince Abate of Collalto
c 1830 (declaration in Gallery archives). Bought by the donor from
Alessandro Ellero, Perugia 1887.
Miss Margaret Peter Dove gift 1915.

CLAUDE LORRAINE (Claude Gellée) 1600–1682
Born at Chamagne, Vosges; settled in Rome c 1613, where he worked.

2240 **Landscape with Apollo and the Muses**
Apollo plays his lyre on Mount Helicon, while five mortal poets
listen unobserved. A figure kneeling on the temple steps is crowned
with a wreath. Below, Pegasus strikes the spring Hippocrene from
beneath his hooves.

Canvas: 73 × 114 (186 × 290) cleaned 1961 (priming and canvas make X-rays illegible). Signed: *CLAVDIO.I . . ROM./1652*. Claude's largest known landscape, painted for Cardinal Pamphili in Rome. The river god is apparently derived from the stone figure then in the via di Marforio, Rome (now in the Capitoline Museum). *Lit: Liber Veritatis . . .*, Earlom's London edition of 1777 (no. 126) as in the collection of Lord George Cavendish at Holker; M. Röthlisberger: *Claude Lorrain: The Paintings* London 1961 vol I p. 308.

Bought, with a Treasury grant and help from the NA-CF, from the Holker Estates Company in 1960.

CLOUET, Jean working 1509–died 1541
Born probably in the Netherlands; settled in France; painter to François I and father of François Clouet.

1930 Madame de Canaples
Judith d'Assigny, a lady of the Court of François I; married 1525 Jean de Créqui, sire de Canaples; died 1558.
Wood (walnut): 14⅜ × 11¼ (36 × 28·5) restored 1941 (X-rayed: the paint on the face is rubbed). The bottom 2·6 cm of the panel was added before 1720 to pair it with our no. 1929 (see p. 36). The attribution depends on a drawing for the head, inscribed *Madame de Canaples*, at Chantilly (*Gazette des Beaux-Arts* LXXVII 1971 p. 311 figs 241–42). *Lit:* A. Blunt: *Art and Architecture in France 1500–1700* London, 1953, p. 38; P. Mellen: *Jean Clouet* London 1971 p. 237 no. 140 pl. 41 (c 1525). *Coll:* Marquess of Lothian by c 1720 (cf no. 1929 p. 36).
11th Marquess of Lothian bequest 1941.

CONSTABLE, John RA 1776–1837
English, worked in Essex and Suffolk, in and near London, and in Salisbury.

1219 On the Stour
Millboard: 8 × 9¼ (20·3 × 23·5). On the back is an oil sketch of two standing and four lying cows. A similar study of cows is on the back of a sketch on board of the same size in the V & A London (R.96a). Both are immature in style and appreciably earlier than the sketch on the face of our picture which, by comparison with three sketches (V & A no. R.403, Tate no. 1814 and RA collection, 9 × 11½), seems to be fairly late, c 1830. *Coll:* Miss Isabel Constable sale, Christie's 17 June 1892 (217); George Salting; thence by descent.
Lady Binning gift 1918.

2016 Vale of Dedham
Based on the view from Langham, showing the Stour flowing towards Dedham and Harwich estuary beyond.

Canvas: 57⅛ × 48 (145 × 122) cleaned 1949. Painted in 1828 and exhibited RA 1828 (no. 7 or 232). The design was inspired by Claude's *Hagar and the Angel* (NG London no. 61), which Constable had copied in 1800 when it was in Sir George Beaumont's collection. An oil sketch of this composition, evidently painted in Sept 1802, is in the V&A London (no. R.37). *Lit:* C. R. Leslie: ... *Life of John Constable* 1951 ed. J. Mayne p. 165. *Coll:* Constable sale 16 May 1838 (75); William Taunton; Sir John Neeld Bart of Grittleton (bought 1877).
Bought, with help from the NA-CF, from L. W. Neeld in 1944.

COROT, Camille 1796–1875
French, born in Paris; in Italy 1825–8 and again later; associated with the Barbizon painters.

1447 **The goatherd**
Canvas: 24 × 20 (61 × 50·8) cleaned 1957. Signed: *COROT*. Begun in Arras and finished in July 1872 in Paris for a Monsieur Tédesco, who bought it from the artist. *Lit:* Robaut, no. 2380.
Dr John Kirkhope bequest 1920.

1448 **Souvenir de la Ferté-sous-Jouarre (morning)**
By *souvenir* Corot meant a painting from studies or from memory.
Canvas: 18¼ × 24⅛ (46·4 × 61·3) cleaned 1957. Signed: *COROT*.
Painted c 1865–70 (Robaut, no. 1827). Hitherto catalogued as *Le soir*.
Ecole des Beaux-Arts Exh: 1875 (182) lent by M. Furtin.
Dr John Kirkhope bequest 1920.

1449 **Landscape with a castle**
Canvas: 15⅞ × 21¼ (40·3 × 54) cleaned 1957. Signed: *COROT*.
Robaut (no. 1960) as painted c 1865–70. *Coll:* With Georges Petit, c 1885.
Dr John Kirkhope bequest 1920.

1681 **Ville d'Avray—entrance to the wood**
Canvas: 18⅛ × 13¾ (46 × 34·9). Signed: *COROT*. Robaut (no. 33) dates it c 1823–5 and records Sensier's account of seeing Diaz, in Corot's studio, paint in the woman seated at the roadside at Corot's suggestion, over a cow that was in the foreground. The area painted by Diaz differs slightly in colour from the paint round it. A copy from Corot's studio showing the cow before Diaz's alteration is in the Göteborg Museum. *Coll:* Bought by the art critic Alfred Sensier from the artist; passed to Georges Petit at Sensier's death 1877; Petit sale Paris 5 March 1921 (65).
Bought, with help from A. E. Anderson in memory of his brother Frank, from Cremetti, London, 1927.

1852 **The artist's mother**
Mme Corot (1769–1851) was born in Switzerland; she ran a milliner's shop in Paris where Corot and his sister were brought up.
Canvas: 16 × 12⅞ (40·6 × 32·8). Restored 1965 (X-rayed): there are areas of missing paint above her left thumb and her right wrist. Signed: *Corot.* Robaut (no. 588) dates it c 1845. *Coll:* Given by Corot to his sister, Mme Sennegon; thence by descent to Léon Chamouillet's daughter Mme Thomas, who sold it to Jean Dieterle et Cie., who sold it to G. Wildenstein.
Bought from Wildenstein and Co. 1936.

COTMAN, John Sell 1782–1842
English; worked, in oil and water-colour, in Norwich, Yarmouth, Normandy and London.

931 **Buildings on a river**
Canvas: 14¼ × 12¼ (36·2 × 31·1) cleaned 1951. One of several small paintings of cottages dating from 1807–10. *Lit:* S. D. Kitson: *Life of J. S. Cotman* London 1937 p. 117. *Coll:* George Holmes, Norwich; with W. B. Paterson in 1904.
National Art-Collections Fund gift 1905.

960 **Lakenham Mills**
Canvas: 13½ × 18 (34·3 × 45·5) cleaned 1943. From the early period, catalogued in 1908 as c 1811. *Coll:* William Martin.
Bought from W. B. Paterson, London, 1908.

COURBET, Gustave 1819–1877
French, born at Ornans; worked there and in Paris, later in Switzerland; founder of realism in French painting.

2233 **The wave**
Canvas: 18 × 21 (45·7 × 53·4) cleaned c 1955. Signed: *G. Courbet.* Perhaps painted c 1871. Some fifty variations on this subject are known, the earliest possibly *The Stormy Sea* (Louvre, Paris) shown in the Paris Salon 1870. *Coll:* Bought from Tooth's by Mr and Mrs Maitland, 1955.
Sir Alexander Maitland gift 1960.

2234 **Trees in snow**
Canvas: 28½ × 36¼ (72·4 × 92·1). Signed: *G. Courbet.* Delestre dates it c 1865. The group of trees recurs in another snow scene (repr J. Meier-Graefe: *Courbet* Munich 1921 pl. 76), in a summer study (repr A. Fontainas: *Courbet* Album d'Art Druet, Paris 1927), and in a large landscape with huntsmen of 1858 (Wallraf-Richartz-Museum,

Cologne). *Lit:* G. Delestre: *Courbet Exh* Boston 1959 catalogue
no. 51. *Coll:* Duc de Trévise, Paris; with Alfred Daber's (1949);
bought from Tooth's by Mr and Mrs Maitland, 1951.
Sir Alexander Maitland gift 1960.

CRANACH, Lucas, the elder 1472–1553
German; Court Painter to the Princes of Saxony from 1505;
assisted by his sons Hans and Lucas the younger.

1942 **Venus and Cupid**
Wood: 15 × 10⅝ (38·1 × 27). Signed with the dragon with upright
wings used up to 1537. In the years around 1530 the Cranachs painted
a number of variations on this theme. Closest to the design of ours is
a life-size painting in Berlin-Dahlem (no. 594), dated c 1530
by M. J. Friedländer and J. Rosenberg (*Lucas Cranach* Berlin 1932
no. 199). *Coll:* Bought by the 8th Marquess of Lothian (1832–70).
11th Marquess of Lothian bequest 1941.

CROME, John 1768–1821
Born Norwich and trained as a sign-painter. Painted landscapes,
mostly in East Anglia, and in 1803 was a founder member of the
Norwich Society of Artists.

2309 **The beaters**
Wood: 21½ × 34 (54·6 × 86·4) cleaned 1969. The painting formerly
bore an inscription in black print, *J. C. Crome 1810*, at an angle
bottom left of the centre, but this inscription, of doubtful authenticity,
was removed when the picture was cleaned. A painting formerly in
Lord Swaythling's collection which contained a figure group similar to
that in *The beaters* was described by Collins Baker as a sketch but
identified by D. and T. Clifford as a copy. *Lit:* C. H. Collins Baker:
John Crome London 1921 pp. 26, 34, 37, 41, 43, 121, 122, 158; D. and
T. Clifford: *John Crome* London 1968 pp. 207-209. *Coll:* J. N.
Sherrington sale 1 May 1858 (23) in which the picture was stated to
have been in John Bracey's collection. It is thus possibly identifiable as
the landscape with a road leading into a wood, painted for Bracey and
advertised by his executors in the *Norwich Mercury* for 10 June 1835,
though D. and T. Clifford think that the *Norwich Mercury* description
may have referred to another painting; H. S. de Zoete sale Christie's
8 May 1885 (166); A. Andrews by 1886; his sale Christie's 14 April
1888 (169) bought by Lawrie; Sir Samuel Montague (later Lord
Swaythling) by 1894; Swaythling sale Christie's 12 July 1946 (23)
bought by Agnew; Sir Brian Mountain; Sir Edward Mountain, Bart
bought from Leggatt's in 1950 by Harold Viscount Mackintosh.
Bought from Agnew's 1970.

CUYP, Aelbert 1620–1691
Born and died in Dordrecht, where he worked.

2314 **Landscape with a view of the Valkhof, Nijmegen**
Canvas: 44½ × 65 (113 × 165); certain areas, especially in the sky
and far background, have been re-touched. Signed: *A. cüyp*. A date
in the mid-1650s has been suggested by Reiss, and 1655–60 by Burnett.
The buildings follow closely a chalk and wash drawing by Cuyp in
the Pierpont Morgan Library, New York (Inv. I, 122), which
represents a view of the south-west corner of the Valkhof at Nijmegen,
a palace built by Charlemagne and demolished after the French
Revolution. The Valkhof stood on high ground above the river Waal,
but the surroundings have been levelled out in the Edinburgh
painting. The landscape is lit by the evening sun. *Lit:* HdG nos. 173
and 174 (De Groot associated his no. 173 with a picture in the John
Newington Hughes sale of 1848, which was in fact HdG 420); D. G.
Burnett in *Apollo* 1969 pp. 379–80; Stephen Reiss: *Aelbert Cuyp*,
Boston 1975, no. 128. (A draft entry on the Pierpont Morgan drawing
from their catalogue of Cuyp's drawings (in preparation) was kindly
provided by J. G. and I. van Gelder-Jost.) *Coll:* Earl of Ashburnham
in 1834 (Smith no. 260); sold by Lady Ashburnham to Alfred de
Rothschild, London, who lent it to RA 1903 (98); bought from
Edmund de Rothschild by L. R. Bradbury, who owned it in 1957.
 Bought from the estate of the late L. R. Bradbury in 1972, with the
aid of a contribution from the NA-CF in recognition of the services
of the Earl of Crawford and Balcarres to the Fund and the National
Galleries of Scotland.

CUYP, Jacob Gerritsz 1594–1652
Born and worked mainly in Dordrecht; father of Aelbert Cuyp.

attributed to J. G. Cuyp

Dutch family group (*two fragments*)
824 Wood: 42½ × 32¾ (108 × 83·2) cleaned 1964.

2259 Wood: 52½ × 45½ (133·4 × 115·6) cleaned 1964. Dated: *Factum
Ano 1633*.

Two fragments cut from a single panel, originally about 52½ × 82
(133 × 208), showing a man and wife both aged 40, their sons 16 and
13 and two daughters, the elder aged 10. River background perhaps
painted by one of the Willaerts. The boat is a Rotterdam boat. Other
family groups undoubtedly painted by the same artist are (1) in Lille
Museum, (2) in the Historisch Museum Rotterdam, (3) Brussels
Museum, 1957 cat. no. 802 (dated 1637). All have an attribution to

J. G. Cuyp, which is not quite convincing. *Coll:* No. 2259 was
with Muijser, The Hague, in the late 19th cent.
(824) Bought, as by Th. de Keyser, from J. St Hensé, Bradford, 1891.
(2259) Bought from Leger Galleries 1963.

DADDI, Bernardo active c 1327–48
Pupil of Giotto, active mainly in Florence.

1904 Triptych with the Crucifixion
Left wing: Nativity; two prophets, Micah and Zachariah (?);
Crucifixion of St Peter. Right wing: Madonna enthroned with
SS John the Evangelist, Peter, Paul and Augustine; two prophets;
St Nicholas and the golden apples. Above the centre panel:
Christ Blessing.
 Panels: (inside mouldings) centre 21 × 11 (53·3 × 28); wings
22¾ × 6 (57·7 × 15·3) restored 1969. An inscription along the
base has been repainted or strengthened, evidently before 1854
(see Waagen III p. 2). It reads ANNO DNI MCCCXXXVIII
FIORENTIA PER . . . Attributed to Daddi by O. Sirén (*Giotto and
some of his followers* Harvard 1917 pp. 167, 184 and 271). Described
by Berenson (1963) as in greater part by Daddi; by Offner (Section III
vol. IV p. 78) as by a close follower of Daddi. *Coll:* Fuller Maitland
by 1854 (Waagen) and in the Stansted Hall catalogues 1872 (p. 5) and
1893 (1) as by Giottino and Taddeo Gaddi; R. Langton Douglas as
Daddi; Julius Böhler, Munich.
 Bought from the Spanish Art Gallery, London, 1938.

DAUBIGNY, Charles-François 1817–1878
French, born in Paris; painted landscapes, mainly in the region
around Paris.

1035 La Frette
The view is taken from La Frette-sur-Seine, north west of Paris,
looking downstream towards Herblay, whose church is on the skyline.
 Wood: 14⅞ × 26⅛ (37·8 × 66·4). Signed: *Daubigny 1869*. *Coll:*
A French dealer's stock number 1142 on the back has not been
identified; with Tooth's, London.
 Hugh A. Laird bequest 1911.

1453 Soleil couchant
Wood: 9⅜ × 19⅝ (23·8 × 49·9). Signed: *Daubigny*. *Coll:* Alexander
Young sale Christie's 1 July 1910 (169) with the present title.
 Dr John Kirkhope bequest 1920.

DAUMIER, Honoré 1808–1879
French cartoonist and lithographer; started painting c 1832–35.

1616 Le peintre
Wood: 11⅜ × 7⅜ (29 × 18·8). Dated 1863–66 by Adhémar and,
more precisely, 1865–66 by Maison. *Lit:* J. Adhémar: *H. Daumier*
Paris 1954 pl. 133; K. E. Maison: *H. Daumier* London 1968 p. 157.
Coll: (in 1878) Geoffrey-Dechaume, a friend of the painter; Dr
George Viau; Reid and Lefevre, 1923.
National Art-Collections Fund gift 1923.

DAVID, Gerard working 1484–died 1523
Netherlandish; worked in Bruges in the 15th-century tradition.

2213 Three legends of St Nicholas
1. He gives thanks to God on the day of his birth.
2. He slips a purse through the window of an impoverished
nobleman as dowry for his daughters.
3. As Bishop of Myra, he resuscitates three boys salted down as
meat in a famine.

Three rectangular panels: each 22 × 13¼ (55·9 × 33·7) (the painted
area is arched at the top in each case and goes up to the edge at the
foot of panels 1 and 3). Restored 1963 (infra-red photographs).
Condition fair: the background of 1 is re-touched, there are paint
losses in the floor and nobleman's coat in 2, and the paint is thin on
the boys in 3.

Part of a large altarpiece with three main panels c 86 in (219 cm)
high of *St Anne with the Virgin and Child, St Nicholas and St Anthony*
(now NG Washington), and another three narrative panels of St
Anthony's life (now Toledo, Ohio). The original polyptych almost
certainly included the *Lamentation* now in the Art Institute Chicago
(J. D. Farmer in *Museum Studies* 8 1976 pp. 38–51). Dated close to
1511 by Friedländer (vi no. 167 and pp. 97–8). *Coll:* Cardinal
Antonio Despuig y Daneto, Archbishop of Valencia (resident in Italy
1787–96; died 1813); by descent to the Count of Montenegro,
Majorca; bought c 1848 by Leon de Somzée, Brussels. The original
altarpiece probably had as a predella the Chicago *Lamentation* between
two sets of three narrative panels. De Somzée had these two
sets framed as a kind of reliquary, and probably modified the main
panels at the same time (the centre panel seems to have been cut at
the sides and all three have been extended at the top). The six small
panels were bought in 1902 for the Wantage collection (1905 catalogue
pp. 52–4); passed by inheritance to Christopher Loyd, who sold
them in 1959.

Bought, with help from the NA-CF and a special Treasury grant,
in 1959.

23

DEGAS, Edgar 1834–1917
French, born and worked in Paris; influenced at first by Ingres and associated for a time with the Impressionists.

1624 **Nude study for 'The 14 year old dancer, dressed'**
Bronze: 28¼ (71·8) high. One of the 22 bronzes (number 56G) cast by Hébrard after Degas' death from the original wax model. Degas made the wax in 1879–80 as a study for the wax figure 39½ in high with real clothes, shown in the Salon des Indépendants 1881. *Lit:* Rewald 1944 no. xix.
Bought from the Leicester Galleries, London, 1923.

1785 **Portrait of Diego Martelli** (1839–96)
Florentine writer and art critic who was in Paris and wrote in defence of impressionism in 1879, the year of this portrait.
　　Canvas: 43½ × 39¾ (110·5 × 101). Signature stamp of Degas sale. Painted in 1879 and shown in the 4th Impressionist Exhibition 1879. Four preparatory drawings are known: our no. D3873; one in Cleveland, Ohio; one in Fogg Art Museum, Harvard; and Degas sale I, no. 326 (signed: *chez Martelli* 3 *avril* 79). An earlier painted version on a horizontal canvas (75 × 116cm) is in Buenos Aires Museum. *Lit:* Lemoisne no. 519. *Coll:* Degas sale I, May 1918 (58) bought by Paul Rosenberg; Mrs R. A. Workman (1922–26).
　　Bought from Reid and Lefevre 1932.

2224 **Before the performance**
Canvas: 18¾ × 24¾ (47·6 × 62·9). Signature stamp of Degas sale. Dated c 1896/8 by Lemoisne (no. 1261). Degas developed this design from an earlier pastel (repr Lemoisne no. 1262). *Coll:* Degas sale I, May 1918 (77); Capt E. Molyneux; David Eccles; bought from Tooth's by Mr and Mrs Maitland 1947.
　　Sir Alexander Maitland gift 1960.

2225 **Group of dancers**
Canvas: 18½ × 24½ (47 × 62·2) cleaned 1968. The arbitrary colour scheme of green and orange suggests a dating in the 1890s. An earlier pastel of this design is reproduced by Lemoisne (no. 768) who dates it 1884. Versions of the main group of figures are Degas sales II (81), II (344) and III (60). *Lit:* Lemoisne no. 770. *Coll:* Degas sale I, May 1918 (51); Hessel; Sevadjian sale Paris 22 Mar 1920 (6); bought from the Strauss family by Tooth's, who sold it to Mr and Mrs Maitland 1953.
　　Sir Alexander Maitland gift 1960.

2226 **Woman drying herself**
Pastel on paper: 25½ × 25 (64·8 × 63·5). A variant of this design (54 × 46cm, dedicated *à J. Blanche*) was in Degas sale II no. 186.

Lemoisne (no. 1113b) dates it 1890–5. *Coll:* Degas sale I (271), bought by Dr George Viau; his sale, Paris 15 May 1930 (9); Maurice Exsteens; bought from Lefevre by Mr and Mrs Maitland 1949. Sir Alexander Maitland gift 1960.

2227 **Study of a girl's head**
Canvas: 22 × 17¾ (55·9 × 45·1). Signature stamp of Degas sale. Subject, *contre-jour* effect, colour and handling suggest a date in the latter 1870s. *Lit:* Lemoisne no. 1021, as c 1890. *Coll:* Degas sale IV, July 1919 (11); bought from Barbizon House by Mr and Mrs Maitland 1926. Sir Alexander Maitland gift 1960.

2285 **Grande arabesque, third time**
Bronze: 15⅝ (40·3) high. Hébrard's cast no. 16G (cf no. 1624 above). From the period 1882–95. *Lit:* Rewald 1944 no. XL. *Coll:* Bought at the *Degas Exh.* Leicester Galleries, London 1923 by Mrs Alexander Maitland. Sir Alexander Maitland bequest 1965.

2286 **The tub**
Bronze: 8¾ high × 18 × 16½ (22·2 × 45·7 × 42). Hébrard's cast no. 26K (cf no. 1624 above). The base cast from wet cloth is not part of Degas' original wax model. Rewald (1944 no. XXVII) suggests a date of c 1886. *Coll:* Acquired from the heirs of Mme Hébrard by Marlborough Fine Art Ltd., who sold it to Mr and Mrs Maitland in 1952. Sir Alexander Maitland bequest 1965.

DELACROIX, Eugène 1798–1863
French, worked in Paris; visited Morocco and Algiers 1832; the leading painter of the romantic movement in France.

2190 **Arabs playing chess**
Canvas: 18⅛ × 21⅞ (46 × 55·5) cleaned 1921; relined before purchase 1957. Signed: *Eug. Delacroix.* Almost certainly the picture Delacroix said he was working on at Champrosay in July 1847, which he sold for 200 francs to the dealer Weill on 13 Mar 1849. *Lit:* A. Robaut: *L'Oeuvre . . . d'E. Delacroix* Paris 1885 (no. 598) as from 1835, which is too early by the style; *Journal d'E. Delacroix* (A. Joubin ed.) Paris 1932 II pp. 236 and 277. *Coll:* Bought from M. Garnier by Durand-Ruel in 1872; Goldschmidt sale Paris 17 May 1888 (30); Secrétan, Paris; Chicago Art Institute (1900–31); J. Stransky (1934). Bought from Reid and Lefevre 1957.

DELEN, Dirck van 1605–1671
Dutch; painter of architectural fantasies in the Flemish tradition
of Steenwijck.

111 **Conversation in a palace courtyard**
Wood: 21¼ × 18½ (54 × 47) restored 1941. Signed: *DV DELEN. F.*
1644 (DV in monogram). Pouncey points out that the Venus and Cupid
in the niche are taken from a Marcantonio engraving (Bartsch XIV
p. 234, 311).
Bought from the Duca Vivaldi Pasqua, Genoa, for the Royal
Institution 1830.

DIAZ de la Peña, Narcisse Virgile 1807–1876
French school; painted landscapes, chiefly at Fontainebleau;
associated with the Barbizon painters.

1043 **A pool in the forest**
Wood: 9⅝ × 12¾ (24·5 × 32·4). Signed: *N. Diaz.* Probably painted in
the 1860s in the Fontainebleau forest. *Coll:* A French stock number
12,294, and the stencil of [G TE]MPELAERE, Paris, are on the back.
Hugh A. Laird bequest 1911.

1044 **Enfants turcs**
Canvas: 8¾ × 6⅞ (22·2 × 17·5). Signed: *N. Diaz. Coll:* Count
Camondo (sold 1893?); with Bernheim-Jeune 1903/5 as *Enfants
sous bois.*
Hugh A. Laird bequest (with the present title) 1911.

DOMENICHINO, Domenico Zampieri 1581–1641
Born in Bologna; went to Rome in 1602 and worked in the circle of
Annibale Carracci. Later, from 1631, active mainly in Naples.

2313 **Adoration of the Shepherds**
Canvas: 56¼ × 45¼ (143 × 115). The blue draperies of the Virgin and
the standing shepherd at the right have been affected by chemical
change. Attributed to Annibale Carracci from 1813 until 1858; later
H. Tietze (*Jahrbuch der kunsthistorischen Sammlungen des allerhöchsten
Kaiserhauses* XXVI 1906–7 p. 144) identified it as Domenichino's copy
of a lost picture by Annibale Carracci described by G. P. Bellori
(*Le Vite de' Pittori* Rome 1672 p. 86). A drawing at Windsor (2083
verso, reproduced in R. Wittkower *The Drawings of the Carracci at
Windsor Castle* London 1952 p. 143 no. 344 fig. 44) of a kneeling
youth with a dove, which is clearly by Annibale Carracci, relates to the
kneeling figure in the right foreground of our picture. Another
drawing at Windsor (5700 *recto* and *verso,* reproduced by Brigstocke
figs. 40 and 41) which, as Schleier first pointed out, may probably be

attributed on stylistic grounds to Domenichino, consists of preparatory studies for two of the figures in our picture: the bagpiper in the left foreground and St Joseph. This suggests that Domenichino made substantial alterations to the original Carracci design. If, as the related drawing indicates, Domenichino invented the figure of the bagpiper or at least gave it a more prominent position than in the lost Carracci he might have also displaced the original figure of St Joseph; this would explain why he found it necessary to make a study for a new figure of St Joseph on the back of his drawing of the bagpiper. Annibale Carracci's lost painting probably dates from c 1596–8. Our variant version by Domenichino seems to date from around 1610. *Lit:* E. Borea: *Domenichino* Milan 1965. p. 147. H. Brigstocke in *Burl. Mag.* August 1973 p. 525. *Coll:* Sent from Rome to an unspecified destination in France by 1672. A *Nativity* attributed to Annibale Carracci which might well be the same picture (or else the lost Carracci) was mentioned by A. Félibien (*Entretiens sur les vies et sur les ouvrages des plus excellens peintres anciens et modernes* Trévoux 1725 III p. 274) as having been sold in France by Pierre Mignard to M. d'Erval; it then passed into the collection of Jean-Baptiste Colbert (1625–83). Then, according to P. J. Mariette (1694–1774), our picture (*ie* the Domenichino *Nativity* engraved by Colbenschlag) belonged to the Duc d'Orléans (*Abecedario de P. J. Mariette* ed. Paris 1859/60 VI p. 149); but there are no readily identifiable references to it in subsequent descriptions of the Orléans collection. The first reference to our picture after its importation into Britain dates from 1813 when it is listed in J. Britton's inventory of the collection of pictures in the house of the late Sir Francis Bourgeois, which had been bequeathed to Dulwich College in 1811 (Dulwich College archives). Sold by the Governors of the Dulwich College Gallery at Sotheby's 24 March 1971 (11).

Bought at Sotheby's 24 March 1971.

DONALD, John Milne 1819–1866
Scottish, born in Nairn; working in London 1840; settled in Glasgow 1844.

987 **A highland stream, Glenfruin**
Canvas: 25½ × 35⅜ (64·8 × 89·9). Signed: *J. Milne Donald 1861.*
Exhibited Glasgow International 1901 (321) lent by Joseph Henderson RSW.
Bought at the Henderson sale, Glasgow, 1909.

DOU, Gerrit 1613–1675
Dutch, born and worked at Leyden; pupil of Rembrandt 1628–31.

Interior with a young violinist
Wood (arched top): 12¼ × 9¼ (31·1 × 23·7). Signed: *GDOV. 1637.*
(*GD* in monogram). Known during the 19th century as a self
portrait. *Lit:* W. Martin: *Dou* London 1902 pp. 44–8 and 144;
KdK 1913 no. 85; HdG no. 82. *Coll:* One of the paintings bought
from Dou between 1637 and 1641 by the Swedish ambassador Pieter
Spiering (Sandrart p. 195) and sent to Queen Christina of Sweden;
returned by Christina to Spiering in 1652 (O. Granberg: *Cat.
raisonné . . . collections privées de la Suède* Stockholm 1886 p. 56
no. 196); Ladbrooke coll. (HdG no. 82); Marquess of Stafford by 1808
(Britton no. 186); thence by inheritance. Bridgewater House no. 244.
Duke of Sutherland loan 1946.

DOUGLAS, Sir William Fettes PRSA 1822–1891
Scottish, born in Edinburgh; self-taught; curator of this Gallery
1877–82; PRSA 1882.

981 **Stonehaven harbour**
Canvas: 47 × 23⅜ (119·4 × 58·8). Exhibited RSA 1876 (244).
RSA 1891/2 (168) lent by Dr Thomas Keith.
Bought at anon sale Christie's 24 Apr 1909 (no. 31).

1479 **Hudibras and Ralph visiting the astrologer**
An illustration to Butler's *Hudibras* Pt II Canto III.
Canvas: 25½ × 41½ (64·8 × 105·5). Signed with a crowned heart over
a W and dated '56. Exhibited RSA 1884 (224). *Coll:* J. Irvine Smith
sale, Dowell's Edinburgh 13 Feb 1909 (79).
Dr John Kirkhope bequest 1920.

DRUMMOND, James RSA 1816–1877
Scottish, born in Edinburgh; studied at the Trustees' Academy
there under William Allan. Curator of this Gallery from 1868.

180 **The Porteous Mob**
A reconstruction of incidents at the execution of Captain Porteous
in the Grassmarket, Edinburgh, in 1736 as described by Scott in his
novel *The heart of Midlothian*. The scene is at the corner of
Candlemaker Row.
Canvas: 44 × 60 (112 × 143). Signed: *J. Drummond 1855*. Exhibited
RSA 1855 (313) with a detailed description. A group of twenty
preliminary drawings is in our collection.
Bought by the Royal Association for the Promotion of the Fine
Arts 1856.

DUGHET, Gaspard 1615–1675
French, working in Rome; pupil of his brother-in-law, Nicolas
Poussin, and influenced by Claude.

2318 Classical landscape with a lake
Canvas: 28¾ × 39⅛ (73 × 99·5). Attributed to Dughet on grounds of
style. Sutton associates our picture with the influence on Dughet of
works by Nicolas Poussin of 1658 and later. The house by the lake
recurs in a landscape attributed to Dughet now at Tatton Park.
Lit: Ideal and Classical Landscape Exh. Cardiff 1960, no. 36, lent by
Mrs R. M. D. Thesiger; D. Sutton in *Gazette des Beaux-Arts* LX
1962 pp. 300–4; F. Arcangeli, catalogue of *L'ideale classico del seicento
in Italia* Exh. Bologna 1962, no. 113, as painted c 1655; L. Salerno:
Pittori di paesaggio del seicento a Roma Rome II [n.d.] p. 526
repr p. 539.
 Bought from Mrs R. M. D. Thesiger 1973.

in the style of Dughet

38 Classical landscape
Canvas: 42½ × 52½ (108 × 133). Cleaned 1941: a strip 7·5 cm wide at
the left side is a later addition. Previously attributed to G. F. Grimaldi.
Close to the style of Gaspard Dughet, the figures by another hand.
Lit: L. Salerno: *Pittori di paesaggio del seicento a Roma* Rome II
[n.d.] p. 670 repr p. 674 (as, Pandolfo Reschi).
 Given to the RSA by Robert Clouston in 1850; transferred 1910.

by a follower of Dughet

88 Landscape
Canvas: 24 × 33½ (61 × 85) cleaned 1960. Catalogued in 1831 as
Tavella (1668–1738), but with a note on its 'strong resemblance' to
Dughet's work. Chiarini points out that its design is related to a
drawing by Dughet in the BM London (1946–7–15–1120) and to his
Landscape with Waterfall in the Royal Collection, and considers our
picture to be a late work by Dughet himself. It is, however, less spatial
and more decorative in effect than the Queen's picture and seems
more likely to be by a later follower. *Lit:* M. Chiarini in *Burl. Mag.*
Dec 1969 p. 750.
 Bought from the Doria family, Genoa, for the Royal
Institution 1830.

DUJARDIN, Karel 1622–1678
Dutch, born in Amsterdam; pupil of N. Berchem; perhaps in Italy
before 1652; in Italy from 1674.

25 Halt at an Italian wine-house
Canvas: 31⅞ × 35¼ (81 × 89·6) cleaned 1936. Identified as one of a
group of late landscapes painted by Dujardin in Italy 1675–78 by

E. Brochhagen (*Bull: des Musées Royaux* . . . Brussels 1957 p. 236).
Sir James Erskine of Torrie bequest to Edinburgh University 1835;
deposited on loan 1845.

DUTCH 17th century

Old lady wearing a ruff
Wood: 20¼ × 17½ (51·3 × 44·4). Formerly attributed to Frans Hals,
and described by Bode in 1883 as painted by Hals c 1640 under
Rembrandt's influence. It is not, however, mentioned by Bode in his
F. Hals (Berlin 1914) and is omitted by E. W. Moes from his list of
1909, and by de Groot in 1910. It was catalogued in the RA Exh 1952
(196) as Dutch school c 1630. It was probably painted in Amsterdam
in the 1630s. *Lit:* W. V. Bode: *Studien zur Geschichte der
holländischen Malerei* Brunswick 1883 pp. 66 and 91; H. de Groot III
p. 138 note 7. *Coll:* Presumably acquired by the Marquess of Stafford
c 1808–15 (not in Britton 1808, but repr in *Stafford Gallery* 1818 III
no. 17 as by Hals); thence by inheritance. Bridgewater House no. 280.
Duke of Sutherland loan 1946.

DYCE, William RA, HRSA 1806–1864
Scottish, born in Aberdeen; in Rome 1825, 1827–29 (when he met
the German Nazarene painters), and later visits; in Edinburgh
1830–37; thereafter mainly in London.

460 Francesca da Rimini
Canvas: 56 × 69¼ (142 × 176) cleaned 1976. Exhibited Society of
Artists, Edinburgh 1837 (49) with a quotation from the 5th Canto
of Dante's *Inferno*. The original size of the picture is given as 58 × 94
(147 × 239). It then showed the deformed brother Gianciotto at the left,
dagger in hand, but the figure was 'found objectionable' and cut away
by the RSA Council in 1881. Infra-red photographs show an earlier
version of Gianciotto's figure in a different position and considerable
alterations in the figure of Paolo.
Bought by the RSA 1864; transferred 1910.

2199 Shirrapburn Loch
Also called *Loch in Arran*. Shirrapburn is perhaps Glen Shira, near
Inveraray.
Wood: 12 × 16 (30·5 × 40·6) cleaned 1959. Painted c 1850–55.
Lit: A. Staley in *Burl. Mag.* 1963 p. 475. *Coll:* Lent by James Brand,
the artist's father-in-law, to Manchester Exh 1887 (860) as
Shirrapburn Loch.
Charles Guthrie ws gift 1961.

2267 **St. Catherine**
Wood: 35 × 25½ (88·9 × 64·8). Painted c 1840, inspired by the
Raphael *St Catherine* which was bought by the National Gallery
London from the Beckford coll. early in 1839. X-ray and infra-red
photographs suggest that Dyce painted out some putti that were in the
clouds and an angel at which the saint gazed. *Coll:* Presumably the
St Catherine in the John Heugh sale, Christie's 24 Apr 1874 (177).
Bought from Sir Alec Martin 1964.

DYCK, Sir Anthony van 1599–1641
Born in Antwerp; in Italy (mainly Genoa) Nov 1621–27; mainly in
England after 1632.

120 **'The Lomellini family'**
Possibly represented are members of the family of Giacomo Lomellini
'il Moro', died c 1653–56 (H. Macandrew in *Burl. Mag.* 1972 pp.
616–17). The identification of the sitters in previous Gallery catalogues
was based on the erroneous assumption that the palace from which the
picture came belonged to Doge Giacomo Lomellini.
Canvas: 106 × 100 (269 × 254). Painted c 1623–27. Restored 1952:
the condition on the whole is bad; there are considerable damages,
especially on the children's faces. Waagen (III p. 268) gives notes on
its condition in 1854. *Lit:* KdK 1931 no. 194. *Coll:* In 1766 Ratti
(p. 136) saw it in the Palazzo of Agostino di Carlo Lomellini,
great-grandfather of the Marchese Luigi Lomellini, Genoa, who sold
it in 1830.
Bought in Genoa by Andrew Wilson for the Royal Institution 1830.

121 **St Sebastian bound for martyrdom**
Canvas: 89 × 63 (226 × 160). Painted c 1621/3. X-rays show that it
began as a version of the early *St Sebastian* in the Louvre, Paris, of
c 1615–16 (KdK 1931 no. 5). Van Dyck painted a quite new design
over the top some time later (perhaps in Genoa). He then used this
canvas as a life-size study for the finished painting in Munich (KdK
1931 no. 66). The only convincing preparatory oil sketch is published
by Voss. Other related works are Van Dyck's *Soldier on horseback*
(Christ Church, Oxford) and *St Sebastian* (N G Dublin), sketches 19v
and 20v (M. Jaffé: *Van Dyck's Antwerp Sketchbook* London 1966) and,
probably, a drawing by G. P. Sweelinck of *The Israelites untying Achior
from the tree* dated 1601 (Rijksmuseum, Amsterdam). *Lit:* C.
Thompson in *Burl. Mag.* 1961 p. 318; H. Voss in *Kunstchronik* XVI
11 1963 p. 294. *Coll:* (An unidentified inventory no. 169 is painted on
the canvas.) In 1766 Ratti (p. 171) saw it in the Palazzo of Giacomo
Balbi, Genoa; by descent to the Marchese Costantino Balbi, whose
daughters sold it in 1830.
Bought for the Royal Institution 1830.

Portrait of a young man
Canvas laid on wood: 30½ × 22 (77·5 × 56). First known as a self
portrait by Velázquez. Cust (no. 41) attributed it to a Spanish painter
with an affinity to van Dyck's Genoese manner. It was included by
Glück in his catalogue of van Dyck (KdK 1931 no. 130). A version
which seems to be unfinished was formerly in the Kunsthistorisches
Museum Vienna (no. 2308, as manner of van Dyck). *Coll:* Bought by
the 3rd Earl of Ellesmere; thence by descent. Bridgewater House
no. 501.
Duke of Sutherland loan 1946.

ELSHEIMER, Adam 1578–1610
German, born in Frankfurt; settled in Rome 1600.

2281 **Stoning of St Stephen**
In the left foreground is St Paul before his conversion; in the sky is
St Stephen's vision (Acts VII 54–60).
Copper, with silvered surface: 13⅝ × 11¼ (34·7 × 28·6) cleaned 1965.
Painted c 1602–5, and possibly the picture of this subject which
belonged to Paul Bril (1626) and later recorded in the collection of
Cardinal Curzio Origo (1712). The standing man at the right is
evidently taken from Vasari's design of the *Stoning of St Stephen*
(versions in S Stefano Pisa and the Vatican). A drawing by Rubens in
the British Museum (Hind no. 44) is a free composition incorporating
numerous figures from Elsheimer's design, proving that Rubens had
seen it: the drawing was engraved by P. Soutman (died 1657) with the
inscription *Adam Elsheimer Inuent.* It seems clear that the design was
also known early to the Dutch: compare for instance Jacob Pynas's
Adoration of the Kings of 1617 (Wadsworth Atheneum Hartford); and
the *St Stephen* by Rembrandt (1625) in Lyons Museum (see Gerson
1968 p. 488). *Lit:* I. Jost in *Burl. Mag.* 1966 p. 3; K. Andrews:
Adam Elsheimer Phaidon 1977 no. 15. *Coll:* Almost certainly the
picture bought by Herzog von Braunschweig c 1775–80 and later sold
by him to a merchant in Hamburg (see J. D. Fiorillo: *Geschichte der
zeichnenden Künste in Deutschland und den vereinigten Niederlanden*
Hamburg 1815–20 vol II p. 553); probably acquired by the Very Rev.
G. D. Boyle (1828–1901); thence by descent to the last owner.
Bought in 1965.

2312 **Il Contento**
Copper: 11¾ × 16½ (30 × 42) cleaned and restored 1970. A late work,
for which Andrews suggests a date of c 1607. It was described as
unfinished at Elsheimer's death (see below). An area at the right-hand
edge was clearly not finished, and weaknesses in some of the
foreground figures indicate that they were completed by another hand.

Andrews shows that this was done soon after Elsheimer died. The story in its main outline was taken from a Spanish picaresque novel *Vida y hechos del picaro Guzman de Alfarache* by Mateo Alemán, published in Madrid 1599 and, in Italian translation, in Venice 1606 (see J. Kuznetsov in *Oud Holland* 1964 pp. 229–30). Jupiter sent Mercury to earth to abduct the god Contento (shown in the painting as a goddess), whom the people were worshipping more than himself, instructing Mercury to deceive the people by leaving Discontent in his stead disguised in the same clothes. *Lit:* Sandrart p. 161, where he calls it Elsheimer's masterpiece; K. Andrews: *Adam Elsheimer— Il Contento*, Edinburgh 1971; K. Andrews: *Adam Elsheimer* Phaidon 1977 no. 19. *Coll:* Described in the inventory of Elsheimer's effects, 19 Dec 1610, eight days after his death, as *Un Rame dove è dipinto Il dio del Contento con molte figure non finito* (see K. Andrews in *Burl. Mag.* 1972 pp. 594–600); Andrews (1971 pp. 19–21) argues that it was owned by a Cardinal in Rome in 1615 (possibly Odoardo Farnese), but had been brought north by 1617. Owned by Du Fay, a Frankfurt merchant, in 1666 and by his descendants until 1734 or later; in the sale of the late Monsieur Poullain, Receveur général des Domaines du Roi, Paris, 20 Mar 1780 (21), bought by the dealer Langlier; Richard Payne Knight (1750–1824), Downtown Castle; thence by descent.
Ceded in lieu of estate duty from the estate of Major Kincaid-Lennox; received 1970.

EMMS, John 1843–1912
English, born in Norfolk; settled in Hampshire 1870; animal painter.

1226 Callum
Portrait of Mr J. Cowan Smith's Dandie Dinmont terrier.
Canvas: 27½ × 35½ (69·9 × 90·2). Signed: *Jno. Emms 1895* and inscribed: *Callum*.
James Cowan Smith bequest, together with a sum of over £55,000 to form a purchasing fund, in 1919.

ETTY, William R A 1787–1849
English, born at York; settled in London 1806, entered the RA Schools 1807 under Lawrence; visited Italy 1822–4.

185 Judith's maid waiting outside the tent of Holofernes
Canvas: 118 × 108 (300 × 274).

186 Judith and Holofernes
Canvas: 120 × 157 (305 × 400).

187 Judith coming out of the tent
Canvas: 118 × 108 (300 × 274).

Three members of a triptych, illustrating the Book of Judith XIII
1–10. Etty showed no. 186 at the RA 1827 (12). It was bought by the
Scottish Academy (later RSA) in 1829, and the two wings were
commissioned by them in 1830. No. 187 was shown RA 1830 (124)
and no. 185 RA 1831 (79). The paintings are now ruined by the
effects of bitumen. For the circumstances in which these three and the
next two paintings by Etty were acquired for Edinburgh, see F. Rinder
and W. D. McKay: *The RSA 1826–1916* Glasgow 1917 pp. xlviii–1,
lvii–lxii. For critical discussion and notes on preparatory studies, see Farr
(pp. 50/1 and catalogue nos. 24–6).

Transferred from the RSA collection 1910.

188 Benaiah slaying two lion-like men of Moab
II Samuel XXIII 20–23.

Canvas: 120 × 157 (305 × 400) now damaged by the effects of
bitumen. Exhibited RA 1829 (16) and British Institution 1830 (444).
Lit: Farr p. 55 and catalogue no. 3.

Bought from the artist by the RSA in December 1831;
transferred 1910.

189 The combat: Woman pleading for the vanquished—An ideal groupe
Canvas: 100 × 134 (254 × 341) now damaged by the effects of
bitumen. Exhibited RA 1825 (1) and British Institution 1826 (343).
For discussion, details of its reception by the public and preparatory
studies, see Farr (pp. 47–50, 62 and catalogue no. 48). *Coll:* Bought
from Etty by the painter John Martin.

Bought from John Martin by the RSA 1831; transferred 1910.

FAED, John RSA 1819–1902
Scottish, born near Gatehouse-of-Fleet; began as a miniature painter;
in Edinburgh from 1839, where he attended the Trustees' Academy; in
London 1862–c 1880.

1142 The evening hour
Portrait group of James Noble Bennie and his two sisters, children of
Dr Archibald Bennie DD (1797–1846).

Water-colour on ivory: 13 × 9½ (33 × 24·2). Exhibited RSA 1847
(454). The affective title dates from 1919.

J. Bray of Penzance gift 1914.

FANTIN-LATOUR, Henri 1836–1904
French, worked in Paris; pupil of Courbet, painted chiefly portraits
and flower studies.

1455 **Roses**
Canvas: 14⅜ × 15⅜ (36·5 × 39) cleaned 1967. Signed: *Fantin*.
Dr John Kirkhope bequest 1920.

1950 **Peaches on a dish**
Wood: 9½ × 13 (24·2 × 33). Signed: *Fantin 73*. *Coll:* Anon sale
Christie's 11 July 1924 (61) bought by Cremetti.
Rev H. G. R. Hay-Boyd bequest 1941.

FERGUSON, William Gouw c 1632/3–after 1695
Born in Scotland; settled in Holland by 1660; painted mainly
still-lives in the style of Jan Weenix.

190 **A ruined altar and figures**
A sinister scene at the mouth of a cave with shattered altars, one of
them with a statue of Cybele(?).
Canvas: 27 × 21¼ (68·6 × 53·7) cleaned 1940. The attribution
goes back at least to 1883 (RSA list p. 20) and is confirmed by a very
similar painting signed *W.G.F.* on the Amsterdam art market in 1967.
Alexander White of Leith gift to the RSA 1858; transferred 1910.

FERRARESE 15th century

1535 **Madonna and Child with two angels**
Wood: 23 × 17⅜ (58·4 × 44·1). The illusionistic frame with torn
vellum strips occurs also in certain manuscripts. Ascribed by Longhi
(p. 48) in 1934 to a Ferrarese miniature painter close to G. Giraldi
(died c 1480), and by Fava and Salmi to one of the miniature painters
of the Missal of Borso d'Este at Modena; Berenson (1968) as Ferrarese
before 1510. *Lit:* D. Fava and M. Salmi: *I manoscritti miniati della
Biblioteca Estense* Florence 1950 I p. 89. *Coll:* Samuel Woodburn sale
Christie's 9 June 1860 (54) as by 'Mosca', bought by Daniell;
RA 1873 (165) lent W. Fuller Maitland.
Bought from the Fuller Maitland collection 1921.

FLEMISH 16th century

1254 **Emperor Charles V** (1500–1558)
Wood: 7¾ × 5⅝ (19·8 × 14·8). A very similar portrait is in the
Musée Granet, Aix (no. 233). Perhaps a contemporary variant of
a lost Bernard van Orley prototype of c 1516, painted at Malines.
Lit: Toison d'Or Exh Bruges 1962, catalogue no. 83. *Coll:* Sir Henry
Hawley.
Bought from R. Langton Douglas 1920.

1541 **Adoration of the Shepherds**
Wood: $26\frac{1}{2} \times 42$ (67·3 × 106·6) painted up to the lower edge only.
Cleaned 1954. The Nativity scene and its setting derive from Rogier
van der Weyden's *Bladelin altar* in Berlin-Dahlem. N. Veronee
Verhaegen (letter of 1969) attributes it to the Brussels school, late in
the 15th century, the faces being characteristic of Brussels painters,
and especially close to Vranck van der Stockt. *Coll:* Fuller Maitland
(Stansted Hall catalogue 1893 no. 50).
Bought, as attr. to Rogier van der Weyden, from the Fuller Maitland
collection 1921.

FLEMISH 16th century

1642 **Pietà**
Wood: $8\frac{1}{2} \times 10\frac{3}{4}$ (21·6 × 27·8). The group of Christ and the Virgin is
a variation of the corresponding group in Isenbrant's *Seven Sorrows
of Mary* (Notre Dame, Bruges) and in a *Pietà* attributed to the school
of David in the Kröller-Müller Museum, Otterlo (1959 cat no. 50).
The design derives from a *Lamentation of Christ* by Gerard David
(J. G. Johnson coll., Philadelphia). Differences in our panel are the
crossed feet of Christ, the unusual gesture of the Virgin's right hand,
which normally holds Christ's body at the waist, and the Dominican
donor. Friedländer (VI 197a) classed it as a free imitation of the
Otterlo panel, which he attributed to David.
Bought, as attributed to Petrus Christus, from the Spanish Gallery,
London, 1925.

FLEMISH 16th century

1929 **Portrait called James IV**
Wood: $14\frac{3}{8} \times 11\frac{1}{2}$ (36·5 × 29·3) cleaned 1941. Probably painted in
Antwerp c 1510–20. By c 1720 it was in the Lothian collection at
Newbattle, paired with our no. 1930 (see p. 17), which was made up
in size to match it. By 1798 the pair was described as portraits of
James IV and Margaret Tudor by Holbein. The identification as
James IV is very unlikely. (The James IV in the Jamesone series at
Newbattle is a copy of our portrait painted after 1720 and is not
helpful evidence.) *Lit:* Newbattle inventories of c 1720 and 1798.
11th Marquess of Lothian bequest 1941.

FLICKE, Gerlach died 1558
Came from Osnabrück and settled in England c 1545.

1933 **Portrait called William, 13th Lord Grey de Wilton** (c1508–1562)
Wood: $41\frac{1}{4} \times 31\frac{1}{4}$ (104·8 × 79·4). Signed: *Gerlacus fliccus/*
Germanicus/faciebat (repeated by a later hand below), and
inscribed (originally in black): AN°. DNI./1547/AETATIS/40.
Restored 1943 (there are some old re-touches in oil paint). The
identification of Lord Grey (suggested by M. Hervey in *Burl. Mag.*
May 1910 p. 68) is not certain. *Coll:* In an inventory of the Lothian
pictures at Newbattle Abbey c 1720.
11th Marquess of Lothian bequest 1941.

FLORENTINE 15th century

Madonna and Child
Wood: painted surface $19\frac{1}{2} \times 13\frac{1}{4}$ (49·5 × 33·7). One of the better
versions of a design frequently used in Florence which, as Hendy
pointed out, very possibly derive from a picture in the Gardner
Museum, Boston, by Pesellino. The National Gallery picture has been
attributed to Piero di Lorenzo by Borenius and to Fra Diamante by
Berenson (1963). *Lit:* T. Borenius in *Apollo* 1925 I p. 65; P. Hendy
in *Burl. Mag.* Aug 1928 p. 67; Davies 1961 p. 194 (no. 6266).
Coll: Possibly Bardini, Florence. Sir Thomas Gibson Carmichael
(Lord Carmichael) before 1902; Lord Carmichael bequest to the
National Gallery, London (received 1956).
National Gallery loan 1958.

FRASER, Alexander ARSA 1786–1865
Scottish, born in Edinburgh; at the Trustees' Academy with Wilkie:
in London from 1813. Reputed to have painted still-life in
Wilkie's pictures.

982 **Fisher folk**
Canvas: $12 \times 16\frac{1}{8}$ (30·5 × 41). Hitherto catalogued as William Kidd.
A characteristic work by Fraser of the 1820s, very possibly RSA 1829
(172) *The fisher boy*. Compare especially *The young boat builders*
of 1824 (Countess of Sutherland coll.).
A. K. Brown RSA gift 1909.

FRENCH (?) 16th century

2274 **George 5th Lord Seton** (1531–86)
Lord Seton was in France 1557–8 for the marriage of Mary Queen
of Scots, to whom he became Master of the Household in 1561 or
perhaps before. He holds a baton of office inscribed MR.
Wood: $47\frac{1}{4} \times 41\frac{5}{8}$ (120 × 105·7) restored 1968. The panel has been cut
down at the right. Inscribed: AETATIS SUAE 27 and *In adversit* [*ate*]/
patiente/In prosperit [*ate*]/*benevole* [*nte*]/*Hasard z* [*et*]/*forduer* [*d*]/*157* .

The sitter's name and arms (Seton quartering Buchan) are at the top, perhaps painted rather later. The inconsistency of a date after Mary's abdication suggests that the painting may have been a record after the event, painted on a later visit to France, perhaps about the time of the family group, no. 2275 (see p. 76). A smaller version ($24\frac{1}{2} \times 19\frac{1}{2}$) inscribed *aetatis 27 1558* was with a branch of the family (recorded at Pinkie House in 1739). *Lit:* A. Nisbet: *System of Heraldry* Edinburgh 1816 I p. 234 (first pubd. 1722); *British Portraits Exh:* RA 1956 (24); D. Piper in *Apollo* Dec. 1956 (p. 196). *Coll:* Lord Somerville (by 1757); by inheritance to the donor.

Sir Theophilus Biddulph bequest, received 1965.

FURINI, Francesco 1603–1646
Born Florence, and mainly active there. Visited Rome and Venice.

30 St Sebastian
Canvas: $19\frac{1}{4} \times 14\frac{3}{4}$ (49 × 37·5) restored 1943. Dated c 1633 by E. Toesca (*Furini* Rome 1950 p. 12). *Coll:* Gerini sale catalogue 1825 (84).

Bought from the Marchese Gerini, Florence, for the Royal Institution 1831.

31 Poetry
Paper laid on panel: $16\frac{1}{4} \times 13\frac{1}{2}$ (41·3 × 34·3) restored 1943. From about the same period as no. 30 but not a companion. *Lit:* C. Thiem: *Florentiner Zeichner des Frühbarock* Munich 1977 p. 378 no. 170 repr. *Coll:* Gerini sale catalogue 1825 (82).

Bought from the Marchese Gerini, Florence, for the Royal Institution 1831.

GAINSBOROUGH, Thomas RA 1727–1788
English, born in Suffolk; in London 1742; Suffolk 1745; Bath 1760; London 1774.

332 The Hon Mrs Graham
The Hon Mary Cathcart (1757–92), daughter of Charles, Baron Cathcart, married in 1774 Thomas Graham of Balgowan, later Lord Lynedoch.

Canvas: $93\frac{1}{2} \times 60\frac{3}{4}$ (237 × 154) restored 1953. Begun in 1775 and exhibited RA 1777 (133). A kitcat size portrait of the sitter (36 × 28 in, now NG Washington) may have been a study for our picture. *Lit:* E. Maxtone Graham: *The Beautiful Mrs Graham* London 1927 p. 47; Waterhouse 1958 no. 323.

Bequest of Robert Graham of Redgorton, Lord Lynedoch's heir, in 1859 on condition that it should never leave Scotland.

1521 **Mrs Hamilton Nisbet** (1756–1834)
Mary, daughter of Lord Robert Manners, married in 1777 William
Hamilton Nisbet of Belhaven and Dirleton.
 Canvas: $91\frac{3}{4} \times 61$ (233 × 155). Painted in Gainsborough's last years
(Waterhouse 1958 no. 516).
 Mrs Nisbet Hamilton Ogilvy of Biel (the sitter's great
grand-daughter) bequest 1921.

2174 **Landscape with distant view of Cornard village, Suffolk**
Canvas: $30 \times 59\frac{1}{2}$ (76·2 × 151) restored 1953. Dated in the early 1750s
by Waterhouse (1958 no. 840), but J. Hayes has adduced reasons for
dating it earlier, c 1747 (in *Apollo* 1962 p. 672). *Coll:* Bought in
London in the 1890s by W. H. Fuller; Fuller sale New York 25 Feb.
1898 (33); J. W. Ellsworth, Chicago; Kenneth Wilson (1927); Countess
of Munster; Alan P. Good sale 15 July 1953 (15) bought by Tooth.
 Bought from Tooth's 1953.

2253 **Rocky landscape**
Canvas: 47×58 (119·4 × 147·3) cleaned 1968. Painted c 1783;
probably RA 1783 (34). A finished study, canvas $27\frac{1}{4} \times 36\frac{1}{2}$
(69·2 × 92·7), is in Mrs Oscar Ashcroft coll., and a preliminary chalk
drawing is in the Cecil Higgins Museum, Bedford. *Lit:* Waterhouse
1958 no. 966. *Coll:* Sale after Gainsborough's death at Schomberg
House, 1789 (72), bought by Lord Gower, later 1st Duke of
Sutherland.
 Bought, with the help of a special Treasury grant, from the
Duke of Sutherland in 1962.

GAROFALO (Benvenuto Tisi) c 1481–1559
Ferrarese; influenced by Raphael.

 32 **Christ driving the money-changers from the temple**
Wood: $18\frac{1}{4} \times 14\frac{1}{2}$ (46·3 × 36·8) cleaned 1954.
 Bought from the Duke of Vivaldi Pasqua, Genoa, for the
Royal Institution 1830.

GAUGUIN, Paul 1848–1903
French; devoted his time to painting from 1883; went to Tahiti 1891
and remained in the South Seas till 1893 and from 1895.

1643 **The vision of the sermon** (*Jacob and the Angel*)
Canvas: $29\frac{1}{4} \times 36\frac{5}{8}$ (74·4 × 93·1). Signed: *Gauguin 1888*. Painted at
Pont-Aven, Brittany, in the summer of 1888. The tree and the wrestling
figures were inspired by Japanese woodcuts; the style and placing of
the peasant women were inspired by a painting by the young Emile
Bernard who was then visiting Gauguin in Pont-Aven. The concept of

the subject was Gauguin's: 'To me . . . the landscape and the struggle exist only in the imagination of these praying people, as a result of the sermon' (letter to van Gogh, Sept 1888). It caused the poet Albert Aurier to hail Gauguin in 1891 as the champion of symbolism in painting. *Lit:* For Gauguin's letter see J. Rewald: *Post-Impressionism* New York 1956 p. 202; A. Aurier in *Mercure de France* Feb 1891; *Gaz. des Beaux-Arts* 1955 p. 227 (H. Dorra); *ibid* issue for Jan/Apr 1956 *passim; ibid* 1959 p. 329 (M. Bodelsen); see further in Wildenstein 1964 no. 245. *Coll:* Offered by Gauguin to the priest of the parish of Nizon, near Pont-Aven, to hang in his church, but refused; *Exposition des XX* Brussels 1889 (Gauguin entry no. 7: *Vision du Sermon*); Gauguin sale Paris 23 Feb 1891 (6) bought by H. Meilheurat des Prureaux; bought 1911 by J. Neville of the Stafford Gallery in Paris through Druet and Vollard for Sir Michael Sadler (M. Sadleir: *M. E. Sadler* . . . London 1949 p. 232), who lent it to *Gauguin/Cézanne Exh.* Stafford Gallery 1911/12 (see painting by S. Gore repr. *Burl. Mag.* 1954 p. 295).

Bought from Sir Michael Sadler in 1925.

2220 Martinique landscape
Canvas: $45\frac{1}{2} \times 35$ (115·5 × 89). Signed: *P. Gauguin 87.* One of about twelve landscapes painted in June and July 1887 in Martinique. *Lit:* Wildenstein 1964 (no. 232). *Coll: M. Chausso[n]* on the stretcher is undoubtedly the composer Ernest Chausson (died 1899), whose widow lent two landscapes to the *Gauguin Exh.* Salon d'Automne, Paris 1906, of which no. 211 was without figures and is probably our picture; Mrs R. A. Workman (1925/6); the Hon Sir Evan Charteris (1932); bought in 1932 by Mr and Mrs Maitland.

Sir Alexander Maitland gift 1960.

2221 Three Tahitians
Canvas: $28\frac{3}{4} \times 37$ (73 × 94). Signed: *P. Gauguin 99.* One of a group of paintings that seem to have been developed from ideas contained in *Faa Iheihe* of 1898 (Tate Gallery). *Lit:* G. Wildenstein: in *Gaz. des Beaux-Arts* Jan/Apr 1956 pp. 137, 155; and 1964 no. 573. *Coll: Gauguin Exh.* Salon d'Automne, Paris 1906 (19) lent by Gustave Fayet of Béziers, one of the first collectors of Gauguin; by descent to Mme d'Andoque (after 1925); with Wildenstein 1931–35; bought by Mr and Mrs Maitland in 1935.

Sir Alexander Maitland gift 1960.

GEDDES, Andrew ARA 1783–1844
Scottish, born in Edinburgh; went to London in 1806; at the Royal Academy Schools with Wilkie; in Edinburgh 1810–14; thereafter mainly in London. Mainly portrait painter and etcher.

191 Summer
Canvas: 32 × 25¼ (81·3 × 64·2) cleaned 1957. Exhibited Royal
Institution, Edinburgh 1828 (42). Based on the Rubens *'Chapeau de
Paille'* (NG London no. 852), which was in the Peel coll. (in England
from 1823). The identification of the sitter as Charlotte Nasmyth
1804–84, daughter of Alexander (which is very likely correct), occurs
first in the 1899 catalogue. Studies by Geddes after Rubens and for
Summer are our nos. D(NG) 1073 a & b. Two other versions painted
by Geddes are known.
Bought from the artist by the Royal Institution 1828.

630 The artist's mother
Canvas: 28½ × 24¼ (72·4 × 61·6). Etched in reverse by the painter in
1822.
Gift of Mrs Geddes, the artist's widow, 1877.

631 Hagar
An illustration to Genesis XXI, 16.
Canvas: 30 × 25 (76·2 × 63·5) cleaned 1961. Exhibited RA London
1842 (301).
Gift of Mrs Geddes, the artist's widow, 1877.

847 Andrew Plimer (1763–1837)
English miniature painter, whose niece Adela married Geddes in 1827.
Wood: 18½ × 15 (47 × 38·1). Signed: *A Geddes 1815.* (*AG* in
monogram). *Coll:* Bought by Colnaghi's from Mrs James, niece of
the sitter's wife.
Bought from Colnaghi's 1900.

GEERTGEN tot SINT JANS
Late 15th century; born perhaps c 1460–65, worked at Haarlem;
died there aged about 28.

by a follower of Geertgen

1253 Crucifixion with SS Jerome and Dominic and scenes from the passion
Wood: painted area 9⅝ × 7¼ (24·4 × 18·4) cleaned 1960 (X-rayed).
One of two known panels from a small altarpiece whose subjects are
connected with the Dominican cult of the rosary. The other panel is
the *Glorification of the Virgin* (Boymans-van Beuningen Museum,
Rotterdam). The two correspond exactly in size and form. Marks, as
if from hinges, are consistent with a diptych having our panel on the
left, but they do not prove it. (Both panels were in the Fesch sale of
1844, but already as separate pendants.) The Rotterdam panel has
been generally attributed to Geertgen, yet our panel is agreed to be
derivative, possibly early 16th century. *Lit: Oud Holland* LXXXI
1966: articles by G. Lemmens (p. 73) and J. Q. van Regteren Altena

(p. 76) citing previous literature; Friedländer v (1969 ed.) p. 92 Add. 140. *Coll:* Both panels in Cardinal Fesch sale in Rome Mar/Apr 1844 no. 263 (ours) and no. 264, both attributed to Herri met de Bles and marked as having been brought from France; our panel only in coll. F. Locker Lampson, Rowfant (1886 catalogue p. 232).

Bought from Colnaghi's 1920.

GEIKIE, Walter RSA 1795-1837
Scottish; deaf and dumb; born and worked in Edinburgh, mainly at etching scenes of Scottish life.

1825 **Scottish roadside scene**
Canvas: 16 × 24 (40·6 × 61) cleaned 1935. Signed: *Wr. Geikie*. The design occurs as no. LXVIII in Geikie's *Etchings illustrative of Scottish Life and Scenery* 1841.

Gift of Harold S. Geikie, the artist's great-nephew, 1935.

GOES, Hugo van der active 1467—died 1482 Netherlandish

Two votive panels known as **The Trinity Altarpiece.**
Left wing: (obverse) James III with St Andrew and Prince James (?); (reverse) the Holy Trinity of the Broken Body. Right wing: (obverse) Margaret of Denmark, Queen of Scotland, with St George (?); (reverse) Sir Edward Bonkil, the first Provost of the Church.

Each panel: $79\frac{1}{2}$ × $39\frac{1}{2}$ (202 × 100·5). Painted c 1478–9 (?) for the Collegiate Church of the Holy Trinity, which was near the site of Waverley Station, Edinburgh, and was demolished in 1848. The two panels, closed, showed Bonkil in prayer with a vision of the Trinity before him; opened, they showed the royal family on either side of a centrepiece, presumably the main altarpiece destroyed at the Reformation whilst the royal portraits survived. (There is no pre-Reformation record either of such an altarpiece or of the surviving panels.) A suggestion by Friedländer (IV p. 45) that the panels were perhaps organ shutters was followed by Panofsky and Winkler. In 1466–7 Bonkil had an organ made in Flanders for the church, and James III contributed generously to it. Yet the heraldic lion in the King's panel is reversed, as if it were turned to respect the devotional image in a central altarpiece. Dating depends partly on the date of the Portinari Altarpiece, on which see B. H. Strens in *Commentari* 1968 p. 315.

The Bonkil panel is in good condition; the others have suffered to some extent, especially the Trinity panel. Winkler suggests that there was much less studio assistance on the King's and Queen's panels than

has sometimes been supposed. The King's head has been re-painted (perhaps in Scotland) over an earlier head, visible under oblique light. *Lit:* D. Laing in *Proc. Soc. Antiquaries of Scotland* III 1862 p. 8, x 1875 p. 310; E. Panofsky: *Early Netherlandish Painting* 1953 I pp. 335/6: O. Millar in *N.G. Scotland catalogue* 1957 pp. 106/7 A. V. B. Norman in *Journal of the Arms and Armour Society* Mar 1957 p. 116; F. Winkler: *H. van der Goes* Berlin 1964 pp. 63–75; C. Thompson and L. Campbell: *Hugo van der Goes and the Trinity Panels in Edinburgh* Edinburgh 1974. *Coll:* First recorded in an inventory of Oatlands (a palace particularly associated with Anne of Denmark) of 7 Oct 1617 (50); sold by the Commonwealth in 1650 but recovered at the Restoration; moved from London to Holyrood in 1857.

Lent by Her Majesty The Queen (received on loan 1912).

GOGH, Vincent van 1853–1890
Dutch; moved to Paris 1886; Arles 1888; St Rémy 1889.

1803 **Olive trees**

Canvas: $19\frac{3}{8} \times 24\frac{3}{4}$ (49·2 × 62·9). One of a series of studies made in the olive orchards at Saint-Rémy in the autumn of 1889. *Lit:* de la Faille no. 714. *Coll: Van Gogh Exh.* Amsterdam 1905 (200) lent by Mme J. van Gogh-Bonger (widow of the painter's brother Théo); sent by her to Leicester Galleries Exh. 1923 (38); Sir Michael Sadler 1923–34.

Bought from Leicester Galleries, London 1934.

2216 **Head of a peasant woman**

Canvas on board: $18\frac{1}{4} \times 14$ (46·4 × 35·6). One of a series of studies of peasants painted in Nuenen, South Holland, in 1885, the year of *The Potato Eaters. Lit:* de la Faille no. 140. *Coll:* Mme J. van Gogh-Bonger; Amsterdam 1905 no. 7 and Leicester Galleries 1923 no. 15 (cf. no. 1803 above); Mrs Fleming (1923–50/1); bought from Reid and Lefevre by Mr and Mrs Maitland 1951.

Sir Alexander Maitland gift 1960.

2217 **Orchard in blossom (plum trees)**

Canvas: $20\frac{3}{4} \times 25$ (52·8 × 63·5) (X-rayed). One of about fifteen paintings of trees in blossom painted at Arles between February and April 1888. Van Gogh planned nine of them as three triptychs, each with an upright canvas between two horizontals. Our picture was apparently grouped with the upright *Pear Tree in Blossom* (Ir. V. W. van Gogh) and *Pink Apricot Trees* (Bührle coll.). *Lit:* de la Faille no. 553; W. Scherjon & J. de Gruyter: *van Gogh's Great Period* Amsterdam 1937, no. 16. *Coll:* Bought by Mr and Mrs Maitland from the William Boyd collection, Dundee, 1937.

Sir Alexander Maitland gift 1960.

GOYA, Francisco de 1746–1828
Spanish; worked mainly in Saragossa and Madrid; from 1824 in
Bordeaux.

1628 **El médico** (*The doctor*)
Canvas: 37⅝ × 47⅜ (95·8 × 120·2) cleaned 1924: the general condition
is poor. A cartoon for a tapestry overdoor, from a series of eleven
designs for the Pardo Palace near Madrid. Goya delivered it to the
Royal Tapestry Factory in 1780. *Lit:* V. de Sambricio: *Tapices de
Goya* Madrid 1946 no. 39. *Coll:* Bought in Saragossa by Sr Linker,
Bilbao, who sold it to Messrs Durlacher.
Bought from Messrs Durlacher 1923.

GOYEN, Jan van 1596–1656
Dutch, born at Leyden; worked principally at Haarlem, Leyden
(from 1618) and The Hague (from 1634).

1013 **Dutch river scene**
Wood: 16¾ × 22¼ (42·6 × 56·5) cleaned 1964 (X-rayed). Signed: *VG*
1646. *Lit:* H. U. Beck: *Jan van Goyen* Amsterdam II 1973 no. 525.
Mrs Mary Veitch bequest to the RSA 1875; transferred 1910.

GRECO, El (Domenikos Theotokopoulos) 1541–1614
Born in Crete; trained in Venice and Rome; settled in Toledo 1577.

1873 **St Jerome in penitence**
Canvas: 41 × 38 (104·2 × 96·5). Generally dated c 1595–1600.
Versions are (1) Castañar coll. Madrid: Wethey (no. 246) gives this as
comparable in quality but slightly later, but he also cites Mayer and
Camón Aznar, who dated it earlier; (2) Diputación Provincial,
Madrid and (3) Hispanic Society, New York, signed but in poor
condition (Wethey nos. 247 and 248 as inferior versions). *Lit:* Wethey
no. 245. *Coll:* Condesa de Arcentales, Madrid.
Bought from Tomás Harris 1936.

2160 **The Saviour of the World**
Canvas: 28½ × 22¼ (72·4 × 56·6) cleaned 1963. Signed with Greek
initials: *delta theta*. Dated c 1600 by Wethey (no. 113). A replica in
the gallery at Reggio Emilia, and a variant in the Prado, Madrid
(no. 2889) are both of lesser quality. The latter belonged to a series of
the Saviour and Apostles. Two other series (Toledo Cathedral and
Museo del Greco, Toledo) contain good three-quarter length figures of
the Saviour, and our picture may also have belonged to such a
series. *Coll:* Juan de Ibarra, Luis Mariá Castillo (1908), Duquesa
de Parcent, Princess Max Hohenlohe-Langenburg, all in Madrid.
Bought from Tomás Harris 1952.

Fábula

Canvas: 26 × 34⅞ (66 × 88). The subject, with a man blowing on charcoal to light his candle and a monkey and grinning man watching expectantly, has a suggestion of the diabolical, but the meaning of the fable is not clear. The central figure is a development from El Greco's picture of a boy lighting a candle (*El soplón*) at Capodimonte, Naples, which almost certainly dates from the artist's Italian period when he was strongly influenced by Jacopo Bassano. Two other versions of the picture in Edinburgh are known: (1) formerly in Rio de Janeiro, and last recorded with Stanley Moss and Co., New York, for which Wethey (no. 124) suggests a date in El Greco's Italian period; (2) Lord Harewood collection (Wethey no. 125). Wethey (no. 126) proposes a date c 1585–90 for the version in Edinburgh. One of these three pictures might well be the *Fábula* recorded in an inventory drawn up by El Greco's son in 1621. *Coll:* Féret, Paris; C. Cherfils, Paris; James Simon, Berlin.

Lent anonymously.

GREUZE, Jean Baptiste 1725–1805
French; settled in Paris 1750.

435 Girl with dead canary

Canvas (oval): 21⅛ × 18⅛ (53·6 × 46·3) cleaned 1964. Lent by M. de La Live de La Briche to the Paris Salon 1765 (110), where Diderot singled it out for special praise, devoting a long passage to it in which he takes the dead bird to symbolise lost innocence or a lost lover. Engraved by J.-J. Flipart. (The painting in the Paris Salon 1759 (107) is probably that now in the Virch Collection, Kiel.) Other treatments of the subject are (1) in the Louvre, Paris and (2) Sotheby sale 10 July 1968 (93), signed and dated 1775. *Lit:* Diderot: *Salons* Seznec/Adhémar ed. Oxford 1960 II p. 145; E. Munhall: catalogue of the *Greuze Exh:* Hartford, San Francisco and Dijon 1976–77 no. 44. *Coll:* By descent from General Ramsay, who owned it in 1837 (Smith no. 77).

Lady Murray of Henderland bequest 1861.

436 Boy with lesson book

Canvas: 24½ × 19¼ (62·4 × 49) cleaned 1964. Painted in Italy, and exhibited Paris Salon 1757 (119). Engraved: C. Levasseur, 1761. *Lit:* E. Munhall (see no. 435, above) no. 15. *Coll:* J. B. de Troy and others, sale Paris Apr/May 1764 (154); Claude Joseph Clos sale Paris 19 Nov 1812 (13); imported from Paris by John Smith in 1816 and owned by General Ramsay in 1837 (Smith no. 138); thence by descent.

Lady Murray of Henderland bequest 1861.

GUARDI, Francesco 1712–1793
Born and worked in Venice; influenced by Canaletto.

1498 **Santa Maria della Salute, Venice**
Canvas: 20 × 16 (50·5 × 40·5) cleaned 1965.

1499 **San Giorgio Maggiore, Venice**
Canvas: 20 × 16 (50·5 × 40·5) cleaned 1965.

A pair. Most suggestions for their dating have been c 1766 and the
early 1770s. *Lit:* P. Zampetti: *Mostra dei Guardi* Venice 1965 p. 170;
H. Bauer in *Kunstchronik* Dec 1967 pp. 366/7. *Coll:* By inheritance
from Rt Hon R. C. N. Hamilton, who lent them to British Institution
1856 (138, 140) and 1867 (78, 94).
Mrs Nisbet Hamilton Ogilvy of Biel bequest 1921.

View of the Piazza S. Marco, Venice
Canvas: 22 × 34 (56 × 86). Watson suggests a date in the early
1780s on the basis of the costumes. Morassi places it c 1775–80.
Lit: F. Watson: *Eighteenth Century Venice* Exhibition catalogue,
Whitechapel Art Gallery, London, and Birmingham 1951 (34);
A. Morassi: *Antonio e Francesco Guardi* Venice 1973 no. 327 fig. 356.
Coll: H. B. Caldwell sale Sotheby's 26 April 1939 (144).
Lent anonymously.

GUERCINO, Il (Giovanni Francesco Barbieri) 1591–1666
Born in Cento, near Bologna; mainly active in Cento and Bologna;
in Rome 1621–3.

39 **St Peter penitent**
Canvas: 41¼ × 34¼ (105 × 87) cleaned 1962. Catalogued in 1957 as
after Guercino, but after cleaning it was recognised as autograph by
D. Mahon, who suggests that it is probably the picture painted for
Cardinal Rocci in 1639, as recorded by Malvasia (*Felsina Pittrice*
1678: Bologna 1841 ed. ii pp. 264 and 318). A copy is in the Palazzo
Venezia, Rome no. 878 (for documentation see D. Mahon: *Guercino
Exh: Catalogue* Bologna 1968 p. 148). *Coll:* Gerini catalogue 1786;
Gerini sale cat. 1825 (282).
Bought from the Marchese Gerini, Florence, for the Royal
Institution 1831.

40 **Madonna and Child with the young St John**
Canvas: 34 × 43½ (86·3 × 110) restored 1960. Dated c 1615–16 by
D. Mahon (*Guercino Exh: Catalogue* Bologna 1968 no. 14). A copy at
Saltram House is probably the picture engraved by J. Boydell 1766
when in the Joshua Reynolds coll.
Bought from the De Franchi family, Genoa, for the Royal
Institution 1830.

GUTHRIE, Sir James PRSA, LLD 1859–1930
Scottish, born at Greenock; largely self-taught; influenced by
Bastien-Lepage; from c 1882 associated with the Glasgow School;
from the early 1890s painted only portraits.

2017 **Portrait of the artist's mother**
Canvas: $36\frac{1}{2}$ × $28\frac{5}{8}$ (92·7 × 72·8). Signed: *J. Guthrie*. Painted in 1893
and exhibited New Salon, Paris, and Glasgow Arts Club in 1895.
Lit: J. L. Caw: *Sir James Guthrie* London 1932 p. 218.
Bought from the artist's trustees 1944.

2087 **Oban**
Canvas: $22\frac{3}{4}$ × $18\frac{1}{4}$ (57·8 × 46·3). Signed: *J. Guthrie 93*. *Coll:*
James MacLehose LLD (1857–1943).
Bought from Doig, Wilson & Wheatley, Edinburgh 1947.

2142 **A hind's daughter**
Canvas: 36 × 30 (91·5 × 76·2) cleaned 1954. Signed:
JAMES GUTHRIE/DECEMBER '83. Glasgow Institute 1884 (197)
bought William Carlaw.
Sir James and Lady Caw bequest 1951.

HALS, Frans c 1580–1666
Born in Antwerp; trained and worked at Haarlem.

691 **A Dutch gentleman**
Canvas: $45\frac{1}{4}$ × $33\frac{7}{8}$ (115 × 86·1) cleaned 1976

692 **A Dutch lady**
Canvas: $45\frac{1}{4}$ × $33\frac{3}{4}$ (115 × 85·8) cleaned 1976

Two portraits that were clearly painted as a pair, c 1643–5,
probably of a wealthy couple from the merchant class in their early
forties. *Lit:* HdG nos. 274 and 377 respectively; KdK 1923 nos.
206/7; Slive nos. 156/7. *Coll:* Bought by the Rt Hon William McEwan
from Major Jackson, St Andrews, in 1885.
Rt Hon William McEwan gift 1885.

1200 **Verdonck**
Wood: $18\frac{1}{4}$ × 14 (46·4 × 35·5) cleaned 1928 (X-rayed). Signed:
FHF (in monogram). Painted c 1627. Engraved by J. van de Velde II
(c 1593–1641) with a Dutch quatrain meaning: 'This is Verdonck,
that outspoken fellow, whose jawbone attacks everyone. He cares for
nobody, great or small—that's what brought him to the workhouse.'
Some time apparently in the 1890s, Verdonck's unruly hair was
painted over with a large beret, and the jawbone with a wine glass, and
the picture was known as *The toper*. These re-paints were removed in

1928. *Lit:* HdG nos. 77 and 235; S. Slive: *Frans Hals Exh:* Haarlem 1962 catalogue no. 16; Slive no. 57. *Coll:* Anon (Lawrence W. Vaile) sale Christie's 13 July 1895 (85): said to have been given to Vaile's father about the 1820s.
John J. Moubray of Naemoor gift 1916.

HAMILTON, Gavin 1723–1798

Scottish, born Lanark; attended Glasgow University. In the 1740s studied under Masucci in Rome where, with visits to Britain, he spent the rest of his life. At first practised as a portraitist, then turned to history painting. From 1760 produced a series of neo-classical paintings on Homeric subjects. Died at Rome.

2339 Achilles lamenting the death of Patroclus
The scene illustrates an episode in Homer's *Iliad* book xix.
 Canvas: $99\frac{1}{2} \times 154$ ($227 \cdot 3 \times 391 \cdot 2$). Painted in Rome 1760–1763 for James Grant of Grant. Exhibited Society of Artists 1765 (46). Engraved by Cunego. In the same exhibition was a crayon study for the head of Achilles (47), almost certainly that which was in the Seafield collection in 1956. A pen and ink drawing of the whole composition was sold by Christie's in Rome 11 and 12 June 1973 (3), but this appears more like a copy after the picture than a preparatory study. *Lit:* Fraser: *Chiefs of Grant* Edinburgh 1883 vol. ii pp. 444–5, 534, 537; E. K. Waterhouse: *The British Contribution to the Neo-Classical Style in Painting* London 1954 p. 71; Basil Skinner in *Burl. Mag.* July 1957 p. 237; David Irwin: *English Neo-Classical Art* London 1966 p. 37; David and Francina Irwin: *Scottish Painters at home and abroad* London 1975 pp. 101–104. *Coll:* James Grant of Grant; thence by inheritance.
 Bought from the Earl of Seafield 1976.

HAMILTON, James c 1640–1720

Scottish, born at Murdieston, Lanarkshire; settled on the continent; died in Brussels.

1833 Still-life
Canvas: $18 \times 15\frac{1}{2}$ ($45 \cdot 8 \times 39 \cdot 4$). Signed: *J. Hamilton 1695.* *Coll:* With Alice Manteau, Paris, in 1935.
 Bought from R. Langton Douglas 1935.

HARVEY, Sir George PRSA 1806–1876

Scottish, born near Stirling; from 1823 in Edinburgh, at first at the Trustees' Academy under Sir William Allan.

919 A schule skailin'
Wood: 27¼ × 47½ (69·3 × 120·7) restored 1904. Signed:
Geo. Harvey 1846. Exhibited RSA 1846 (63). *Coll:* Drysdale
Carstairs, the artist's brother-in-law, who lent it to RA London
1871 (87) as *School dismissing.*
Mrs Duncan J. Kay gift 1904.

1579 The curlers
Canvas: 14⅛ × 31¼ (35·9 × 79·4). A study for the large picture which
was exhibited RSA 1835 (50) and was in the Hutchinson sale,
Christie's 13 Dec 1951 (94) bought for Lord Kinnaird. Another study
on wood was (1966) in coll. J. H. Sawers, Belfast.
Bought from J. Connell and Sons, Glasgow, 1922.

HEEM, Jan Davidsz. de 1606–1683/4
Born at Utrecht and trained in Holland; in Antwerp from 1636 to
1658 and from 1672.

1505 Fruit and lobster
Wood: 13¼ × 16⅜ (33·7 × 41·6) restored 1954. Remains of the
signature: . . . *heem f. 1650. Coll:* British Institution 1856 (144), lent
by Rt Hon R. C. N. Hamilton.
Mrs Nisbet Hamilton Ogilvy of Biel bequest 1921.

HERDMAN, Robert RSA 1829–1888
Scottish, born at Rattray, Perthshire. Studied at the Trustees'
Academy under R. Scott Lauder. Painted many scenes from Scottish
history.

2136 Evening thoughts
Millboard mounted on canvas: 24 × 18 (61 × 45·8) cleaned 1976.
This picture, formerly attributed to Thomas Faed on the basis of a
signature and date *T. Faed '89* in the lower left corner, was identified
as a painting by Herdman, *Daydreams,* illustrated in Edmiston's
Glasgow sale catalogue 24 and 25 April 1917 (81). Cleaning tests
revealed, in the bottom right corner, the traces of Herdman's original
monogram and the date 1864 which appear in the 1917 reproduction
of the picture. The spurious signature *T. Faed '89* was removed
during cleaning.
Gift of Mrs Dunlop, from the collection of George B. Dunlop, 1951.

HILL, David Octavius RSA 1802–1870
Scottish, born at Perth; worked in Edinburgh, at first at the Trustees'
Academy. Pioneer of photography with Robert Adamson.

210 On the quay at Leith
Wood: 11¾ × 13½ (29·9 × 34·3). Exhibited Royal Institution,
Edinburgh, 1826 (134); it was one of four 'pictures of the young
artists who have been unsuccessful in selling during the exhibition'
that were bought there by the Royal Institution (Board minute of
14 Mar 1826).

HOBBEMA, Meindert 1638–1709
Dutch; influenced by Jacob van Ruisdael; painted little after 1670.

1506 Waterfall in a wood
Wood: 10½ × 8¾ (26·7 × 22·3). Restored 1958; the upper part of the
sky is rubbed. (?) Signed: *M. Hobbema*, but possibly not autograph.
It corresponds with the artist's style of the early 1660s, although
Rosenberg suggests that Hobbema's few upright compositions date
from after 1668. *Lit:* J. Rosenberg in *Jahrb. der preussischen
Kunstsamml.* XLVIII 1927 p. 139; Broulhiet no. 296. *Coll:* By
inheritance from Mrs Hamilton Nisbet Ferguson, who lent it to the
Royal Institution, Edinburgh 1826 (31).
 Mrs Nisbet Hamilton Ogilvy of Biel bequest 1921.

Landscape with a view of the Bergkerk, Deventer
Wood: 15⅜ × 21⅛ (39 × 53·5). Signed: *m. Hobbema/f. 16* . . . Up to
1903 the date was read as 1657, but the style is not before 1665. The
very late date of 1689, which was read by Broulhiet (no. 53) and
MacLaren, would put the painting in the year now accepted for the
Avenue in Middelharnis (NG London). For the discussion of this
problem, see MacLaren and Rosenberg/Slive. *Lit:* N. MacLaren:
Dutch School National Gallery London catalogue 1960 pp. 165–8;
J. Rosenberg, S. Slive, E. H. ter Kuile: *Dutch Art and Architecture
1600–1800* London 1966 p. 158. *Coll:* HdG no. 77, as probably
J. van der Marck sale Amsterdam 25 Aug 1773 (127) bought by
Fouquet. R. de Saint-Victor sale Paris 26 Mar 1822; acquired by
Lord Francis Egerton between then and 1835 (Smith no. 51); thence
by descent. Bridgewater House no. 148.
 Duke of Sutherland loan 1946.

HOGARTH, William 1697–1764 English

838 Sarah Malcolm
Sarah Malcolm was executed at the age of 25 for the murder of her
mistress Lydia Duncombe and two fellow-servants in 1732–3. She is
seen in Newgate Prison, where she sat for Hogarth two days before
her execution on 7 March.

Canvas: 19¼ × 15¼ (48·9 × 38·7). Engraved (with variations) by Hogarth in 1732–3. *Lit:* R. B. Beckett: *Hogarth* 1949 no. 60. *Coll:* Horace Walpole, who is said to have bought it from Hogarth; Strawberry Hill sale, Robins 14 May 1842 (72) bought by C. K. Sharpe; thence by inheritance.
Lady Jane Dundas bequest 1897.

HOPPNER, John RA 1758–1810 English

1216 **Admiral Viscount Duncan** (1731–1804)
Defeated the Dutch fleet at Camperdown 1797.
　　Canvas: 30 × 25 (76·2 × 63·5). A study probably taken from life and adapted to the formal portraits of the Admiral (*cf.* the full-length engraved by J. Ward 1798 and the three-quarter length in the Guildhall, London).
Earl of Camperdown bequest 1918.

ITALIAN (Genoese?) 18th century

833 **Virgin of the Immaculate Conception**
Marble: 49 (124·5) high, including base. Formerly attributed to Alonso Cano (1601–67); catalogued in 1957 as Austrian 18th century. What is known of the donor makes an Italian provenance likely. The possibility that it is Genoese has been pointed out, independently, by J. Pope Hennessy, who tentatively suggested Schiaffino, and by A. Ciechanowiecki, who suggested the Parodi. C. Avery points out that the existence of a virtual duplicate, lacking the architectonic and integral pedestal, in the collection of Sir Karl Parker, indicates a workshop dedicated to the production of religious images derived from an as yet unidentified original.
Sir Hugh Hume Campbell Bart of Marchmont bequest 1894.

JAMESONE, George 1589/90–1644
Scottish, born in Aberdeen; apprenticed in Edinburgh 1612; c 1620 in Aberdeen; from 1633 mainly in Edinburgh and Aberdeen.

958 **Lady Mary Erskine, Countess Marischal**
Wife of the 6th Earl and mother of the 7th, both painted by Jamesone in 1636.
　　Canvas: 26½ × 21½ (67·3 × 54·6) restored c 1935. Inscribed: *Anno 1626./Ætatis 29./Maria Ersken/Countess Marschaill. Lit:* D. Thomson: *The Life and Art of George Jamesone* 1974 pp. 60 ff. *Coll:* One of several portraits of the children of Lady Maria Stuart, Countess of Mar, which she left to a younger son Charles Erskine (see J. Bulloch: *G. Jamesone* Edinburgh 1885 pp. 162–3); thence by descent.
Bought from Erskine Murray 1908.

JOOS van CLEVE active 1511—died 1540/1
Head of a large workshop in Antwerp. His name may cover the work
of more than one workshop.

1252 **Triptych with The Deposition from the Cross**
Left wing: St John Baptist with a donor; right wing: St Margaret with
a donatrix. (Their arms, at the top of the wings, have not been
identified.)
 Wood, with shaped tops: centre 42 × 28 (106·7 × 71·1); each wing
43 × 12½ (109·2 × 31·8). The wing panels have been sawn through,
presumably so that paintings on their reverse sides could be sold
separately. These have not been traced. Restored 1958; the paint in
many places is very thin. Dated c 1518 by Friedländer (IX no. 14).
Coll: New Gallery Exh. 1899–1900 (22) as *Early Flemish School,* lent
by John Hardman.
 Bought from Tooth's 1920.

KAUFFMAN, Angelica 1741–1807
Born in Switzerland; in Italy by 1763; in England 1766–81; then
mainly in Rome.

651 **Michael Novosielski** (1750–95)
Polish architect who practised in England. He holds his plan for the
re-building of the King's Theatre, Haymarket, of 1790–1.
 Canvas: 50½ × 40 (128 × 101·6). Signed: *Angelica Kauffman/Pinxt.*
Roma 1791. Finished in March 1792, according to a note by the artist
(see V. Manners and G. C. Williamson: *A. Kauffman* London 1924
p. 90, also reproducing a companion portrait of the sitter's wife).
 Bequeathed by Mrs Elizabeth Stewart, the sitter's daughter-in-law,
in 1879.

KEY, Willem active 1542—died 1568
Born at Breda; worked as portrait painter in Antwerp.

attributed to Key

1938 **Mark Ker, Commendator of Newbattle (?)**
Mark Ker (died 1584), father of the 1st Earl of Lothian, was provided
to the Abbacy (held *in commendam*) of Newbattle in 1547.
 Wood: 15½ × 11⅜ (39·3 × 29), painted up to the edges; cleaned
c 1950. Inscribed: *1551* and *Ætatis 40* (both repeated by a later
hand).

1939 **Lady Helen Leslie, his wife (?)**
Daughter of the 4th Earl of Rothes, married Gilbert Seton c 1542 and
secondly Mark Ker, died 1594. She points to a tablet with musical
notation, headed *ca . . . 4 in eodem.*

52

Wood: 15⅝ × 11⅜ (39·5 × 29), painted up to the edges. Inscribed: *1551* (repeated by a later hand). An indistinct inscription on the back reads, approximately, *W . . m Kàr fc*.

Very likely companion portraits, attributed in the 18th century to Moro. The Newbattle inventory of c 1720 lists companion portraits by *Antony Moore* and also *a young lady by William Karr*, which also seems to refer to no. 1939. The identification of the sitters first appears in the Lothian inventory of March 1798. The attribution to Key derives from the inscription on no. 1939. *Lit:* L. Cust in *Burl. Mag.* Oct 1910 p. 12 and Friedländer xiii no. 351, as possibly originals by Moro.

11th Marquess of Lothian bequest 1941.

LANCRET, Nicholas 1690–1743
French, born and worked in Paris; influenced mainly by Watteau.

440 The toy windmill
Canvas (circular): 19½ (49·5) diam.; cleaned 1942. The figures are based on a group in *L'Air*, one of four pictures of the Elements by Lancret (now at Waddesdon Manor), which were engraved in 1732. *Lit:* G. Wildenstein; *Lancret* Paris 1924 no. 245. *Coll:* Fortier sale, Paris 2 Apr 1770 (36 bis); Baron de St Julien sale, Paris 14 Feb 1785 (86). Probably inherited from General Ramsay by Lord Murray, who owned it in 1856 as by Watteau (Waagen suppl. p. 430).

Lady Murray of Henderland bequest 1861.

LAUDER, James Eckford RSA 1811–1869
Scottish, born in Edinburgh, brother of R. S. Lauder; studied at the Trustees' Academy, and in Rome 1834–38; thereafter in Edinburgh.

915 Bailie Duncan McWheeble at breakfast
An illustration to Scott's *Waverley* (ch. 37).
Canvas: 26½ × 19¾ (67·3 × 50·2). Signed: *Jas. E. Lauder pinxt. 1854* and initialled *J. E. L.* Exhibited RSA 1854 (224), bought by the RAPFA; Dundee loan exh: 1867 (75) lent by J. T. Gibson-Craig. A pencil study for the head and shoulders of McWheeble is our D4371.

Lady Dawson Brodie bequest 1903.

LAUDER, Robert Scott RSA 1803–1869
Scottish, born in Edinburgh; studied at the Trustees' Academy and in London; Edinburgh 1827–34; abroad 1835–38; London 1839–52; then in Edinburgh, 1852 Master of the Trustees' Academy.

1003 **Henry Lauder, the artist's brother** (1807–27)
Canvas: 29½ × 24½ (75 × 62·3). Evidently painted c 1825–27.
A pencil study for it is our no. D4371.
Dr Scott Lauder RN gift to the RSA (after 1882); transferred 1910.

LAWRENCE, Sir Thomas PRA 1790–1830 English

1522 **Lady Robert Manners** (1737–1829)
Mary, daughter of Colonel Thomas Digges of Roehampton, married
in 1756 Lord Robert Manners son of 2nd Duke of Rutland.
Canvas: 54½ × 43½ (138·5 × 110·5) cleaned 1954. Exhibited RA
1826 (75). A portrait painted of her some 70 years earlier is no. 1523
by Allan Ramsay. *Lit:* K. Garlick: *Lawrence* London 1954 p. 49.
Coll: Passed by descent.
Mrs Nisbet Hamilton Ogilvy of Biel bequest 1921.

LÉPINE, Stanislas 1835–1892
French; said to have been a pupil of Corot, influenced by Jongkind.

1047 **'La Seine à Bercy'**
Canvas: 12 × 21 (30·5 × 53·4). Signed: *S. Lépine.* Probably painted
in the 1860s. A view on the Seine; its identification with Bercy in SE
Paris, which does not seem to be correct, dates from 1902–11. *Coll:*
With Bernheim-Jeune, Paris, in or after 1902 as *Bords de Seine.*
Hugh A. Laird bequest 1911.

LIEVENS, Jan 1607–1674
Born at Leyden, where he worked 1621–32, latterly in close
association with Rembrandt; 1635–44 in Antwerp; thereafter in the
Netherlands.

attributed to Jan Lievens

68 **A woodland walk**
Canvas: 20¼ × 27¾ (51·5 × 70·5) cleaned 1931. One of a group of
landscapes of unusual character inspired by Adriaen Brouwer, whom
Lievens knew in Antwerp 1635–7. The only signed one is in Berlin,
and the Torrie picture is quite closely related to it. Schneider dates the
Berlin picture after 1650 and the Torrie picture a little earlier, the
sharp greens 'strange for Lievens but still possible'. *Lit:*
H. Schneider: *J. Lievens* Haarlem 1932 p. 63 and no. 302. *Coll:*
Royal Institution, Edinburgh 1830 (120) as Rembrandt, lent Sir John
Erskine of Torrie.
Sir James Erskine of Torrie bequest to Edinburgh University 1835;
deposited on loan 1845.

1564 **Portrait of a young man**
Canvas: 44 × 38¼ (111·8 × 97·2). Cleaned 1970; the remains of an old
inscription, evidently *Rembrandt*, are visible bottom right. The surface
is rubbed. Schneider attributes it to Lievens, painted in Leyden
c 1628–30. Gerson suggests it may be by Bol, painted somewhat
later. Closely related to the figure is the boy in *'Jacob Cats
instructing the Prince of Orange'*, Lady Craven sale Sotheby
27 Nov 1968 (88) as by Lievens (now Getty Museum, Malibu).
Engraved in mezzotint by J. R. Smith 1772 as a portrait of
Wallenstein by Dou. *Lit:* HdG listed the engraving as Rembrandt
c 1632 (no. 799A); J. C. van Dyke: *Rembrandt and his School*
New York 1923 p. 112 (as Salomon Koninck); H. Schneider:
J. Lievens Haarlem 1932 p. 29 and no. 283; H. Gerson in *Burl. Mag.*
Dec 1969 p. 782. *Coll:* Mary, Lady Carbery sale (from Castle Freke,
Co. Cork) 4 Mar 1921 (9) as Wallenstein by Dou.
　Bought from Agnew's, as by Bol, in 1922.

LIPPI, Filippino 1457–1504
Florentine, son of Filippo Lippi; worked with him and later with
Botticelli.

1758 **The Nativity with two angels**
Wood: painted surface 9⅞ × 14½ (25 × 37) (X-rayed). The condition
of the paint surface is good, and the report on the picture's condition
in the 1970 edition of this catalogue is too pessimistic. A predella panel.
The delicate quality of the handling suggests it is almost certainly by
Filippino Lippi himself. E. Fahy (letters 1969 and 1976) compares
it to the *Virgin adoring the Child with six angels* in the Hermitage,
Leningrad, and to the tondo of the *Holy Family with the Infant St John
and St Margaret* in Clevand, both of which are generally attributed
to Filippino Lippi. It might date from the early 1490s, on the
evidence of stylistic comparison with Filippino Lippi's work in the
Caraffa chapel of S. Maria sopra Minerva, Rome. *Lit:* A. Scharf:
Filippino Lippi Vienna 1935 pp. 57, 107; K. B. Neilson: *Filippino Lippi*
Cambridge (Mass.) 1938 p. 136. *Coll:* From a Hungarian coll;
at one time with Silbermann Galleries, Vienna.
　Bought from Knoedler's 1931.

LIZARS, William Home 1788–1859
Scottish, born in Edinburgh; apprenticed to his father as an engraver;
at the Trustees' Academy with Wilkie; after 1812 he worked only as
engraver.

423 **Reading the will**
Wood: 20¼ × 25½ (51·5 × 64·8).

55

424 **A Scotch wedding**
Wood: 23¼ × 26 (59·1 × 66).

Respectively: Associated Artists Exh. Edinburgh 1811 (nos. 63 and
48); RA London 1812 (nos. 62 and 75). *Coll:* Presumbably Lord
Eldin sale by Winstanley, Edinburgh, 14 March 1833 (nos. 35 and 36).
A study for no. 423 was in the Eldin sale 15 March (75) and
J. T. Gibson-Craig sale, Dowell's 12 March 1887 (931).
Gift of Mrs Lizars, the artist's widow, 1861.

LORENZO MONACO before 1372–1422/4
Came from Siena to settle in Florence, where he became a
Camaldolese monk.

2271 **Madonna and Child**
The lion-headed throne is the throne of Solomon or Sedes Sapientiae
(I Kings x 18–20).
Wood: the painted surface of 40 × 24½ (101·6 × 62·3) goes up to
the edges except round the arched top. Restored 1965 (X-rays;
infra-red photographs): substantial repairs are in the gold round the
Child's head and in the centre of the floor; the lions' heads have been
strengthened. The panel was evidently the centre part of an
altarpiece (a fragment of crimson drapery at the left evidently
belonged to a subsidiary figure). A late work, designed by Lorenzo
Monaco and probably executed with workshop assistance.
Marvin Eisenberg (letter of May 1969) suggests a date of c 1418–20.
Coll: William Drury-Lowe: probably bought in Italy 1840–65 (see
J. P. Richter: *Locko Park Cat.* 1901 no. 25); he did buy a Lorenzo
Monaco in 1863 (see J. Cornforth in *Country Life* 1969 p. 1602).
Bought at Capt. P. J. B. Drury-Lowe sale, Sotheby's 24 Mar 1965
(no. 56).

LORIMER, John Henry RSA 1856–1936
Scottish, born in Edinburgh; studied at the RA Schools and under
Carolus Duran in Paris.

1879 **The ordination of elders in a Scottish kirk**
Canvas: 43 × 55 (109·2 × 140). Signed: *J. H. Lorimer 1891*.
Exhibited RA London 1891 (685). The models for the seven men are
named in a letter from the artist in the Gallery files. Nine pencil
studies for the figures and three for the pulpit are in the Gallery's
collection of drawings.
Mrs McGrath gift, received 1936.

LOTTO, Lorenzo c 1480–1556/7 Venetian

Virgin and Child with SS Peter, Jerome, Clare (?) and Francis
Canvas transferred from wood: $32\frac{1}{2} \times 41\frac{3}{8}$ (82·5 × 105). (X-rayed)
signed: *L. Lotus. F.* Berenson suggests a date of 1505–10 (*Lorenzo Lotto* London 1956 p. 8). *Coll:* Duc d'Orléans by 1727 (Dubois
p. 294); not recorded in 1724 inventory (Stryienski no. 43); sale
Lyceum, London 1798 (234), reserved for the Duke of Bridgewater
(see p. viii); thence by inheritance. Bridgewater House no. 90.
Duke of Sutherland loan 1946.

McCULLOCH, Horatio RSA 1805–1867
Scottish, born Glasgow; studied landscape under John Knox (a pupil
of A. Nasmyth); moved to Edinburgh 1838.

288 Inverlochy Castle
On the river Lochy NE of Fort William.
Canvas: $35\frac{1}{2} \times 59\frac{1}{2}$ (90·2 × 151). Signed: *H. McCulloch 1857.*
Exhibited RSA 1857 (79).
Bought by the Royal Association for the Promotion of the Fine
Arts 1857, and given by them 1897.

MACGREGOR, William York RSA 1855–1923
Scottish, born in Dunbartonshire; studied at the Slade School,
London, under Alphonse Legros; worked in Glasgow, known as
'father' of the Glasgow School.

1915 The vegetable stall
Canvas: $41\frac{1}{2} \times 59\frac{1}{4}$ (105·5 × 150·5). Signed: *W. Y. MACGREGOR
1884.* No record has been traced of its exhibition in Scotland or
London. The first known reference to it is in 1908 (J. L. Caw: *Scottish
Painting 1620–1908* Edinburgh 1908 p. 381).
Mrs W. Y. Macgregor gift 1939.

2086 Winter landscape
Canvas: 36 × 32 (91·5 × 81·3) cleaned 1954. Signed: *W. Y. Macgregor.*
Exhibited RSA 1908 (152) and reproduced in G. B. Brown: *The
Glasgow School of Painters* Glasgow 1908 pl. 33. Macgregor later
glued another canvas over the top and painted on it *Loch a Ghille
Ghobaich* (Glasgow Institute 1918 no. 249). The two canvases were
separated by T. C. Annan, who made the discovery when he bought
them in 1946.
Bought from T. & R. Annan, Glasgow, 1947.

2200 **A rocky solitude**
Canvas: $24\frac{3}{4} \times 26\frac{5}{8}$ (62·9 × 67·7) cleaned 1959. Signed: *W. Y. Macgregor 1806*. Exhibited Glasgow Institute 1896 (133). *Coll:* New English retrospective Exh: 1925 (24) lent by Frank Gibson; *Scottish Art Exh:* RA London 1939 (321) lent by Mr and Mrs Maitland.
Gift of Mr (later Sir) Alexander Maitland and his wife, 1958.

MACNEE, Sir Daniel PRSA 1806–1882
Scottish, born at Fintry; studied under John Knox with McCulloch (q.v.) and later at the Trustees' Academy, Edinburgh; worked mainly in Glasgow.

1679 **Lady in grey**
Portrait of the artist's daughter, later Mrs Wiseman (died 1926).
Canvas: 50 × 40 (127 × 101·6) cleaned 1935. Signed: *Daniel Macnee RSA 1859*. Presumably RA 1859 (245) called *Miss Macnee*. London International 1862 (602) called *Mrs Wiseman*, lent by the artist; Glasgow International 1901 (223) *Lady in grey*, lent by Lady Macnee. No. 2254 (see p. 139) is a preparatory study. The sitter's pose is based on Reynolds' portrait of Nelly O'Brien in the Wallace Collection, London.
Lady Macnee gift 1927.

McTAGGART, William RSA 1835–1910
Scottish, born on Kintyre; studied at the Trustees' Academy, Edinburgh, under R. Scott Lauder 1852–9; best known for his coast and sea scenes painted on Kintyre from the early 1870s onwards.

1071 **The coming of St Columba**
St Columba crossed from Ireland to Iona in AD 563.
Canvas: $51\frac{1}{2} \times 81$ (131 × 206). Signed: *W. McTaggart 1885*. McTaggart visited Iona in 1884. Caw dated the picture to 1898 claiming that it was associated with the centenary of St Columba's death in 1897, and was painted at Cauldron Bay, Kintyre, not on Iona. He may have been confusing our picture with an undated picture of *St Columba preaching*, in Edinburgh City Art Gallery. A study for our picture, said to be dated 1895 was in *McTaggart Exh:* Fine Art Society 1967 (36) as painted on Iona, lent H. Esslemont, Aberdeen. *Lit:* Caw 1917 pp. 172 and 270.
Bought from William McTaggart's Trust 1911.

1482 **The young fishers**
Canvas: $28\frac{1}{2} \times 42\frac{1}{2}$ (72·4 × 108). Signed: *W. McTaggart 1876*. Begun at Kilkerran, Ayrshire, in 1874. Exhibited RSA 1876 (289) and Glasgow Institute 1877 (380). *Lit:* Caw 1917 p. 238. *Coll:* (by 1880

and until 1910) George B. Hart, Edinburgh, who bought it from the artist; (1911) John Kirkhope.

Dr John Kirkhope bequest 1920.

1757 The sailing of the emigrant ship
Canvas: 29¾ × 34 (75·6 × 86·4). Signed: *W. McTaggart 1895.*
McTaggart also painted emigrants leaving the west of Scotland in pictures of 1890–91. *Lit:* Caw 1917 pp. 171, 184, 269.
Coll: Bought from the artist's trustees by Sir James Caw.

Gift of Sir James and Lady Caw, on his retirement as Director of the Galleries 1931.

1834 The storm
Canvas: 48 × 72 (121·9 × 183). Signed: *W. McTaggart 1890.*
Painted in the studio from a smaller version (32 × 52 in., now in Kirkcaldy Art Gallery), which was painted at Carradale in 1883. Another oil sketch, dated 1890, is in the Orchar Art Gallery, Broughty Ferry. *Lit:* Caw 1917 pp. 136n, 185, 262. *Coll:* Bought by Andrew Carnegie at *McTaggart Exh:* Glasgow and Edinburgh, 1901 (32).

Mrs Andrew Carnegie gift in 1935, the centenary of the birth of the artist and of her husband.

2137 Spring
Canvas: 17¾ × 23¾ (45·1 × 60·4). Signed: *WMT* (monogram) *1864.*
Painted in 1863 for G. B. Simpson, Dundee, who lent it to the RSA 1864 (561). A study of the figures was sold at Dowell's, Edinburgh, 6 Mar 1909. *Lit:* Caw 1917 pp. 39 and 226/7. *Coll:* J. J. Weinberg (1908); R. B. Steven (1917); J. L. Caw (by 1928).

Sir James and Lady Caw bequest 1951.

2139 The past and the present
Also called *The builders.* The scene is the old graveyard of Kilchousland, near Campbeltown.

Canvas: 8¾ × 10¾ (22·3 × 27·4). Finished study for the painting of 29½ × 35½ in. (RSA 1860 no. 159; John Curley coll. in 1946). *Lit:* Caw 1917 pp. 26/7. *Coll:* Simpson (1880); J. J. Watson, Broughty Ferry (1917); anon. sale Dowell's Edinburgh in 1946, bought after the sale by Sir James Caw.

Sir James and Lady Caw bequest 1951.

2158 Mrs William Lawrie
Wife of William Lawrie, art dealer in Glasgow.

Canvas: 35¾ × 23¾ (90·8 × 60·4) cleaned 1952. Signed: *WMT* (monogram) *1881.* Exhibited RSA 1882 (409). *Lit:* Caw 1917 pp. 82, 247.

Gift of Mme Violante Lawrie, the sitter's daughter-in-law, 1952.

2185 **A study of oak leaves in autumn (self portrait)**
Canvas: 33 × 28 (83·8 × 71·2). Signed: *W. McTaggart 1892.*
Exhibited RSA 1893 (237); Glasgow Institute 1894 (389). *Lit:* Caw
1917 pp. 125, 265.
Gift of the William McTaggart Trust 1956.

MAES, Nicolaes 1634–1693
Pupil of Rembrandt around 1650; in Dordrecht c 1654–73, then in
Amsterdam.

1509 **Dutch family group**
Wood (arched top): $19\frac{7}{8}$ × 15 (50·5 × 38·1) cleaned 1952 (X-rayed).
Probably close in date to two family groups from the mid 1650s
(cf. A. Staring in *Oud Holland* 1965 no. 3 p. 177). *Lit:* HdG, listed as
Rembrandt no. 937. *Coll:* John Clerk, Lord Eldin: Royal Institution
Edinburgh Exh. 1819 (23) and Eldin sale Edinburgh 16 Mar 1833
(170), both as Rembrandt; British Institution Exh. 1856 (27) as Maes,
lent Rt Hon R. C. N. Hamilton.
Mrs Nisbet Hamilton Ogilvy of Biel bequest 1921.

MAILLOL, Aristide 1861–1944
French; began as a painter; worked as a sculptor from 1897.

2178 **Eve**
Bronze: ht. $22\frac{7}{8}$ (58·2). No. 1 of six casts. John Rewald dates it c 1902
(*Maillol,* Paris 1939, pl. 76).
Bought from Reid and Lefevre 1955.

MARMITTA, Il active c 1500—died 1505 or before.
Painter and miniaturist in Parma.

attributed to Marmitta

1673 **The Scourging of Christ**
Wood: $14\frac{1}{8}$ × 10 (36·2 × 25·4) restored 1955. Bought as by Francesco
Bianchi Ferrari; *Italian Art Exh:* RA 1930 (264) as early
Bramantino(?). Attributed in 1934 by Longhi (p. 57) to Il Marmitta,
whose only certain work is an illumination of Petrarch in the library
at Cassel. P. Toesca (in *L'Arte* 1948, p. 33) as from Marmitta's early
period, close to Ercole Roberti's style. *Lit:* M. Levi d'Ancona in
Boll: dei Musei Civici Veneziani 4 1967 p. 9. *Coll:* Said to be
Emile Gavet coll. but not in his sale catalogue, Paris 5 June 1897;
Sir George Donaldson.
Bought from Messrs Durlacher, 1927.

MARTIN, David 1737–1797

Scottish, born at Anstruther; portrait painter; pupil and assistant of Allan Ramsay: in Edinburgh from 1775; influenced by Reynolds.

569 Self-portrait

Canvas: $19\frac{1}{2} \times 15\frac{1}{2}$ (49·5 × 39·4). Painted c 1760. Our 1874 catalogue records a replica given by Martin to Allan Ramsay and sold with part of Lord Murray of Henderland's collection (although there was none in the sale at Christie's 19/20 June 1855). There is a version in a private coll. in Ontario.

Given to the RSA in 1869 by the Misses Bryce, relatives of the artist; transferred 1910.

MARTIN, John 1789–1854

English; inspired by Turner; best known for his large Biblical and Miltonic compositions.

2115 Macbeth

'Stay you imperfect speakers, tell me more'. Act I iii.

Canvas: 20 × 28 (50·8 × 71) cleaned 1955. Martin exhibited a big painting, 68 × 96 (173 × 244) framed, at the British Institution 1820 (141). It was mezzotinted by T. Lupton in 1828; Walter Scott admired it in Martin's studio in 1831, but it is now lost. Our picture is a small version of it. Another version, 30·5 × 46·3 cm, is in Stratford Memorial Theatre. *Lit:* T. Balston: *John Martin* London 1947 p. 51; W. M. Merchant: *Shakespeare in Art* Arts Council 1964 catalogue no. 45. *Coll:* Cadeby Hall, Lincs; anon. sale Sotheby's 30 Mar 1949 (105) as bought from the artist by George Baron, Drewton Manor, nr. Cave.

Bought from Robert Frank, London, 1949.

MASSYS, Quentin 1465/6–1530

Netherlandish, worked in Antwerp.

2273 Portrait of a man

Wood: $31\frac{1}{2} \times 25\frac{1}{4}$ (80 × 64·5). Restored 1967 (X-rayed): there are considerable losses of black paint in the robes and in the right-hand side of the hat. Of the various objects either held by the sitter or placed on the ledge in front of him only the rose is original. The others, as well as the halo and rings on his left hand, are later additions— not all of the same date, but perhaps mainly 18th century. Friedländer (VII no. 45) dates the portrait 1510–20. It was called Holbein in Vernon sale Christie's 15 April 1831 (43); and in anon. sale Christie's 26 May 1832 (126); and *Portrait of St Fiacre* (supposedly as the patron

saint of notaries) by Massys in the Northwick Park catalogue 1864 (65). *Lit:* T. Borenius: *Catalogue of Northwick Pictures* London 1921 no. 147.

Ceded in lieu of estate duty by the executors of the estate of Captain E. G. Spencer-Churchill, Northwick Park, 1965.

MASTER OF 1419

Named after a *Madonna and Child* in Cleveland (no. 54.834) which is dated 1419 (see G. Pudelko *Art in America* XXVI 1938 p. 63). Influenced by Lorenzo Monaco.

1540a **The stigmatization of St Francis**
Wood: $8\frac{1}{2} \times 12$ (21·6 × 30·5) restored 1950.

1540b **St Anthony Abbot exorcizing a woman possessed by the devil**
Wood: $8\frac{1}{2} \times 12$ (21·6 × 30·5) restored 1950.

Two panels from a predella. Longhi suggested they are the work of a miniature painter c 1420. Berenson (1932 and 1963) as 'Andrea di Gusto?'. R. Offner has suggested an attribution to the Master of 1419 (unpublished list dated 1951 from Klara Steinweg in Gallery files). This is consistent with the style of our panels which appear to be by an artist active in Florence around 1420, close to Andrea di Giusto and Giovanni Toscani. *Lit:* R. Longhi in *Critica d'Arte* 1940 p. 182 note 15; Kaftal 1952 no. 24, as Master of the St Julian at S. Gimignano. *Coll:* Fuller Maitland (Stansted Hall Catalogues 1872 (p. 6) and 1893 (no. 7) as 'Gaddi?').
Bought from the Fuller Maitland collection 1921.

MASTER of the S. LUCCHESE ALTARPIECE

Florentine mid 14th century; a close follower of Maso di Banco. His style has been defined on the basis of a triptych, formerly in the church of S. Lucchese, Poggibonsi, and now destroyed.

1539a **A baptism**
Wood: $7\frac{1}{2} \times 12\frac{1}{2}$ (19 × 31·8) restored 1951.

1539b **A martyrdom**
Wood: $7\frac{1}{2} \times 11\frac{3}{4}$ (19 × 29·9) restored 1951.

The scenes represented have not been identified. Two out of five panels from a predella, which were all in the Woodburn sale (lot 39 is now York Art Gallery no. 727; lot 47, ex-Langton Douglas coll., is

published by Zeri; lot 40 is lost). Our panels were attributed to the
Master of the S. Lucchese altarpiece by Offner (III 8 1958 p. 166 n. 2)
followed by Zeri and by M. Boskovits (*Pittura Fiorentina alla viglia
del Rinascimento* Florence 1975 p. 200). *Lit:* Kaftal 1952 no. 328;
F. Zeri in *Burl. Mag.* 1965 p. 252. *Coll:* S. Woodburn sale,
Christie's 9 June 1860 (37 and 41) as Giotto, bought by Daniell for
Fuller Maitland.
Bought from the Fuller Maitland collection 1921.

MATTEO di GIOVANNI active 1452 died 1495 Sienese

1023 **Madonna and Child with SS Sebastian and Francis**
Wood: $20 \times 15\frac{1}{2}$ ($50 \cdot 8 \times 39 \cdot 4$) cleaned 1956: there is no evidence to
support earlier statements that the picture has been cut down on all
four sides, or that the punched border at the top and left is a later
addition. *Coll:* Burlington Fine Arts Club 1904 (42) lent Arthur
Severn, as bought by Ruskin in Siena. *Lit:* Berenson 1968.
Bought from R. Langton Douglas 1910.

MAUVE, Anton 1838–1888
Dutch, settled in The Hague 1874; van Gogh's principal teacher
1881–2.

1056 **The tow-path—no. 1**
Canvas: $13 \times 9\frac{1}{4}$ ($33 \times 23 \cdot 5$). Signed: *A. Mauve*. The title is
descriptive only, to distinguish it from no. 1058.
Hugh A. Laird bequest 1911.

MICHEL, Georges 1763–1843
French, born and worked in Paris; an early French painter of pure
landscape, much influenced by Jacob Ruisdael.

1028 **The lime kiln**
Canvas: 22×28 ($55 \cdot 9 \times 71 \cdot 1$) cleaned 1953. *Coll:* Bought by
George R. MacDougall at the S. P. Avery Jr sale, New York,
20 Mar 1902.
George R. MacDougall, New York, gift 1911.

MOLA, Pier Francesco 1612–1666
Trained in Rome; influenced by Guercino and the Venetians.

attributed to a follower of Mola

29 **St Jerome**
Canvas: 24 × 31 (61 × 78·7) cleaned 1962. Catalogued in 1957 as
either an original Guercino or a good early imitation. Its strong
Venetian flavour caused D. Mahon to reject the attribution to
Guercino and he suggests (verbally 1962) that it is nearer to
P. F. Mola. Czobor as a late work of Mola, but rejected by R. Cocke
(*Pier Francesco Mola* Oxford 1972 p. 66 no. R.18). Since the
predominant stylistic influence is that of Mola, our picture may well
turn out to be by one of his many pupils who have yet to be seriously
studied. *Lit:* A. Czobor in *Burl. Mag.* Oct 1968 p. 565.
 Bought, as by Franceschini, from the De Franchi family, Genoa,
for the Royal Institution 1830.

MONET, Claude 1840–1926
French, born in Paris and worked mainly in and near Paris; one of the
original impressionist group.

1651 **Poplars on the Epte**
The view is at Giverny, near Paris, where Monet went to live in 1890.
 Canvas: $32\frac{1}{4}$ × 32 (81·9 × 81·3). Signed: *Claude Monet*. Between
1890 and 1892 Monet painted a series of canvases of this row of
poplars, mostly from the same point of view under different lights
(*eg* Tate Gallery no. 4183; Philadelphia Museum of Art; coll.
Durand-Ruel, Paris 1960). Our picture is different from these, but
similar to a canvas $31\frac{1}{2}$ × $36\frac{1}{4}$ (80 × 92) exhibited with Bernheim-Jeune,
Nov 1961 (29). *Coll:* (An inscription on the stretcher: *D R No 6 la
rivière de l'Epte à Giverny* suggests that it was shown, like
most of the series, at Durand-Ruel's, but it is not on the Durand-Ruel
or Bernheim-Jeune stock-lists.)
 Bought from Alexander Reid, Glasgow, 1925.

2283 **Haystacks: snow effect**
Canvas: $25\frac{1}{2}$ × $36\frac{1}{4}$ (64·8 × 92·1) cleaned 1967. Signed: *Claude
Monet 91*. One of a series of about eighteen canvases of this subject
painted in 1890–1, fifteen of which were exhibited at Durand-Ruel's
in May 1891. *Coll:* First recorded as bought from Chavasse by
Durand-Ruel in 1898; *Monet Exh:* Edinburgh 1957 (92) lent Sir A.
Chester Beatty; bought by Sir Alexander Maitland from Tooth's 1960.
 Sir Alexander Maitland bequest 1965.

MONTI, Francesco 1685–1767
Born Bologna. Pupil of dal Sole. Also active in Brescia, Cremona and
Bergamo.

2120 **Rebecca at the well**
Canvas 31 × 33¼ (78·5 × 85). Catalogued up to 1978 as Venetian, but clearly by Monti, probably from the relatively late period when he was influenced by Venetian artists including G. B. Tiepolo and Pittoni. Miss Ida Hayward bequest 1950.

MONTICELLI, Adolphe 1824–1886
Born at Marseille; influenced by Diaz and Delacroix; in Paris 1862–70; then in Marseille.

961 **A gypsy encampment**
Wood: 8¾ × 18 (22·2 × 45·8). The scene is most likely to be Provençal, and the date soon after 1870. *Coll:* Bought by W.B. Paterson from a lady in Paris to whom the artist is said to have given it.
Bought from W. B. Paterson 1908.

1022 **La fête**
Scene in a park
Wood: 15¼ × 23⅛ (38·8 × 58·8) restored 1968. Painted 1867–9 (P. Ripert in *Marseille: revue municipale* 3rd series no. 49 p. 34, as c 1869). *Coll:* Alexander Young sale Christie's 30 June 1910 (101) as *Fête champêtre.*
Bought from Alexander Reid, Glasgow, 1910.

1464 **Garden fête**
Wood: 12¼ × 23½ (31·2 × 59·7). Probably painted c 1870–72.
Dr John Kirkhope bequest 1920.

MORE, Jacob 1740–1793
Scottish, born in Edinburgh; trained in landscape painting under the Nories (q.v.); settled in Rome c 1773.

1897 **The Falls of Clyde**
Canvas: 31¼ × 39½ (79·4 × 100·4). The artist's name and title of the picture are painted on the back. Perhaps exhibited Society of Artists, London, 1771 (91). In the catalogue of the Walker sale our picture was called *The great fall of Clyde called Cora-Linn.* An almost identical version of the same subject was in Dowell's sale 21 Nov 1958, called *Corehouse Linn,* but David Irwin has suggested that our picture may represent Bonnington rather than Cora Linn. Versions by More of two of the other falls of Clyde are in the Fitzwilliam Museum and the Tate Gallery. *Lit:* David Irwin in *Burl. Mag.* Nov 1972 p. 775. *Coll:* Sir Joshua Reynolds; George Walker (landscape painter) sale Christie's 26/7 June 1807; Francis Lord Gray (1828); passed to the Earl of Moray; Earl of Moray sale Sotheby's 9 June 1932 (56).
Rt Hon J. Ramsay MacDonald bequest 1938.

MOREELSE, Paulus 1571–1638
Born at Utrecht, where he worked, principally as a portrait painter.

52 Shepherd with a pipe
Canvas: $37\frac{3}{8} \times 28\frac{5}{8}$ (95 × 72·8) cleaned 1940. In the Gerini collection
in 1786 (engraved by L. Lorenzi as by the early 16th-century painter
Andrea Morinello). Attributed to 'Morillo' (as Moreelse was
sometimes called) in the Gerini sale catalogue 1825 (278).
 Bought from the Marchese Gerini, Florence, for the Royal
Institution 1831.

1024 Cimon and Pero
The subject of the woman suckling her starving father in prison is
known also as *Roman Charity* or *The Grecian Daughter*.
 Canvas: $58\frac{1}{4} \times 64\frac{1}{2}$ (148 × 164) restored 1957. Signed:
P Moreelse/1633 (*P M* in monogram). A late work clearly influenced
by Rubens (compare his *Cimon and Pero* of c 1612 in the Hermitage,
Leningrad). The subject is taken from the chapter of Valerius
Maximus *On piety towards parents. Lit:* C. H. de Jonge: *P. Moreelse*
Assen 1938, no. 286.
 Alexander Wood Inglis gift 1909.

MORISOT, Berthe 1841–1895
French; pupil of Corot, sister-in-law of Manet.

2269 Woman and child in a garden
Canvas: $23\frac{3}{4} \times 28\frac{3}{4}$ (60·4 × 73) cleaned 1964. Signed or stamped:
Berthe Morisot. Probably one of the scenes with the painter's daughter
Julie and her nurse painted in the Bois de Boulogne and at Bougival
in 1883–4. *Lit:* M.-L. Bataille and G. Wildenstein: *Berthe Morisot*
Paris 1962, no. 158. *Coll:* Gabriel Thomas; R. A. Peto.
 Bought from Tooth's 1964.

MORLAND, George 1763–1804
English genre painter.

1835 The comforts of industry
Canvas: $12\frac{1}{4} \times 14\frac{1}{2}$ (31·2 × 36·9).

1836 The miseries of idleness
Canvas: $12\frac{1}{4} \times 14\frac{1}{2}$ (31·2 × 36·9).

A pair. Both engraved by H. Hudson 1790. *Coll:* Given by the
artist to E. Collins of Maize Hill, Greenwich; E. Collins Wood sale,
Christie's 2 July 1909 (93); S. B. Joel sale, Christie's 31 May 1935 (36).
 Lord and Lady Craigmyle gift 1935.

2015　**The public house door**
Canvas: $23\frac{3}{4} \times 30\frac{1}{2}$ ($62\cdot9 \times 77\cdot5$). Engraved by W. Ward 1801.
Coll: Bought from A. J. Sulley by Arthur Lee MP; Arthur Lee sale,
Christie's 19 May 1911 (97); S. B. Joel sale, Christie's 31 May 1935
(17).
Lord Craigmyle gift 1944.

MORONI, Giovanni Battista　active by 1547—died 1578
His home town was probably Albino, to the north east of Bergamo,
but his early training was in Brescia where he was a pupil of Moretto.
He was particularly successful as a portrait painter.

2347　**Portrait of a scholar, possibly Basilio Zanchi.**
Canvas: $45\frac{3}{4} \times 35$ ($116\cdot2 \times 88\cdot8$); original painted surface $43\frac{3}{4} \times 32$
($114\cdot2 \times 81$). Cleaned 1977/78 (X-rayed). Signed on the base of the
inkwell: 10 BAP MORONO/PINXIT QVEM NON VIDIT (Giovanni
Battista Moroni painted him whom he did not see); and inscribed
and dated on the manuscript in the centre: CORPORIS EFFIGIEM
ISTA QVIDEM BENE PICTA TABELLA/EXPRIMIT, AST ANIMI TOT
MEA SCRIPTA MEI/MDLXII (This painted picture well depicts the
image of my body but that of my spirit is given by my many
writings, 1562). The manuscript in his left hand begins with the word
SEMPRE. Although there is some doubt as to the autograph status
of the inscriptions, they are clearly old and the information they
convey may well be correct. In any case the attribution of our
picture to Moroni is not in doubt. The picture was known in the
19th century as a portrait of Michelangelo. But it may probably be
identified as the portrait seen by F. M. Tassi (*Vite de' Pittori Scultori
e Architetti Bergamaschi* Bergamo 1793 I p. 169) in the Zanchi
collection, Bergamo, in which case it might be a posthumous portrait
of the distinguished theologian and writer, Basilio Zanchi, who was
born in Bergamo in 1501. He entered the order of the Regular Canons
of the Lateran in 1524 and was a librarian at the Vatican from
1550–53. In 1558 he died in the Castel S. Angelo, Rome, where he
had been imprisoned for his refusal to reside in his monastery in
accordance with the orders of Pope Paul IV.　*Coll:* Conte
Giambattista Zanchi, Bergamo, by 1793; Manfrini collection,
Venice, by 1852 (see P. Selvatico and V. Lazari *Guida di Venezia e delle
isole circonvicine* Venice–Milan–Verona 1852 p. 297); bought,
probably in 1856, by Alexander Barker, apparently with a view to
subsequent sale to Baron Meyer Amschel de Rothschild of Mentmore;
Rothschild collection by 1860 (see *Mentmore* [Catalogue] Edinburgh
1883 (8)); lent by Baron Meyer de Rothschild to the RA 1870 (20);
by inheritance to his daughter Hannah who in 1878 married the 5th
Earl of Rosebery; lent by the 6th Earl of Rosebery to the RA
Italian Art and Britain 1960 (72); Mentmore sale catalogue IV, Sotheby's

25 May 1977 (2049), withdrawn for sale to the Gallery by private treaty.

Bought by private treaty from the estate of the 6th Earl of Rosebery 1977.

NASMYTH, Alexander HRSA 1758–1840
Scottish, born in Edinburgh; probably in Ramsay's London studio 1774–8; apprenticed to James Cumming, coach-painter, 1782, but in Rome 1783–5; thereafter in Scotland. The first important and influential painter of Scottish scenery.

291 Distant view of Stirling
Canvas: 33 × 46 (83·9 × 116·9) cleaned 1957.
Commissioned by the Royal Institution, Edinburgh, and exhibited there in 1827 (no. 6).

1383 The windings of the Forth
Looking west over Alloa towards Stirling.
Canvas: 18 × 29 (45·7 × 73·7). From the style, probably quite close in date to no. 291 above. *Coll:* Patrick Blair; RSA 1880 (234) lent Mrs Blair.
R. K. Blair ws gift 1920.

NASMYTH, Patrick 1787–1831
Scottish, born in Edinburgh; eldest son and pupil of Alexander; called the English Hobbema; settled in London c 1807.

2101 A woodman's cottage
Wood: 16⅜ × 22 (41·6 × 55·9). *Coll:* A picture with this title was British Institution 1856 (110) lent Keith Barnes. F. J. Nettlefold coll. (1937 catalogue vol. III p. 136).
F. J. Nettlefold gift 1948.

NASON, Pieter 1612–c 1689
Worked mainly as a portrait painter, from 1638 at The Hague.

117 A man and wife
Canvas: 53⅜ × 58 (135 × 147·3) cleaned 1955. Traces of the signature: *P Na . . . f* (P N in monogram). Style and costume suggest a date in the 1650s.
Bought for the Royal Institution in 1840.

21 Cain killing Abel
Canvas: 75 × 56½ (190 × 143) restored 1970. Catalogued until 1978 as Ludovico Carracci. It is probably by a South Italian artist, perhaps active in Naples in the second quarter of the 17th century. A *Cain fleeing from the body of Abel,* now in the Corsini collection, Florence, and formerly in the Barberini collection, Rome, might well be by the same hand. Unfortunately the Corsini picture is listed without attribution in the old Barberini inventories (see M. Lavin *Seventeenth-Century Barberini Documents and Inventories of Art* New York 1975 p. 265 vii Inv. 55 no. 24.)
Sir Alexander Crichton gift to the Royal Institution 1834.

NORIE, James
Scottish. James Norie the elder (1684–1757) founded a firm of decorative landscape painters in Edinburgh which survived till 1854.

1768 Classical landscape with architecture
Canvas: 25½ × 52 (64·8 × 132) cleaned 1956. Signed: *Ja. Norie, Edin. 1736.*

1769 Classical landscape with trees and lake
Canvas: 25½ × 52 (64·8 × 132) cleaned 1957. Signed: *Ja. Norie, Edin. 1736.*

A pair, described in 1931 as by Norie and Runciman.
Bought at the Lady Sinclair sale, Edinburgh, May 1931.

NOVELLI, Pietro 1603–1647
Worked mainly in Palermo, but probably visited Naples in the early 1630s; strongly influenced by Ribera after about 1640.

83 ' A mathematician'
Canvas: 46 × 36 (116·9 × 91·5) restored 1960, when additional strips at the sides were removed. Catalogued until 1970 under Ribera, and probably based on one of his designs, but painted by Novelli c 1640 or a little later. Other versions are recorded in colls: Carvalho, France; Casa Torres, Spain; O. Falkmann, Stockholm. *Lit:* E. Frankfort in *Archivo Español de Arte* xxxvi 1963 p. 131.
Acquired by the RSA by 1859; transferred 1910.

OEVER, Hendrick ten 1639–1716
Dutch, born in Zwolle where he worked from 1665. His landscapes
were influenced by Cuyp.

22 **Canal landscape with figures bathing**
The town of Zwolle is on the horizon.
Canvas: 26¼ × 34¼ (66·7 × 87) cleaned 1936. Signed: *H. ten Oever*
1675. A landscape showing the same view, with different figures and
animals, is reproduced in J. Verbeek and J. W. Schotman: *H. ten Oever,*
Zwolle 1957 (pl. 22). *Coll:* Lent by Sir John Erskine to the
Royal Institution, Edinburgh 1830 (98) as Cuyp.
 Sir James Erskine of Torrie bequest to Edinburgh University 1835;
deposited on loan 1845.

ORCHARDSON, Sir William Quiller RA, HRSA 1832–1910
Scottish, born in Edinburgh; entered the Trustees' Academy there
1845; settled in London 1862.

1138 **Master Baby**
Canvas: 42¼ × 65½ (108 × 166). Signed: *W.Q.O./86*. Exhibited
Grosvenor Gallery 1886 (31). According to Sir Arthur Cope, the
models were his mother and youngest brother Gordon. For Sickert's
unreserved (and Degas' reserved) admiration for the picture, see
A Free House (W. R. Sickert) ed. O. Sitwell, London 1947 p. 149.
Lit: H. Orchardson Gray: *Life of Orchardson* London n.d. pp. 256,
270, 313. *Coll:* Bought from the painter by James McCulloch in
1906; RSA 1911 (96) lent Mrs Coutts Michie; G. McCulloch sale,
Christie's 29 May 1913 (179) bought by Sir Hugh Lane.
 Bought, with help from an anonymous donor, from Sir Hugh Lane
1913.

ORLEY, Bernard van c 1488–1541
Born and worked in Brussels; Court painter there from 1518.

995 **Before the Crucifixion**
Wood: 26½ × 33¾ (67·3 × 85·7). Associated with two other panels
of roughly the same size from the Alfred Stowe coll. (1911):
Scourging of Christ (Landesgalerie, Hanover) and *Procession to Calvary*
(Oriel College, Oxford). These, together with a fourth panel
representing *The Agony in the Garden* (as yet untraced), were
painted for Henry III Count of Nassau and his third wife Mencia de
Mendoza, married 1522. (Their arms are painted on the backs of the
Stowe panels and corresponding traces can be seen on the back of our
picture.) The panels, datable c 1530, are listed in an inventory of the
Mendoza coll. in the castle at Jadraque, Spain, 1535. The theme of

the figure of Christ bound, seated on a stone, was common in sculpture and prints (see Mâle pp. 94/6); its use in a larger composition is very unusual. *Lit:* Friedländer VIII nos. 97 and 111; O. Pächt in *Oriel Record* 1952. *Coll:* Catalogued in 1910 as from the Dukes of Medina-Caeli.

Bought from A. van Branteghem, London, 1909.

1895 Marie Haneton
Panel: 29⅝ × 22⅛ (75·2 × 56·1). Her identity is established by the epitaph inscribed on the back of the panel and revealed by cleaning in 1971. The second daughter of Philippe Haneton (died 1522) Marie is portrayed with her mother and sisters on the right wing of the Haneton triptych of the *Lamentation* Musées royaux des Beaux-Arts Brussels (no. 559; Friedländer VIII no. 86). The portrait in the latter depends on that at Edinburgh (c 1518/19) which possibly formed a diptych with another panel representing either the Virgin and Child or the Magdalen. *Lit:* Friedländer VIII no. 152 (c 1522). *Coll:* T. B. Brydges Barrett of Lee Priory Kent (as Queen Margaret of Scotland); inherited by Sir John Brydges Bart sold Christie's 28 May 1859 (94) bt for Sir Hugh Hume Campbell Bart by whom bequeathed (as Queen Margaret wife of James IV of Scotland, by Mabuse).

Sir Hugh Hume Campbell bequest 1894.

OSTADE, Isack van 1621–1649
Born and worked in Haarlem, brother and pupil of Adriaen.

951 Sportsmen halting at an inn
Wood: 21 × 23½ (53·4 × 59·7). Signed: *Isack. van. Ostade/1646.*
Coll: HdG (no. 74) gives J. van der Grijp and others, sale Soeterwoude 25 June 1784 (37). Prince Demidoff, San Donato, sale Florence 15 Mar 1880 (1110); Secrétan sale, Christie's 13 July 1889 (7); H. Bingham Mildmay sale, Christie's 24 June 1893 (46).

Henry Callcot Brunning bequest 1908.

PAGGI, Giovanni Battista 1554–1627
Genoese; influenced by Cambiaso; worked at first in Florence, in Genoa from 1599.

55 Rest on the Flight into Egypt
Canvas: 34⅛ × 26¾ (86·7 × 68) cleaned 1950. Signed:
G. BTA/PAGGI/F.
Bought from the Doria family, Genoa, for the Royal Institution in 1830.

71

PATER, Jean-Baptiste 1695–1736
Worked in Paris from 1718; probably for a short time a pupil of
Watteau.

441 Ladies bathing
Canvas: 23 × 28 (58·4 × 71·1) cleaned 1965. This subject, which
Pater developed by 1721 or before, was inspired by Titian's *Diana and
Actaeon* (see p. 106), which was in Paris soon after 1704. Two smaller
variants of this design are in Angers and Stockholm museums.
Coll: Chevalier de Clesne sale Paris, 4 Dec 1786, no. 58 (F. Ingersoll-
Smouse *Pater* Paris 1928, no. 320); later probably General John
Ramsay (died 1845); Lord Murray in 1856 (Waagen suppl. p. 430).
Lady Murray of Henderland bequest 1861.

PATERSON, James RSA 1854–1932
Scottish, born in Glasgow, trained in Glasgow and Paris; member of
the Glasgow School.

2023 Edinburgh from Craigleith
Canvas: $26\frac{1}{2}$ × 45 (67·4 × 114·3). Signed: *James Paterson, Edinburgh.*
Perhaps the picture exhibited RSA 1899 (260) *The quarry and the town.*
Coll: A. Cameron Corbett MP, in 1907.
Bought at Dowell's sale, Edinburgh, 21 Oct 1944 (no. 78).

PATON, Sir Joseph Noel RSA, LLD 1821–1901
Scottish, born at Dunfermline; in London 1842–4 where he became
friends with Millais; thereafter in Dunfermline and Edinburgh.

293 The quarrel of Oberon and Titania
A Midsummer Night's Dream II ii.
 Canvas: 39 × 60 (99 × 152) cleaned 1966. Exhibited RSA 1850
(151), described as a companion to our no. 294 (although it is larger),
painted in 1847. A first study, c 17 × 25 in., dated 1846 and exhibited
RSA 1846 (121) is in the RSA Diploma Collection. Five drawings for
it are our nos. D3804-6, 3913, 4252a. Some preparatory drawings
of the fairies, in the possession of the artist's family, were made
from clay models.
 Bought by the Royal Association for the Promotion of the Fine
Arts 1850.

294 The reconciliation of Oberon and Titania
A Midsummer Night's Dream IV i.
 Canvas: 30 × $48\frac{1}{4}$ (76·2 × 122·6) cleaned 1966. Signed: *J. Noel
Paton, Feb. 1847.* Exhibited RSA 1847 (362). It won one of the
Government premiums at the Westminster Hall competition, 1847.

A pen drawing, 15 × 23¾in., dated May 1846 is in the Glasgow Art
Gallery. *Lit:* T. S. R. Boase in *Warburg Journal* 1954 xvii nos. 3–4
p. 343.
Bought by the RSA 1848; transferred 1910.

1230 Dawn: Luther at Erfurt
Canvas: 36½ × 27⅛ (92·7 × 69) cleaned 1967. The painted surface
is arched. In the left spandrel is written: *commenced to paint Jany 23
1861—finished April 2nd.* ... Signed in monogram and dated 1861.
Exhibited RA 1861 (10); RSA 1862 (490). Miss M. H. Noel-Paton
writes that she has an early pencil drawing of the head for which her
grandmother, the artist's wife, posed. *Coll:* R. H. Brechin by 1898.
Bought at R. H. Brechin sale, Glasgow, Mar 1919 (no. 54).

PÉREZ, Gonzalo active 1412–51

attributed to Gonzalo Pérez

1021 St Michael killing the dragon
Wood: painted surface 71½ × 36¼ (182 × 92); the frame (original
except for the top bar): 74½ × 40¾ (188 × 103·5). The centre panel
from an altarpiece. Post suggested that it might be by the painter of a
St Bartholomew (Worcester Art Museum no. 1919–315) and was
followed by Saralegui, who identified him as Gonzalo Pérez, active
in Valencia 1412–51. Saralegui also suggests three scenes of St Michael
(Ourousoff coll: repr *Oesterreichische Kunstschätze* i pls. 62/3) as
perhaps from the same altarpiece. *Lit:* C. R. Post: *History of
Spanish Painting* iii 1930 p. 96 and ix 1947 p. 759; L. de
Saralegui in *Bol. Soc. Española de Excursiones* xlvi 1942 p. 129,
and in *Archivo de Arte Valenciano* xxviii 1957 p. 5; A. L. Mayer:
Historia de la Pintura Española Madrid 1947 p. 71; H. Wethey:
European Paintings in the Collection of the Worcester Art Museum
(Spanish School) Worcester (Mass.) 1974 p. 507.
Bought from The Spanish Art Gallery, 1910.

PERUGINO (Pietro Vannucci) c 1445/46–1523
Umbrian; worked mainly in Florence, where his style was formed,
and Perugia.

1805 A fragment: four male nude figures
Linen: 29 × 21¾ (73·5 × 55·5); the paint surface is damaged. The
bottom left hand corner from a design that was probably much larger,
perhaps around 350 cm. wide. Fischel (p. 70) suggests that it is from
the lost *Mars and Venus in the net of Vulcan*, offered after
Perugino's death by his widow Chiara Fancelli to the Duchess of
Mantua in 1524, but since it is fairly close in style to the *Combat
of Love and Chastity* (Louvre, Paris no. 1567) finished in 1505,
it seems rather unlikely that it would still have been in Perugino's

studio at the time of his death. *Coll:* Bought from Bardini, Florence, by Sir Thomas Gibson Carmichael Bt; his sale, Christie's 13 May 1902 (269); F. A. White, London, in 1902.
Bought at F. A. White sale, Christie's 20 Apr 1934 (no. 127) and given by the National Art-Collections Fund.

PETTIE, John RA, HRSA 1839–1893
Scottish, born in Edinburgh; entered the Trustees' Academy there in 1856 under R. Scott Lauder; settled in London 1862.

1187 Cromwell's Saints
Canvas: $16\frac{3}{4} \times 20\frac{1}{2}$ (42·5 × 52). Signed: *J.Pettie/62*. Exhibited RSA 1863 (150) lent by John Charles Bell. The last picture Pettie painted before he left Edinburgh for London. The man smoking is Sam Bough. *Lit:* M. Hardie: *J. Pettie* London 1908 p. 30. *Coll:* J. C. Bell sale, Dowell's, Edinburgh 17 Mar 1877 (61); lent to NG Edinburgh 1901 by John Jordan.
John Jordan bequest 1914.

PHILLIP, John RA, HRSA 1817–1867
Scottish, born in Aberdeen; entered the RA Schools, London, 1837; returned to Aberdeen 1846; visited Spain 1851, 1856–7 and 1860–1.

836 La Gloria: a Spanish wake
Canvas: $56\frac{1}{2} \times 85\frac{1}{2}$ (144 × 217) restored 1967. Signed: *JP* (in monogram) *1864*. Exhibited RA London 1864 (51). A sketch in pencil and wash is in Aberdeen City Art Gallery, and an oil sketch is in Carlisle City Art Gallery. *Lit: Art Journal* 1864 p. 160. *Coll:* Lent by Sir John Pender to RSA 1865 (453).
Bought, with a contribution from J. R. Findlay, at Sir John Pender sale, Christie's 29 May 1897 (no. 64).

PISSARRO, Camille 1830–1903
Born in the West Indies, brought up in France; impressionist painter working mainly in and near Paris.

2098 The Marne at Chennevières
Chennevières is on the south-eastern outskirts of Paris.
Canvas: 36 × $57\frac{1}{4}$ (91·5 × 145·5). Signed: *C. Pissarro*. A major work from the pre-impressionist period, before 1870; dated c 1864–5 by L. R. Pissarro and L. Venturi (*Camille Pissarro,* Paris 1939, no. 46 and p. 20). Probably Paris Salon 1865 (1723) *Chennevières au bord de*

la Marne; Pissarro Centenary Exh: Orangerie, Paris 1930 (7) lent by
Ambroise Vollard.
Bought from Dr T. J. Honeyman 1947.

PITTONI, Giovanni Battista 1687–1767 Venetian

2238 **St Jerome, with St Peter of Alcantara**
St Peter (1499–1562) was a Franciscan of great austerity and a
prominent figure in the Spanish counter-reformation.
 Canvas: 108 × 56 (275 × 143) cleaned 1962. (The present stretcher
has a flat arch made up at the top. Originally the top seems to have
been semi-circular.) Altarpiece from the Church of S Maria dei
Miracoli in Venice, where it was recorded in 1733 by A. M. Zanetti
(p. 380). The reputation and history of the picture while still in
the church are considered by F. Haskell (*Burl. Mag.* 1960 p. 366).
Coll: Cooper Union, New York (probably bought in 1903).
 Bought from Colnaghi's 1960.

POLIDORO da LANCIANO c 1515–1565
Worked in Venice. Most of his compositions derive from Titian.

1931 **Madonna and sleeping Child**
Canvas: $20\frac{3}{4}$ × $26\frac{1}{2}$ (52·7 × 67·8) cleaned 1943. Berenson (1957) as an
early work. A painting of this design, with St Joseph added, was in the
Archduke Leopold Wilhelm coll. Brussels in 1659 as by Polidoro
(engraved P. Lisebetius in Teniers' *Theatrum Pictorium* 1660).
Coll: Bought in Rome as by Titian in 1861 by the 8th Marquess of
Lothian.
 11th Marquess of Lothian bequest 1941.

POPPI, Il (Francesco Morandini) 1544–1597
Worked in Florence; pupil and assistant of Vasari.

2268 **The Golden Age**
The first of the four ages of the world in classical mythology. The
figures at the top represent the four seasons.
 Wood: $16\frac{7}{8}$ × $12\frac{1}{2}$ (43 × 31·8) (X-rayed). Presumably the *Golden
Age* which, according to Raffaello Borghini, was painted by Poppi for
Francesco I de' Medici. The composition follows closely a detailed
programme written for Vasari by his friend Vincenzo Borghini in
1565–7. A drawing attributed to Vasari, which follows Borghini even
more exactly than our painting, is in the Louvre, Paris, no. 2170
(*Vasari Exh:* catalogue Paris 1965 p. 26). *Lit:* R. Borghini:
Il Riposo Florence 1584 IV p. 642; Vincenzo Borghini's text is quoted
by P. Barocchi: *Vasari Pittore* Milan 1964 p. 141; L. Berti:
Il Principe dello Studiolo Florence 1967 p. 82.
 Bought from Colnaghi's 1964.

POURBUS, Frans, the elder 1545–1581
Flemish; pupil of Frans Floris in Antwerp, where he worked.

attributed to Frans Pourbus

2275 **5th Lord Seton and his family**
Initials and ages have been inscribed (probably later) beside the five children.
Wood: $42\frac{7}{8} \times 31$ (109 × 79) restored 1968. Signed: *1572/FP.*
Coll: According to a later description in the Somerville archives, seen by Charles I 'at Seton House'. Apparently bought by Lord Somerville by 1757; presumably the *Earl of Winton and family—Sir A. More* in a Somerville family valuation of 1869; thence by inheritance.
Sir Theophilus Biddulph bequest, received 1965.

POUSSIN, Nicolas 1594 (?)–1665
French; settled in Rome 1624; visited Paris 1640–42.

2319 **Mystic Marriage of St Catherine**
Wood: $49\frac{5}{8} \times 66\frac{1}{4}$ (126 × 168) cleaned and restored 1973. Painted on five oak planks lying horizontally (considerable paint losses along the joins of the planks, especially the topmost join). The whole panel appears to have been sawn through, $16\frac{1}{2}$ in (42 cm) from the right-hand edge, and joined together again. X-rays reveal either extensive changes to the central area of the design, or (less probably) a different composition altogether underneath. A variant of the composition with the martyrdom of St Catherine in the right background, is recorded in a drawing at Cleveland (Museum of Art). The large oak panel, the scale of the figures and certain weaknesses and uncharacteristic passages in the painting have led to doubts about Poussin's authorship (eg by Grautoff). A proposal to re-attribute this and other pictures to Charles Mellin is unconvincing (see D. Wild in *Gazette des Beaux-Arts* 1966 LXVIII pp. 177ff). The attribution to Poussin in the dal Pozzo collection is important (see below), and the picture's style relates it particularly to the early *Martyrdom of St Erasmus* (Vatican) of 1628–9 and *Virgin appearing to St James* (Louvre, Paris).
Lit: D. Mahon in *Burl. Mag.* 1960 p. 299 as 1631; Blunt no. 95 as c 1627–9, and in *Burl. Mag.* 1974 p. 762–3. *Coll:* Almost certainly the picture described among the Poussins in the dal Pozzo collection (inventory of Carlo-Antonio dal Pozzo, 1689, and later lists: see F. Haskell and S. Rinehart in *Burl. Mag.* 1960 pp. 318–26; and A. B. de Lavergnée in *Revue de l'Art* no. 19 1973 pp. 79–96). Humphrey Morice, Chiswick, in 1781 (see *Walpole Society* XVI 1927–8 pp. 77–8). Apparently not in the collection Morice inherited from his cousin Sir William Morice (died 1750), which already included Poussin's *Landscape with Pyramus and Thisbe*, almost certainly also from the dal Pozzo collection (see E. K. Waterhouse in

Nicolas Poussin (Colloques Poussin) Paris 1960 I p. 293). For later history see Blunt no. 95.

Sir John Heathcoat Amory Bart bequest, received 1973.

Moses striking the rock
Canvas: 38¾ × 53½ (98·5 × 136). Probably painted c 1637. Almost certainly the version painted, according to Félibien, for Melchior Gillier by 1637. If so, it was later with de l'Isle Sourdière; de Bellièvre; Dreux; J.-B. Colbert, Marquis de Seignelay (in 1685).
Lit: A. Félibien: *Entretiens sur les . . . peintres* Trévoux 1725 IV p. 24; D. Mahon in *Burl. Mag.* 1960 p. 304; Blunt no. 22. *Coll:* Duc d'Orléans, in the 1724 inventory (Stryienski no. 346); sale Bryan's Gallery, London 1798 (54), reserved for the Duke of Bridgewater (see p. viii); thence by inheritance. Bridgewater House no. 62.

Duke of Sutherland loan 1946.

Sacrament of Baptism
John baptising Christ in the river Jordan.
Canvas: 46¼ × 69½ (117·5 × 177). Painted between February and November 1646. Bridgewater House no. 63.

Sacrament of Confirmation
The scene seems to be the Roman catacombs. The lighting of the Paschal candle implies that it is Easter Eve.
Canvas: 46¼ × 69½ (117·5 × 177). Painted between April and December 1645. Bridgewater House no. 64.

Sacrament of Marriage
The scene represents the marriage of the Virgin.
Canvas: 46¼ × 69½ (117·5 × 177). Painted between November 1647 and March 1648. Bridgewater House no. 65.

Sacrament of Penance
The Magdalen washing Christ's feet in the house of Simon the Pharisee.
Canvas: 46¼ × 69½ (117·5 × 177). Painted between February and June 1647. Bridgewater House no. 66.

Sacrament of Ordination
Christ giving the keys to St Peter; the background is a careful reconstruction of an ancient town.
Canvas: 46¼ × 69½ (117·5 × 177). Painted between June and August 1647. Bridgewater House no. 67.

Sacrament of Holy Eucharist
The Last Supper, with Christ blessing the cup.
Canvas: 46¼ × 69½ (117·5 × 177). Painted between September and November 1647. Bridgewater House no. 68.

Sacrament of Extreme Unction

The scene shows the giving of the sacrament in the time of the
Emperor Constantine (indicated by the monogram on the shield).
Canvas: 46¼ × 69½ (117·5 × 177). Painted between April and
October 1644. Bridgewater House no. 69.

In 1636–40 Poussin had already painted the Seven Sacraments for
Cassiano dal Pozzo in Rome (5 still in Duke of Rutland coll., one in
N G Washington). It is the first known instance of the sacraments
represented in a series of separate canvases. Fréart de Chantelou,
when he saw them, asked Poussin to provide him with copies, but
Poussin preferred to paint an entirely new series, which he began in
1644. Poussin's aim to represent his subjects in conformity with the
practice of the early Church, the sources for his designs and the
important evidence of his preparatory drawings are investigated and
fully discussed by Blunt (*Catalogue:* nos. 12–8; *Text:* references
p. 398). *Coll:* Fréart de Chantelou (died 1694) Paris; his nephew
Roland Fréart (died 1707); the latter's nephews, the brothers Favry
(M. Rambaud: *Documents du Minutier central*. . . . Paris II 1971
p. 798); in the coll. of Jaques Meyers of Rotterdam by 1714
(P. J. B. Nougaret: *Anecdotes des Beaux-Arts* . . . Paris 1776 II p. 128);
bought 1716 by Duc d'Orléans through Abbé Dubois (Stryienski
p. 15); sale Bryan's Gallery London 1798, reserved for the Duke of
Bridgewater (see p. viii); thence by inheritance. Bridgewater House
nos. 63–69.
Duke of Sutherland loan 1946.

formerly attributed to Poussin

458 **The Feast of the Gods** (after Giovanni Bellini)
Canvas: 68½ × 75¾ (174 × 192·4) (X-rayed). A full-size replica of
Bellini's picture later modified by Titian (now NG Washington). It is
universally agreed to be an unusually good copy, more or less
Poussinesque in character, painted c 1625–50 in Rome where the
original then was. The attribution to Poussin, which is recorded by
1849, has been questioned by Davies and Kauffmann and rejected by
Wild and Mahon. It was accepted without reserve in 1966 by Blunt
who later expressed some doubts about the attr. to Poussin
(letter, 29.iii.1978). Walker argued convincingly that a faithful facsimile
of this kind was surely commissioned by a collector, not made by a
painter for his own edification. *Lit:* J. Walker: *Bellini and Titian
at Ferrara* London 1956, pp. 106–8; Martin Davies in *Burl. Mag.*
1957, p. 253; D. Wild in *Pantheon* May 1960, p. 159; D. Mahon
in *Burl. Mag.* 1960, p. 290; G. Kauffmann in *Kunstchronik* 14 1961,
p. 97; Blunt no. 201. *Coll:* W. Coningham sale, Christie's 9 June 1849
(4) as by Poussin, bought by Sir Charles Eastlake.
Sir Charles Eastlake gift 1862–3.

PROCACCINI, G. C. 1574–1625
Born at Bologna; active in Milan, first as sculptor, later as painter; visited Genoa 1618.

2276 The Raising of the Cross
Canvas: 86 × 58½ (218 × 148·6) restored 1965/66. A late work, probably painted c 1616–20. Similar pictures from the same period are *The Mocking of Christ*, 85¾ × 58 in., signed *G.C.P.* (Graves Art Gallery, Sheffield); and *The Capture of Christ*, 83 × 55¾ in. (ex Tomás Harris, 1937). There is no evidence as to whether or not they belonged to a single series. *Lit:* M. Valsecchi in *Paragone* May 1970 p. 22; P. Cannon-Brookes: *Lombard Paintings c 1595–1630* Exhibition Catalogue, Birmingham 1974 p. 184; H. Brigstocke in *Burl. Mag.* Nov 1974 p. 691 and in *Jahrbuch der Berliner Museen* 18 1976 p. 88.
Bought from Colnaghi's 1965.

PROVOST, Jan active 1494–died 1529
Settled in Bruges 1494, where he was a leading figure after Gerard David's death.

1537 Virgin and Child
Wood (arched top): 14 × 8⅜ (35·6 × 21·3). Attributed to Provost, as a fairly early work, by Friedlaender (IX no. 169). *Coll:* Fuller-Maitland, Stansted Hall, catalogue 1893 (48) as by van der Goes.
Bought from the Fuller-Maitland collection 1921.

RAEBURN, Sir Henry RA 1756–1823
Scottish, born in Edinburgh; apparently largely self-taught. His earliest certain portrait is the *George Chalmers* (Dunfermline Town Council) of 1776. From c 1785 he was in London, where he is said to have met Reynolds, and in Italy; back in Edinburgh in 1787.

302 Mrs Scott Moncrieff
Margaritta Macdonald (died 1824) wife of Robert Scott Moncrieff, who later took the name Scott Moncrieff Wellwood.
Canvas: 29½ × 24½ (75 × 62·3). Probably painted c 1814.
Bequeathed to the RSA by the sitter's husband in 1854; transferred 1910.

420 Colonel Alastair Macdonell of Glengarry (1771–1828)
Chief of the Macdonells of Glengarry, said to be the original of Fergus MacIvor in *Waverley*.
Canvas: 95 × 59 (241 × 150). Exhibited RA 1812 (1). *Lit:* W. D. McKay: *Scottish School of Painting*, London 1906, pp. 66–8.
Bought from John Cunninghame of Balgownie, the sitter's great-grandson, 1917.

623 Mrs Hamilton of Kames
Harriet Frances (1784–1860) daughter of Richard Wynne of
Folkingham, Lincolnshire, wife of James Hamilton w s (1776–1849)
of Kames Castle, Bute.
 Canvas: 93 × 58½ (236 × 148·6) cleaned 1965. Painted before June
1811 (see *The Wynne Diaries* London 1935 iii p. 334). Raeburn family
sale, Christie's 7 May 1877 (48), bought in and sold privately to
Sir William Stirling Maxwell.
 Sir William Stirling Maxwell gift 1877.

837 Mrs Campbell of Ballimore (1735–1810)
Christiane Lamont daughter of Alexander Drummond, customs
officer at Greenock, married Colonel Dougall Campbell of Ballimore.
 Canvas: 48¼ × 38½ (122·6 × 97·8). Probably painted around 1790.
 Bequest of Lady Riddell, widow of Sir Thomas Milles Riddell Bart,
the sitter's great-grandson, 1897.

903 Major William Clunes
Major Clunes fought at Corunna in 1809 as captain in the 50th
regiment of foot. In July 1809 he was promoted major in the 54th foot.
His name last appears in the Army List in 1812.
 Canvas: 93 × 59 (236 × 150) cleaned 1956. Presumably painted
1809–12, since Clunes is shown in the uniform of the 54th foot.
Coll: Passed by descent.
 Lady Siemens bequest to the RSA 1902; transferred 1910.

930 Self-portrait
Canvas: 35¼ × 27½ (89·5 × 69·9) cleaned 1957. Raeburn probably
painted it not long before he offered it as his diploma work on his
election as R A in 1815. Since self-portraits were inadmissible, it
remained with the Raeburn family. *Coll:* By inheritance to Sir
William Patrick Andrew; his sale at Christie's 9 July 1887 (142).
 Bought at Lord Tweedmouth's sale, Christie's 3 June 1905 (no. 34).

1026 Henry Raeburn on a grey pony
Raeburn's second son Henry (1784–1863).
 Canvas laid on board: 13⅞ × 9¼ (35·3 × 23·5). This sketch,
presumably painted around 1795, is unique in Raeburn's known
work. It was the study for a life-size painting c 93 × 59 (236 × 150):
Raeburn Exh: 32 York Place, Edinburgh, 1824 (7); Raeburn family
sale, Christie's 7 May 1877 (49) and later with Marquise de Ganay,
Paris. This is presumably different from the picture exhibited RSA
1834 (185) by John Syme (born 1795) *Equestrian portrait of Henry
Raeburn Esq of St Bernard's. The Horse painted by the late Sir Henry
Raeburn RA. Coll:* Probably *Henry Raeburn and Horse,* anon. sale by
Robinson & Fisher 27 June 1901 (99) bought by Shepherd 95 gns.
 Bought from Carfax & Co., London, 1911.

1027 **John Smith of Craigend** (1739–1816)
4th Laird of Craigend, Stirlingshire, and member of a firm of West
India merchants.
Canvas: 29¼ × 24¾ (74·3 × 62·9). Almost certainly painted before
1790. *Coll:* Passed by inheritance.
Bought from Rev. F. S. Ranken, South Walsham, 1911.

1224 **Lieutenant-Colonel Lyon**
George Lyon entered the 11th Light Dragoons as a Cornet on 5 Mar
1788 and became a Lieutenant-Colonel in 1798.
Canvas: 35½ × 27 (90·2 × 68·6) cleaned 1951. Evidently painted
when the sitter was a Cornet in 1788, since the type of 'Dress Coat' he
wears was superseded in 1798. *Coll:* David Smith (1876); by descent
to Lord Kinnear.
Miss Kinnear bequest 1919.

1878 **Miss Lamont of Greenock**
Canvas: 29¾ × 24½ (75·6 × 62·3). Probably painted c 1810–15. The
sitter has not been identified. *Coll:* French Gallery, London, 1911 (25).
Gift of Robert Miller of London, through his widow Mrs Agnes
Duncan Miller, 1937.

1959 **Medallion: self-portrait**
Plaster: 3⅞ × 2¾ (9·5 × 7). Inscribed: *H. Raeburn 1792.* An old label
on the back reads: *Presented to Adam Smith by his much esteemed
friend Henry Raeburn Author of this model 1792.* This confirms a
family tradition that the original of this medallion, in the style of
Tassie, was modelled by Raeburn. *Lit:* J. Greig: *Sir Henry
Raeburn RA* London 1911, p. 57.
Bought from T. J. Watkins, Edinburgh, 1942.

2112 **The Reverend Robert Walker skating on Duddingston Loch**
Robert Walker DD (1755–1808) was minister of the Canongate Kirk,
Edinburgh, from 1784, and joined the Skating Society in 1780 when
he was minister of Cramond.
Canvas: 30 × 25 (76·2 × 63·5) cleaned 1949. According to family
tradition, Raeburn painted it in 1784 for his own entertainment and
gave it to the widow after the sitter's death. The skater's apparent age,
however, indicates a date at least 10 years later. Type of canvas, style
of painting and scale of figure have no parallel in Raeburn's work.
Coll: Passed by descent to Miss Beatrix Scott, who sold it to Miss Lucy
Hume, Bournemouth, in 1926.
Bought at Miss Hume's sale, Christie's 25 Feb 1949 (no. 80).

2147 **Sir Patrick Inglis, 5th Bart of Cramond** (died 1817)
Canvas: 49½ × 39½ (125·7 × 100·3) cleaned 1955. Probably painted
c 1785–90. *Coll:* Passed by descent.
Sir John Douglas Don-Wauchope, Bart of Edmonstone bequest 1951.

2148 **James Wauchope** (1767–1797)
Eldest son of John Wauchope of Edmonstone (cf no. 2149 below).
Canvas: 35½ × 27¼ (90·2 × 69·3) cleaned 1955. Probably painted
c 1785–90. *Coll:* Passed by descent.
Sir John Douglas Don-Wauchope, Bart of Edmonstone bequest 1951.

2149 **John Wauchope of Edmonstone** (1742–1810)
Canvas: 29¾ × 24¾ (75·6 × 62·9).

2150 **Anne Erskine, his wife** (1740–1811)
Canvas: 29¾ × 24¾ (75·6 × 62·9).

A pair, probably painted c 1800–05. Anne, elder daughter of
John Erskine, 14th Laird of Dun, and Margaret Inglis, married John
Wauchope in 1766. Raeburn's portrait of their son James is no. 2148
above. *Coll:* Passed by descent.
Sir John Douglas Don-Wauchope, Bart of Edmonstone bequest 1951.

2181 **Thomas Kennedy of Dunure** (died 1819)
Canvas: 50 × 40 (127 × 101·6).

2182 **Mrs Kennedy of Dunure**
Canvas: 50 × 40 (127 × 101·6).

A pair. Jean, daughter of John Adam (elder brother to the
architect Robert Adam) married Thomas Kennedy in 1779. In the
Raeburn Exh: Edinburgh 1876, Mrs Kennedy is said to be painted
c 1811, Mr Kennedy c 1812. A view of Dunure Castle is seen through
the window in each portrait. A replica of no. 2182 is also in the
collection (no. 626). *Coll:* Family possession at Dalquharan Castle,
Ayrshire, until after 1911; later Elspeth Lady Invernairn
(Mrs Thynne).
Offered by Elspeth Lady Invernairn of Strathnairn and accepted
after her death, 1956.

2301 **Sir John Sinclair, 1st Bart of Ulbster** (1754–1835)
Editor of the *Statistical Account of Scotland;* shown in the uniform of
the Rothesay and Caithness Fencibles which he raised in 1794.
Canvas: 93½ × 60½ (238 × 154). Probably painted 1794–5.
Coll: Raeburn family sale, Christie's 7 May 1877 (2); Sir John
Tollemache Sinclair sale, Christie's 16 July 1909 (139) bought by
Colnaghi's; RA 1910 (109) lent Archibald H. M. Sinclair. On loan
to the Gallery from 1910.
Bought with the aid of a special Treasury grant from the
Hon R. M. Sinclair 1967.

RAMSAY, Allan 1713–1784

Scottish, born in Edinburgh, son of Allan Ramsay the poet; in Italy 1736–8 and 1754–7, otherwise working in London where for about ten years around 1750 he was the leading portrait painter. Court painter from 1767.

430 The painter's wife

Margaret, daughter of Sir Alexander Lindsay of Evelick, eloped with Ramsay as his second wife in 1752. She died in 1782.

Canvas: 30 × 25 (76·2 × 63·5) cleaned 1960. Painted in 1754–5 in Italy. This was formerly presumed to be the portrait mentioned by Robert Adam in a letter of 2 Jan 1756, but A. Smart in a letter of 1978 claims that it was not our picture but a half-length portrait in a private collection that Adam saw. One of the first portraits in Ramsay's later style. A chalk study for the left hand is our no. D2094. A replica is in the Marquess of Lansdowne coll. *Lit:* A. Smart: catalogue of *Ramsay Exh:* RA London 1964, p. 21.

Bequest of Lady Murray of Henderland, widow of the sitter's nephew, in 1861.

820 Jean-Jacques Rousseau (1712–78)

The French philosopher came to England in 1766 to escape persecution, under the protection of David Hume. He is seen in the Armenian costume that he liked to wear at this time.

Canvas: $29\frac{1}{2} \times 25\frac{1}{2}$ (75 × 64·8). Painted in 1766, at the request of Hume, who was a close friend of Ramsay's. A replica is owned by the Bromley-Davenports, who commissioned it in 1767 for Wootton Hall, where Rousseau had stayed. Engraved by David Martin in 1766. Other versions are known. *Lit:* J. Seznec in *Scottish Art Review* VIII 3 1962 p. 21; A. Smart: catalogue of *Ramsay Exh:* RA London 1964 pp. 35–7. *Coll:* Given by the painter to Hume, whose niece, Mrs Agnes M. Hume, gave it to the Hon Lord Wood.

Bought from Lord Wood's grandson 1890–1.

946 Mrs Bruce of Arnot (died 1810)

Anna Bruce, daughter of Sir John Bruce-Hope of Kinross and heiress of Arnot, married in 1774 an Edinburgh surgeon Thomas Williamson, who took the name of Bruce.

Canvas: 29 × 24 (73·7 × 61) cleaned 1962. Signed: *A. Ramsay.* Painted c 1765.

Bought from Sir Charles Bruce KCMG 1907.

1523 Lady Robert Manners

Cf. her portrait by Lawrence no. 1522.

Canvas (oval): $29\frac{1}{4} \times 24\frac{1}{4}$ (74·3 × 61·6). Painted about the time of her marriage in 1756. *Coll:* Passed by descent.

Mrs Nisbet Hamilton Ogilvy of Biel bequest 1921.

1960 **Sir Peter Halkett Wedderburn, 1st Bart** (c 1659–1746)
Canvas: 29¼ × 24¼ (74·3 × 61·6) cleaned 1954. Signed: *A. Ramsay
1746*. *Coll:* By descent to Miss Katherine Halkett, 1906; with Aitken
Dott, 1908; bought by C. J. G. Paterson of Castle Huntly.
C. J. G. Paterson bequest 1942.

2151 **Sir John Inglis, 2nd Bart of Cramond** (1683–1771)
Canvas: 30 × 25 (76·2 × 63·5) cleaned 1955.

2152 **Lady Inglis**
Anne, daughter of Adam Cockburn of Ormiston.
Canvas: 30 × 25 (76·2 × 63·5) cleaned 1955.

Companion portraits, probably painted c 1745. *Coll:* Passed by
inheritance (James Don-Wauchope married Sir John Inglis' second
daughter in 1733).
Sir John Douglas Don-Wauchope, Bart of Edmonstone bequest 1951.

R A P H A E L (Raffaello Santi) 1483–1520
Umbrian; in Florence c 1504–8; thereafter in Rome.

Holy Family with a palm tree
Canvas transferred from wood (circular): 40 (101·5) diam. It was on
canvas by 1808 (Britton p. 14); the outer edge of between 2 and 4cm.
is made up. Painted c 1506–07. A drawing for the Madonna and Child
is in the Louvre (Fischel III 139). A copy, now lost, was painted by
P. de Champaigne for the church of Port Royal in Paris as a pendant
to his own *La Samaritaine* (now Caen Museum), also a tondo.
Lit: Passavant 1836 I p. 122 and 1860 II p. 38; KdK 1909 no. 38.
Coll: Possibly one of two pictures mentioned by Vasari (IV p. 321) as
painted for Taddeo Taddei in Florence. A. Félibien (*Entretiens sur les
vies et sur les ouvrages des plus excellens peintres anciens et
modernes* Trévoux 1725 I p. 339) gives the following provenance:
Henri Hurault, Comte de Cheverny; la Marquise d'Aumont who sold
it (probably c 1648–50) to l'Abbé de La Noue; Antoine Tambonneau;
M. de Vannolles who sold it to the Duc d'Orléans. Orléans coll. by
1724 (Stryienski no. 122); sale Bryan's Gallery 1798 (113), reserved
for the Duke of Bridgewater (see p. viii); thence by inheritance.
Bridgewater House no. 35.
Duke of Sutherland loan 1946.

Madonna with the Veil
Wood: 27 × 18⅞ (68·5 × 48). A good old version of a Raphael
design, of which no original by Raphael himself is known. The best
known version which is in the Louvre, Paris (KdK 1909 no. 76)

was probably painted by one of Raphael's workshop assistants. In the Bridgewater House picture, the soft modelling of the flesh and the use of brown glazes in the shadows suggest a later technique than Raphael's. *Lit:* Passavant 1836 I p. 127. *Coll:* Sir Joshua Reynolds collection by 1791 when it was offered for sale in Ralph's Exhibition (A.56). Reynolds (deceased) sale Christie's 17 March 1795 (95) bt in. According to Farington's Diary (British Museum typescript), by 8 March 1797 it had been acquired by Michael Bryan, who sold it to the 3rd Duke of Bridgewater by 26 March 1797. Recorded in the Stafford Gallery by 1808 (Britton p. 13); thence by inheritance. Bridgewater House no. 36.

Duke of Sutherland loan 1946.

Madonna del Passeggio
Wood: $35\frac{1}{2} \times 25$ (90 × 63·3). Probably painted c 1516 and undoubtedly the best of several versions known of this design. It was considered an original Raphael of high quality when in the Christina and Orléans collections. It was first questioned by Passavant (1836 I p. 126), who suggested it was executed by G. F. Penni from Raphael's design. Most writers since Passavant have agreed in excluding it from Raphael's autograph works. *Lit:* KdK 1909 no. 206. *Coll:* First recorded in Queen Christina's collection in an inventory of her possessions made in Antwerp in May 1656 (Antwerp Inv. no. 1). According to a subsequent inventory of her collection (Palazzo Riario Inv. p. 56) it had been given to her by Philip IV of Spain; bought by Duc d'Orléans 1721 (no. 7 in inventory at time of sale, see Granberg no. 12); sale Bryan's Gallery London 1798 (31), reserved for the Duke of Bridgewater (see p. viii); thence by inheritance. Bridgewater House no. 37.

Duke of Sutherland loan 1946.

The Bridgewater Madonna
Canvas transferred from wood: 32 × 22 (81 × 56). It was evidently on wood up to 1729 (Crozat vol. I); transferred to canvas in the Orléans coll. (see Passavant 1836 I p. 125–6.) An arched opening originally occupied most of the wall to the right of the Madonna's head. The paint that covers it was probably there in 1727, for Dubois (p. 432) says: 'Le fond du tableau est brun.'

De Tolnay showed that the design was inspired by Michelangelo's Taddei tondo (RA London coll.) of c 1504–5, a study from which is at Chatsworth (J. Byam Shaw *Old Master Drawings from Chatsworth* International Exhibitions Foundation 1969–70 p. 31 no. 57.) Two studies probably made by Raphael before he left Florence are Fischel III 109 and 111. A subsequent preparatory sketch is Fischel VIII 358. Two further studies related to the *Bridgewater Madonna* design (Fischel VIII 350, 351) come from Fischel's 'Pink Sketchbook', which was made in Rome. Pouncey and Gere consider these to precede the painting, which they date in the early Roman period. Crowe and

Cavalcaselle, and Shearman prefer an earlier date c 1506–07.
Lit: Waagen II p. 27; J. A. Crowe and G. B. Cavalcaselle: *Raphael.*
His Life and Works London 1882 II pp. 345 ff; C. de Tolnay: *The
Youth of Michelangelo* Princeton 1943 I p. 163; O. Fischel: *Raphael*
London 1948 I pp. 127 and 359; P. Pouncey and J. A. Gere: *Italian
Drawings . . . in the BM: Raphael etc.* London 1962 pp. 15 and 19;
J. Shearman in *Burl. Mag.* 1965 p. 35, and verbally. J. Pope-Hennessy:
Raphael. The Wrightsman Lectures, New York University Institute of
Fine Arts, London 1974 p. 187. *Coll:* Marquis de Seignelay (Dubois
p. 432); then (according to Crozat) M. de Montarsis *(sic) ie* the
jeweller Laurent le Tessier de Montarsy and sold to the Duc d'Orléans
by M. Rondé the King's jeweller; according to J. Couché (I 1786)
bought by the Regent, Duc d'Orléans, but not in the 1724 Inv at his
death (Stryienski no. 123); first recorded in the Orléans coll. 1727
(Dubois p. 432); sale Bryan's Gallery 1798 (64), reserved for the
Duke of Bridgewater (see p. viii); thence by inheritance. Bridgewater
House no. 38.

Duke of Sutherland loan 1946.

REMBRANDT van RIJN 1606–1669 Dutch

827 **A woman in bed**
Previously known as Hendrickje Stoffels.
Canvas (arched top): 32 × 26¾ (81·3 × 68) restored 1966 (X-rayed).
Signed: *Rembra. . /f.164.* The last figure of the date is missing. The
canvas was at one time laid on boards and there are paint losses at the
position of the joints, especially through both hands. The top was
arched by 1757; it seems likely that it was so originally. A seam in the
canvas coincides roughly with the edge of the vertical curtain fold; it
looks original in the X-rays but it is certainly unusual in a picture of
this size and may indicate a change of idea. The picture does not seem
to have been otherwise reduced.
Painted c 1645–6. The woman is hardly Hendrickje, who entered
Rembrandt's household c 1649 aged 24 or 25. She may well be
Geertje Dircx, who lived with Rembrandt c 1643–49. The attitude of
the figure recalls strongly the *Danaë* in Leningrad, dated 1636 but
re-worked about 1645–50 (see Gerson 1968 no. 270). Our picture is
almost certainly connected with a biblical story, most probably that of
Sarah on her wedding night, watching anxiously as her bridegroom
Tobias puts the devil to flight (Tobit VIII 1–4). The subject was also
painted by Bol (adapting Rembrandt's *Danaë*) and by Lastman in a
picture in Boston Museum of Fine Arts. Gerson (1968 no. 227)
suggests that Lastman's picture was the source for ours. *Coll:*

Prince de Carignan sale, Paris 30ff. July 1742; François Tronchin, Geneva (shown in Liotard's portrait of Tronchin dated 1757—Givaudon coll. Geneva); exchanged by him with Count Vitturi, Venice 1761–65; thence consecutively T. M. Slade; Viscount Maynard; Sir Henry St John Mildmay; Samson Wertheimer sale, Christie's 19 Mar 1892 (706).
Rt Hon William McEwan gift 1892.

Study of a man's head
Also known as *Portrait of a Jew*
Wood: $8\frac{1}{4} \times 6\frac{3}{4}$ (21 × 17·2). Probably painted in the mid-1640s.
The picture evidently entered the collection as school of Rembrandt and was so listed in *Stafford Gallery* 1818 (III no. 70). It was accepted as by Rembrandt himself by later writers up to and including Bredius in 1936 (no. 247), but recently the old idea that it is by a pupil has come back. Gerson (1969 p. 568) finds a similarity to Eeckhout's work. A head of the same model seen full-face exists in several versions (see Kassel Gallery catalogue 1958 no. 248). *Coll:* (An old inventory number 31 is painted on the panel.) Not in Britton, therefore it presumably entered the collection 1808–18; thence by inheritance. Bridgewater House no. 136.
Duke of Sutherland loan 1946.

Hannah and Samuel (?)
Wood: $16 \times 12\frac{1}{2}$ (40·6 × 31·8). Signed: *Rembrandt f./1650.* (This reading of the date by infra-red photograph agrees with Smith's in 1836.) Called *Hannah instructing her son Samuel* (*ie* illustrating I Samuel II) in the de Flines sale of 1700, and later also *Timothy and his grandmother* (II Timothy I 5). Tümpel has recently reverted to the suggestion made by Smith (no. 123) in 1836 that it shows the aged prophetess Hannah at the scene of Christ's presentation in the temple, with the figure of Simeon in the background (Luke II 21–39). Reservations about Rembrandt's authorship, first expressed by Bredius (no. 577), seem to have arisen in connection with the problem of the subject and the way it is presented, not from the method of painting. This has led to the suggestion that the picture may have been begun by a pupil and finished by Rembrandt (see Gerson 1968 p. 497). *Lit:* HdG no. 154; K. Bauch: *Rembrandt Gemälde* Berlin 1966 no. 81; C. Tümpel, see Gerson 1968 p. 497. *Coll:* Philips de Flines sale, Amsterdam 20 Apr 1700 no. 30 (Hoet I 55); Jacques de Roore of Amsterdam, sale The Hague 4 Sept 1747 no. 106 (Hoet II 208); from its size and description, clearly de Julienne sale Paris 30 Mar 1767 (129) *St Anne and the Virgin* (bought *pour l'Angleterre*); Marquess of Stafford by 1808 (Britton no. 193); thence by inheritance. Bridgewater House no. 168.
Duke of Sutherland loan 1946.

Self-portrait aged 51
Canvas: 21 × 17⅜ (53·3 × 44). Signed: *Rembrandt/f. 1657*. Additions
to the canvas (shown in KdK 1909 pl. 401) were removed when the
painting was cleaned some time before 1937. Gerson (1969 p. 551)
suggests that the canvas was originally larger than its present size, but
X-rays show that at least the left and lower edges have not been
materially reduced. The other two sides can hardly have been cut to
any significant extent. *Coll:* Countess of Holderness sale, Christie's
6 Mar 1802 (56) bought by Earl Gower; thence by inheritance.
Bridgewater House no. 186.
 Duke of Sutherland loan 1946.

Young woman with flowers in her hair
Wood (oval): 28 × 21 (71 × 53·2). Signed: *Rembrandt/f. 1634*.
Presumed to be the pendant to a portrait of a man also dated 1634,
acquired from Duchesse de St Leu in 1829 by the Hermitage, Leningrad
(Bredius no. 196). *Lit:* Bredius no. 345. *Coll:* Probably Comte de
Merle sale Paris 1 Mar 1784 (55); almost certainly Destouches
sale Paris 21 Mar 1794 (14); Marquess of Stafford by 1808 (Britton no.
138); thence by inheritance. Bridgewater House no. 187.
 Duke of Sutherland loan 1946.

RENOIR, Auguste 1841–1919
French; one of the original impressionist group.

2230 Mother and child
Canvas: 16¼ × 13 (41·3 × 33). Signed: *Renoir*. Painted about
1893–4. *Coll:* Bought from Renoir by Durand-Ruel in 1898;
Durand-Ruel family collection until 1949; bought then by Alexandre
de Biedermann, who sold it indirectly to Reid and Lefevre, who sold it
to Mr and Mrs Maitland in 1954.
 Sir Alexander Maitland gift 1960.

RESCHI, Pandolfo c 1640–96
Born in Danzig but went to Rome at an early age. He moved to
Tuscany soon after 1663, and was patronised by the Gerini family.

70 A battle
Canvas: 37½ × 58 (95 × 147·3) restored 1977. Acquired from the Gerini
collection in Florence and subsequently catalogued under this
traditional and entirely convincing attribution. *Lit:* M. Chiarini in
Pantheon xxxi (2) 1973 p. 154.
 Bought from the Marchese Gerini, Florence, for the Royal
Institution 1831.

REYNOLDS, Sir Joshua PRA 1723–1792 English

1215 Captain (later Admiral Viscount) Duncan
Cf. his portrait by Hoppner no. 1216.
Canvas: 50 × 39¾ (127 × 101) cleaned 1960. Painted 1760.
Lit: Waterhouse 1941 p. 48.
Earl of Camperdown bequest 1918.

1666 A little girl (Lady Frances Scott?)
Canvas: 29¼ × 24¼ (74·3 × 61·6). The quite probable identification
of the sitter, as Lady Frances Scott (1750–1817) later Lady Douglas,
is based on the 1758 portrait of her with her brothers (coll. John S.
Phipps, New York, 1942). She also sat in 1759, possibly for our
portrait. *Lit:* Waterhouse 1941 p. 46. *Coll:* Bishop Turton sale,
Christie's 14 April 1864 (294); C. T. D. Crews (by 1899); Crews sale,
Christie's 1 July 1915 (112) bought Leggatt, who sold it to Dr Percy
Mitchell; bought from Dr Mitchell by Agnew's.
Bought from Agnew's 1926.

2171 The Ladies Waldegrave
Left to right: the Ladies Maria, Laura and Horatia, daughters of
James, 2nd Earl of Waldegrave.
Canvas: 56½ × 66 (143·5 × 168). Exhibited RA 1781 (187). Painted
for Horace Walpole, the sitters' great uncle (who identified the sitters
in a MS label on the back). On 28 May 1780 he wrote to the Rev Wm.
Mason: 'I rather wished to have them drawn like the Graces adorning
a bust of the Duchess as the Magna Mater; but my ideas are not
adopted'. (The *Duchess* was their mother, re-married.)
Lit: Waterhouse 1941 p. 72. *Coll:* Strawberry Hill sale, Robins
18 May 1842 (35); Daniel Thwaites (1886); thence by descent.
Bought from Lord Alvingham, with help from the National Art-
Collections Fund, 1952.

2183 Alexander, later 10th Duke of Hamilton (1767–1852)
Canvas: 27 × 21⅝ (68·5 × 55) cleaned 1956. Painted in 1782, and paid
for in 1785 by William Beckford of Fonthill. (The sitter was a cousin
of Beckford's wife and married Beckford's daughter in 1810.)
Lit: Waterhouse 1941 p. 74. *Coll:* William Beckford (listed in 1844
inventory); 10th Duke of Hamilton; Hamilton sale Christie's
6 Nov 1919 (51).
Offered by Elspeth Lady Invernairn of Strathnairn and accepted
after her death, 1956.

RICCI, Marco 1676–1729
Worked in Venice; collaborated with his uncle Sebastiano Ricci,
Magnasco and others.

attributed to Marco Ricci

7 Landscape with monks
Canvas: 37 × 49½ (94 × 126) restored 1965. The landscape is probably
by Marco Ricci, although Longhi attributed it to Tavella and Gregori
raised the possibility of an attribution to Peruzzini. The figures are
in the style of Magnasco, but might have been painted in imitation
of his manner by Sebastiano Ricci, as Fiocco first suggested. For,
according to Soprani, Sebastiano Ricci made particular efforts to
imitate the figure style of the Genoese master. The alternative
possibility that Marco Ricci painted the figures also deserves
consideration, since the manner in which they are assimiliated into
the landscape does not suggest that we are necessarily concerned
with a collaborative work. The picture probably dates from c 1705
when Magnasco, Peruzzini and the two Riccis were all in Florence.
Lit: R. Soprani: *Vite de' Pittori Scultori e Architetti Genovesi* 1674
(ed. C. Ratti, Genoa 1768 II p. 159); G. Fiocco: *Venetian painting of
the seicento and settecento* Verona 1929 p. 63; R. Longhi quoted by
B. Geiger: *Magnasco* Bergamo 1949 p. 85; M. Gregori in *Paragone*
169, Jan 1964 p. 25; W. Arslan in *Studies . . . dedicated to W. E. Suida*
London 1959 p. 304; M. Chiarini: *The Twilight of the Medici*
Exhibition Catalogue Detroit/Florence 1974 (English ed. p. 302 no.
178); J. Daniels: *Sebastiano Ricci* Hove 1976 p. 26 no. 86 fig. 87.
Coll: Marchese Gerini, Florence, whose ancestor was a patron of
Magnasco. Presumably Gerini sale 1825 (98), as by Cav. Bernasco
(i.e. Magnasco). Catalogued in Edinburgh 1832 as 'Bernasio',
presumably misread from Bernasco.
 Bought from the Marchese Gerini for the Royal Institution 1831.

ROBERTS, David R A, H R S A 1796–1864
Scottish, born in Edinburgh; settled in London 1822; travelled
extensively in Europe and the Near East.

2261 View of Rome
Wood: 8½ × 16⅛ (21·6 × 41). Study for the large painting no. 304
(see page 149) that was exhibited at the RA London 1855 (594).
 Bought from J. S. Maas & Co., London, 1963.

RODIN, François Auguste 1840–1917 French

1747 La Défense
Also known as *La Défense et la Bellone* and *L'Appel aux Armes*
 Bronze: ht. 45 (114·3). Signed: *Rodin;* incised on the base:
GRIFFOUL ET LORGE, FONDEURS A PARIS. The original
terracotta was submitted unsuccessfully to the competition in 1879

for a monument to commemorate the Franco-Prussian war. Our
bronze was probably cast in the same year. Rodin made a first
enlargement of 235cm. in 1912; a second of 470cm. in 1916–20,
called *Défense de Verdun*, was made for a commission of 1916
from the Dutch government. *Lit:* A. E. Elsen: *Rodin*, New York
1963 pp. 67–70; John Tancock: *Rodin Exh.* catalogue, Arts Council,
1966 no. 4 (and letter of 1969); I. Jianou and C. Goldscheider:
Rodin Paris 1967 pp. 86 and 103. *Coll:* Sold by Rodin to M. Diot
(letter from Rodin of 13 Mar 1897); (1897) Mr. Collie of Aberdeen;
W. B. Paterson, who sold it to J. J. Cowan.
 J. J. Cowan gift 1930.

2054 Le lion qui pleure
Bronze: height 10½ (26·7). On a pennant are the words GARDE BIEN.
Incised: *A. Rodin/1881/11 MAI*, and *Banjean. Fondeur/No. IV PARIS*.
Designed as a decorative figure for a family tomb. A marble version is
in the Musée Rodin, Paris (1944 cat. no. 62).
 Sir D. Y. Cameron bequest 1945.

2290 The young mother
Marble: ht. 23½ (59·7). (The marks left by the copying instrument are
visible in numerous places.) The design is a variation on a theme
known as *La jeune mère* (cf Rodin Museum, Paris, 1944 cat. nos. 130
and 132, both of 1885). *Coll:* Bought from Rodin's studio before
1906 by Mrs Craig Sellar, who lent it to RSA 1908 (307) as *Love the
Conqueror;* by descent to Rosalind, wife of Sir Alexander Maitland.
 Sir Alexander Maitland bequest 1965.

ROMNEY, George 1734–1802
Born in Lancashire; settled ,in London 1762.

1674 Mrs Wilbraham Bootle
Mary, daughter of Robert Bootle of Lathom House, married in 1775
Richard Wilbraham M P for Chester; died 1813.
 Canvas: 48¾ × 39¼ (123·9 × 99·7) cleaned 1960. Sittings were given
in March and April 1781. Probably a companion to the portrait of the
sitter's husband now in the Wadsworth Atheneum, Hartford. Both
portraits descended to the 3rd Earl of Lathom, who sold them in 1927.
Lit: H. Ward and W. Roberts: *Romney* London 1904 vol II p. 15.
 Bought in 1927.

ROSSELLI, Cosimo 1439–1507
Active in Florence; pupil of Neri di Bicci and perhaps of Gozzoli;
working in Rome 1482.

**1030 St Catherine of Siena as spiritual mother of the second and third
Orders of St Dominic**

St Catherine, in Dominican habit, trampling a red devil, hands a
bound volume of the Rule to members of the second Order and a
paper of regulations to members of the third. Beside her are, from the
left, SS Lawrence, Dominic, Peter Martyr and Raphael with the
young Tobias.

Tempera on wood: painted area $61\frac{1}{2} \times 62\frac{1}{2}$ (156 × 159).
The subject is mystical rather than historical. Gronau has speculated
that our picture might have been commissioned for the church of
S. Domenico al Maglio, attached to the convent of St Catherine in
Florence, where three of Cosimo Rosselli's nieces received the habit
in 1499 (G. Gronau in Thieme-Becker XXIX p. 35, followed by
W. and E. Paatz: *Die Kirchen von Florenz* Frankfurt 1955 II p. 6).
The convent was not apparently opened until very shortly before
this date, and on this basis our picture would have to be identified
as a very late work. Although in style it shows some affinity with
relatively early works by Rosselli, such as the *Annunciation* in the
Louvre, dated 1473, it is not impossible that it was painted as late
as c 1500, since the artist's stylistic development was apparently
not strictly progressive. *Lit:* G. Kaftal: *St Catherine in Tuscan
Painting,* Oxford 1949 p. 132; and Kaftal 1952 no. 63. *Coll:* Charles
Butler, by 1885 (possibly bought in Florence 1883).

Bought at the Charles Butler sale, Christie's 25 May 1911 (no. 76).

RUBENS, Sir Peter Paul 1577–1640 Flemish

2097 Study of a head (St Ambrose)
Wood: $19\frac{1}{2} \times 15$ (49·6 × 38·1) painted up to the edges (X-rayed). The
head used for St Ambrose in *St Ambrose refusing the emperor
Theodosius admission to the church of Milan* (canvas: 308 × 248 cm.,
Kunsthistorisches Museum Vienna), which was carried out,
principally by van Dyck, in Rubens' studio c 1618. The head
also occurs in a sheet of heads by Rubens in the BM London
(Hind no. 98). M. Jaffé (letter of Dec 1969) kindly draws attention to a
later study of the same head (on wood: $22\frac{1}{2} \times 12\frac{3}{4}$in., coll. the late
C. G. Hoare). He suggests that our panel was a study made from
life, that the BM drawing was made as a record of it (and of other
oil studies of heads) and that Rubens referred to our panel in planning
the Vienna picture and painted Mr Hoare's study for the guidance of
his assistants. *Coll:* Probably Major-General Sir Claud Alexander of
Ballochmyle (1831–99). Sir Claud Alexander, 2nd Bart (died 1945).

Bought from Agnew's 1947.

2193 Feast of Herod

Canvas: 82 × 104 (208 × 264) cleaned before purchase. Dates suggested are either c 1633 or c 1637–8. X-rays show that, after the canvas had been stretched and primed, a piece was added at the left, the seam bisecting the negro's face. A preparatory drawing in Cleveland Museum stops short (perhaps not fortuitously) at the same place in the design. The gesture of Herodias, piercing the Baptist's tongue in revenge for his invective, is taken from St Jerome's *Apologia contra Rufino* (*cf* Mâle pp. 57–8). Already by c 1640 the picture was in Gaspar de Roomer's collection in Naples and was a powerful influence on the Neapolitan painters. Copies of our design are in Copenhagen Museum and Brigham Young University, Utah. The very numerous other known copies follow an engraving by Schelte a Bolswert which has extra figures etc. at the left. Held argues convincingly that this was an unwarranted addition, not evidence of the original appearance of our canvas. *Lit:* B. de Dominici *Vite dei Pittore . . . Napoletani* Naples 1742–4 (1840–6 ed: III p. 161, IV p. 50) L. Burchard in *Burl. Mag.* 1953 p. 383; J. S. Held in *Burl. Mag.* 1954 p. 122; F. Bologna: *Solimena* Naples 1958 pp. 20, 22; F. Haskell: *Patrons and Painters* London 1963 pp. 206–7; L. Burchard and R. A. d'Hulst *Rubens Drawings* Brussels 1963 no. 196. *Coll:* G. de Roomer (died 1674); his son-in-law Ferdinando van den Eynden; bought in Naples c 1830 by 2nd Marquess of Breadalbane; by inheritance until Christie's sale 6 July 1917 (63), bought Lord Leverhulme.

Bought from Port Sunlight 1958.

2311 Adoration of the Shepherds

Wood: 29 × 36⅜ (73·8 × 92·4) cleaned 1969: in good condition. A strip of c 6 in. (15 cm.) has been cut from the right-hand side. An engraving by Joan Witdoeck shows that the original design included an old man and woman with a candle entering the stable through an archway (part of the woman's head is still visible on the painting). Identified as by Rubens by M. Jaffé, who published it and reproduced the engraving (*Jacob Jordaens Exh.* Ottawa 1969 pp. 20, 151). The size and degree of finish suggest that this was a sketch or *modello*. No larger work dependent at all closely on the design is known (the association with an altarpiece in Lille is mistaken, and the design was certainly not used for an altarpiece). Furthermore, Witdoeck's engraving appears to have been made directly from our painting. The unusually intimate character of the design, and its strong reminiscences of Elsheimer, suggest that Rubens may have painted it with no commission in mind, although he later adapted the design, *eg* for the altarpiece for the Jesuit church in Neuburg in 1619 (now Pinakothek, Munich). The striding shepherd derives from a Titian *Nativity*, probably taken from the woodcut of it by Master IB, and the two kneeling peasants derive from Caravaggio's *Loreto Madonna* (Chiesa di Sant'Agostino, Rome). Jaffé suggests a date of c 1617, but the

relationship to certain pictures, especially the Kassel *Flight into Egypt,* dated 1614, suggests the possibility of a rather earlier date. *Coll:* Passed by inheritance from Henri-Frédéric Comte de Diesbach-Torny (1818–67). It seems probable that the picture was brought into the family by Louis-Augustin Comte d'Affry, who was French Ambassador at The Hague from 1755 for ten years under Louis xv. D'Affry's only daughter married in 1762 François-Pierre-Frédéric Cotte de Diesbach-Torny (1739–1811).

Bought from Franz Muheim of Balliswyl, Fribourg, 1970.

RUISDAEL, Jacob van c 1628–1682
Born at Haarlem; moved to Amsterdam c 1656.

75 The banks of a river
Canvas: $52\frac{3}{4}$ × 76 (134 × 193). Cleaned in 1962, revealing the very indistinct signature and date bottom left: *JvRuisdael 1649 (JvR* in monogram). An important early work, whose indistinct date confirms Rosenberg's dating of 1649–50. It is an elaboration on an imposing scale, with foreground trees and figures added, of a landscape on wood, $26\frac{1}{2}$ × $38\frac{1}{2}$ (67 × 98) dated 1647, in the Hage coll., Nivaa (HdG 694). The figures, which are not by Ruisdael, are evidently based on those of Wouverman at this period (cf especially his *Watering-place* HdG 71, with Böhler, Lucerne 1949).
Lit: J. Rosenberg: *Jacob van Ruisdael* Berlin 1928 p. 22; K. E. Simon: *Jacob van Ruisdael* Berlin 1930 p. 23.

Sir James Erskine of Torrie bequest to Edinburgh University 1835; deposited on loan 1845.

Ruins beside a river
Canvas: $20\frac{3}{4}$ × 25 (52·7 × 63·5). Signed: *JvRuisdael (JvR* in monogram). Probably painted in the 1660s. *Lit:* H. de Groot saw it on two occasions, once at Gosford in 1893, and described it twice (nos. 685 and 754); he was followed by J. Rosenberg: *J.v.Ruisdael* Berlin 1928 nos. 432 and 470. *Coll:* Bought by the 7th Earl of Wemyss (1723–1808) and recorded with measurements in his inventory of pictures at Amisfield House of 1771 (24).

Earl of Wemyss and March loan 1957.

RUNCIMAN, Alexander 1736–1785
Scottish, born in Edinburgh; apprenticed in 1750 to Norie (q.v.); in Rome 1766–71 where he met Fuseli; from 1772 in Edinburgh.

790 Italian river landscape with a hermit
Wood: $11\frac{1}{4} \times 14\frac{1}{2}$ (28·6 × 36·8). Signed: *A R* in monogram. A water-
colour sketch $5\frac{1}{4} \times 8\frac{3}{4}$in. is our no. D.NG791. *Coll:* Lord Eldin
sale Edinburgh 15 Mar 1833 (62); Thomas Sivright sale Edinburgh
16 Feb 1836 (2742).
Bought at J. T. Gibson-Craig sale Edinburgh 12 Mar 1887 (no. 938).

RUNCIMAN, John 1744–1768/9
Scottish, born in Edinburgh; younger brother of Alexander, who
probably taught him and with whom he went to Rome in 1766; died
in Naples.

570 King Lear in the storm
The mad king is seen with his hand on the Fool's shoulder and
(probably) Gloucester behind his right shoulder and Kent and Edgar
on his left.
Wood: $17\frac{1}{2} \times 24$ (44·4 × 61). Signed: *J. Runciman p. 1767* (*J R* in
monogram). The picture is unique at this period, for it evokes the
imagery of the words instead of illustrating a particular moment of
the play. *Lit:* Waterhouse 1953 pp. 212–3; W. M. Merchant in
Warburg Journal XVIII 1954 p. 385, and *Shakespeare and the Artist*
London 1959 ch. 12. *Coll:* Lord Eldin sale Edinburgh 16 Mar
1833 (162); David Laing, by 1862.
David Laing LLD bequest 1879.

648 The Flight into Egypt
Wood: $11\frac{3}{4} \times 8\frac{3}{4}$ (29·9 × 22·3). Signed: *J Runciman* (*J R* in
monogram). *Coll:* David Laing, by 1863.
David Laing LLD bequest 1879.

793 The Road to Emmaus
Copper: $6\frac{1}{2} \times 8\frac{1}{2}$ (16·5 × 21·6). Signed: *J R.* *Coll:* Lord Eldin sale,
Edinburgh 14 Mar 1833 (27).
Bought at J. T. Gibson-Craig sale, Edinburgh 12 Mar 1887
(no. 960).

2116 The Good Samaritan
Wood: $7\frac{7}{8} \times 11\frac{1}{8}$ (22·6 × 28·3). Cleaned 1975. Presumably the picture
lent to Royal Institution, Edinburgh, 1820 (35) by James Russell, and
1830 (13) by Prof. Russell.
Bought from J. Kent Richardson 1949.

SAFTLEVEN, Herman 1609–1685
Born in Rotterdam; from 1633 working mainly in Utrecht.

1508 **Christ preaching from a boat**
Wood: 29½ × 42½ (75 × 108) cleaned 1941. A Guild mark is on the
back. Signed: *HSL* (monogram) *1642.* One of few biblical subjects
by Saftleven; he painted different versions of it in 1648 (col¹.
Dr Pathuis, Amsterdam) and 1667 (NG London). The influence of the
Utrecht 'Italianist' painters in the scene of rocks, combined with the
influence of van Goyen's style, is unusual. Attributed up to 1929 to
Lingelbach. *Lit:* J. Nieuwstraten in *Nederlands Kunsthistorisch
Jaarboek* 16 1965, p. 81; W. Stechow: *Dutch Landscape Painting*
London 1966, p. 212 n. 36.
Mrs Nisbet Hamilton Ogilvy of Biel bequest 1921.

SARTO, Andrea del 1486–1530 Florentine

2297 **Self-portrait**
Wood: 33⅞ × 26¼ (86 × 66·6). Restored 1967 (X-rays; infra-red
negs.): there are paint losses in the right side of the coat and in the
lower right corner of the panel round the hands, above the bowl;
otherwise well preserved. The only reasonably sure self-portrait by
del Sarto is on tile (Uffizi no. 1694), probably the picture recorded by
Vasari (v pp. 48/9) as painted c 1528–29. For further discussion see
Shearman who dates our picture ɛ 1528–30. Freedberg's suggestion
that it is a portrait of del Sarto by an imitator, using as a model a
small roundel self-portrait in the Art Institute, Chicago (no. 64.1097a),
is hard to follow and seems to be contradicted in any case by
pentimenti in the cap in our picture. Shearman also accepts (verbally)
the Chicago panel as a much damaged del Sarto but dates it after our
picture. *Lit:* J. Shearman: *A. del Sarto* Oxford 1965 pp. 128 and
282/3; S. J. Freedberg: *A. del Sarto* Cambridge Mass. 1963 II p. 221,
and in *Museum Studies* I Chicago 1966 p. 27. *Coll:* Ricci, Florence;
Galeria Dini, Florence; bought in Florence by the Rev. John Sanford
1832; by inheritance to Lord Methuen; Corsham Court sale,
Christie's 13th May 1899 (88).
Bought at Oliver Watney, Cornbury Park, sale, Christie's 23 June
1967 (no. 38).

SCORZA, Sinibaldo 1589–1631
The earliest of the Genoese specialists in naturalistic rustic landscapes
in the Flemish mode, often including animals.

76 **Landscape with the story of Philemon and Baucis**
The two peasants are seen welcoming their guests, Jupiter and
Mercury.
Canvas: 19 × 28½ (48·3 × 72·5) cleaned 1941.

77 **Landscape with the story of Latona and the peasants**
Latona, with her children Apollo and Diana, angrily turns the Lycian peasants into frogs.
Canvas: 19 × 28½ (48·3 × 72·5) cleaned 1941.

A pair of landscapes, bought as by Scorza with figures by Domenico Fiasella, but probably by Scorza alone. The subjects are taken from Ovid's *Metamorphoses*, VIII 621–96 and VI 314–81.
Bought from the Doria family, Genoa, for the Royal Institution in 1830.

SCOTT, David RSA 1806–1849

Scottish, born and worked in Edinburgh; son of Robert Scott, engraver, and apprenticed to him; at the Trustees' Academy 1820; in Italy 1832–4.

342 **Vintager**
Canvas: 46 × 38¼ (116·9 × 97·2) cleaned 1934. Signed: *DAVID SCOTT P*. Exhibited RSA 1835 (1). The first sketch was made in Rome in April 1833. *Lit:* W. B. Scott, pp. 125 and 199. *Coll:* Andrew Coventry, Edinburgh, by 1850.
Andrew Coventry gift 1859.

825 **Philoctetes left in the Isle of Lemnos by the Greeks in their passage towards Troy**
Canvas: 39¾ × 47 (101 × 119·4) cleaned 1955. Exhibited RSA 1840 (131). *Lit:* E. K. Waterhouse in *Burl. Mag.* June 1949 p. 153.
Coll: Lent by George Cousin to RSA 1863 (299).
J. W. Cousin, Edinburgh, gift 1890.

843 **The Traitor's Gate**
Wood: 54 × 72 (137·2 × 183). Exhibited RSA 1842 (164): *Thomas, Duke of Gloucester, having been secretly carried off from England at the command of King Richard the Second, taken into Calais, where he was murdered.* A study in wash (21 × 29 in.) is in the RSA collection.
Lit: W. B. Scott, pp. 257–9. *Coll:* Bought in 1842 by the RAPFA and allotted to their subscriber Rev S. Cowan, Kitton, Castle Douglas; Robert Carfrae, by 1862.
Robert Carfrae gift 1899.

992 **Puck fleeing from the dawn**
An illustration of Puck's lines at the end of *A Midsummer Night's Dream*.
Canvas: 37½ × 57½ (95·3 × 146). Signed: *DAVID SCOTT 1837*.
Exhibited RSA 1838 (64). *Coll:* James Campbell (1901).
Bought at W. McOran Campbell sale, Christie's 2 July 1909 (no. 112).

SCOTT, William Bell HRSA, LLD 1811–1890
Scottish, born in Edinburgh; son of Robert, brother of David; poet
and writer, friend of Rossetti; London 1836–43, Newcastle 1843–58,
then London; in Ayrshire from 1885.

969 **Albrecht Dürer in Nürnberg**
Canvas: 23¾ × 28¾ (60·4 × 73). Painted in Nürnberg early in 1854
and exhibited Portland Gallery 1854 and RSA 1856, no. 456.
Lit: W. B. Scott: *Autobiographical Notes* London 1892 I pp. 319 and
322. *Coll:* Mrs Ballantine, Edinburgh (1886).
 Bought from Aitken Dott & Son, Edinburgh, 1909.

SCOUGALL
A family of Scottish portrait painters: David was active 1654–77;
John, known latterly as *Old Scougall*, died at Prestonpans in 1730
aged 84; George was active in Glasgow 1715–24.

traditionally ascribed to John Scougall

2032 **Self-portrait**
Canvas laid on panel: 24½ × 19¾ (62·3 × 50·2) cleaned 1945. Quite
likely a self-portrait, apparently painted in the Mytens tradition of the
1630s or early 1640s. For the Scougall family and the difficulty of
associating this picture with them, see Waterhouse (1953 pp. 44 and
83/4). A copy signed *Jo. Medina pinxit 1760* was bequeathed to the
Gallery in 1867 by John Scougall of Leith 'a descendant of the
painter', as a self-portrait by 'Scougall' (no. 554, see p. 141).
Coll: James Wright, Stirling (died c 1823); his daughter, Mrs Clark of
Ulva, and in her inventory of 1826 as *Earl of Essex* by van Dyck.
 Bought from Mrs Clark of Ulva 1945.

SELLAIO, Jacopo del 1441/2–1493
Florentine, pupil of Filippo Lippi. (His work has not been separated
from that of Filippo di Giuliano.)

1941 **Christ as the Man of Sorrows, with S. Raphael and the young Tobias
and S. Sebastian**
Wood: 12½ × 18⅛ (31·8 × 46). The centre panel of a predella. The
iconography derives from a panel by Fra Angelico in the Alte
Pinakothek, Munich. First attributed to Sellaio by Berenson in 1909
(p. 185). *Coll:* A note on the back says: *Sold at Ottley's as Pollaiolo.*
Possibly Rev W. Davenport-Bromley sale Christie's 12 June 1863 (124)
as Castagno; Marquess of Lothian apparently after 1870, and lent by
him to Edinburgh Exh. 1883 (512).
 11th Marquess of Lothian bequest 1941.

attributed to Sellaio

1538 **Cassone panel: Triumphal procession; reception and coronation of a prince or victor**
Wood: painted area $16\frac{3}{8} \times 65\frac{3}{8}$ (41·5 × 166). The scene is almost certainly Roman but has not been identified. Probably painted in the early 1480s. *Lit:* Berenson 1963. *Coll:* Possibly the *David crowned by Samuel* by Filippino Lippi, Rev W. Davenport-Bromley sale Christie's 12 June 1863 (32). Fuller Maitland, Stansted Hall, catalogues 1872 (p. 13) and 1893 (34) as *A Coronation, with Procession* by Filippino Lippi.
Bought from the Fuller Maitland collection 1921.

SERODINE, Giovanni 1600–1630
Born at Ascona, Ticino; settled in Rome, probably by 1616; a follower of Caravaggio.

1513 **The Tribute Money**
Canvas: $57 \times 89\frac{1}{2}$ (145 × 227). The paint surface is considerably damaged. Attributed by Fiocco. Longhi has shown that it was a companion to *The Meeting of St Peter and St Paul* (Palazzo Mattei, Rome). The two pictures show an awareness of Terbrugghen's work of 1620–22 and Nicolson (p. 11) dates them soon after 1625. *Lit:* G. Fiocco in *Burl. Mag.* Oct 1929 p. 190; R. Longhi: *G. Serodine* 1955 pp. 21 and 31 and in *Paragone* 233, July 1969 p. 59. R. Spear: *Caravaggio and His Followers* Exhibition Catalogue, Cleveland 1971 p. 164 no. 2. *Coll:* Palazzo Mattei Inv 1631 as by Giovanni della Voltolina (*ie* Serodine): see G. Panofsky in *Römisches Jahrb. für Kunstgeschichte der Bibl. Hertziana* XI 1967/8 p. 185. A receipt (GD 205 Portfolio 18) in Scottish Record Office shows that it was sold to William Hamilton Nisbet in 1802 as by Rubens; thence by descent. Edinburgh Exh. 1883 (349) attributed to Ribera.
Mrs Nisbet Hamilton Ogilvy of Biel bequest 1921.

SETON, John Thomas active 1761–1806
Scottish; studied under Francis Hayman; in Edinburgh 1772–4; India 1776–85; then in Edinburgh.

1837 **William Fullerton of Carstairs** (1720–1806) **and Ninian Lowis** (died 1790).
Canvas: $29\frac{1}{4} \times 24\frac{1}{4}$ (74·3 × 61·6). Signed on back: *J.T.Seton 1773*.
Probably painted at Carstairs House, where Lowis also seems to have lived in his latter years.
Bequeathed (as by Zoffany) by Miss W. M. Fullerton, Edinburgh, 1936.

1840 Lady Barrowfield, aged 92
Katherine Paterson (c 1683–1780), wife of John Walkinshaw of
Barrowfield, and mother of Clementina Walkinshaw.
 Canvas: 30 × 25 (76·2 × 63·5). Signed on back: *J. T. Seton pinxit 1776*.
No. 1841 (see p. 151) is a portrait also of 1776 of the sitter's
sister, aged 86.
 Bought from P. M. Turner 1936.

SEURAT, Georges 1859–1891
French, born and worked in Paris; principal exponent of the neo-
impressionist, pointillist style.

2222 Study for 'Une Baignade'
Wood: $6\frac{1}{4}$ × $9\frac{3}{4}$ (15·9 × 24·8). Facsimile signature stamp, probably
applied by the dealer Moline c 1894/5. One of 14 known studies or
croquetons that led up to the big *Baignade* (NG London), which
Seurat exhibited in 1884. These studies and the development of the
Baignade are discussed by B. Nicolson in *Burl. Mag.* Nov. 1941 p. 139
(our picture pl. IIc). *Lit:* H. Dorra and J. Rewald: *Seurat* Paris 1959
(no. 95); C. M. de Hauke: *Seurat et son Oeuvre* Paris 1961 (no. 88).
Coll: Presumably among the studies for the *Baignade* in the inventory
of 3 May 1891 at Seurat's death. Perhaps given by the family to
Seurat's mistress Madeleine Knobloch, since her surname is on the
back of the panel. Lefevre Gallery; Lord Ivor Spencer Churchill
(acquired 1926); bought for Mr and Mrs Maitland at Miss Helen
Sutherland sale Sotheby's 26 Mar 1958 (152).
 Sir Alexander Maitland gift 1960.

2324 La luzerne, Saint-Denis
Canvas: $25\frac{1}{4}$ × 32 (64 × 81) cleaned 1972. Signed: *Seurat*. Exhibited
Salon des Indépendants Paris 1886 (359) but probably painted earlier,
according to Blunt c 1884–1885 but according to Dorra and Rewald
c 1885–1886. The style is transitional, combining the criss-cross
brushstrokes found in Seurat's paintings of 1883 with a spacial
conception apparent in his 1885 landscapes. *Lit:* H. Dorra and
J. Rewald: *Seurat* Paris 1959 (no. 159); A. Blunt: *Seurat* London
1965 (no. 25). *Coll:* Bernheim-Jeune Paris by 1920; bought by Roger
Fry by 1922; thence by descent; on loan to the Courtauld
Institute Gallery from 1934.
 Bought with a Treasury grant, help from the NA-CF and from the
family of Roger Fry 1973.

SIMSON, William RSA 1800–1847
Scottish, born in Dundee; trained at the Trustees' Academy
Edinburgh under Andrew Wilson; in Italy 1834–5; settled in
London 1838.

369 **Twelfth of August**
Wood: $9\frac{1}{2} \times 15\frac{1}{2}$ (24·1 × 39·4). Catalogued in 1914 as a sketch for
the larger picture exhibited Royal Institution 1829, bought from the
artist by H. W. Williams. RI 1829 (35) was *The Twelfth of August
Badenoch: Portraits*, lent by Alexander Smith.
Mrs Williams gift 1860.

SIRANI, Elisabetta 1638–1665
Born in Bologna, where she worked; follower of Guido Reni.

79 **The child St John in the wilderness**
Canvas: $29\frac{3}{4} \times 24\frac{1}{4}$ (75·5 × 61·6) cleaned 1935. Signed: *ELISAB.
SIRANI F/MDCLXIIII*. Undoubtedly the picture of this title
painted in 1664 *per un Cavallier Fiorentino,* according to Malvasia
(*Felsina Pittrice* 1678: Bologna 1841 ed., vol. II p. 398).
Coll: Gerini catalogue 1786; Gerini sale catalogue 1825 (106).
Bought from the Marchese Gerini, Florence, for the Royal
Institution 1831.

SISLEY, Alfred 1839/40–1899
English, born and lived in France; one of the original impressionist
group.

2235 **Molesey Weir, Hampton Court**
Canvas: $20\frac{1}{4} \times 27$ (51·5 × 68·6). Signed: *Sisley 74.* One of several
views of the Thames painted by Sisley during his visit to England
from July to October 1874. *Lit:* F. Daulte: *Sisley* Switzerland 1959
no. 118. *Coll:* Daulte states that it belonged to the singer J.-B. Faure,
who invited Sisley to England in 1874 and acquired five pictures from
this visit, but it is apparently not in the 1902 catalogue of Faure's
collection. NG London·Exh 1942 (53) lent Mrs C. Kleinwort; RA 1949
(233) lent Mrs Oliver Parker; bought from Tooth's by Mr and Mrs
Maitland 1957.
Sir Alexander Maitland gift 1960.

STEEN, Jan 1626–1679
Born at Leyden; worked there and for periods at The Hague
and Haarlem.

86 **The doctor's visit**
The girl is not sick but love-sick, as is indicated by the picture of
Venus and Adonis on the wall and her lover looking in at the window.
Canvas: $28 \times 22\frac{1}{2}$ (71·1 × 57·2) cleaned 1935. Signed: *JSteen*
(*JS* in monogram). Variant of a design in quite different colouring in
the Mauritshuis, The Hague. A painting of the same size and design

as the Torrie picture was in the Baron de Beurnonville, Sir J. B.
Robinson and Princess Labia collections and with L. Koetser in 1964.
The Torrie picture may be an autograph work in poor condition, but
de Groot's view that it is a copy is more likely to be correct.
Lit: H. de Groot in *Oud Holland* 1893 p. 129. *Coll:* Either the
Torrie picture or Koetser's was bought by Maclean at the Braamcamp
sale, Amsterdam 31 July 1771 no. 213 (see Bille pp. 52 and 119).
Pace Bille, the evidence is in favour of Koetser's.

Sir James Erskine of Torrie bequest to Edinburgh University 1835;
deposited on loan 1845.

A school for boys and girls

Canvas: 33 × 43 (83·8 × 109·2). Probably painted c 1670. The scene is
a moral lesson on the evils of inattentiveness. The boy handing
spectacles to the owl, who perches near a lantern, illustrates the Dutch
proverb: *What profit candles or spectacles if the owl will not see?*
Lit: HdG no. 287. *Coll:* (Wrongly identified with the upright picture
in the Willem Lormier sale, The Hague 4 July 1763, which is Dublin
no. 226). Braamcamp collection Amsterdam: in the 1752 inventory
there and his sale 31 July 1771 no. 211 (Bille pp. 51 and 118);
Marquess of Camden sale, Christie's 12 June 1841 (70), bought by
Seguier for Lord Francis Egerton; thence by inheritance. Bridgewater
House no. 153.

Duke of Sutherland loan 1946.

TENIERS, David, the younger 1610–1690

Flemish, born and worked in Antwerp; moved to Brussels 1651.

90 **Peasants playing bowls**

Wood: $13\frac{3}{4}$ × $22\frac{1}{2}$ (35 × 57·2) cleaned 1934. Signed: *D. TENIERS F.*
An early work influenced by Adriaen Brouwer, who died in Antwerp
in 1637. Probably painted 1636–9. *Lit:* Smith suppl no. 126.

Sir James Erskine of Torrie bequest to Edinburgh University 1835;
deposited on loan 1845.

TERBORG see under BORCH

TERBRUGGHEN, Hendrik 1588–1629

Working in Utrecht from 1615; pupil of Bloemaert; in Rome 1604–14.

attributed to Hendrik Terbrugghen

28 **The beheading of St John Baptist**

Canvas: 66 × $85\frac{3}{4}$ (168 × 218). Cleaned 1952; apparently cut by c $3\frac{1}{2}$ (9)

on right and 2 (5) at bottom. The composition derives from Dürer's woodcut B.125. Nicolson (pp. 64–5) dates it c 1617–20, as one of Terbrugghen's earliest known works. Not accepted as autograph by R. Longhi (in *Paragone* 201 1966 p. 72) or P. van Thiel (in *Bulletin van het Rijksmuseum* 1971 no. 3 pp. 103–4). A supposed monogram, *HTB* on the executioner's block, is not convincing.
James S. Wardrop gift 1850.

TESTA, Pietro 1612–1650
Born in Lucca; moved to Rome before c 1630. Strongly influenced by N. Poussin. His fame rests chiefly on his graphic work and only about 18 of his paintings have been securely identified.

2325 **Adoration of the Shepherds**
Canvas: 34¾ × 49¼ (88·3 × 125·5). Damages affect the head of the Child and the heads of the cherubs; and there is a patch, replacing another damaged area, which includes the head of the crouching shepherd in the left foreground and the right arm of the shepherdess immediately above. The attribution to Testa, which dates from 1958 when the picture first came to light at Christie's, has not been doubted and is confirmed by the existence of numerous drawings attributed to Testa which are connected with its design. There are compositional studies at the Ashmolean Museum, Oxford, (K. T. Parker: *Catalogue of the Collection of Drawings in the Ashmolean Museum* Oxford 1956 II p. 481) and the Pierpont Morgan Library, New York (Inv. IV 180 C); another, now destroyed, was formerly in the Aschaffenburg collection, in Germany, and yet another is known only from a reproductive engraving by F. Collignon. Testa also made individual chalk studies for each of the two shepherdesses at the left of the picture and for the shepherd with arms raised at the right; these are all bound into the artist's *Treatise* which is now in Düsseldorf. To judge from its style our picture might have been completed shortly before the altarpiece of *S Domenico* in S Romano, Lucca, which according to Dr Elizabeth Cropper (letter in Gallery files) can be dated c 1637 on the basis of an unpublished document. *Coll:* Christie's 25 July 1958 (101) bought by A. P. Oppé.
Bought from Miss A. Oppé with help from the NA-CF 1973.

THOMSON, Rev John HRSA 1778–1840
Scottish, born in Ayrshire; minister of Duddingston, by Edinburgh, from 1805; began painting as an amateur taking lessons from Alexander Nasmyth.

556 **Aberlady Bay**
Canvas: 25¼ × 37¼ (64·2 × 94·6). Exhibited at the Royal Institution, Edinburgh 1822 (8).
Katherine Lady Stuart of Allanbank bequest 1867.

2039 Fast Castle from below
Canvas: 30 × 41½ (76·2 × 105·4) restored 1955. One of many views of
Fast Castle on the Berwickshire coast. Napier lists this as the view of
Fast Castle exhibited at the Royal Institution Edinburgh 1824 (10).
The view exhibited was, however, paired with one showing the castle
from the opposite side, whereas our picture in both the Hume and the
Macdonald collections was paired with a view of the castle from above.
On stylistic grounds our picture may well be later than 1824. *Lit:*
R. W. Napier *Thomson of Duddingston* Edinburgh 1919 pp. 414, 490.
Coll: Baron Hume; Sir J. H. A. Macdonald; Albert Lamb (1926).
 Bought at the anon (=A. Lamb) sale Dowell's, Edinburgh,
16 Feb 1946.

2191 Landscape composition
Wood: 14½ × 19 (36·8 × 48·3) cleaned 1958. Two variants are known:
W. Telfer coll. catalogue 1950 no. 38 (8½ × 12 in), and R. W. Napier
Thomson of Duddingston Edinburgh, 1919 p. 415 (29½ × 19¾ in). *Coll:*
William Allan of Glen; R. W. Napier (1919); Rev J. Benn Moore,
sold to James Beasley.
 Bought from Mr Beasley 1957.

TIEPOLO, Giovanni Battista 1696–1770 Venetian

91 The meeting of Antony and Cleopatra
Canvas: 26¼ × 15 (66·7 × 38·1) cleaned 1942. Sketch for a fresco
forming part of a decorative scheme in the principal saloon of the
Palazzo Labia, Venice. A companion sketch for the *Banquet* is in
Stockholm University Museum. Both are similar in style to sketches
for frescoes of 1743 at Montecchio Maggiore. There is a further sketch
for the Palazzo Labia *Meeting*, but of horizontal format, now in the
Wrightsman collection, New York. A large horizontal composition of
the *Meeting* in Archangel (338 × 600 cm), which is dated 1747, may be
based on the Wrightsman collection sketch. At least part of the Palazzo
Labia room is also known to have been finished by 1747. *Lit:* M.
Levey: *Banquet of Cleopatra*, Charlton Lecture, Newcastle, publ 1965;
E. Fahy: *Wrightsman Collection Paintings, Drawings* New York 1973
p. 18 no. 24.
 Bought in Venice for the Royal Institution 1845.

92 The finding of Moses
Canvas: 79 × 134 (202 × 342) cleaned 1950. A piece 203 × 133 cm
depicting a halberdier and dog was cut (probably before 1830) from
the right-hand side of the original canvas. This fragment was in
Lord Blantyre sale 19 Apr 1912 (60) and was in Turin in 1968. A
reduced copy of the original composition is in Stuttgart Gallery

(no. 575). Probably painted in the early 1730s. The design is a fantasy in 16th-century costume inspired by a painting by Veronese which was in Venice until 1747 (now Dresden Gallery no. 229). *Lit:* F. C. Willis in *Cicerone* Feb 1913 p. 139; R. Hénard in *L'Art* 2 1914 p. 218; G. Robertson in *Burl. Mag.* Apr 1949 p. 99; M. Levey in *Art Bulletin* Sept 1963 p. 294. *Coll:* Possibly the picture in the 2nd Marquess of Bute sale (from Luton Park, Bedfordshire) Christie's 7 June 1822 (50) as 'Cagliari The Finding of Moses, a Gallery Picture by Tiepolo, in the manner of—*very spirited*' bought Emmerson. But the first certain reference to our picture is Thomas Hamlet sale, Christie's 22 May 1841 (87) bought Heilbron and subsequently acquired by Robert Clouston.

Robert Clouston gift to the Royal Institution 1845.

TINTORETTO (Jacopo Robusti) 1518–1594 Venetian

Portrait of a Venetian

Canvas: $29\frac{1}{4} \times 24\frac{1}{2}$ (74·5 × 62). The painted surface continues over the sides and lower edge of the present stretcher, but it is not known how much the picture has been reduced. Berenson (1957) as an early work. *Lit:* P. Rossi: *Jacopo Tintoretto I Ritratti* Venice 1974 p. 105. *Coll:* W. Coningham sale, Christie's 9 June 1849 (8) bought Farrer; 1st Earl of Ellesmere by 1854 (Waagen II p. 33); thence by descent. Bridgewater House no. 15.

Duke of Sutherland loan 1946.

The Deposition of Christ

Canvas: 80 × 59 (203 × 150). The surviving original canvas is $64\frac{1}{2} \times 50\frac{1}{2}$ (164 × 128), made up by $11\frac{1}{4}$ (28·5) at the top, from just above the head of Nicodemus, by 4 (10) at the bottom, and $4\frac{3}{8}$ (11) at the sides. Dubois (p. 220) was evidently describing it in 1727 as we see it now. X-rays show some boldly brushed in underpainting and a number of substantial changes that were made in the principal group of figures.

Tietze dates the painting in the 1560s and Vasari (VI p. 592) had recorded it by 1568. It was then the altarpiece of the Bassi chapel in the church of San Francesco della Vigna, Venice. It had an arched top containing an angel descending, holding the crown of thorns. The complete design is recorded in a drawing in the Walker Art Gallery, Liverpool (no. 5109), and in an engraving by J. Matham of 1594. Between then and 1648 the Bridgewater House portion was cut down, as Ridolfi (II p. 40) records, the piece with the angel being left behind in the frame. *Lit:* H. Tietze: *Tintoretto* London 1948 p. 353. *Coll:* Duc d'Orléans by 1727, Dubois (p. 220) says *de Madrid*. Not in the 1724 inventory (Stryienski no. 68). Sale Lyceum, London 1798 (no. 208), reserved for the Duke of Bridgewater (see p. viii); thence by inheritance. Bridgewater House no. 40.

Duke of Sutherland loan 1946.

TITIAN (Tiziano Vecellio) working 1511–died 1576 Venetian

Diana and Actaeon
Actaeon whilst hunting surprises Diana bathing in the grotto
Gargaphia (Ovid: *Metamorphoses* III 138–253).
Canvas: 74 × 80 (188 × 203). Bridgewater House no. 17.

Diana and Calisto
Diana discovers the pregnancy of Calisto after her seduction by
Jupiter (Ovid: *Metamorphoses* II 442–53).
Canvas: 74 × 81 (188 × 206). Signed: *Titianus F.* Bridgewater
House no. 18.

Two of a series of seven *poesie*, painted for Philip II of Spain, at
least six of which were completed between 1550 and 1562. The others
are *Danaë* and *Venus and Adonis* (Prado), *Perseus and Andromeda*
(Wallace coll. London), *Rape of Europa* (Gardner Museum, Boston),
and *Actaeon torn by his hounds* (National Gallery, London) which was
never delivered. The two *Dianas* were begun c 1556 and finished in
1559 and despatched from Venice via Genoa to Madrid in October.
A different version of *Diana and Calisto* in the Kunsthistorisches
Museum, Vienna (KdK 1907 no. 152), was begun with the design of
the Bridgewater House picture and is probably later. The Vienna
version may have been more or less complete by 1566 when C. Cort,
who came to Venice in 1565, engraved a variant of its design. *Lit:*
J. A. Crowe and G. B. Cavalcaselle: *Life of Titian* London 1877 II
p. 512 ff., quoting the correspondence between Titian and Philip II;
A Stix in *Jahrbuch der Kunsthistorischen Sammlungen des Allerhöchsten
Kaiserhauses* XXXI 1914 p. 335; Kennedy North in *Burl. Mag.* Jan
1933 p. 10, reporting on cleaning and X-rays; Tietze pp. 219/20;
E. K. Waterhouse: *Titian's Diana and Actaeon* Charlton lecture,
Newcastle University, pubd. London 1952; H. Wethey: *Titian, the
Mythological and Historical Paintings* London 1975 p. 138. *Coll:*
Intended in 1623 as a wedding gift to Charles I, then Prince of Wales,
had he married the Infanta; given by Philip V to the French
ambassador, Antoine 4th Duc de Gramont (1641–1720) on 1 Sept
1704 (see *Bol Soc Española de Excursiones* XXXV 1927 p. 116); in the
Duc d' Orléans inventory of 1724 (Stryienski nos. 21, 22); sale
Lyceum, London 1798 (nos. 240, 249), reserved for the Duke of
Bridgewater (see p. viii); thence by inheritance.
 Duke of Sutherland loan 1946.

Venus Anadyomene (*Venus rising from the sea*)
Canvas: 29⅞ × 22½ (76 × 57·3). Kennedy North, who cleaned and
X-rayed the painting in 1931/2, describes the good condition of the
paint surface except on the face. This judgement still seems correct.

The X-rays show that originally the head of Venus was turned to the left instead of the right. In this form the figure would have closely resembled a marble relief of the same subject by Antonio Lombardo (c 1458–1516) in the V&A London. Both works may derive from an antique prototype. Kennedy has suggested that Titian may have been inspired by Pliny's tale of the fate of the *Venus Anadyomene* of Apelles. There is no firm evidence on which to date the picture, and suggestions have ranged from 1517–30. Gronau believed it might be the picture of a *bagno* mentioned in a letter from Titian to Alfonso d'Este in 1517. Mayer dated it c 1530. Comparison with *The Andrians* in the Prado, Madrid, might indicate a date for the Bridgewater House picture in the first half of the 1520s. *Lit:* G. Gronau: *Titian* London 1904 p. 53; KdK 1907 no. 36; S. Kennedy North in *Burl. Mag.* Mar 1932 p. 158; Tietze p. 160; A. L. Mayer in *Gaz. des Beaux-Arts* 1937 p. 304; R. Kennedy in *Essays in Memory of Karl Lehmann* ed. L. Sandler New York 1964 p. 162; H. Wethey: *Titian, the Mythological and Historical Paintings* London 1975 p. 187 no. 39. *Coll:* Queen Christina, Palazzo Riario Inv 1662 p. 45; bought by Duc d'Orléans 1721 (no. 41 in inventory at time of sale, see Granberg no. 20); sale Bryan's Gallery 1798 (49), reserved for the Duke of Bridgewater (see p. viii); thence by inheritance. Bridgewater House no. 19.

Duke of Sutherland loan 1946.

Holy Family with St John the Baptist

Canvas: $24\frac{1}{4} \times 36$ (61·5 × 91·5). The attribution in 1727 was to Palma Vecchio (Dubois p. 209), and it was still listed under Palma by Crowe and Cavalcaselle in 1871, but with a suggested attribution to Licinio or Polidoro Lanciano. In 1892 Morelli proposed an attribution to Titian, and this was followed by Gronau, Fischel and Mayer (all as c 1510–12), Berenson 1957 (as early), Suida (as c 1512), Wethey (as c 1510). A variant of the design, engraved as after Titian by V. Lefebvre 1680, relates to a painting in Glasgow Art Gallery (no. 192). *Lit:* J. Crowe and G. Cavalcaselle: *History of Painting in North Italy* (1871) London 1912 ed III pp. 381/2; G. Morelli: *Italian painters, Critical Studies . . .* London 1892 I p. 47; G. Gronau: *Titian* London 1904 p. 281; O. Fischel: *Tizian* KdK 1907 no. 16; A. L. Mayer in *Gaz. des Beaux-Arts* 1937 p. 304; W. Suida in *Arte Veneta* XIII–IV 1959–60 p. 62; H. Wethey: *Titian, the Religious Paintings* London 1969 p. 94. *Coll:* Duc d'Orléans by 1727, from Prince de Condé coll. (Dubois p. 209). Not in 1724 Orléans inventory (Stryienski no. 46). Sale Bryan's Gallery, London 1798 (112) as 'Giacomo Palma', reserved for the Duke of Bridgewater (see p. viii); thence by inheritance. Bridgewater House no. 29.

Duke of Sutherland loan 1946.

Three Ages of Man

Canvas: $35\frac{1}{2} \times 59\frac{1}{2}$ (90 × 151). The picture area is $34\frac{1}{8} \times 57\frac{1}{8}$
(86·5 × 145), enclosed in a border which is original, but later painted
grey. Painted c 1510–15. Tietze (p. 94) points out that the two
sleeping putti are derived from Mantegna's engraving *Bacchanalian
Group with a Vat* (Bartsch XIII 19). The present title was used in 1675
by Sandrart (p. 272) and on a version in the Renieri sale 1666
(Campori). An engraving of the design by V. Lefebvre of 1680 shows
no old man, extra buildings in the centre background, a T-shaped
object in the tree behind the putti, a second of whom has wings, and
the shepherdess with no flute in her left hand. The X-rays of the
Bridgewater House canvas offer no evidence about the old man, but
they show that there was some basis for Lefebvre's buildings, T-shaped
object and extra wings, and the shepherdess's left hand and flute have
been moved several times. This suggests that Lefebvre, who used
16th-century drawings or prints in some cases, was working from
some record of an earlier stage of this design or from an earlier
painting. The X-rays also show two more skulls at the old man's feet.
The painting out of these looks original, but the skulls appear correctly
placed in a copy in the Doria Gallery, Rome, painted in the late
16th or 17th century. (A copy attributed to Sassoferrato in the
Borghese Gallery, Rome, was made from the Doria copy or from a
common source: cf P. della Pergola: *Borghese catalogue* 1955 I p. 133.)
Lit: G. Campori: *Raccolta di cataloghi ed inventarii* . . . Modena 1870
p. 443; KdK 1907 no. 20; G. Robertson in *Burl. Mag.* Dec 1971
p. 721; H. Wethey: *Titian, the Mythological and Historical Paintings*
London 1975 p. 182 no. 36. *Coll:* (This or another version was owned
by Giovanni di Castel Bolognese 1494–1553 in Faenza and recorded
by Vasari VII p. 435). Seen in the Matthäus Hopfer coll. Augsburg
c 1628 by Sandrart (p. 272), who states that it came from Otto
Truchsess von Waldburg, Bishop of Augsburg (1514–73) and was
later (*ie* before 1675) sold by von Walberg (*sic*) to Queen Christina of
Sweden. Recorded in her collection by c 1662 (Palazzo Riario inv
p. 45); bought by Duc d'Orléans 1721 (no. 19 in inventory at time of
sale, see Granberg no. 28); sale Lyceum, London 1798 (278) reserved
for the Duke of Bridgewater (see p. viii); thence by inheritance.
Bridgewater House no. 77.
 Duke of Sutherland loan 1946.

TOSCANI, Giovanni active c 1420 died 1430
Worked in Florence; probably painted the group of pictures and
cassoni formerly attributed to the Master of the Griggs Crucifixion.

Workshop of Giovanni Toscani

1738 **Cassone with a scene from the Decameron**
The main feature is the front panel, which illustrates the tale of

the Lady Ginevra, wife of Bernabo of Genoa, and the young man who introduced himself into her house in a chest (Boccaccio: *Decamerone,* Giornata II, Nov 9).

Area of front panel with cusped border: $16\frac{1}{2} \times 56$ ($41\cdot9 \times 142$) restored 1943. Painted c 1420–5. The chest, which is $32\frac{1}{4}$ (high) \times $71\frac{3}{4} \times 23\frac{1}{2}$ ($82 \times 182 \times 60$), follows a design of cassone popular much later in the 15th century in Florence and seems to be a later reconstruction. Coats-of-arms at the sides have not been identified. Tentatively attributed by Antal to Rossello di Jacopo Franchi and so catalogued in 1957; convincingly described by Bellosi as close but perhaps inferior to Giovanni Toscani. *Lit:* F. Antal: *Florentine painting and its social background* London 1947 p. 367; L. Bellosi in *Paragone* 193 Mar 1966 p. 53. *Coll:* Captain G. Pitt-Rivers sale Christie's 2 May 1929 (80).

Dr John Warrack gift 1929.

TURNER, Joseph Mallord William 1775–1851 English

1614 Somer Hill, Tonbridge
Somerhill Park, three miles from Tunbridge Wells, Kent, seen from the west.

Canvas: $36 \times 48\frac{1}{8}$ ($91\cdot5 \times 122\cdot3$). Exhibited RA 1811 (177) *Somer Hill near Tunbridge, the seat of W. F. Woodgate, Esq. Lit:* A. J. Finberg: *J. M. W. Turner* Oxford 1961 ed no. 163; M. Butlin and E. Joll: *The Paintings of J. M. W. Turner* London 1977 no. 116. *Coll:* Bought in at the James Alexander sale Christie's 24 May 1851 (38) as *painted for Mr Alexander* (who, however, only bought the estate from Woodgate in 1816); Wynn Ellis sale Christie's 6 May 1876 (120); Ralph Brocklebank (by 1880).

Bought at the Brocklebank sale, Christie's 7 July 1922 (no. 71).

VELÁZQUEZ, Diego 1599–1660
Spanish, born in Seville and worked there until 1623; thereafter Court Painter to Philip IV in Madrid.

2180 An old woman cooking eggs
Canvas: 39×46 (99×117). Restored 1957, revealing clear remains of the date, *16.8,* which must therefore be 1618. (X-rayed.) One of a group of kitchen and tavern scenes (*bodegones*) popular with the young painters in Seville at the time, which were inspired by engravings from Holland (especially those after Pieter Aertsen). The two models and elements of the still life recur in other *bodegones* by Velázquez. *Lit:* A. L. Mayer: *Velázquez* London 1936 no. 111. *Coll:* According to W. H. J. Weale's notebook C.4 p. 18 (V & A Library), imported from Spain by Le Brun and later in the Woollett sale 8 May 1813 (45). Cook collection, Doughty House from 1863.

Bought, with a special Treasury grant and help from the NA-CF, from the Cook collection 1955.

109

VELDE, Willem van de, the younger 1633–1707
Born in Amsterdam, pupil of his father; settled in Greenwich 1677.

114 **Fishing boats in a calm**
Canvas: $16\frac{1}{2} \times 22\frac{1}{8}$ (41·9 × 56·2) cleaned 1934. Signed: *W. V. Velde 1658*. *Lit:* HdG no. 190.
Sir James Erskine of Torrie bequest to Edinburgh University 1835; deposited on loan 1845.

VENETIAN 16th century

690 **An archer**
Wood: $21\frac{1}{4} \times 16\frac{1}{4}$ (54 × 41·3) restored 1937 (X-rayed). The paint surface is so damaged and restored as to preclude a reliable assessment of its original quality and authorship. Listed by Berenson (1957) under Giorgionesque paintings. Possibly connected with the description of 1648 in Ridolfi (I p. 106) of a Giorgione in the van Voert (*sic*) coll. Antwerp, of a young man whose hand is reflected in his armour. *Lit:* C. Garas in *Bulletin du Musée . . .*, Budapest 1964 no. 25 p. 51.
Mary Lady Ruthven bequest 1885.

VERMEER, Jan, of Delft 1632–1675 Dutch

1670 **Christ in the house of Martha and Mary**
Luke x 38–42.
Canvas: $63 \times 55\frac{3}{4}$ (160 × 142) restored 1935 (X-rayed). Signed: *IVMeer* (*IVM* in monogram). The largest known Vermeer and probably the earliest, generally dated c 1654–5. Identified as by Vermeer in 1901 when the signature (whose age has since been tested) was revealed. In pigment analyses of Vermeer, including the early works, Kühn found indigo present and ultramarine absent only in our picture, which supports the general view that ours is the earliest. For the tradition of the figure of Christ in this attitude see L. Goldscheider (*Vermeer* London 1958 p. 133). The most likely source, however, of the composition of the three figures is an engraving by G. van Velden after Otto van Veen of c 1597/8 (repr *Bull: des Musées Royaux . . .* Brussels 1957 3–4 p. 163). *Lit:* H. Kühn in *Report and Studies . . .* NG Washington 1968 p. 155. *Coll:* Miles family, Leigh Court near Bristol; with Forbes and Paterson, London, in 1901; sold by them to W. A. Coats before 1904.
Given by the two sons of W. A. Coats, in memory of their father, 1927.

VERONESE, Paolo (Caliari) 1528–1588
Born in Verona; from 1551 working in Venice.

1139 **St Anthony Abbot as patron of a kneeling donor**
The Saint wears a dark, silver-grey *mozzetta* edged with scarlet
piping, with a white T on his right shoulder: an unusual version of
the habit of the Order of St Anthony. The order of Antonites was
principally concerned with the care of those suffering from
contagious diseases.

Canvas: 78 × 46½ (198·5 × 117·8) restored, and repaints removed,
in 1958. The lower left of three surviving fragments of a large,
arched altarpiece around 4½ metres high which showed, above, the
Vision of the Dead Christ (now Ottawa no. 3336), at the right another
donor with his patron St Jerome (now Dulwich no. 270) and, mostly
in a missing strip of c 60 cm in the centre, St Michael and the dragon.
Probably a late work after 1570. *Lit:* T. Pignatti: *Veronese, L'Opera
Completa* Venice 1976 I p. 166 no. 338. *Coll:* The altarpiece had
evidently been cut up by 1795. This fragment was W. Comyns sale,
Christie's 6 May 1815 (61); Duke of Sutherland (Passavant 1836 I
p. 142); Duke of Sutherland sale, Christie's 11 July 1913 (94), when
it measured 93 × 47 (236 × 119).

Bought from Agnew's 1913.

VERROCCHIO, Andrea del c 1435–88
Florentine. Active as a sculptor and painter; and head of a busy studio.
Described by Vasari as a master of perspective.

2338 **Madonna and Child**
Canvas transferred from wood: 42 × 30 (106·7 × 76·3) cleaned and
restored 1973–75. The original panel consisted of three planks lying
vertically, to judge from the evidence of paint losses along the joins.
The right-hand plank apparently retained less of the pigment than the
other two, so that the condition of the paint surface to the right of a
line through the Madonna's left shoulder is noticeably worse than
elsewhere. This has left the whole essential structure of the design
comparatively free of damage. The original transfer from wood to
canvas took place in 1877 and it was transferred a second time around
1891 (W. White: *Principles of Art as illustrated by examples in the
Ruskin Museum* London 1895 p. 72). E. Fahy (unpublished lecture
Edinburgh 1976) has pointed out that our picture represents the
adoration of the Child *alla antica*. The ruins in the background
are the remains of the Temple of Peace, a Roman basilica that was
supposed to have collapsed the night Christ was born. Throughout
the middle ages and the Renaissance, the Temple of Peace was
identified with the Basilica of Constantine at the NE corner of the
Forum in Rome. The earliest record of our picture dates from 1852

when it was in Venice, attributed to Filippo Lippi (P. Selvatico and
V. Lazari: *Guida di Venezia* . . . Venice 1852 p. 299). Until the
picture was cleaned most writers followed Ruskin (*The Works of John
Ruskin* Library Edition ed. E. Cook and A. Wedderburn London 1907
xxix p. 165) in describing it as an important picture of high quality
produced in Verrocchio's workshop. Martini has argued that it might
have been painted in the workshop by the young Leonardo. Since the
picture was cleaned, Zeri (letter 9 September 1976) and Fahy have
independently raised the possibility that it might be an early work by
Domenico Ghirlandaio, a pupil of Baldovinetti (according to Vasari).
But the possibility that it was designed and painted by Verrocchio
himself c 1468–70 still cannot be excluded. *Lit:* Van Marle xi
p. 547; Berenson 1932 and in *Boll. d'Arte* Nov/Dec 1933 p. 203;
E. Waterhouse in *Burl. Mag.* September 1955 p. 295; J. Shearman in
Burl. Mag. March 1967 p. 127 note 4; A. Martini in *Arte figurativa:
antica e moderna* viii 1960 p. 32. *Coll:* Manfrini Collection, Venice,
by 1852. Bought by John Ruskin, through Charles Fairfax Murray, in
1877 and exhibited at Walkley; transferred 1890 to the Ruskin
Museum at Meersbrook Park, Sheffield. Deposited by Trustees of
Guild of St George in Graves Art Gallery, Sheffield c 1952–73; lent to
the Birmingham *Exhibition of Italian Art* 1955 (114) and to the RA
Italian Art and Britain 1960 (318).·
 Bought with help from the NA-CF and the Pilgrim Trust from the
Trustees of the Guild of St George 1975.

VITALE da BOLOGNA active 1334–1359/61
The first painter of importance in Bologna whose works are identifiable.

952 Adoration of the Kings
St Ursula and St Catherine of Alexandria lower left; the
Annunciation in the spandrels.
 Wood: $23\frac{3}{4} \times 15\frac{1}{4}$ (60·4 × 39); main painted area $21\frac{3}{4} \times 12\frac{5}{8}$
(55·3 × 32). Restored 1977. The left wing of a diptych: the right wing,
Pietà and saints, is in the R. Longhi Foundation collection, Florence.
Longhi dates them 1345–50; Gnudi suggests a more probable dating
of 1353–5. *Lit:* R. Longhi in *Paragone* 5 May 1950 p. 9; C. Gnudi:
Vitale da Bologna Milan 1962 pp. 66 and 70.
 Bought from the Fine Art Society, London, 1908.

VUILLARD, Edouard 1868–1940
French, lived and worked in Paris; with Bonnard, a member of the
Nabi movement.

2228 **The open window**
Millboard: $21\frac{1}{2} \times 17$ (54·6 × 43·2) cleaned 1967. Signed: *E. Vuillard.*
Painted about 1899. *Coll:* D. W. T. Cargill, Lanark; bought by
Mr and Mrs Maitland from Tooth's in 1947.
Sir Alexander Maitland gift 1960.

2229 **La causette** (*The chat*)
Canvas: $12\frac{3}{4} \times 16\frac{1}{4}$ (32·4 × 41·3). Signed: *E. Vuillard.* Painted about
1892. *Coll:* A. de Lampe; bought by Mr and Mrs Maitland from
Tooth's in 1950.
Sir Alexander Maitland gift 1960.

WARD, James 1769–1859
English, born in London; began as an engraver; mainly known for
his animal paintings.

2306 **The Eildon Hills and the Tweed**
Wood: $40\frac{1}{2} \times 68$ (103 × 173). Signed: *J WARD* (in monogram) 1807.

2307 **Melrose Abbey, The Pavilion in the distance**
Wood: $40\frac{1}{2} \times 68$ (103 × 173). Signed: *J. Ward.*

A pair, exhibited RA London 1807: no. 323 *Littleden Tower, on the
Tweed; Merton, the seat of Hugh Scott, Esq: and the Eildon Hills, at the
foot of which stands Melrose;* no. 266 *Melrose Abbey, on the river Tweed;
Melrose Bridge, and the pavilion, the seat of the Right Hon Lord
Somerville: in the distance the Selkirkshire Hills.* *Lit:* C. R. Grundy
James Ward RA London 1909 pp. 35, 48. *Coll:* Commissioned by
Lord Somerville; MS inventory of the Somerville pictures at The Pavilion
1869 (nos. 3 and 37); passed by inheritance, remaining at The Pavilion
until 1969.
Sir Theophilus Biddulph bequest, received 1969.

WATTEAU, Antoine 1684–1721
Born at Valenciennes; settled in Paris 1702.

370 **Le dénicheur de moineaux** (*The robber of the sparrow's nest*).
Paper on canvas, laid on wood: $9\frac{1}{8} \times 7\frac{3}{8}$ (23·2 × 18·8) photographed in
infra-red. The painting was originally $14\frac{7}{8} \times 10\frac{1}{8}$ (37·8 × 25·7) and an
engraving of it by F. Boucher (published 1734 with the present title)
shows the figures and landscape as a vignette in the centre of an
ornamental design. Traces of decorative swags at the top and a stone
cartouche at the bottom, corresponding to the engraving, are visible
under later over-painting. Probably painted c 1712. *Lit:* M. de
Fourcaud in *Revue de l'art anc. et mod.* XXV 1909 p. 52; E. Dacier
and A. Vuaflart III no. 5; Adhémar p. 211. *Coll:* Jean de Jullienne
sale Paris 30 Mar 1767 (255); this or a smaller version was in the
Giroux sale, Paris 1816 (423); Mme Craufurd sale Paris 18 Feb 1834
(12); Auguste sale Paris 28 May 1850 (68).
Mrs Williams gift 1860.

439 **Fêtes Vénitiennes**
Canvas: 22 × 18 (55·9 × 45·7). Cleaned 1968 (photographed by infra-red: the canvas and ground are such as to make the X-ray nearly illegible). The paint surface is unusually well preserved for Watteau. A late work, probably painted c 1718–19 when Watteau was living with his fellow Flemish painter Nicolas Vleughels (1668–1737). The title appears on the engraving by L. Cars of 1732, when Jean de Jullienne owned the picture. Bouvy suggests a connection with a ballet by Danchet of this name performed several times in Paris from 1710. Several changes in the figures, common with Watteau, are visible by normal light or infra-red. The male dancer and bagpiper are painted over different figures. They are based on two known drawings (Parker/Mathey nos. 660 and 823 respectively), but with different heads. The dancer's head is a portrait of Vleughels. Levey suggests convincingly that the bagpiper's head is a self portrait, and the other dancer perhaps the actress Charlotte Desmares, so that the picture may have had a private meaning. *Lit:* E. Bouvy in *Etudes Italiennes* Apr Jne 1921 p. 65; Dacier & Vuaflart III no. 6; Adhémar no. 197; K. T. Parker and J. Mathey: *A. Watteau . . . son oeuvre dessiné* Paris 1957; M. Levey in *The Times* 17 May 1966. *Coll:* Jean de Jullienne sale Paris 30 Mar 1767 (250); Randon de Boisset sale Paris 27 Feb 1777 (178). It has been reported that Allan Ramsay bought it then, directly or through Le Brun; otherwise it was acquired later by General Ramsay. This or a copy in anon sale Paris Apr 1782 (76); Clos sale Paris 19 Nov 1812 (50). Lord Murray coll. in 1856 (Waagen suppl. p. 430).
Lady Murray of Henderland bequest 1861.

WEENIX, Jan Baptist 1621–c 1660
Born in Amsterdam; c 1643–46 in Rome where his style was formed; thereafter in Utrecht.

51 **Figures near a seaport**
Canvas: $26\frac{1}{4}$ × $28\frac{1}{2}$ (66·7 × 72·4) cleaned 1961. Hitherto as Jan Miel; attributed to Weenix by M. Waddingham. Probably a fairly early work painted before 1650.
Bought from the Marchese Gerini, Florence, for the Royal Institution in 1831.

WIJNANTS, Jan active 1643–died 1684
Born and worked in Haarlem: moved to Amsterdam c 1660.

1945 **Landscape with figures**
Canvas: $24\frac{5}{8}$ × 29 (62·6 × 73·7). Signed: *J. Wijnants 1665*. Smith records it as (no. 128), with a companion picture of *A farm-house and*

surrounding country, in the Donaldson collection, Edinburgh in 1835; the figures attributed to Lingelbach. *Lit:* HdG no. 246.

Miss Alice Anne White, Edinburgh, bequest 1941.

WILKIE, Sir David R A 1785–1841
Scottish, born at Cults, Fife; studied at the Trustees' Academy, Edinburgh; settled in London 1805; visited Italy and Spain 1825–8.

1032 Sheepwashing
A scene in Wiltshire, associated by local tradition with Fisherton de la Mere, near Salisbury.

Wood: 35 × 53 (88·9 × 134·6) cleaned 1944. Mentioned in a letter from Wilkie to Sir George Beaumont of 12 Dec 1816 as painted 'from a sketch I made in Wiltshire'. A water-colour study of c $6\frac{1}{2}$ × $10\frac{1}{4}$ (16·5 × 26) dated 1816 is now in the RA coll. London (cut in two). *Lit:* Cunningham I p. 454. *Coll:* Painted for Sir Thomas Baring; British Institution 1817 (55); Baring sale, Christie's 2 June 1848 (59); bought by John Gibbons (died 1851); Benjamin Gibbons sale, Christie's 26 May 1894 (74).

Hugh Laird bequest 1911.

1445 The bride at her toilet on the day of her wedding
Canvas: $38\frac{1}{4}$ × $48\frac{1}{4}$ (97·2 × 122·6). Signed: *David Wilkie ft London./ 1838.* Exhibited RA 1838 (201). A chalk study for the background is our no. D4981 p. 6; two pen and ink studies for one of the hands are our nos. D5013 J. and D5013 K. Two small pen sketches and a chalk study (37·1 × 27 cm) of versions of the main group are in coll. Prof and Mrs I. R. C. Batchelor. *Lit:* Cunningham III pp. 241–3–7. *Coll:* Painted for Rudolf Arthaber, Vienna; David Price (1886); his sale, Christie's 2 Apr 1892 (111); Arthur Sanderson (1901); Sir T. Glen Coats (1911).

Bought at Sir T. Glen Coats sale, Christie's 2 July 1920 (no. 36).

1527 Pitlessie Fair
The annual fair in Pitlessie, in the parish of Cults, Fife, was held in May.

Canvas: 23 × 42 (58·5 × 106·7) cleaned 1951. Signed *D. Wilkie/ Pinxt. 1804* (date retouched). Painted in Cults in 1804, but Wilkie had it in London to work on it in 1806. Exhibited Pall Mall 1812 as *The Country Fair.* Subject and design were evidently inspired by Alexander Carse, who painted two water-colours of Oldhamstocks Fair, one dated 1796 (our no. D4395). Preparatory studies, including one of Pitlessie village, are our nos. D4893 and 4904. Two chalk studies for hands are in the BM. *Lit:* B. R. S. Megaw in *Scottish Studies* 1966 x 2 p. 178; K. Andrews in *Scottish Art Review* 1966 x 3 p. 6. *Coll:* Sold to Charles Kinnear of Kinloch, who lent it to Royal Institution, Edinburgh 1821 (11).

Bought from Mrs Jessie Kinnear 1921.

1890 The letter of introduction
Wood: 24 × 19¾ (61 × 50·2) cleaned 1942. Signed: *D. Wilkie 1813.*
The idea was suggested by an incident when Wilkie himself presented
a letter of introduction to Caleb Whitefoord on his arrival in London.
Wilkie based his design on Ter Borch *The Messenger* (now
Philadelphia Museum of Art). An oil study of the setting (15 × 11¾in)
is in the V & A London. Five preparatory drawings are known
(RA, Prof and Mrs I. R. C. Batchelor coll., and our nos. D3941–3).
Lit: Cunningham I pp. 383/4; A. S. Marks in *Burl. Mag.* Mar 1968,
p. 125. *Coll:* Bought by Samuel Dobree in March 1814; Bonamy
Dobree Jr (1857); Ralph Brocklebank by 1874.
 Bought from the Trustees of Mrs Thomas Brocklebank 1938.

2114 Josephine and the fortune-teller
It is said that, before she left her native Martinique, the future
Empress Josephine had her hand read by a negress who predicted
that she would be greater than a queen.
 Canvas: 83 × 62 (211 × 158) cleaned 1949. Signed: *DAVID
WILKIE f. 1837.* Exhibited RA 1837 (144). A preliminary drawing
(Birmingham Art Gallery) and a study of the negro (Duke of
Buccleuch coll.) are both dated 1836. A chalk study for the hands of
Josephine and the fortune teller is in the V & A London. *Coll:*
Painted for John Abel Smith of Dale Park; passed by inheritance to
the Earl of Ducie.
 Bought at the Earl of Ducie sale, Christie's 17 June 1949 (no. 137a,
not in catalogue).

2130 The Irish whiskey still
Wood: 47 × 62 (119·4 × 158) restored 1951. Signed: *David Wilkie
f. 1840.* Exhibited RA 1840 (252). An earlier version without the
figures at the door, on wood: 15¾ × 20 (40 × 50·8) dated London 1839,
was bought by F. W. Brederlo (died 1862) of Riga and is now in the
Museum of Art, Riga. Pen and ink studies are our nos. D4981 p. 48B
and D4981 p. 51A. *Lit:* Cunningham III pp. 274, 281 (and cf. p. 100).
Coll: Painted for Nieuwenhuys, who sold it to the King of Holland;
his sale at Amsterdam 12ff. Aug 1850, bought for John Naylor.
 Bought at the sale (of J. Naylor's grandson) at Christie's 20 Oct
1950 (no. 76).

2173 The artist's parents
The Rev David Wilkie (1738–1812), minister of Cults, and his wife
Isabella Lister (died 1824).
 Wood: 10 × 8 (25·5 × 20·3) cleaned 1955. Painted in 1813. Wilkie
had painted an earlier version for his sister Helen in 1807: 12 × 8
(30·5 × 20·3) in a London private coll. in 1958. *Lit:* Cunningham I

pp. 386/7. *Coll:* Given by Wilkie in 1813 to his brother John in India, and passed by inheritance to W. R. Chrystal. Bought from W. R. Chrystal 1953.

2315 **The confessional. Pilgrims confessing in the Basilica of St Peter's**
Canvas: $18\frac{3}{8} \times 14\frac{5}{16}$ (46·7 × 36·3) cleaned 1972. Signed: *D. Wilkie Roma 1827.* Exhibited RA 1829 (293). The subject was based on Wilkie's observation of pilgrims in Rome during Holy Week of the Holy Year, which he describes in a letter of 27 December 1825. *I Pifferari* and *A Roman Princess washing the feet of Pilgrims* (both in the Royal Collection), also exhibited at the RA in 1829, show other episodes connected with the Roman pilgrims and appear to have been companion pieces to *The confessional,* being of approximately similar sizes and painted in the same year. In a letter of 27 April 1827 Wilkie states that he has completed two small pictures in the last five months, one of which has been sold. These were almost certainly *I Pifferari* and *The confessional.* In a letter of 22 November 1827 Wilkie mentions James Morrison who had bought *The confessional* and wanted *I Pifferari* also, described by Wilkie as 'the companion picture'. *A Roman Princess* which is on panel, and slightly larger than the other two pictures, was begun on 20 June in Geneva. *Lit:* Cunningham II pp. 210, 414, 475, 476, 482, and III p. 527; Waagen: *Supplement* p. 303. *Coll:* Bought by James Morrison of Basildon Park by 27 April 1827; thence by inheritance.
Bought at Sotheby's 22 March 1972 (no. 114).

2337 **Distraining for rent**
Wood: $32 \times 48\frac{7}{16}$ (81·3 × 123). Signed: *D. Wilkie 1815.* Exhibited RA 1815 (118). An oil sketch signed *D. Wilkie 1815* is in the collection of the Duke of Buccleuch. It is possible that the date and signature on the sketch were added by Wilkie at a later period and refer to the completion of the finished painting rather than to the execution of the sketch, and that this is the one which he began on 7 April 1814. Another oil sketch (or possibly a copy) was with Leggatt in 1899 but has since disappeared. A chalk study for the head and hand of the farmer seated at the table was with the Sabin Galleries London in 1963. A pen and ink study for the whole composition is in the Courtauld Institute Collection, and our nos. D4981/46A and B (versos) are very slight drawings for the wife and children on the left of the picture. Pasted to the back of the panel are a letter from Clarkson Stanfield, and a copy of a letter from Wilkie to Stanfield dated January 1832 and referring to the performance of *The Rent Day,* a play by Jerrold which included a tableau of *Distraining for rent.* *Lit:* Cunningham I pp. 432–6; William Bayne: *Sir David Wilkie* London 1903 pp. 70–72; John Woodward: *Paintings and drawings by Sir David Wilkie* (exhibition catalogue) Edinburgh 1958 no. 22; Francis Russell in *Master Drawings* vol. XL 1972 p. 38. *Coll:* Bought by the Directors of the British Institution in 1816; bought by A.

Raimbach; William Wells sale Christie's 12 May 1848 (75), bought in; Wells sale Christie's 10 May 1890 (81) bought by Agnew; Lord Masham and thence by descent.

Bought from the Trustees of the Swinton settled Estates 1975.

Self-portrait

Canvas: $29\frac{1}{4}$ × 24 (74·3 × 61). A study for the hands on the same sheet as studies for *Pitlessie Fair* (our no. D4904) suggests a date before May 1805 when Wilkie left for London. *Lit:* J. Steegman in *Burl. Mag.* Apr 1938 p. 189; K. Andrews in *Scottish Art Review* 1966 x 3, p. 6. *Coll:* Sir William Knighton sale 23 May 1885 (437); Robert Rankin (by 1888).

Given by John Rankin to the Scottish National Portrait Gallery, in fulfilment of the wish of his brother Robert, 1898 (SNPG no. 573).

WILSON, Andrew 1780–1848

Scottish, born in Edinburgh. Trained under Alexander Nasmyth and at the RA Schools, London. Master of the Trustees' Academy, Edinburgh, 1818–26. He was in Italy (mainly Genoa) 1803–6 and from 1826, where he bought old paintings for the British market (cf. Bassano no. 100 and van Dyck no. 120).

326 View of Tivoli

Canvas: $11\frac{1}{4}$ × $17\frac{1}{4}$ (28·6 × 43·8). Probably painted at the same time as a canvas in the RSA collection which is inscribed on a label: *Study from Nature/View in Adrian's Villa/Tivoli/The Campagna and Monte/Gennaio. A. Wilson 1834.* Though hardly pendants, the two pictures are the same size and both were bought in the same year, as 'painted on the spot' (RSA list p. 49).

Bought by the RSA 1851; transferred 1910.

WILSON, Richard 1713–81

Welsh, born in Montgomeryshire; in Italy 1750–c 1757.

331 An Italian landscape

Canvas: $20\frac{1}{4}$ × $28\frac{3}{4}$ (51·5 × 73). Probably painted in Italy, close in date to a painting of similar colour, handling and type of design which Wilson gave to Zuccarelli in 1751 (now V & A London no. 501–1883). *Lit:* W. G. Constable: *Richard Wilson* London 1953 pp. 78, 216. *Coll:* Probably Royal Institution 1819 (no. 2 or 87) lent Sir James Erskine.

Sir James Erskine of Torrie bequest to Edinburgh University 1835; deposited on loan 1845.

WINGATE, Sir James Lawton PRSA 1846–1924
Scottish, born at Kelvinhaugh, Glasgow. At first self-taught; at art
school in Edinburgh from 1872.

1488 Ash trees in spring
Canvas: 17 × 12¼ (43·2 × 31·1). Signed: *Wingate*. Probably painted
1900–10. *Coll:* James Wilson.
Dr John Kirkhope bequest 1920.

1649 A summer's evening
Canvas: 21½ × 29¼ (54·5 × 74·3). Signed: *Wingate 88*. Painted at
Muthill, near Crieff. Exhibited RSA 1888 (171) lent by T. H. Cooper.
Mrs T. H. Cooper bequest 1925.

WITTE, Emanuel de c 1618–1692
Dutch; working in Delft 1641–50 and thereafter in Amsterdam.

990 Church interior
Canvas: 74¾ × 63¾ (190 × 162) cleaned 1960. An unusually large
painting for de Witte, perhaps his largest. A smaller painting in the
Rijksmuseum, Amsterdam (no. 2697), shows a different view of the
same church, which appears to combine the general aspect of
Amsterdam New Church with parts of the Old Church.
Bought at Christie's, anon sale 2 July 1909 (no. 56).

ZURBARÁN, Francisco de 1598–1664
Spanish; trained in Seville, where he knew Velázquez, and worked
mainly in the Seville district.

340 The Immaculate Conception
Canvas (arched top): 100 × 69¾ (255·5 × 177). Restored 1954: the
lower edge of the canvas is too damaged to show if it has been cut.
One of at least eight versions that Zurbarán painted of the *Immaculate
Conception*. Symbols of the Virgin, which appear in the landscape, are
derived from an engraving by Sadeler of 1605. The horns of the
crescent moon point downwards, following a Jesuit doctrine published
in Seville in 1604 (see F. Pacheco: *El Arte de la Pintura* Seville 1649
p. 483). Soria dates the picture as 1638, pointing out that it is close to
pictures dated 1638–9 from the Carthusian Monastery in Jerez and
may have come from the same monastery. A date around 1638–40
seems probable but the suggested connection with the monastery at
Jerez should be treated with caution. *Lit:* M. Soria: *Zurbarán*
London 1953 no. 143. *Coll:* Probably Galerie Espagnole, Louvre
1838 (342). Louis Philippe sale London 7 May 1853 (147) bought
by Hickman.
Bought from Lord Elcho for the Royal Institution 1859.

119

COMPLETE LIST OF THE PERMANENT COLLECTION and
works held on extended loan

***167** AIKMAN, William: *Self-portrait* 29 × 24½ (73·6 × 62·2) J. T. Gibson-Craig gift (RSA) 1859

***1882** ALEXANDER, Cosmo: *Adrian Hope of Amsterdam* 29½ × 24½ (74·9 × 62·2) Bt 1937

2022 ALEXANDER, Cosmo: *James Duff of Corsindae* 29¼ × 24¼ (74·3 × 61·6) Miss Henrietta Tayler gift 1944

***1784** ALEXANDER, John: *Rape of Proserpine* 28 × 31¾ (71·1 × 80·7) Bt 1932

1798 ALEXANDER, John: *Portrait of an old lady* 30 × 25 (76·2 × 63·5) Bt 1934

1648 ALEXANDER, Robert: *The happy mother* 31¼ × 45 (79·4 × 114·3) Mrs T. H. Cooper bequest 1925

***415** ALLAN, David: *Mrs Tassie* 30 × 25 (76·2 × 63·5) William Tassie bequest 1860

***612** ALLAN, David: *The Origin of Painting* W (oval): 15 × 12 (38·1 × 30·5) Mrs Byres gift 1874

2126 ALLAN, David: *The uncultivated genius* M: 9⅜ × 7¼ (23·9 × 18·5) Bt 1950

***2157** ALLAN, David: *Sir John Halkett, Bart of Pitfirrane, his wife and family* 60¼ × 94 (153 × 239) Miss Madeline Halkett bequest 1951

2256 ALLAN, David: *The continence of Scipio* 66½ × 53¾ (161 × 137) Bt 1962

***2260** ALLAN, David: *The connoisseurs* 34 × 38½ (86·4 × 97·8) Bt 1963

2292 ALLAN, David: *Portrait of a man* 14¾ × 11⅞ (37·5 × 30·2) Miss E. N. Adam gift 1967

***172** ALLAN, William: *The Black Dwarf* W: 13 × 17½ (33 × 44·5) Commissioned (RI) 1827

1677 ALLAN, William: *Murder of Rizzio* W: 40½ × 64 (102·9 × 163) Lord Strathcona gift 1927

***1528** AMEDEI, Giuliano: *Death of St Ephraim* W: 13½ × 17½ (34·3 × 43·5) Bt 1921

***1940** APOLLONIO DI GIOVANNI (follower): *Triumphs of Love and Chastity* W: 15⅞ × 55¾ (40·5 × 141·6) Marquess of Lothian bequest 1941

1974 APOLLONIO DI GIOVANNI (workshop): *Rape of the Sabines* W: 15⅜ × 24¼ (39·1 × 61·6) Bt 1942

1729 ARCHER, James: *Emelye* B (arched top): $13\frac{1}{2} \times 9$ ($34\cdot3 \times 22\cdot9$) A. F. Roberts bequest 1929

1927 ASPER, Hans (by or after): *Portrait of Zwingli* W: $10 \times 7\frac{1}{2}$ ($25\cdot5 \times 19$) Marquess of Lothian bequest 1941

1014 ASSELIJN, Jan: *Roman ruins* 20×26 ($50\cdot8 \times 66$) Mrs Mary Veitch bequest (RSA) 1875

AUSTRIAN: *Madonna* see under ITALIAN, 18th cent no. 833*

***647** AVERCAMP, Hendrick: *Winter landscape* M: $11\frac{1}{4} \times 16\frac{5}{8}$ ($28\cdot6 \times 42\cdot2$) David Laing bequest 1879

***2291** BACCHIACCA: *Moses striking the rock* W: $39 \times 31\frac{1}{2}$ (100×80) Bt 1967

***2** BACKHUYZEN, L.: *A squall* $18\frac{1}{4} \times 24$ ($46\cdot4 \times 61$) Torrie collection

1946 BACKHUYZEN, L.: *Shipping in a choppy sea* $23\frac{1}{2} \times 33$ ($59\cdot7 \times 83\cdot8$) Miss Alice Anne White bequest 1941

1543 BARTHOLOMÉ, P. A.: *L'enfant mort* Bronze: ht 41 ($104\cdot2$) Bt 1921

1626 BARYE, A. L.: *Tigre dévorant une gazelle* Bronze: ht $21\frac{3}{4}$ ($55\cdot3$) Bt 1923

2053 BARYE, A. L.: *Puma and deer* Bronze: ht $11\frac{1}{4}$ ($28\cdot6$) Sir D. Y. Cameron bequest 1945

2059 BARYE, A. L.: *Sheep* Bronze: ht 6 ($15\cdot2$) Sir D. Y. Cameron bequest 1945

***3** BASSANO, Jacopo: *Portrait of a gentleman* $50 \times 38\frac{3}{4}$ (127×98) Bt (RI) 1830

***100** BASSANO, Jacopo: *Adoration of the Kings* $72 \times 92\frac{1}{2}$ (183×235) Bt (RSA) 1856

BASSANO, Jacopo (attr): *Scholar with inkstand* see under VENETIAN, 16th cent no. 704

4 BASSANO, Jacopo (studio): *Christ and the moneychangers* $66 \times 90\frac{1}{2}$ (168×230) Bt (RI) 1826

1511 BASSANO, Jacopo (studio): *Adoration of the shepherds* $38 \times 49\frac{1}{2}$ ($96\cdot5 \times 125\cdot8$) Mrs Nisbet Hamilton Ogilvy bequest 1921

***1635** BASSANO, Jacopo (studio): *Madonna and Child with St John and a donor* $30 \times 30\frac{1}{2}$ ($76\cdot2 \times 77$) Sir Claude Phillips bequest 1924

1636 BASSANO, Jacopo (after): *St Francis kneeling before the Virgin and Child* $14 \times 11\frac{3}{4}$ ($35\cdot6 \times 29\cdot9$) Sir Claude Phillips bequest 1924

***1133** BASTIEN-LEPAGE, J.: *Pas Mèche* $52 \times 35\frac{1}{4}$ ($132\cdot1 \times 89\cdot5$) Bt 1913

***** BELLOTTO, Bernardo: *View of Verona* 52×90 ($132 \times 233\cdot7$) Anonymous loan

***2024** BENSON, Ambrosius: *Madonna and Child with St Anne* W (ogee top): $31\frac{3}{4} \times 23\frac{1}{4}$ ($80\cdot7 \times 59\cdot1$) Bt 1945

1793 BOGLE, John: Three miniatures Miss Jane Deuchar bequest 1925

1996 BOGLE, J.: *Portrait of a man* Miniature Kenneth Sanderson bequest 1943

1997 BOGLE, J.: *Man in blue coat* Miniature Kenneth Sanderson bequest 1943

1998 BOGLE, J.: *James Ferguson* Miniature Kenneth Sanderson bequest 1943

1999 BOGLE, J.: *Girl in white dress* Miniature Kenneth Sanderson bequest 1943

2128 BOGLE, J.: *Capt Charles Kerr* Miniature Miss D. I. K. Stevenson gift 1950

2154 BOGLE, J.: *Portrait of a gentleman* Miniature Miss D. I. K. Stevenson gift 1950

660 BONE, Henry: *Sir Francis Drake* Miniature copy Dr Donald Fraser bequest 1880

661 BONE, Henry: *Old woman with lighted candle* Miniature copy Dr Donald Fraser bequest 1880

9 BONIFAZIO VERONESE (studio): *The Last Supper* $55\frac{3}{4} \times 111$ ($141\cdot6 \times 278\cdot5$) Bt (RI) 1849

***1017** BONINGTON, R. P.: *Landscape with mountains* B: $9\frac{7}{8} \times 13$ ($25\cdot1 \times 33$) Bt 1910

***2164** BONINGTON, R. P.: *Venice: Grand Canal* Paper on canvas: $8\frac{7}{8} \times 11\frac{7}{8}$
(22·5 × 30·1) Lady Binning bequest 1952

***2165** BONINGTON, R. P.: *Estuary with a sailing boat* B: 9 × 14 (22·8 × 35·5)
Lady Binning bequest 1952

642 BONNAR, William: *Self-portrait* W: 13 × $10\frac{1}{4}$ (33 × 26·1) Thomas Bonnar
gift 1879

***2223** BONNARD, Pierre: *Landscape* 19 × 18 (48·3 × 45·7) Sir Alexander Maitland
gift 1960

***2245** BONNARD, Pierre: *Lane at Vernonnet* $29\frac{1}{4} \times 24\frac{3}{4}$ (74 × 62·9) Bt with money
given by Mrs Charles Montagu Douglas Scott, 1961

***** BORCH, Gerard ter: *A singing practice* $29\frac{1}{8} \times 31\frac{3}{8}$ (74 × 79·7) Duke of
Sutherland loan 1946

***10** BORDON, Paris: *Venetian woman at her toilet* $38\frac{1}{4} \times 55\frac{1}{4}$ (97·2 × 140·4)
Bt (RI) 1830

***48** BORGIANNI: *St Christopher* 41 × $30\frac{3}{4}$ (104·1 × 78·1) Sir John Watson
Gordon gift (RSA) 1850

20 BORGIANNI (after): *St Christopher* $38\frac{1}{2} \times 28\frac{3}{4}$ (97·8 × 73) Bt (RI) 1830

1468 BOSBOOM, J.: *The preacher* W: $11\frac{1}{4} \times 16\frac{3}{4}$ (28·6 × 42·6) Dr John Kirkhope
bequest 1920

1469 BOSBOOM, J.: *Interior of Alkmaar church* W: $7\frac{1}{4} \times 5\frac{3}{4}$ (18·5 × 14·6)
Dr John Kirkhope bequest 1920

912 BOTH, Jan: *Landscape* W: $17\frac{1}{4} \times 21\frac{1}{4}$ (43·8 × 54) Patrick Shaw bequest 1902

913 BOTH, Jan: *Landscape* M: $19\frac{1}{2} \times 25\frac{1}{2}$ (49·6 × 64·8) Patrick Shaw bequest 1902

13 BOTH, Jan (attr): *Landscape* $19\frac{1}{4} \times 28$ (48·9 × 71·1) Bt (RI) 1831

***1536** BOTTICELLI (workshop): *Virgin and St John adoring the Infant Christ* W: $18\frac{3}{4} \times 16\frac{3}{4}$
(46·5 × 41·5) Bt 1921

1792 BOTTICELLI (after): *Portrait of a youth* W: $19\frac{1}{2} \times 15\frac{7}{8}$ (50 × 40·3) Bt 1933

***429** BOUCHER, François (studio): *Madame de Pompadour* $14\frac{1}{4} \times 17\frac{3}{8}$ (36·2 × 44·1)
Lady Murray of Henderland bequest 1861

***1072** BOUDIN, E.: *Port of Bordeaux* $15\frac{3}{4} \times 25\frac{3}{4}$ (40 × 65·4) George R. MacDougall
gift 1912

***2349** BOUDIN, E.: *Washerwomen on the banks of the Touques* W: $10\frac{1}{2} \times 16\frac{1}{8}$ (26·7 × 41)
Alastair Russell MacWilliam bequest 1977

***2350** BOUDIN, E.: *Kerhors; fisherwomen resting* W: 9 × 16 (22·9 × 40·6) Robert A.
Lillie bequest 1977

***2351** BOUDIN, E.: *Fishing boat, Trouville* W: $10\frac{11}{16} \times 8\frac{3}{8}$ (27·1 × 21·3) Robert A. Lillie
bequest 1977

801 BOUGH, Sam: *Royal Volunteer Review, 7 August, 1860* $46\frac{1}{2} \times 70\frac{5}{8}$ (118·1 × 179)
Charles T. Combe gift 1887

819 BOUGH, Sam: *English canal scene* W: $11\frac{5}{8} \times 17\frac{5}{8}$ (29·5 × 44·8)
David B. Anderson gift 1889–90

1475 BOUGH, Sam: *Off St Andrews* $14\frac{1}{4} \times 18$ (36·2 × 45·8) Dr John Kirkhope
bequest 1920

1476 BOUGH, Sam: *The Solway at Port Carlisle* W: 10 × $12\frac{3}{4}$ (25·5 × 32·5) Dr John
Kirkhope bequest 1920

***2121** BOUGH, Sam: *Berwick-on-Tweed* W: $8\frac{1}{4} \times 11\frac{5}{8}$ (21 × 29·5) Miss Ida M.
Hayward bequest 1950

***1500** BRAY, Jan de: *A Dutch gentleman* W (oval): $8\frac{3}{4} \times 6\frac{1}{4}$ ($22\cdot2 \times 15\cdot8$)
Mrs Nisbet Hamilton Ogilvy bequest 1921

***1501** BRAY, Jan de: *His wife* W (oval): $9 \times 6\frac{1}{2}$ ($22\cdot8 \times 16\cdot5$) see no. 1500 above

***1502** BRAY, Jan de: *His younger son* W (oval): $7\frac{3}{4} \times 5\frac{1}{2}$ ($19\cdot7 \times 14$) see no. 1500 above

***1503** BRAY, Jan de: *His elder son* W (oval): $7\frac{3}{4} \times 5\frac{1}{2}$ ($19\cdot7 \times 14$) see no. 1500 above

***1492** BRIL, Paul: *Fantastic landscape* M: $8\frac{3}{8} \times 11\frac{1}{2}$ ($21\cdot3 \times 29\cdot2$) Mrs Nisbet
Hamilton Ogilvy bequest 1921

1824 BRITISH, 17th cent: *Portrait of a young man* $30\frac{3}{4} \times 24\frac{1}{4}$ ($78\cdot1 \times 61\cdot7$) Bt 1934

2001 BRITISH, 18th cent: *Mrs Siddons* (?) Miniature Kenneth Sanderson bequest
1943

2071 BRITISH, 19th cent: *Miss Crooks* Miniature Capt C. J. Peebles Chaplin gift
1946

2093b BRITISH, 19th cent: *Portrait of a lady* Miniature Mrs Ethel M. Pearse gift 1947

2093c, d, e BRITISH, 19th cent: Three miniatures Mrs Ethel M. Pearse gift 1947

2094 BRITISH, 19th cent: *Portrait of a lady* (c 1860–70) Miniature Mrs Ethel M.
Pearse gift 1947

904 BRODIE, William: *Scots girl* Marble: ht $21\frac{1}{2}$ ($54\cdot6$) Miss Ada Barclay gift
c 1902

1908 BRODIE, William: *Draped head* Marble: ht $18\frac{1}{2}$ (47) James and William Watt
gift 1938

1943 BRONZINO, A. (after): *Garzia de' Medici* (?) $10\frac{1}{4} \times 7\frac{3}{4}$ ($26\cdot1 \times 19\cdot7$) Marquess
of Lothian bequest 1941

938 BROUGH, Robert: *W. Dallas Ross* $28\frac{1}{4} \times 22\frac{5}{8}$ ($71\cdot8 \times 57\cdot5$) W. Dallas Ross
gift 1907

***1759** BURNET, John: *Oyster-cellar in Leith* W: $11\frac{1}{2} \times 14$ ($29\cdot2 \times 35\cdot5$) Bt 1931

811 BURNETT, T. S.: *Florentine priest* Marble: ht $26\frac{1}{2}$ ($67\cdot3$) RAPFA gift 1897

1015 BURNETT, T. S.: *Baby* Marble: ht 13 (33) Acquired (RSA) before 1910

***1000** BURR, A. H.: *The night stall* $20\frac{1}{2} \times 18\frac{1}{2}$ ($52\cdot1 \times 47$) Bt 1910

***1001** BURR, John: *Grandfather's return* $9\frac{3}{4} \times 11\frac{1}{4}$ ($24\cdot8 \times 28\cdot6$) Bt 1910

***1746** BUTINONE, B.: *Christ disputing with the doctors* W: $9\frac{7}{8} \times 8\frac{3}{4}$ ($25\cdot1 \times 22\cdot3$)
Bt 1930

2106 CADENHEAD, James: *Highland pastoral* $29\frac{1}{4} \times 40\frac{1}{4}$ ($74\cdot3 \times 102\cdot3$)
Miss Grace H. Findlay gift 1948

1493 CALRAET, A. (attr): *The start* W: $13\frac{1}{4} \times 18\frac{1}{4}$ ($33\cdot7 \times 46\cdot4$) Mrs Nisbet
Hamilton Ogilvy bequest 1921

***18** CAMBIASO, L.: *Holy Family* $56\frac{5}{8} \times 42\frac{1}{8}$ ($143\cdot8 \times 107$) Bt 1830

8 CAMERARIUS, Adam: *Young man in fur cap* 31×26 ($78\cdot8 \times 66$) Bt (RI) 1838

***652** CAMERON, Hugh: *Going to the hay* $22\frac{1}{2} \times 16\frac{3}{4}$ ($57\cdot2 \times 42\cdot5$) J. T. Gibson-Craig
gift 1879

1444 CAMERON, Hugh: *Toiler of the hills* $29\frac{3}{4} \times 37\frac{3}{4}$ ($75\cdot6 \times 95\cdot9$) Bt 1920

1717 CAMERON, Hugh: *A lonely life* $33\frac{1}{4} \times 25$ ($84\cdot5 \times 63\cdot5$) Bt 1928

1730 CAMERON, Hugh: *Girl sewing* $18\frac{1}{4} \times 13\frac{1}{4}$ ($46\cdot4 \times 33\cdot7$) Arthur F. Roberts
bequest 1929

1763 CAMERON, Hugh: *Buttercups and daisies* $26\frac{3}{4} \times 18\frac{3}{4}$ ($68 \times 47\cdot6$) Miss M. Kerr
Cameron gift 1931

1764 CAMERON, Hugh: *Toiler of the hills* $13\frac{1}{4} \times 19\frac{1}{4}$ ($33\cdot7 \times 48\cdot9$) Miss M. Kerr
Cameron gift 1931

2162 CAMERON, Hugh: *Youth's bright sunny day* 25 × 42¾ (63·5 × 108·6)
John Mackie Croall bequest 1952

17 CANALETTO (follower): *Venice* 25 × 32½ (63·5 × 82·6) Bt (RI) 1831

2014 CANALETTO (follower): *Grand Canal* 14¼ × 21⅜ (36·2 × 54·3) Miss Margaret
Leadbetter bequest 1944

42 CANTARINI, Simone: *Holy Trinity* 75 × 50 (191 × 127) Edward Cruickshank
gift (RI) 1844

***459** CARDUCHO, V.: *Dream of St Hugh* 22¾ × 18 (57·8 × 45·7) Andrew Coventry
gift 1863

CARRACCI, L. (attr): *Cain killing Abel* see under NEAPOLITAN no. 21*

***780** CARSE, Alexander: *The new web* 18⅝ × 24⅝ (47·3 × 62·5) R. Findlay gift 1885

1828 CARSE, Alexander: *Brawl outside an ale house* 17 × 21 (43·2 × 53·4) Bt 1935
CARSE, Alexander: *The Penny Wedding* 34¾ × 51¾ (88·2 × 131·5) Flight
Lieutenant G. N. Statham loan

***1210** CASTAGNO (follower): *The Last Supper* W: 11¾ × 14¼ (29·9 × 36·2) Bt 1917

1675 CATENA, Vicenzo: *Portrait of a Venetian lady* W: 13¾ × 10⅝ (35 × 27) Bt 1927

***2236** CÉZANNE, P.: *Montagne Sainte-Victoire* 21½ × 25½ (54·6 × 64·8) Sir Alexander
Maitland gift 1960

2113 CHALMERS, George: *Portrait of an old lady* 30 × 25 (76·2 × 63·5) Miss Ella
R. Christie bequest 1949

***657** CHALMERS, G. P.: *The legend* 40½ × 60¾ (102·9 × 154·3) RAPFA gift 1897

924 CHALMERS, G. P.: *A quiet cup* W: 11¾ × 9¾ (29·9 × 24·8) Bt 1905

1477 CHALMERS, G. P.: *Modesty* 25 × 18¾ (63·5 × 47·6) Dr John Kirkhope bequest
1920

1478 CHALMERS, G. P.: *The tired devotee* (oval) 10½ × 8⅞ (26·7 × 22·6) Dr John
Kirkhope bequest 1920

1629 CHALMERS, G. P.: *The eagle's nest, Skye* 25½ × 37½ (64·8 × 95·3) Bt 1924

1891 CHALMERS, G. P.: *An old woman* 16½ × 13½ (41·9 × 34·3) Sir Andrew T. Taylor
bequest 1938

***959** CHARDIN: *Still-life: the kitchen table* 16 × 12¾ (40·6 × 32·4) Bt 1908

***1883** CHARDIN: *Vase of flowers* 17¼ × 14¼ (43·8 × 36·2) Bt 1937

942 CHARLES, James: *Cornfield near Wooler* 19½ × 30½ (49·6 × 77·5) Sir T. D.
Gibson Carmichael Bart (Lord Carmichael) gift 1907

2303 CHINNERY, George: *Self-portrait* 16 × 13 (40·6 × 33) Bt 1935

175 CHRISTIE, Alexander: *Four saints* 4 canvases, two 85 × 15 (216 × 38·1), two
82 × 15 (208 × 38·1) The artist's gift, by 1859

578 CHRISTIE, Alexander: *Incident in the Great Plague* W: 36 × 27½ (91·5 × 69·9)
J. T. Gibson-Craig gift, by 1881

1231 CHRISTIE, J. E.: *The Pied Piper of Hamelin* 26⅞ × 37 (68·3 × 94) Bt 1919

***799** CHURCH, Frederick: *Niagara Falls* 102½ × 91 (260 × 231) John S. Kennedy
gift 1887

***1190** CIMA DA CONEGLIANO: *Virgin and Child with Saints* W: 22 × 18¼ (55·9 × 46·4)
Miss Margaret Peter Dove gift 1915

***2240** CLAUDE: *Landscape with Apollo and the Muses* 73 × 114 (186 × 290) Bt 1960

962 CLAUDE (follower): *Landscape with bridge* 24¾ × 30½ (62·9 × 77·5) Bt 1908

2046 CLAUSEN, George: *Frieda* 18 × 14 (45·7 × 35·6) Sir D. Y. Cameron bequest
1945

2340 CLAUSEN, George: *The stars coming out* 20 × 24 (50·8 × 61) Edward A. C. MacCurdy bequest 1976

***1930** CLOUET, Jean: *Mme de Canaples* W: $14\frac{1}{8}$ × $11\frac{1}{4}$ (36 × 28·5) Marquess of Lothian bequest 1941

CONINXLOO: *A Flemish village* see under GRIMMER no. 2040

***1219** CONSTABLE, John: *On the Stour* B: 8 × $9\frac{1}{4}$ (20·3 × 23·5) Lady Binning gift 1918

***2016** CONSTABLE, John: *Vale of Dedham* $57\frac{1}{8}$ × 48 (145 × 122) Bt 1944

2163 CONSTABLE, John: *Noon* $13\frac{1}{4}$ × $21\frac{3}{4}$ (33·7 × 55·3) Lady Binning bequest 1952

1037 COROT: *Landscape at Coubron* $15\frac{7}{8}$ × $21\frac{3}{8}$ (40·4 × 54·3) Hugh A. Laird bequest 1911

1038 COROT: *Man scything by a willow-plot—Artois* $13\frac{1}{8}$ × $21\frac{1}{8}$ (33·4 × 53·7) Hugh A. Laird bequest 1911

1039 COROT: *Landscape with two cows* $10\frac{1}{4}$ × $15\frac{1}{2}$ (26·1 × 39·4) Hugh A. Laird bequest 1911

***1447** COROT: *The goatherd* 24 × 20 (61 × 50·8) Dr John Kirkhope bequest 1920

***1448** COROT: *Souvenir de la Ferté-sous-Jouarre (morning)* $18\frac{1}{4}$ × $24\frac{1}{8}$ (46·4 × 61·3) Dr John Kirkhope bequest 1920

***1449** COROT: *Landscape with a castle* $15\frac{7}{8}$ × $21\frac{1}{4}$ (40·3 × 54) Dr John Kirkhope bequest 1920

1450 COROT: *Gathering primroses* $11\frac{1}{8}$ × $18\frac{1}{2}$ (28·3 × 47) Dr John Kirkhope bequest 1920

1452 COROT: *The watering place* $9\frac{3}{4}$ × $12\frac{7}{8}$ (24·8 × 32·8) Dr. John Kirkhope bequest 1920

***1681** COROT: *Ville d'Avray* $18\frac{1}{8}$ × $13\frac{3}{4}$ (46 × 34·9) Bt 1927

***1852** COROT: *The artist's mother* 16 × $12\frac{7}{8}$ (40·6 × 32·8) Bt 1936

1451 COROT (imitator): *Evening landscape* $17\frac{3}{4}$ × $13\frac{3}{4}$ (45·1 × 35) Dr John Kirkhope bequest 1920

2294 COTES, Francis: *Catherine Gunning* Pastel: $23\frac{7}{8}$ × $17\frac{7}{8}$ (60·7 × 45·5) Miss A. C. Watson bequest 1967

***931** COTMAN, J. S.: *Buildings on a river* $14\frac{1}{4}$ × $12\frac{1}{4}$ (36·2 × 31·1) NA-CF gift 1905

***960** COTMAN, J. S.: *Lakenham Mills* $13\frac{1}{2}$ × 18 (34·3 × 45·5) Bt 1908

1135 COTMAN, J. S. (follower): *The meadow* $12\frac{7}{8}$ × $18\frac{1}{2}$ (32·7 × 47) Bt 1913

2232 COURBET, G.: *River in a gorge* $31\frac{3}{8}$ × 25 (79·7 × 63·5) Sir Alexander Maitland gift 1960

***2233** COURBET, G.: *The wave* 18 × 21 (45·7 × 53·4) Sir Alexander Maitland gift 1960

***2234** COURBET, G.: *Trees in snow* $28\frac{1}{2}$ × $36\frac{1}{4}$ (72·4 × 92·1) Sir Alexander Maitland gift 1960

621 COURTOIS, J.: *Battle piece* $35\frac{5}{8}$ × $57\frac{7}{8}$ (90·5 × 147) Mrs Mary Veitch bequest (RSA) 1875

1202 COUTURE, T.: *Une patricienne* $25\frac{1}{8}$ × $21\frac{1}{2}$ (63·8 × 54·6) William Leiper bequest 1916

***1942** CRANACH: *Venus and Cupid* W: 15 × $10\frac{5}{8}$ (38·1 × 27) Marquess of Lothian bequest 1941

176 CRAWFORD, E. T.: *Group of trees* W: $10\frac{3}{4}$ × $15\frac{3}{4}$ (27·3 × 40) Bt (RI) 1826

421 CRAWFORD, E. T.: *Crossing the bar* 24 × $36\frac{1}{4}$ (61 × 92·1) RAPFA gift 1897

1641 CRAWHALL, Joseph: *Arab ploughing, Tangiers* Pastel: $11\frac{1}{8}$ × $17\frac{3}{4}$ (28·3 × 45·1) Bt 1925

1843 CRAWHALL, Joseph: *Study of a goat* Body colour on canvas: $14\frac{7}{8} \times 16\frac{3}{8}$ (37·8 × 41·6) Bt 1936

1211 CRAYER, Gaspar de (attr): *Assumption of St Catherine* $29\frac{1}{2} \times 18\frac{5}{8}$ (75 × 47·3) A. W. Inglis gift 1918

CREDI, Lorenzo di (studio): *Holy Family* see under LORENZO DI CREDI (follower) no. 646

2129 CRESPI, G. B. (attr): *Head of St Francis* W: $16\frac{1}{8} \times 14$ (41 × 35·6) Col J. A. Stirling gift 1950

*2309 CROME, John: *The beaters* W: $21\frac{1}{2} \times 34$ (54·6 × 86·4) Bt 1970

944 CROME, John (attr): *Mountain scene* $29\frac{5}{8} \times 23\frac{1}{4}$ (75·3 × 59·1) Bt 1907

844 CROME, John (follower): *A heath—sunset* $23\frac{7}{8} \times 48\frac{1}{2}$ (60·7 × 123·2) J. Staat Forbes gift 1899

1074 CROSSE, Richard: *Portrait of a gentleman* Miniature Sir James L. Caw gift 1912

*2314 CUYP, Aelbert: *Landscape with a view of the Valkhof, Nijmegen* $44\frac{1}{2} \times 65$ (113 × 165) Bt 1972

*824 CUYP, J. G. (attr): *Dutch family group* (fragment) W: $42\frac{1}{2} \times 32\frac{3}{4}$ (108 × 83·2) Bt 1891

*2259 CUYP, J. G. (attr): *Dutch family group* (fragment) W: $52\frac{1}{2} \times 45\frac{1}{2}$ (133·4 × 115·6) Bt 1963

*1904 DADDI: *Triptych with the Crucifixion* W: 21×11 (53·3 × 28); wings $22\frac{3}{4} \times 6$ (57·7 × 15·3) Bt 1938

908 DALOU: *Lavoisier* Bronze: ht 38 (96·5) Sir George Reid gift 1902

*1035 DAUBIGNY, C.: *La Frette* W: $14\frac{7}{8} \times 26\frac{1}{8}$ (37·8 × 66·4) Hugh A. Laird bequest 1911

1036 DAUBIGNY, C.: *Coucher de soleil* W: $9\frac{3}{8} \times 17\frac{3}{4}$ (23·9 × 45·1) Hugh A. Laird bequest 1911

1076 DAUBIGNY, C.: *Cottages at Barbizon* W: $9\frac{5}{8} \times 16\frac{1}{8}$ (24·5 × 41) Bt 1912

*1453 DAUBIGNY, C.: *Soleil couchant* W: $9\frac{3}{8} \times 19\frac{5}{8}$ (23·8 × 49·9) Dr John Kirkhope bequest 1920

*1616 DAUMIER, H.: *Le peintre* W: $11\frac{3}{8} \times 7\frac{3}{8}$ (29 × 18·8) NA-CF gift 1923

*2213 DAVID, Gerard: *Three legends of St Nicholas* W: each $22 \times 13\frac{1}{4}$ (55·9 × 33·7) Bt 1959

1045 DECAMPS, A.: *Les mendiants* W: $6\frac{1}{2} \times 10\frac{5}{8}$ (16·5 × 27) Hugh A. Laird bequest 1911

*1624 DEGAS: *Study for 'The 14 year old dancer, dressed'* Bronze: ht $28\frac{1}{4}$ (71·8) Bt 1923

*1785 DEGAS: *Diego Martelli* $43\frac{1}{2} \times 39\frac{3}{4}$ (110·5 × 101) Bt 1932

*2224 DEGAS: *Before the performance* $18\frac{3}{4} \times 24\frac{3}{4}$ (47·6 × 62·9) Sir Alexander Maitland gift 1960

*2225 DEGAS: *Group of dancers* $18\frac{1}{2} \times 24\frac{1}{2}$ (47 × 62·2) Sir Alexander Maitland gift 1960

*2226 DEGAS: *Woman drying herself* Pastel: $25\frac{1}{2} \times 25$ (64·8 × 63·5) Sir Alexander Maitland gift 1960

*2227 DEGAS: *Study of a girl's head* $22 \times 17\frac{3}{4}$ (55·9 × 45·1) Sir Alexander Maitland gift 1960

*2285 DEGAS: *Grande arabesque* Bronze: ht $15\frac{7}{8}$ (40·3) Sir Alexander Maitland bequest 1965

*2286 DEGAS: *The tub* Bronze: ht $8\frac{3}{4}$ (22·2) Sir Alexander Maitland bequest 1965

*2190 DELACROIX: *Arabs playing chess* $18\frac{1}{8} \times 21\frac{7}{8}$ (46 × 55·5) Bt 1957

***111** DELEN, Dirck van: *Conversation in a palace courtyard* W: $21\frac{1}{4} \times 18\frac{1}{2}$ (54 × 47)
 Bt (RI) 1830

1966 DENUNE, William: *Portrait of a young lady* 22 × $17\frac{1}{2}$ (55·9 × 44·5) Bt 1942

2037 DENUNE, William: *Portrait of a gentleman* $29\frac{1}{2} \times 24\frac{1}{2}$ (75 × 62·2) Bt 1945

1130 DESBOUTIN, M.: *Mother and child* 18 × $14\frac{3}{4}$ (45·7 × 37·5) Bt 1913

1042 DIAZ, N.: *Clairière en forêt* W: $11\frac{1}{4} \times 16\frac{1}{2}$ (28·6 × 41·9) Hugh A. Laird
 bequest 1911

***1043** DIAZ, N.: *A pool in the forest* W: $9\frac{5}{8} \times 12\frac{3}{4}$ (24·5 × 32·4) Hugh A. Laird
 bequest 1911

***1044** DIAZ, N.: *Enfants turcs* $8\frac{3}{4} \times 6\frac{7}{8}$ (22·2 × 17·5) Hugh A. Laird bequest 1911

1454 DIAZ, N.: *Flowers* $18\frac{5}{8} \times 15\frac{1}{8}$ (47·4 × 38·4) Dr John Kirkhope bequest 1920

***2313** DOMENICHINO: *Adoration of the Shepherds* $56\frac{1}{4} \times 45\frac{1}{4}$ (143 × 115) Bt 1971

***987** DONALD, M.: *Highland stream—Glenfruin* $25\frac{1}{2} \times 35\frac{3}{8}$ (64·8 × 89·9) Bt 1909

2000 DONALDSON, J.: *Lady with powdered hair* Miniature Kenneth Sanderson
 bequest 1943

***** DOU, G.: *Interior with a young violinist* W: (arched top): $12\frac{1}{4} \times 9\frac{1}{4}$ (31·1 × 23·7)
 Duke of Sutherland loan 1946

179 DOUGHTY, Thomas: *View of the flat rock on the Scuylkill, near Philadelphia*
 $27\frac{1}{2} \times 39\frac{3}{4}$ (69·9 × 101) Philip Teddyman gift (RI) 1828

1919 DOUGLAS, William: *Portrait of a man* Miniature Mrs Charlotte Rollo gift 1939

1920 DOUGLAS, William: *Portrait of a girl* Miniature Mrs Charlotte Rollo gift 1939

669 DOUGLAS, W. Fettes: *David Laing* Transferred SNPG no. 2041

779 DOUGLAS, W. Fettes: *The spell* $30\frac{1}{2} \times 61\frac{3}{4}$ (77·5 × 157) J. T. Gibson-Craig
 gift 1886

***981** DOUGLAS, W. Fettes: *Stonehaven harbour* 47 × $23\frac{1}{8}$ (119·4 × 58·8) Bt 1909

1002 DOUGLAS, W. Fettes: *Street in Rome* W: $6\frac{1}{2} \times 4$ (16·5 × 10·2) Artist's gift
 (RSA) 1865

1020 DOUGLAS, W. Fettes: *Wishart preaching against Mariolatry* $30\frac{3}{4} \times 67\frac{3}{8}$ (78·1 × 175)
 Dr John Kirkhope gift 1910

***1479** DOUGLAS, W. Fettes: *Hudibras and Ralph* $25\frac{1}{2} \times 41\frac{1}{2}$ (64·8 × 105·5) Dr John
 Kirkhope bequest 1920

1731 DOUGLAS, W. Fettes: *Bric-a-brac* $7\frac{1}{4} \times 15\frac{1}{2}$ (18·5 × 39·4) A. F. Roberts
 bequest 1929

1896 DOUGLAS, W. Fettes: *Head of a woman* $5\frac{1}{2} \times 5\frac{1}{2}$ (14 × 14) Mrs M. B. Stuart
 bequest 1938

***180** DRUMMOND, James: *The Porteous Mob* 44 × 60 (112 × 143) Bt (RAPFA) 1856

624 DRUMMOND, James: *James Graham, Marquis of Montrose* 44 × $72\frac{3}{4}$ (111·8 × 185)
 Artist's bequest 1877

625 DRUMMOND, James: *Return of Mary Queen of Scots to Edinburgh* 34 × $49\frac{1}{4}$
 (86·4 × 125·1) Artist's bequest 1877

***2318** DUGHET, G.: *Classical landscape with a lake* $28\frac{3}{4} \times 39\frac{1}{8}$ (73 × 99·5) Bt 1973

***38** DUGHET, G. (style): *Classical landscape* $42\frac{1}{2} \times 52\frac{1}{2}$ (108 × 133)
 Robert Clouston gift (RSA) 1850

62 DUGHET, G. (follower): *Landscape with figures* $37\frac{7}{8} \times 52\frac{7}{8}$ (96·2 × 134·5)
 Bt (RI) 1830

***88** DUGHET, G. (follower): *Landscape* 24 × $33\frac{1}{2}$ (61 × 85) Bt (RI) 1830

1512 DUGHET, G. (follower): *Classical landscape* $47\frac{3}{8} \times 67$ (120·3 × 170)
 Mrs Nisbet Hamilton Ogilvy bequest 1921

1839 D u g u i d, Henry: *Old Trinity Church, Edinburgh* B: $8\frac{1}{2} \times 11\frac{1}{2}$ (21·6 × 29·2) Bt 1936

*25 D u j a r d i n: *Halt at an Italian wine-house* $31\frac{7}{8} \times 35\frac{1}{4}$ (81 × 89·6) Torrie collection

106 D u n c a n, Thomas (after Titian): *The Entombment* $31\frac{1}{4} \times 45$ (79·4 × 114·3) Acquired (r i) 1845–59

107 D u n c a n, Thomas (after Titian): *'Marquis di Guasto and his mistress'* (KdK 1907 no. 58) 24×20 (61 × 50·8) Acquired (r i) 1845–59

128 D u n c a n, Thomas (after Veronese): *Study of the Marriage in Cana* $33\frac{3}{4} \times 47\frac{1}{2}$ (85·8 × 120·7) Acquired (r i) before 1845

182 D u n c a n, Thomas: *Self-portrait* $49\frac{3}{4} \times 39\frac{5}{8}$ (126·4 × 100·7) Gift to the r s a 1845

448 D u n c a n, Thomas: *Anne Page inviting Slender to dinner* W: $51\frac{3}{4} \times 40\frac{5}{8}$ (131·5 × 103·2) Bt (r s a) 1861

466 D u n c a n, Thomas: *Lady Stuart of Allanbank* $29\frac{3}{8} \times 24$ (74·7 × 61) J. T. Gibson-Craig gift (r s a) 1863

604 D u n c a n, Thomas: *Bran, a celebrated deerhound* $48\frac{3}{4} \times 64\frac{5}{8}$ (123·9 × 139) Rt Hon Lord Colonsay bequest 1874

707 D u n c a n, Thomas: *Self-portrait* after Rembrandt $12\frac{3}{4} \times 11$ (32·4 × 28) Lady Ruthven bequest 1885

1040 D u p r é, Jules: *Un pêcheur* 18×15 (45·7 × 38·1) Hugh A. Laird bequest 1911

1041 D u p r é, Jules: *Le moulin* W: $8\frac{1}{2} \times 13\frac{1}{2}$ (21·6 × 34·3) Hugh A. Laird bequest 1911

* D u t c h, 17th cent: *Old lady wearing a ruff* $20\frac{1}{4} \times 17\frac{1}{2}$ (51·3 × 44·4) Duke of Sutherland loan 1946

619 D u t c h, 17th cent (?): *Landscape with figures* $28\frac{5}{8} \times 40\frac{1}{4}$ (72·8 × 102) Mrs Mary Veitch bequest (r s a) 1875

794 D u t c h, 17th cent (?): *Portrait of a lady* $28\frac{1}{4} \times 22$ (71·8 × 55·9) Bt 1887

989 D u t c h, 17th cent: *Still-life* $24\frac{1}{2} \times 21$ (62·3 × 53·4) Bt 1909

1510 D u t c h, 17th cent (?): *The toast* W: $14\frac{1}{2} \times 11\frac{1}{2}$ (36·9 × 29·3) Mrs Nisbet Hamilton Ogilvy bequest 1921

1686 D u t c h, 17th cent: *Silent companions* Canvas on wood: 7×6 (17·8 × 15·3) n a - c f gift 1928

1832 D u t c h, 17th cent: *Portrait of a man* W: $15\frac{7}{8} \times 13\frac{1}{8}$ (40·4 × 33·4) Bt 1935

1932 D u t c h, 17th cent: *Still-life* W: 16×13 (40·7 × 33) Marquess of Lothian bequest 1941

D u t c h: *Portrait of two youths* see under C u y p, J. G. no. 824*

184 D y c e, William: *Infant Hercules* 36×28 (91·5 × 71·2) Sir John Hay bequest (r i) 1831

*460 D y c e, William: *Francesca da Rimini* $56 \times 69\frac{1}{4}$ (142 × 176) Bt (r s a) 1864

521 D y c e, William: *Judgment of Solomon* $59\frac{1}{2} \times 96\frac{1}{2}$ (151·2 × 245) Professor Goodsir gift (r s a) 1864

*2199 D y c e, William: *Shirrapburn Loch* W: 12×16 (30·5 × 40·6) Charles Guthrie gift 1961

*2267 D y c e, William: *St Catherine* W: $35 \times 25\frac{1}{2}$ (88·9 × 64·8) Bt 1964

119 D y c k, Anthony van: *An Italian noble* $92 \times 59\frac{3}{4}$ (234 × 152) Bt (r i) 1830

*120 D y c k, Anthony van: *'The Lomellini family'* 106×100 (269 × 254) Bt (r i) 1830

*121 D y c k, Anthony van: *St Sebastian* 89×63 (226 × 160) Bt (r i) 1830

 * DYCK, Anthony van: *Portrait of a young man* $30\frac{1}{2}$ × 22 (77·5 × 56) Duke of Sutherland loan 1946

122 DYCK, van (attr): *Study of a head* $16\frac{3}{4}$ × $14\frac{3}{4}$ (42·6 × 37·5) Bt (RI) 1846

87 DYCK, van (studio): *Marchese Ambrogio Spinola* 48 × 38 (121·9 × 96·5) Bt (RI) 1830

1944 DYCK, van (after): *Geneviève d'Urfé, Duchesse de Croy* $44\frac{1}{2}$ × $35\frac{1}{2}$ (113 × 90·2) Marquess of Lothian bequest 1941

***2281** ELSHEIMER, Adam: *Stoning of St Stephen* M: $13\frac{5}{8}$ × $11\frac{1}{4}$ (34·7 × 28·6) Bt 1965

***2312** ELSHEIMER, Adam: *Il Contento* M: $11\frac{3}{4}$ × $16\frac{1}{2}$ (30 × 42) Ceded from the estate of Major Kincaid-Lennox 1970

1634 EMILIAN, 15th cent: *Madonna and Child with Saints* W: 44 × $36\frac{3}{4}$ (111·8 × 93·3) Sir Claude Phillips bequest 1924

19 EMILIAN, 17th cent: *St Peter delivered* $41\frac{1}{2}$ × 37 (105·4 × 94) Bt (RI) 1840

***1226** EMMS, John: *Callum* $27\frac{1}{2}$ × $35\frac{1}{2}$ (69·9 × 90·2) James Cowan Smith bequest 1919

127 ETTY, William (after Veronese): *St John Baptist preaching* $27\frac{1}{4}$ × $21\frac{1}{4}$ (69·2 × 54) Bt (RSA) 1853

***185** ETTY, William: *Judith's maid outside the tent of Holofernes* 118 × 108 (300 × 274) Commissioned by the RSA 1830

***186** ETTY, William: *Judith and Holofernes* 120 × 157 (305 × 400) Bt (RSA) 1829

***187** ETTY, William: *Judith coming out of the tent* 118 × 108 (300 × 274) Commissioned by the RSA 1830

***188** ETTY, William: *Benaiah slaying two lion-like men of Moab* 120 × 157 (305 × 400) Bt (RSA) 1831

***189** ETTY, William: *The combat* 100 × 134 (254 × 341) Bt (RSA) 1831

672 EWBANK, John: *Harbour scene* W: $11\frac{1}{2}$ × $17\frac{1}{2}$ (29·3 × 44·5) Lord President Inglis gift 1883

1007 EWBANK, John: *On the east coast* W: $9\frac{5}{8}$ × $19\frac{5}{8}$ (24·5 × 34·7) Acquired (RSA) by 1883

***1142** FAED, John: *The evening hour* Water-colour on ivory: 13 × $9\frac{1}{2}$ (33 × 24·2) J. Bray gift 1914

1984 FAED, John: *Rev Robert Jeffrey* Miniature Bt 1943

 FAED, Thomas: *Evening thoughts* see under HERDMAN, no. 2136*

***1455** FANTIN-LATOUR: *Roses* $14\frac{3}{8}$ × $15\frac{3}{8}$ (36·5 × 39) Dr John Kirkhope bequest 1920

1456 FANTIN-LATOUR: *Spring flowers* $9\frac{1}{2}$ × $9\frac{3}{8}$ (24·2 × 23·9) Dr John Kirkhope bequest 1920

***1950** FANTIN-LATOUR: *Peaches on a dish* W: $9\frac{1}{2}$ × 13 (24·2 × 33) Rev H. G. R. Hay-Boyd bequest 1941

2107 FANTIN-LATOUR: *Roses* $18\frac{3}{8}$ × 16 (46·7 × 40·7) Miss Elizabeth Sutherland gift 1948

1063 FARQUHARSON, David: *Cornish valley* $17\frac{1}{2}$ × $29\frac{1}{2}$ (44·5 × 75) Hugh A. Laird bequest 1911

2008 FERGUSON, James: *Richard Bulstrode* Miniature Kenneth Sanderson bequest 1943

***190** FERGUSON, W. G.: *A ruined altar and figures* 27 × $21\frac{1}{4}$ (68·6 × 53·7) Alexander White gift (RSA) 1858

970 FERGUSON, W. G.: *Still-life: dead game* 26 × 21 (66 × 53·4) Bt 1908

1029 FERGUSON, W. G.: *Still-life: dead game* 41½ × 33¾ (105·4 × 85·8) Arthur Kay
 gift 1911

2096 FERGUSON, W. G.: *Still-life: dead game* 59 × 48 (149·9 × 121·9) F. J. Nettlefold
 gift 1947

*1535 FERRARESE, 15th cent: *Madonna and Child* W: 23 × 17⅜ (58·4 × 44·1) Bt 1921

1745 FERRARESE, c 1500 *St Francis receiving the stigmata* W: 15¼ × 16⅜ (38·8 × 24·2)
 Bt 1930

2153 FERRIERE, F. (after Raeburn): *James Wauchope* Miniature Sir John
 Don-Wauchope bequest 1951

1786 FIELDING, A. V. Copley: *Newark Castle* W: 6¾ × 8¾ (17·2 × 22·3) Bt 1932

 FIORENTINO, Pier Francesco: *Madonna and Child with St John* see under
 PESELLINO no. 1250

 FIORENZO DI LORENZO (attr): *St Francis receiving the stigmata* see under
 FERRARESE no. 1745

101 FLEMISH, 16th cent: *Landscape—midday* W: painted area 14½ × 78¾ (36·9 × 200)
 Bt (RI) 1830

*1254 FLEMISH, 16th cent: *Charles V* W: 7¾ × 5⅝ (19·8 × 14·8) Bt 1920

*1541 FLEMISH, 15th cent: *Adoration of the shepherds* W: 26½ × 42 (67·3 × 106·6)
 Bt 1921

1544 FLEMISH, 16th cent: *Derick Anthony* W: 35⅝ × 26½ (90·5 × 67·4) Mrs Nisbet
 Hamilton Ogilvy bequest 1921

*1642 FLEMISH, 16th cent: *Pietà* W: 8½ × 10¾ (21·6 × 27·8) Bt 1925

1728 FLEMISH, 17th cent: *Cavalier in yellow coat* 26⅞ × 21¾ (68·3 × 55·3) A. W. Inglis
 bequest 1929

*1929 FLEMISH, 16th cent: *Portrait, called James IV* W: 14⅜ × 11½ (36·5 × 29·3)
 Marquess of Lothian bequest 1941

2074 FLEMISH, 16th cent: *Madonna and Child* W: 25¾ × 20 (65·5 × 50·8) Bt 1946

 FLEMISH: *Crucifixion* see under GEERTGEN no. 1253*

 FLEMISH, 16th cent: *Infant Christ* see under ITALIAN, 15th cent no. 1665

*1933 FLICKE, G.: *Lord Grey de Wilton* (?) W: 41¼ × 31¼ (104·8 × 79·4) Marquess of
 Lothian bequest 1941

1934 FLICKE, G.: *Sir Peter Carew* W: 33½ × 22½ (85·1 × 57·2) Marquess of Lothian
 bequest 1941 (loan to Tower of London)

1016 FLORENTINE, 15th or 16th cent: *Bust of a young man in a beret* Terracotta:
 ht 22½ (57·2) Bt (RSA) 1851

* FLORENTINE, 15th cent: *Madonna and Child* W: 19½ × 13¼ (49·5 × 33·7)
 National Gallery loan 1958

 FLORENTINE: *Burial of St Ephraim* see under AMEDEI no. 1528*

 FLORENTINE: *Baptism and martyrdom of two saints* see under MASTER OF
 S. LUCCHESE ALTAR nos. 1539a b*

 FLORENTINE, 15th cent: *Stigmatization of St Francis* see under MASTER OF
 1419 no. 1540a*

 FLORENTINE, 15th cent: *St Anthony Abbot exorcizing a woman* see under
 MASTER OF 1419 no. 1540b*

 FLORENTINE, 15th cent: *Cassone* see under TOSCANI no. 1738*

 FLORENTINE, 15th cent: *Triumphs of Love and Chastity* see under APOLLONIO
 DI GIOVANNI no. 1940*

FLORENTINE, 15th cent: *Rape of the Sabines* see under APOLLONIO DI GIOVANNI no. 1974

FLORENTINE, 15th cent: *Triumph of a Roman general* see under MASTER OF THE ADIMARI CASSONE no. 1975

2266 FORAIN, J. L.: *Lady in a fur cape* $8\frac{1}{2} \times 6\frac{1}{2}$ (21·6 × 16·5) R. H. Walpole bequest 1963

2036 FORBES, Anne: *Lady Anne Stewart* $29\frac{1}{2} \times 24\frac{1}{2}$ (75 × 62·3) Bt 1945

1526 FORD, Onslow: *Folly* Plaster: ht $35\frac{1}{2}$ (90·3) Mrs Widdrington gift 1921

1875 FORD, Onslow: *Folly* Bronze: ht $35\frac{1}{2}$ (90·3) Bt 1937

1853 FORD, Onslow: *Sir W. Q. Orchardson* Bronze: ht $17\frac{1}{4}$ (43·9) Bt 1921

1189 FORTUNY, Mariano: *In the arena* $38\frac{5}{8} \times 25\frac{3}{4}$ (98·1 × 65·5) Bt 1915

***982** FRASER, Alexander (1786–1865): *Fisher folk* $12 \times 16\frac{1}{8}$ (30·5 × 41) A. K. Brown gift 1909

1887 FRASER, Alexander (1786–1865): *Portrait of a young man* W: $6\frac{3}{8} \times 4\frac{7}{8}$ (16·3 × 12·5) J. C. Wardrop gift 1937

1888 FRASER, Alexander (1786–1865): *Portrait of a young man* W: $6\frac{1}{2} \times 5$ (16·5 × 12·7) J. C. Wardrop gift 1937

2134 FRASER, Alexander (1786–1865): *Highland sportsman* W: $30\frac{3}{4} \times 43$ (78·1 × 109·3) Bt 1951

1188 FRASER, Alexander (1827–99): *Entrance to Cadzow Forest* $25\frac{1}{2} \times 35\frac{1}{2}$ (64·8 × 90·2) Bt 1915

1480 FRASER, Alexander (1827–99): *A glade in Cadzow Forest* $27\frac{1}{2} \times 36\frac{1}{4}$ (69·9 × 92·1) Dr John Kirkhope bequest 1920

1481 FRASER, Alexander (1827–99): *A sheepfold, Haslemere* $9\frac{3}{4} \times 13\frac{3}{4}$ (24·8 × 35) Dr John Kirkhope bequest 1920

1980 FRASER, Alexander (1827–99): *Haymaking on the Avon* $34\frac{3}{8} \times 46\frac{1}{2}$ (87·4 × 118·1) Bt 1943

2352 FRASER, Alexander (1827–99): *Atholl* $8\frac{7}{8} \times 13$ (22·5 × 33) Robert A. Lillie bequest 1977

826 FRENCH, 17th cent (?): *Venus and Adonis* M: $8\frac{1}{4} \times 6\frac{1}{2}$ (21 × 16·5) Bt 189!

1664 FRENCH, 14th cent: *Madonna and Child* Alabaster: ht $19\frac{3}{8}$ (49·2) John Warrack gift 1926

2179 FRENCH, 18th cent: *Assumption of the Virgin* $50\frac{1}{4} \times 29\frac{1}{4}$ (127·6 × 74·4) R. T. G. Paterson bequest 1955

***2274** FRENCH (?), 16th cent: *5th Lord Seton* W: $47\frac{1}{4} \times 41\frac{5}{8}$ (120 × 105·7) Sir Theophilus Biddulph bequest 1965

***30** FURINI, F.: *St Sebastian* $19\frac{1}{4} \times 14\frac{3}{4}$ (49 × 37·5) Bt (RI) 1831

***31** FURINI, F.: *Poetry* Paper on wood: $16\frac{1}{4} \times 13\frac{1}{2}$ (41·3 × 34·3) Bt (RI) 1831

529 FYT, Jan: *A Wolf* $36\frac{1}{2} \times 29\frac{1}{4}$ (92·7 × 74·3) Bt (RSA) 1866

530 FYT, Jan: *A Dead Wolf* $23\frac{3}{4} \times 36\frac{1}{4}$ (60·4 × 92·1) Bt (RSA) 1866

***332** GAINSBOROUGH, T.: *The Hon Mrs Graham* $93\frac{1}{2} \times 60\frac{3}{4}$ (237 × 154) Robert Graham bequest 1859

***1521** GAINSBOROUGH, T.: *Mrs Hamilton Nisbet* $91\frac{3}{4} \times 61$ (233 × 155) Mrs Nisbet Hamilton Ogilvy bequest 1921

***2174** GAINSBOROUGH, T.: *Landscape with a view of Cornard village* $30 \times 59\frac{1}{2}$ (76·2 × 151) Bt 1953

***2253** GAINSBOROUGH, T.: *Rocky landscape* 47×58 (119·4 × 147·3) Bt 1962

2009 GALLOWAY, A.: *Man and wife* Miniature Kenneth Sanderson bequest 1943

1936 GARDNER, Daniel: *Two children* Body colour on paper 20 × 15¾ (50·8 × 40)
Marquess of Lothian bequest 1941

***32** GAROFALO, Il: *Christ driving the money-changers from the Temple* W: 18¼ × 14½
(46·3 × 36·8) Bt (RI) 1830

***1643** GAUGUIN, Paul: *The vision of the sermon* 29¼ × 36⅝ (74·4 × 93·1) Bt 1925

***2220** GAUGUIN, Paul: *Martinique landscape* 45½ × 35 (115·5 × 89) Sir Alexander
Maitland gift 1960

***2221** GAUGUIN, Paul: *Three Tahitians* 28¾ × 37 (73 × 94) Sir Alexander Maitland
gift 1960

***191** GEDDES, Andrew: *Summer* 32 × 25¼ (81·3 × 64·2) Bt (RI) 1828

416 GEDDES, Andrew: *George Sanders* W: 27¼ × 19 (69·2 × 48·3)
Thomas Menzies gift (RSA) 1861

***630** GEDDES, Andrew: *The artist's mother* 28½ × 24¼ (72·4 × 61·6) Mrs Andrew
Geddes gift 1877

***631** GEDDES, Andrew: *Hagar* 30 × 25 (76·2 × 63·5) Mrs Andrew Geddes gift 1877

***847** GEDDES, Andrew: *Andrew Plimer* W: 18½ × 15 (47 × 38·1) Bt 1900

848 GEDDES, Andrew: *Mrs Douglas Dickson* 34⅞ × 27¼ (88·7 × 69·3) Sir Douglas
Maclagan bequest 1900

1073a GEDDES, Andrew: *Summer* Pastel: 4½ × 3½ (11·5 × 8·9) Sir James L. Caw gift
1912

1073b GEDDES, Andrew: *Summer* Pastel: 5⅝ × 4¾ (14·4 × 11·1) Sir James L. Caw
gift 1912

2127 GEDDES, Andrew: *Mrs Harris Prendergast* 49¾ × 39¾ (123·9 × 101)
Canon C. E. M. Fry bequest 1950

2156 GEDDES, Andrew: *Anne Geddes* 50 × 37¼ (127 × 94·7) Mrs H. F. Rose gift
1951

2293 GEDDES, Andrew: *Archibald Scot Skirving* 28½ × 23½ (72·4 × 59·7)
A. A. Scott Skirving bequest 1967

2320 GEDDES, Andrew: *Landscape* W: 7⅞ × 11⅝ (20 × 29·6) Mr Charles Ballantyne
gift 1973

1967 GEDDES, A. (attr): *Portrait of a man* 23⅛ × 20 (58·8 × 50·8) Dr John
MacGregor bequest 1942

***1253** GEERTGEN TOT S. JANS (follower): *Crucifixion* W: 9⅝ × 7¼ (24·4 × 18·4)
Bt 1920

***1825** GEIKIE, Walter: *Scottish roadside scene* 16 × 24 (40·6 × 61) Harold S. Geikie
gift 1935

2335 GEIKIE, Walter: *Fruit seller* W: 16 × 13½ (40·6 × 34·3) Bt 1975

GENOESE (?): *Virgin of the Immaculate Conception* see under ITALIAN, 18th cent
no. 833*

1496 GÉRARD, F.: *Mary Nisbet, Countess of Elgin* 25½ × 21½ (64·8 × 54·6)
Mrs Nisbet Hamilton Ogilvy bequest 1921

998 GERMAN, 16th cent (?): *St John, with a donor and his sons* W: 22⅞ × 10
(58·1 × 25·4) Bt 1910

999 GERMAN, 16th cent (?): *St Andrew, with the donor's wife and daughters*
W: 22⅞ × 10 (58·1 × 25·4) Bt 1910

1928a GERMAN, 16th cent (?): *St Christopher and a donor* W: 20¾ × 8½ (52·7 × 21·6)
Marquess of Lothian bequest 1941

1928b GERMAN, 16th cent (?): *St Catherine and the donor's wife* W: $20\frac{3}{4} \times 8\frac{1}{2}$
(52·7 × 21·6) Marquess of Lothian bequest 1941

2310 GERMAN, 15th cent: *20 scenes from the Life of Christ* 5 wood panels, each
$49\frac{5}{8} \times 42$ (126 × 106·5) Transferred from Royal Scottish Museum 1936

193 GIBB, Robert: *Craigmillar Castle* B: $10\frac{3}{4} \times 15\frac{3}{4}$ (27·3 × 40) Bt (RI) 1826

2194 GIBB, Robert: *Half length portrait of a girl* $16\frac{1}{4} \times 12\frac{3}{8}$ (41·3 × 31·5) Sir James
Caw gift 1939

2195 GIBB, Robert: *Five monks* $10\frac{5}{8} \times 10\frac{1}{8}$ (27·2 × 25·8) Sir James Caw gift 1939

2064 GILBERT, Alfred: *St George* Bronze: ht 20 (50·8) Sir D. Y. Cameron bequest
1945

2287 GILBERT, Alfred: *Comedy and tragedy* Bronze: ht $27\frac{1}{4}$ (69) Sir Alexander
Maitland bequest 1965

2288 GILBERT, Alfred: *Perseus arming* Bronze: ht $28\frac{1}{2}$ (72·4) Sir Alexander
Maitland bequest 1965

35 GIORGIONE (imitator): *Portrait of a man holding a recorder* $17\frac{3}{4} \times 13\frac{1}{4}$ (45 × 33·7)
Bt (RI) 1830

638 GIULIO ROMANO (and workshop): *Two heads* Tempera on paper: $20\frac{1}{8} \times 14$
(51·1 × 35·5) Sir David Monro bequest (RSA) 1878

***** GOES, Hugo van der: *The Trinity Altarpiece* two panels, each $79\frac{1}{2} \times 39\frac{1}{2}$
(202 × 100·5) Lent by Her Majesty The Queen (received on loan 1912)

***1803** GOGH, Vincent van: *Olive trees* $19\frac{3}{8} \times 24\frac{3}{4}$ (49·2 × 62·9) Bt 1934

***2216** GOGH, Vincent van: *Head of a peasant woman* $18\frac{1}{4} \times 14$ (46·4 × 35·6)
Sir Alexander Maitland gift 1960

***2217** GOGH, Vincent van: *Orchard in blossom* $20\frac{3}{4} \times 25$ (52·8 × 63·5) Sir Alexander
Maitland gift 1960

204 GORDON, J. Watson: *Peter Spalding* $29\frac{1}{2} \times 24\frac{1}{2}$ (75 × 62·2) Commissioned
(RI) 1828

649 GORDON, J. Watson: *Roderick Gray* $49\frac{3}{4} \times 39\frac{1}{2}$ (126·3 × 100·3) Henry G.
Watson bequest 1879

650 GORDON, J. Watson: *Portrait of a lady* 50 × $39\frac{3}{4}$ (127 × 101) Henry G. Watson
bequest 1879

2177 GORDON, J. Watson: *Return from a foray* $39\frac{1}{2} \times 49\frac{3}{4}$ (100·3 × 126·3) Bt 1954
GORDON, J. Watson: *Mr Kippen* see under WATSON, G. no. 2170

***1628** GOYA, Francisco de: *El médico* $37\frac{5}{8} \times 47\frac{3}{8}$ (95·8 × 120·2) Bt 1923

***1013** GOYEN, J. van: *Dutch river scene* W: $16\frac{3}{4} \times 22\frac{1}{4}$ (42·6 × 56·5) Mrs Mary
Veitch bequest (RSA) 1875

1497 GOYEN, J. van (follower): *Village with church* W: $15\frac{3}{4} \times 23$ (40 × 58·4)
Mrs Nisbet Hamilton Ogilvy bequest, 1921

953 GOZZOLI, Benozzo (style of): *Christ on the road to Calvary* W: $28\frac{3}{4} \times 46\frac{1}{4}$
(72 × 117·5) Bt 1908

1986 GRAHAM, Peter: *Wandering shadows* $51\frac{1}{2} \times 70\frac{1}{2}$ (130·8 × 179) Bt 1944

957 GRAHAM, Thomas: *A young Bohemian* $35\frac{1}{2} \times 25\frac{1}{8}$ (90·2 × 63·8) Bt 1908

198 GRAHAM-GILBERT, J.: *John Gibson* $29\frac{1}{8} \times 24\frac{1}{8}$ (74 × 61·2) Artist's gift (RSA) 1852

***1873** GRECO, El: *St Jerome in penitence* 41 × 38 (104·2 × 96·5) Bt 1936

***2160** GRECO, El: *The Saviour of the World* $28\frac{1}{2} \times 22\frac{1}{4}$ (72·4 × 56·6) Bt 1952

***** GRECO, El: *Fábula* 26 × $34\frac{7}{8}$ (66 × 88) Anonymous loan

***435** GREUZE, J.: *Girl with dead canary* (oval): $21\frac{1}{8} \times 18\frac{1}{8}$ (53·6 × 46·3) Lady
Murray of Henderland bequest 1861

***436** GREUZE, J.: *Boy with lesson book* $24\frac{1}{2} \times 19\frac{1}{4}$ (62·4 × 49) Lady Murray of
Henderland bequest 1861

437 GREUZE, J.: *Girl with joined hands* $18 \times 14\frac{3}{4}$ (45·7 × 37·5) Lady Murray of
Henderland bequest 1861

438 GREUZE, J. (after): *The broken pitcher* 16×13 (40·7 × 33) Lady Murray of
Henderland bequest 1861

GRIMALDI: *Landscape composition* see under DUGHET no. 38*

2040 GRIMMER, Abel (attr): *A Flemish village* W: $13\frac{3}{4} \times 19\frac{1}{8}$ (34·9 × 48·5) Sir James
L. Caw gift 1946

664 GRIMOU, Alexis: *Man drinking* $44\frac{5}{8} \times 33\frac{1}{2}$ (113·4 × 85) William Wright gift 1881

***1498** GUARDI, Francesco: *Santa Maria della Salute* 20×16 (50·5 × 40·5)
Mrs Nisbet Hamilton Ogilvy bequest 1921

***1499** GUARDI, Francesco: *San Giorgio Maggiore* 20×16 (50·5 × 40·5) Mrs Nisbet
Hamilton Ogilvy bequest 1921

***** GUARDI, Francesco: *Piazza S. Marco, Venice* 22×34 (56 × 86) Anonymous
loan

828 GUARDI, Francesco (style of): *View in Italy* $9\frac{1}{2} \times 16$ (24 × 40·7) Bt 1891

829 GUARDI, Francesco (style of): *View in Italy* $9\frac{3}{4} \times 16$ (24·8 × 40·7) Bt 1891

GUERCINO, Il: *St Jerome* see under MOLA no. 29*

***39** GUERCINO, Il: *St Peter penitent* $41\frac{1}{4} \times 34\frac{1}{4}$ (105 × 87) Bt (RI) 1831

***40** GUERCINO, Il: *Madonna and Child with the young St John* $34 \times 43\frac{1}{2}$
(86·3 × 110) Bt (RI) 1830

***2017** GUTHRIE, James: *The artist's mother* $36\frac{1}{2} \times 28\frac{5}{8}$ (92·7 × 72·8) Bt 1944

2018 GUTHRIE, James: *Pastoral* $25\frac{1}{2} \times 37\frac{1}{2}$ (64·7 × 95·3) Bt 1944

***2087** GUTHRIE, James: *Oban* $22\frac{3}{4} \times 18\frac{1}{4}$ (57·8 × 46·3) Bt 1947

2088 GUTHRIE, James: *Rev Andrew Gardiner* $49 \times 38\frac{1}{4}$ (124·5 × 97·1)
Lady Gardiner bequest 1947

***2142** GUTHRIE, James: *A hind's daughter* 36×30 (91·5 × 76·2) Sir James and Lady
Caw bequest 1951

2176 GUTHRIE, James: *Mrs Craig Sellar of Ardtornish* $77\frac{1}{2} \times 45\frac{1}{2}$ (197 × 115·5)
G. H. Craig Sellar bequest 1954

2284 GUTHRIE, James: *The velvet cloak* 79×43 (201 × 109) Sir Alexander
Maitland bequest 1965

2353 GUTHRIE, James: *In a monastery garden* $10\frac{7}{8} \times 13\frac{3}{8}$ (27·7 × 34) Robert A. Lillie
bequest 1977

2354 GUTHRIE, James: *The shepherd boy* $21\frac{1}{4} \times 30\frac{1}{4}$ (54 × 76·5) Robert A. Lillie
bequest 1977

***691** HALS, Frans: *A Dutch gentleman* $45\frac{1}{4} \times 33\frac{7}{8}$ (115 × 86·1) Rt Hon William
McEwan gift 1885

***692** HALS, Frans: *A Dutch lady* $45\frac{1}{4} \times 33\frac{3}{4}$ (115 × 85·8) Rt Hon William McEwan
gift 1885

***1200** HALS, Frans: *Verdonck* W: $18\frac{1}{4} \times 14$ (46·4 × 35·5) John J. Moubray gift 1916

***2339** HAMILTON, Gavin: *Achilles lamenting the death of Patroclus* $99\frac{1}{2} \times 154$
(227·3 × 391·2) Bt 1976

1829 HAMILTON, Gavin (attr): *Hector dead attached to Achilles' chariot* $23\frac{1}{2} \times 23\frac{1}{2}$
(59·7 × 59·7) Bt 1935

***1833** HAMILTON, James: *Still-life* $18 \times 15\frac{1}{2}$ (45·8 × 39·4) Bt 1935

1048 HARPIGNIES, H.: *Les bords de la Loire* $25\frac{1}{4} \times 31\frac{3}{4}$ (64 × 80·7) Hugh A. Laird bequest 1911

608 HARVEY, George: *Covenanters' Communion* W: $30\frac{3}{4} \times 44\frac{3}{4}$ (80·7 × 113·7) William Forrester gift (RSA) 1874

***919** HARVEY, George: *A schule skailin'* W: $27\frac{1}{4} \times 47\frac{1}{2}$ (69·3 × 120·7) Mrs Duncan J. Kay gift 1904

949 HARVEY, George: *The bowlers* $35\frac{1}{2} \times 71\frac{1}{2}$ (90·2 × 182) Sir Donald Currie gift 1907

1193 HARVEY, George: *Six oil sketches for the Covenanters' Baptism* B: each c $13\frac{1}{4} \times 11$ (33·6 × 28) Miss Ellen Harvey bequest 1915

***1579** HARVEY, George: *The curlers* $14\frac{1}{8} \times 31\frac{1}{4}$ (35·9 × 79·4) Bt 1922

2045 HARVEY, George: *Two children* B: $21\frac{1}{2} \times 18$ (54·6 × 45·7) Mrs Ethel M. Pearse gift 1946

2089 HARVEY, George: *Learning to walk* W: $16 \times 23\frac{1}{8}$ (40·6 × 58·7) Mrs Ethel M. Pearse gift 1947

2090 HARVEY, George: *The village school* W: $16\frac{3}{4} \times 23$ (42·5 × 58·4) Mrs Ethel M. Pearse gift 1947

2091 HARVEY, George: *Two women and a boy* B: $13\frac{1}{4} \times 10\frac{3}{8}$ (33·6 × 26·3) Mrs. Ethel M. Pearse gift 1947

2092 HARVEY, George: *Man with a pike* B: $12\frac{3}{4} \times 10\frac{1}{2}$ (32·4 × 26·7) Mrs Ethel M. Pearse gift 1947

2308 HARVEY, George: *Quitting the manse* 60 × 96 (152 × 244) Presented 1860

***1505** HEEM, J. D. de: *Fruit and lobster* W: $13\frac{1}{4} \times 16\frac{3}{8}$ (33·7 × 41·6) Mrs Nisbet Hamilton Ogilvy bequest 1921

78 HEMESSEN, J. S. (attr): *Bacchus and Ariadne* W: $41\frac{1}{4} \times 47\frac{1}{4}$ (104·8 × 120) Bt (RI) 1830

2361 HENRY, George: *Barr Ayrshire* $8\frac{7}{8} \times 12$ (22·5 × 30·5) Bt 1978

1905 HERALD, James: *The circus* Pastel: $13\frac{3}{4} \times 14\frac{1}{4}$ (35 × 36·2) Bt 1938

599 HERDMAN, Robert: *After the battle* $45\frac{5}{8} \times 68$ (115·8 × 173) RAPFA gift 1897

934 HERDMAN, Robert: *Lady Shand* $86\frac{5}{8} \times 57\frac{1}{4}$ (220 × 145·5) Lady Shand gift 1906

***2136** HERDMAN, Robert: *Evening Thoughts* B: 24 × 18 (61 × 45·8) Mrs Dunlop gift • 1951

***210** HILL, D. O.: *On the quay at Leith* W: $11\frac{3}{4} \times 13\frac{1}{2}$ (29·9 × 34·3) Bt (RI) 1826

1964 HILL, D. O.: *Edinburgh old and new* W: $45\frac{3}{4} \times 75\frac{1}{2}$ (116·2 × 192) Bt 1942

***1506** HOBBEMA, M.: *Waterfall in a wood* W: $10\frac{1}{2} \times 8\frac{3}{4}$ (26·7 × 22·3) Mrs Nisbet Hamilton Ogilvy bequest 1921

***** HOBBEMA, M.: *Landscape with a view of the Bergkerk, Deventer* W: $15\frac{3}{8} \times 21\frac{1}{8}$ (39 × 53·5) Duke of Sutherland loan 1946

***838** HOGARTH, William: *Sarah Malcolm* $19\frac{1}{4} \times 15\frac{1}{4}$ (48·9 × 38·7) Lady Jane Dundas bequest 1897

1657 HOGARTH, W. (after): *Gustavus Hamilton, 2nd Viscount Boyne* 20 × $14\frac{7}{8}$ (50·8 × 37·8) Bt 1925

980 HOLLAND, James: *The Rialto, Venice* (circular): 9 (22·8) Bt 1909

2109 HONE, Horace: *Mr Cathcart* Miniature Lt Col J. M. Fleming bequest 1949

2110 HONE, Horace: *Mrs Cathcart* Miniature Lt Col J. M. Fleming bequest 1949

***1216** HOPPNER, John: *Admiral Viscount Duncan* 30 × 25 (76·2 × 63·5) Earl of Camperdown bequest 1918

135

46 HOUCKGEEST, Gerrit: *Architectural fantasy with figures* $51\frac{1}{2} \times 59\frac{3}{4}$ (130·8 × 151·8) Bt (RI) 1830

914 HOUSTON, John: *Curiosity dealer* $23\frac{3}{4} \times 18\frac{5}{8}$ (60·3 × 47·3) Patrick Shaw bequest 1902

213 HOWARD, Henry: *Venus carrying off Ascanius* $27\frac{1}{2} \times 35\frac{7}{8}$ (69·8 × 91) Bt (RI) 1826

2131 HUDSON, Thomas: *Charles Erskine* (1716–49) $29\frac{3}{4} \times 24\frac{1}{2}$ (75·5 × 62·2) Bt 1950

571 HUTCHISON, John: *Pasquaccia, a Roman Contadina* Marble: ht $23\frac{1}{4}$ (59) RAPFA gift 1897

2333 HUTCHISON, R. Gemmell: *Strawberries and cream* $31\frac{5}{8} \times 40\frac{1}{4}$ (80·3 × 102·2) Mrs A. Laidlaw gift 1974

47 HUYSMANS, Cornelis: *Landscape* $33\frac{1}{4} \times 47\frac{1}{2}$ (84·5 × 120·5) Robert Clouston gift (RI) 1852

2159 HYSING, Hans: *Sir Peter Halkett, 2nd Bt of Pitfirrane* (?) $29\frac{7}{8} \times 24\frac{7}{8}$ (75·9 × 63·2) Bt 1951

1059 ISRAELS, Josef: *Watching the flock* W: $11\frac{3}{4} \times 16\frac{3}{4}$ (29·8 × 42·5) Hugh A. Laird bequest 1911

1060 ISRAELS, Josef: *Bringing home the calf* W: $11\frac{3}{4} \times 16\frac{1}{2}$ (29·8 × 41·9) Hugh A. Laird bequest 1911

1061 ISRAELS, Josef: *A sea urchin* W: $10 \times 7\frac{1}{2}$ (25·4 × 19) Hugh A. Laird bequest 1911

56 ITALIAN, 16th cent (?): *Adoration of the shepherds* $18 \times 13\frac{3}{4}$ (45·7 × 34·9) Bt (RI) 1830

85 ITALIAN, 17th cent: *Battlefield* $41 \times 90\frac{1}{4}$ (104 × 229) James S. Wardrop gift 1850

108 ITALIAN: *Elevation of the Cross* $18 \times 13\frac{3}{4}$ (45·7 × 34·9) James Johnston gift (RI) before 1845

645 ITALIAN: 16th cent: *Holy Family* W (circular): $34\frac{1}{2}$ (87·5) diam David Laing bequest 1879

812 ITALIAN, c 1630: *A hermit saint doing penance* $41\frac{1}{2} \times 35\frac{1}{2}$ (105·5 × 90·2) Henry Doig gift 1888

***833** ITALIAN, 18th cent: *Virgin of the Immaculate Conception* Marble: ht 49 (124·5) Sir Hugh Hume Campbell Bt bequest 1894

910 ITALIAN, 18th or 19th cent: *A city square* $26\frac{5}{8} \times 36\frac{1}{2}$ (67·6 × 92·7) Patrick Shaw bequest 1903

1638 ITALIAN, 18th cent: *Portrait of a man* $31\frac{1}{4} \times 23\frac{1}{2}$ (79·4 × 59·8) Sir Claude Phillips bequest 1924

1665 ITALIAN, 15th cent: *Baby resting on a hand* Carrara marble: ht $15\frac{1}{2}$ (39·5) Bt 1926

1683 ITALIAN, 15th cent: *Head of a female saint* Greek marble: ht $12\frac{3}{4}$ (32·3) Bt 1928

ITALIAN, 17th cent: *St Peter delivered* see under EMILIAN, 17th cent no. 19

ITALIAN, 17th cent: *Secretary of Pope Leo X* see under PIETRO DA CORTONA (after) no. 109

ITALIAN, *St Peter* see under RAPHAEL (after) no. 110

JACOPO DI CIONE (workshop): *Triptych with the Adoration of the Kings* see under TUSCAN, 14th cent no. 1958

1046 JACQUE, Charles: *Moutons à l'abreuvoir* $32\frac{1}{4} \times 26$ (81·9 × 66) Hugh A. Laird bequest 1911

1457 JACQUE, Charles: *Leaving the stall* $17\frac{1}{2} \times 26$ (44·4 × 66) Dr John Kirkhope bequest 1920

***958** JAMESONE, George: *Lady Mary Erskine, Countess Marischal* $26\frac{1}{2} \times 21\frac{1}{2}$
(67·3 × 54·6) Bt 1908

1973 JAMESONE, George (attr): *Robert, Mester Erskine* $90\frac{1}{2} \times 59$ (230 × 150) Bt 1942

1749 JOHNSTONE, W. B.: *The daughters of Thomas Duncan* Miniature $11\frac{3}{8} \times 8\frac{7}{8}$
(28·9 × 22·5) Bt 1930

***1252** JOOS VAN CLEVE: *Triptych with the Deposition* W: 42 × 28 (106·7 × 71·1);
wings 43 × $12\frac{1}{2}$ (109·2 × 31·8) Bt 1920

1678 JOOS VAN CLEVE (follower): *Madonna and Child* W: $14\frac{1}{4} \times 9\frac{1}{2}$ (36·2 × 24·1)
Mrs E. M. C. Thompson bequest 1927

579 JORDAENS, J. (after): *Portrait of a man* $38\frac{1}{4} \times 29$ (97·1 × 73·7) Alexander
Wood Inglis gift 1870

***651** KAUFFMANN, Angelica: *Michael Novosielski* $50\frac{1}{2} \times 40$ (128 × 101·6)
Mrs Elizabeth Stewart bequest 1879

***1938** KEY, William (attr): *Mark Ker* W: $15\frac{1}{2} \times 11\frac{3}{8}$ (39·3 × 29) Marquess of
Lothian bequest 1941

***1939** KEY, William (attr): *Lady Helen Leslie* W: $15\frac{5}{8} \times 11\frac{3}{8}$ (39·5 × 29) Marquess of
Lothian bequest 1941

KIDD, W.: *Fisher folk* see under FRASER, A. (1786–1865) no. 982*

***440** LANCRET, Nicolas: *The toy windmill* (circular) $19\frac{1}{2}$ (49·5) diam Lady Murray of
Henderland bequest 1861

586 LANDSEER, Edwin: *Rent-day in the wilderness* 48 × $104\frac{1}{2}$ (122 × 265)
Sir Roderick Murchison bequest 1871

***915** LAUDER, J. E.: *Bailie McWheeble at breakfast* $26\frac{1}{2} \times 19\frac{3}{4}$ (67·3 × 50·2)
Lady Dawson Brodie bequest 1903

221 LAUDER, R. S.: *Christ teacheth humility* 92 × 139 (234 × 353) RAPFA gift 1897

830 LAUDER, R. S.: *Sir John Steel* W: 8 × $6\frac{1}{2}$ (20·3 × 16·5) Miss Steel gift 1893

***1003** LAUDER, R. S.: *Henry Lauder* $29\frac{1}{2} \times 24\frac{1}{2}$ (75 × 62·3) Dr Scott Lauder gift
(RSA) after 1882

2203 LAUDER, R. S.: *Christ and the woman taken in adultery* Oil on paper: 15 × $9\frac{3}{4}$
(38·1 × 24·8) W. F. Watson bequest 1886

2316 LAUDER, R. S.: *Study for 'Christ teacheth humility'* $12\frac{1}{4} \times 22\frac{1}{4}$ (31·1 × 56·5)
Bt 1972

***1522** LAWRENCE, Thomas: *Lady Robert Manners* $54\frac{1}{2} \times 43\frac{1}{2}$ (138·5 × 110·5)
Mrs Nisbet Hamilton Ogilvy bequest 1921

966 LAWSON, Cecil: *The old mill—sunset* $41\frac{1}{4} \times 53\frac{1}{4}$ (104·8 × 135·2) Bt 1908

1372 LAWSON, Cecil: *A Surrey landscape* $11\frac{5}{8} \times 9\frac{5}{8}$ (29·5 × 24·5) Bt 1920

572 LAWSON, George: *The bard* Terracotta: ht $19\frac{1}{2}$ (49·5) RAPFA gift 1897

1623 LEGROS, Alphonse: *The sermon* $29\frac{1}{2} \times 37$ (75 × 94) Bt 1923

2050 LEGROS, Alphonse: *Torso of a young woman* Bronze: ht $18\frac{1}{2}$ (47) Sir D. Y.
Cameron bequest 1945

2289 LEGROS, Alphonse: *Torso of a young woman* Bronze: ht $18\frac{1}{2}$ (47) Sir Alexander
Maitland bequest 1965

1507 LELY, Peter: *Lady Diana Bruce, Duchess of Rutland* 48 × 38 (122 × 96·5)
Mrs Nisbet Hamilton Ogilvy bequest 1921

916 LENBACH, Franz von: *Prince Bismarck* W: $29\frac{1}{4} \times 23\frac{3}{4}$ (74·3 × 60·3)
J. Kennedy Tod gift (RSA) 1903

2270 LEONARDO DA VINCI (after): *Madonna with the yarnwinder* W: $24\frac{3}{8} \times 19\frac{1}{8}$
(62 × 48·5) Capt Douglas Hope gift 1964

***1047** LÉPINE, Stanislas: '*La Seine à Bercy*' 12 × 21 (30·5 × 53·4) Hugh A. Laird
 bequest 1911

1458 LÉPINE, Stanislas: *Sunset on river* $10\frac{1}{2}$ × 13 (26·7 × 33) Dr John Kirkhope
 bequest 1920

1459 LÉPINE, Stanislas: *Montmartre* 13 × $9\frac{1}{2}$ (33 × 24·1) Dr John Kirkhope
 bequest 1920

1969 LÉPINE, Stanislas: *Landscape with farm buildings* W: $6\frac{3}{4}$ × $13\frac{1}{2}$ (17·2 × 34·3)
 Dr John MacGregor bequest 1942

1460 LHERMITTE, Léon: *Grandmother* Pastel: $15\frac{1}{2}$ × 21 (39·3 × 53·3) Dr John
 Kirkhope bequest 1920

***68** LIEVENS, Jan (attr): *A woodland walk* $20\frac{1}{4}$ × $27\frac{3}{4}$ (51·5 × 70·5) Torrie collection

***1564** LIEVENS, Jan (attr): *Portrait of a young man* 44 × $38\frac{1}{4}$ (111·8 × 97·2) Bt 1922

***1758** LIPPI, Filippino: *The Nativity* W: $9\frac{7}{8}$ × $14\frac{1}{2}$ (25 × 37) Bt 1931

2099 LIPPI, Filippino: *St John Baptist* W: $13\frac{3}{4}$ × $5\frac{1}{4}$ (34·9 × 13·3) Lord Carmichael
 bequest 1948

***423** LIZARS, W. H.: *Reading the will* W: $20\frac{1}{4}$ × $25\frac{1}{2}$ (51·5 × 64·8) Mrs Lizars gift
 1861

***424** LIZARS, W. H.: *A Scotch wedding* W: $23\frac{1}{4}$ × 26 (59·1 × 66) Mrs Lizars gift 1861

945 LOCKHART, W. E.: *Gil Blas and the Archbishop of Granada* $59\frac{1}{2}$ × $36\frac{1}{2}$
 (151 × 92·7) Bt 1907

60 LOMBARD, 16th cent: *Christ on the Mount of Olives* 36 × $70\frac{1}{2}$ (91·4 × 179)
 Bt (RI) 1830

 LONGHI, A. (imitator): *Venetian gentleman* see under ITALIAN, 18th cent
 no. 1638

646 LORENZO DI CREDI (follower): *Holy Family* W (circular): 11 (28) David Laing
 bequest 1879

***2271** LORENZO MONACO: *Madonna and Child* W: 40 × $24\frac{1}{2}$ (101·6 × 62·3) Bt 1965

***1879** LORIMER, J. H.: *Ordination of elders* 43 × 55 (109·2 × 140) Mrs McGrath
 gift 1936

***** LOTTO, Lorenzo: *Virgin and Child with Saints* $32\frac{1}{2}$ × $41\frac{3}{8}$ (82·5 × 105) Duke of
 Sutherland loan 1946

1504 LUTTICHUYS, Simon: *Still-life* $28\frac{1}{2}$ × $32\frac{1}{2}$ (72·4 × 82·6) Mrs Nisbet Hamilton
 Ogilvy bequest 1921

***288** McCULLOCH, Horatio: *Inverlochy Castle* $35\frac{1}{2}$ × $59\frac{1}{2}$ (90·2 × 151) RAPFA 1897

587 McCULLOCH, Horatio: *Lowland river* 39 × 59 (99 × 150) Robert Cox bequest
 1872

2334 MACGEORGE, W. S.: *A Galloway peat moss* Canvas on wood: 32 × 53
 (81·2 × 134·6) Dr Samuel Murdoch Riddick bequest 1975

1770 MACGREGOR, W. Y.: *Winter landscape* Pastel: $34\frac{1}{2}$ × $27\frac{1}{4}$ (87·6 × 69·2) Mrs
 W. Y. Macgregor gift 1931

***1915** MACGREGOR, W. Y.: *Vegetable stall* $41\frac{1}{2}$ × $59\frac{1}{4}$ (105·5 × 150·5) Mrs W. Y.
 Macgregor gift 1939

1957 MACGREGOR, W. Y.: *Castle on a cliff* $13\frac{1}{2}$ × $15\frac{1}{2}$ (34·2 × 39·4) Mrs W. Y.
 Macgregor bequest 1942

***2086** MACGREGOR, W. Y.: *Winter landscape* 36 × 32 (91·5 × 81·3) Bt 1947

***2200** MACGREGOR, W. Y.: *A rocky solitude* $24\frac{3}{4}$ × $26\frac{5}{8}$ (62·9 × 67·7) Gift of Sir
 Alexander Maitland and his wife 1958

1804 McINNES, Robert: *Self portrait* 29 × $23\frac{1}{4}$ (73·7 × 59) Bt 1934

1669 MCKAY, W. D.: *Field working in spring: at the potato pits* $25\frac{1}{4} \times 38\frac{3}{8}$
(64·2 × 97·5) The Misses Stodart gift 1926

1799 MCKAY, W. D.: *Haymakers* $19\frac{1}{4} \times 26\frac{1}{2}$ (48·8 × 67·3) Gift of the artist's
executors 1934

1800 MCKAY, W. D.: *Green landscape* $13\frac{1}{2} \times 23\frac{1}{2}$ (34·2 × 59·7) Gift of the artist's
executors 1934

1977 MCKENZIE, Robert Tait: *The modern discus thrower* Bronze: ht $28\frac{1}{2}$ (72·4)
Mrs R. Tait McKenzie gift 1943

1978 MCKENZIE, Robert Tait: *The relay* Bronze: ht 22 (55·8) Mrs R. Tait McKenzie
gift 1943

1979 MCKENZIE, Robert Tait: *The athlete* Bronze: ht $16\frac{3}{4}$ (42·5) Mrs R. Tait
McKenzie gift 1943

1732 MACKIE, Charles: *Belvedere, Venice* $27\frac{1}{4} \times 34\frac{3}{4}$ (69·2 × 88·3) A. F. Roberts
bequest 1929

2038 MACKIE, Charles: *The bathing pool* $59\frac{3}{4} \times 59$ (152 × 150) Mrs Charles Mackie
gift 1946

2044 MACKIE, Charles: *Entrance to Grand Canal, Venice* $32 \times 39\frac{1}{2}$ (81·3 × 100·3)
Bt 1946

1892 MCLACHLAN, T. H.: *Christobel under the oak* $24\frac{1}{4} \times 37\frac{1}{4}$ (61·6 × 94·6) Mrs
H. P. Fry gift 1938

1009 MACLEAY, Kenneth: *Miss Wilhelmina Sheriff* Miniature Miss Margaret Kerr
gift (RSA) 1885.

 610 MACNEE, Daniel: *Horatio McCulloch* $29\frac{1}{2} \times 24\frac{1}{2}$ (75 × 62·2) Artist's gift
(RSA) 1859

***1679** MACNEE, Daniel: *Lady in grey* 50 × 40 (127 × 101·6) Lady Macnee gift 1927

1817 MACNEE, Daniel: *Six frames of portrait sketches* Bt 1935
to
1822

1921 MACNEE, Daniel: *Mrs James Mackenzie* $81\frac{3}{8} \times 55\frac{1}{2}$ (207 × 141) Mrs James
Mackenzie gift 1940.

2201 MACNEE, Daniel: *A woman* B: $12\frac{1}{4} \times 10$ (31·1 × 25·4) Kenneth Sanderson
bequest 1943

2202 MACNEE, Daniel: *Burns and his Highland Mary* Oil on paper: $6\frac{5}{8} \times 5\frac{5}{8}$
(16·8 × 14·3) W. F. Watson bequest 1881

2254 MACNEE, Daniel: *Sketch for 'Lady in grey'* B: $11\frac{1}{8} \times 9\frac{1}{8}$ (28·3 × 23·1) Miss
Gertrude Hermes gift 1962

***1071** MCTAGGART, William: *The coming of St Columba* $51\frac{1}{2} \times 81$ (131 × 206)
Bt 1911

1201 MCTAGGART, William: *Mrs Leiper* $29\frac{3}{8} \times 24\frac{1}{2}$ (74·6 × 62·2) William Leiper
bequest 1916

***1482** MCTAGGART, William: *The young fishers* $28\frac{1}{2} \times 42\frac{1}{2}$ (72·4 × 108) Dr John
Kirkhope bequest 1920

1483 MCTAGGART, William: *By summer seas* $17\frac{1}{2} \times 25\frac{1}{2}$ (44·4 × 64·8) Dr John
Kirkhope bequest 1920

1659 MCTAGGART, William: *Molly* 39 × 25 (99 × 63·5) Mrs L. Pilkington gift
1925

***1757** MCTAGGART, William: *The sailing of the emigrant ship* $29\frac{3}{4} \times 34$ (75·6 × 86·4)
Sir James and Lady Caw gift 1931

***1834** M c T A G G A R T, William: *The storm* 48 × 72 (121·9 × 183) Mrs Andrew Carnegie
gift 1935

1906 M c T A G G A R T, William: *Machrihanish Bay* 32½ × 48½ (82·5 × 123·2) Mr and
Mrs D. W. T. Cargill gift 1938

1907 M c T A G G A R T, William: *Harvest at Broomieknowe* 34⅜ × 51¼ (87·3 × 130)
Mr and Mrs D. W. T. Cargill gift 1938

***2137** M c T A G G A R T, William: *Spring* 17¾ × 23¾ (45·1 × 60·4) Sir James and Lady Caw
bequest 1951

2138 M c T A G G A R T, William: *Snow in April* W: 7¾ × 11¼ (19·7 × 28·6) Sir James
and Lady Caw bequest 1951

***2139** M c T A G G A R T, William: *The past and the present* 8¾ × 10¾ (22·3 × 27·4) Sir
James and Lady Caw bequest 1951

2140 M c T A G G A R T, William: *Quiet sunset, Machrihanish* 15 × 18 (38 × 45·7) Sir
James and Lady Caw bequest 1951

***2158** M c T A G G A R T, William: *Mrs William Lawrie* 35¾ × 23¾ (90·8 × 60·4) Mme
Violante Lawrie gift 1952

***2185** M c T A G G A R T, William: *Oak leaves in autumn (self-portrait)* 33 × 28
(83·8 × 71·2) William McTaggart Trust gift 1956

2186 M c T A G G A R T, William: *The artist's mother* 36½ × 26¾ (92·7 × 68) William
McTaggart Trust gift 1956

2214 M c T A G G A R T, William: *The sailor's yarn* Canvas on board: 6¼ × 5¼ (15·8 × 13·3)
Sir James and Lady Caw bequest 1951

2355 M c T A G G A R T, William: *Halfway home* 28⅜ × 21½ (72 × 54·5) Robert A. Lillie
bequest 1977

2356 M c T A G G A R T, William: *Harvest moon* W: 6⅞ × 10 (17·4 × 25·2) Robert A.
Lillie bequest 1977

***1509** M A E S, Nicolaes: *Dutch family group* W: 19⅞ × 15 (50·5 × 38·1) Mrs Nisbet
Hamilton Ogilvy bequest 1921

***2178** M A I L L O L, A.: *Eve* Bronze: ht 22⅞ (58·2) Bt 1955

1054 M A R C K E, Emile van: *Bestiaux au pâturage* 20 × 26 (50·8 × 66) Hugh A. Laird
bequest 1911

1055 M A R C K E, Emile van: *The pond on the common* 17¼ × 23¼ (43·8 × 59) Hugh A.
Laird bequest 1911

1049 M A R I S, Jacob: *On the Amstel* 36¼ × 49⅛ (92 × 125) Hugh A. Laird bequest 1911

1050 M A R I S, Jacob: *Amsterdam* 13½ × 23 (34·3 × 58·4) Hugh A. Laird bequest 1911

1051 M A R I S, Jacob: *Scheveningen* 16¾ × 11¼ (42·5 × 28·5) Hugh A. Laird bequest
1911

1052 M A R I S, Jacob: *Outside a café* W: 10¾ × 8¼ (27·3 × 21) Hugh A. Laird bequest
1911

1471 M A R I S, Jacob: *The watermill, Bougival* W: 6 × 8¼ (15·2 × 21) Dr John Kirkhope
bequest 1920

1053 M A R I S, Willem: *A silver stream* 18½ × 14¾ (47 × 37·4) Hugh A. Laird bequest
1911

431 M A R L O W, W.: *A town and castle on the Rhône* 32 × 45½ (81·3 × 115·5) Lady
Murray of Henderland bequest 1861

***1673** M A R M I T T A, Il (attr): *The Scourging of Christ* W: 14⅛ × 10 (36·2 × 25·4) Bt 1927

447 M A R S H A L L, William: *Hebe rejected* Marble: ht 54 (137) Professor Douglas
Cheape bequest 1861

***569** M ARTIN, David: *Self-portrait* 19½ × 15½ (49·5 × 39·4) The Misses Bryce gift
(RSA) 1869

1718 M ARTIN, David: *Lady Seton-Steuart* 49½ × 39½ (125·7 × 100·3) Sir Douglas
Seton-Steuart gift 1928

1926 M ARTIN, David (attr): *Mary Martin* 33½ × 28 (85 × 71) Miss Jane Gowan
gift 1940

***2115** M ARTIN, John: *Macbeth* 20 × 28 (50·8 × 71) Bt 1949

***2273** M ASSYS, Quentin: *Portrait of a man* W: 31½ × 25¼ (80 × 64·5) Ceded from the
estate of Capt E. G. Spencer-Churchill 1965

1975 M ASTER OF THE ADIMARI CASSONE: *Triumph of a Roman general* W: 15¼ × 27½
(38·8 × 69·9) Bt 1942

***1540a** M ASTER OF 1419: *Stigmatization of St Francis* W: 8½ × 12 (21·6 × 30·5) Bt 1921

***1540b** M ASTER OF 1419: *St Anthony Abbot exorcizing a woman* W: 8½ × 12 (21·6 × 30·5)
Bt 1921

***1539a** M ASTER OF S. Lucchese Altar: *A baptism* W: 7½ × 12½ (19 × 31·8) Bt 1921

***1539b** M ASTER OF S. Lucchese Altar: *A martyrdom* W: 7½ × 11¾ (19 × 29·9) Bt 1921

***1023** M ATTEO DI GIOVANNI: *Madonna and Child with Saints* W: 20 × 15½
(50·8 × 39·4) Bt 1910

***1056** M AUVE, Anton: *Tow-path—No. 1* 13 × 9¼ (33 × 23·5) Hugh A. Laird bequest
1911

1057 M AUVE, Anton: *Field labour* W: 10 × 16 (25·4 × 40·6) Hugh A. Laird bequest
1911

1058 M AUVE, Anton: *Tow-path—No. 2* W: 9⅞ × 7⅛ (25 × 18) Hugh A. Laird bequest
1911

554 M EDINA, John: *Copy of portrait of Scougall* (?) *no. 2032* 25½ × 20 (64·8 × 50·8)
John Scougall bequest 1867

948 M ELVILLE, Arthur: *Christmas Eve* 75 × 80 (191 × 203) Bt 1907

2144 M ELVILLE, Arthur: *Arab interior* 37 × 28 (94 × 71) Sir James and Lady Caw
bequest 1907

433 M ERCIER, Philippe: *Girl holding a cat* 36 × 27¾ (91·5 × 70·5) Lady Murray
bequest 1861

434 M ERCIER, Philippe: *Girl knitting* 30 × 25 (76·2 × 63·5) Lady Murray bequest
1861

627 M ERCIER, Philippe: *Mr Dawson* 35½ × 26½ (90·2 × 67·3) Rev Henry Humble
bequest 1877

628 M ERCIER, Philippe: *Mrs Dawson* 35½ × 26½ (90·2 × 67·3) Rev Henry Humble
bequest 1877

1961 M ERCIER, Philippe (imitator ?): *Boy and dog* 22 × 27¾ (55·8 × 70·5) C. J. G.
Paterson bequest 1942

1962 M ERCIER, Philippe (imitator ?): *Girl with tea-cup* 22 × 27¾ (55·8 × 70·5) C. J. G.
Paterson bequest 1942

***1028** M ICHEL, Georges: *The lime kiln* 22 × 28 (55·9 × 71·1) George R. MacDougall
gift 1911

1461 M ICHEL, Georges: *Montmartre* 8 × 12⅛ (20·3 × 30·8) Dr John Kirkhope
bequest 1920

526 M ICHELANGELO (after): *Giuliano de' Medici* Wax: ht 22 (55·8) Sir Hugh Hume
Campbell Bart gift 1866

527 MICHELANGELO (after): *Madonna and Child* Wax: ht 26 (66) Sir Hugh Hume
 Campbell Bt. gift 1866

528 MICHELANGELO (after): *Lorenzo de' Medici* Wax: ht 21½ (54·6) Sir Hugh
 Hume Campbell Bt. gift 1866

693 MICHELANGELO (after): *Lorenzo de' Medici* Terracotta: ht 18¼ (46·4) Mary,
 Lady Ruthven bequest 1885

 MIEL, Jan: *Figures near a seaport* see under WEENIX no. 51*

2003 MIERS, J.: *Mrs Burns* Miniature Kenneth Sanderson bequest 1943

2004 MIERS, J.: *Marquess of Bute* Miniature Kenneth Sanderson bequest 1943

2005 MIERS, J.: *Portrait of an Admiral* Miniature Kenneth Sanderson bequest 1943

2006 MIERS, J.: *Profile to right* Miniature Kenneth Sanderson bequest 1943

2007 MIERS, J.: *Profile to left* Miniature Kenneth Sanderson bequest 1943

2067 MILLAIS, John: *'Sweetest eyes were ever seen'* 39¼ × 28 (99·7 × 71) Melville
 J. Gray bequest 1946

1802 MILLAR, William: *Thomas Trotter* 29 × 24½ (73·7 × 62·2) Bt 1933

*29 MOLA, P. F. (attr to follower): *St Jerome* 24 × 31 (61 × 78·7) Bt (RI) 1830

*1651 MONET, Claude: *Poplars on the Epte* 32¼ × 32 (81·9 × 81·3) Bt 1925

*2283 MONET, Claude: *Haystacks: snow effect* 25½ × 36¼ (64·8 × 92·1) Sir Alexander
 Maitland bequest 1965

*2120 MONTI, Francesco: *Rebecca at the well* 31 × 33¼ (78·5 × 85) Miss Ida M.
 Hayward bequest 1950

*961 MONTICELLI, Adolphe: *Gypsy encampment* W: 8¾ × 18 (22·2 × 45·8) Bt 1908

*1022 MONTICELLI, Adolphe: *La fête* W: 15¼ × 23⅛ (38·8 × 58·8) Bt 1910

1462 MONTICELLI, Adolphe: *The garden of love* W: 15¼ × 23¼ (38·7 × 59) Dr John
 Kirkhope bequest 1920

1463 MONTICELLI, Adolphe: *Woodland fête* W: 9¾ × 17¼ (24·8 × 43·8) Dr John
 Kirkhope bequest 1920

*1464 MONTICELLI, Adolphe: *Garden fête* W: 12¼ × 23½ (31·2 × 59·7) Dr John
 Kirkhope bequest 1920

1465 MONTICELLI, Adolphe: *In the grotto* W: 13¼ × 21¼ (33·6 × 54) Dr John
 Kirkhope bequest 1920

1019 MOORE, Albert: *Beads* 11¾ × 20¼ (29·8 × 51·4) Bt 1910

290 MORE, Jacob: *Mount Vesuvius in eruption* 59½ × 79 (151 × 201) Sir James
 Stuart Bart gift (RI) 1829

*1897 MORE, Jacob: *The Falls of Clyde* 31¼ × 39½ (79·4 × 100·4) Rt Hon J. Ramsay
 MacDonald bequest 1938

*52 MOREELSE, Paul: *Shepherd with a pipe* 37⅜ × 28⅝ (95 × 72·8) Bt (RI) 1831

*1024 MOREELSE, Paul: *Cimon and Pero* 58¼ × 64½ (148 × 164) A. W. Inglis gift 1909

*2269 MORISOT, Berthe: *Woman and child in a garden* 23¾ × 28¾ (60·4 × 73) Bt 1964

993 MORLAND, George: *Selling fish* 22¾ × 19¾ (45 × 50·2) George R. MacDougall
 gift 1909

994 MORLAND, George: *Fighting dogs* 25¼ × 32¼ (64 × 82) W. B. Paterson gift 1909

*1835 MORLAND, George: *Comforts of industry* 12¼ × 14½ (31·2 × 36·9) Lord and
 Lady Craigmyle gift 1935

*1836 MORLAND, George: *Miseries of idleness* 12¼ × 14½ (31·2 × 36·9) Lord and Lady
 Craigmyle gift 1935

*2015 MORLAND, George: *The public house door* 24¾ × 30½ (62·9 × 77·5) Lord
 Craigmyle gift 1944

789 MORLAND, George (imitator): *The stable door* $12\frac{1}{4} \times 14\frac{1}{2}$ (31 × 36·8) Bt 1887

*2347 MORONI, Giovanni Battista: *Portrait of a scholar (Basilio Zanchi?)* $45\frac{3}{4} \times 35$ (116·2 × 88·8) Bt 1977

1752 MOSMAN, William: *Elizabeth Drummond* $32\frac{1}{4} \times 26\frac{1}{4}$ (82 × 66·7) M. V. Erskine Stuart gift 1930

909 MOUCHERON, F. de: *Landscape with figures* $47 \times 40\frac{3}{4}$ (119·3 × 103·5) Patrick Shaw bequest 1903

2166 MÜLLER, William: *Heath scene* W: $10\frac{1}{4} \times 14\frac{3}{4}$ (26 × 37·5) Lady Binning bequest 1952

432 MURILLO, B. (attr): *Boy drinking* $17\frac{3}{4} \times 14\frac{3}{4}$ (45 × 37·5) Lady Murray of Henderland bequest 1861

1886 MURRAY, David: *Loch Coruisk, Skye* $27\frac{3}{4} \times 35\frac{1}{2}$ (70·5 × 90) D. Fraser gift 1937

*291 NASMYTH, Alexander: *Distant view of Stirling* 33 × 46 (83·9 × 116·9) Commissioned (RI) 1827

*1383 NASMYTH, Alexander: *The windings of the Forth* 18 × 29 (45·7 × 73·7) R. K. Blair gift 1920

2100 NASMYTH, Alexander: *Woody landscape* W: $17\frac{3}{4} \times 22\frac{3}{4}$ (45 × 57·8) F. J. Nettlefold gift 1948

2104 NASMYTH, Alexander: *Edinburgh Castle and the Nor' Loch* $17\frac{3}{4} \times 23\frac{3}{4}$ (45 × 60·3) Mrs E. Pringle gift 1948

1893 NASMYTH, Charlotte: *Pastoral landscape* $15\frac{1}{4} \times 20\frac{1}{2}$ (38·7 × 52) Bt 1928

1912 NASMYTH, Elizabeth: *The Falls of Clyde* $17\frac{1}{2} \times 23\frac{1}{8}$ (44·4 × 58·7) Bt 1939

1894 NASMYTH, Patrick: *English landscape* 14 × 19 (35·5 × 48·2) Bt 1938

1948 NASMYTH, Patrick: *Landscape* 9 × 11 (22·8 × 28) Miss Alice Anne White bequest 1941

1968 NASMYTH, Patrick: *Wooded landscape* $8\frac{1}{2} \times 11\frac{3}{4}$ (21·6 × 29·8) Dr John MacGregor bequest 1942

1981 NASMYTH, Patrick: *Scene in Hampshire* $8\frac{3}{4} \times 12$ (22·2 × 30·5) J. Cathcart White bequest 1943

*2101 NASMYTH, Patrick: *A woodman's cottage* W: $16\frac{3}{8} \times 22$ (41·6 × 55·9) F. J. Nettlefold gift 1948

2102 NASMYTH, Patrick: *The valley of the Tweed* $31\frac{1}{2} \times 44\frac{1}{2}$ (80 × 113) F. J. Nettlefold gift 1948

589 NASMYTH, P. (attr): *Glenshira* $27\frac{1}{4} \times 35\frac{7}{8}$ (69·2 × 91) R. M. Smith gift 1885

*117 NASON, Pieter: *A man and wife* $53\frac{3}{4} \times 58$ (135 × 147·3) Bt (RI) 1840

*21 NEAPOLITAN: *Cain killing Abel* $75 \times 56\frac{1}{2}$ (190 × 143) Sir Alexander Crichton gift (RI) 1834

84 NEAPOLITAN, 17th cent: *Martyrdom of St Sebastian* 79 × 57 (201 × 145) Charles O'Neil gift (RI) 1834

1473 NEUHUIJS, Albert: *The old, old story* $12\frac{3}{4} \times 16\frac{5}{8}$ (32·4 × 42·2) Dr John Kirkhope bequest 1920

1474 NEUHUIJS, Albert: *Busy* $38\frac{5}{8} \times 32$ (98 × 81·3) Dr John Kirkhope bequest 1920

1913 NICHOLSON, William: *Miss Charlotte Nasmyth* $30\frac{1}{4} \times 25$ (76·8 × 63·5) Bt 1939

925 NICOL, Erskine: *Irish emigrant landing at Liverpool* $55\frac{3}{4} \times 39\frac{3}{4}$ (142 × 101) Sir A. Oliver Riddell gift 1905

1146 NOBLE, J. Campbell: *Sunset near Glencaple on Solway* $27\frac{1}{2} \times 35\frac{1}{2}$ (70 × 90) Presented 1914

1208 NOBLE, Robert: *Springtime, Prestonkirk* $29\frac{1}{8} \times 35\frac{1}{2}$ (74 × 90) Presented 1917

***1768** NORIE, James: *Classical landscape with architecture* $25\frac{1}{2} \times 52$ (64·8 × 132) Bt 1931

***1769** NORIE, James: *Classical landscape with trees and lake* $25\frac{1}{2} \times 52$ (64·8 × 132) Bt 1931

***83** NOVELLI, Pietro: '*A mathematician*' 46×36 (116·9 × 91·5) Acquired (RSA) by 1859

***22** OEVER, Hendrick ten: *Canal landscape with figures bathing* $26\frac{1}{4} \times 34\frac{1}{4}$ (66·7 × 87) Torrie collection

911 OPIE, John: *Self-portrait* (oval) $27\frac{1}{2} \times 22\frac{7}{8}$ (69·8 × 58) Patrick Shaw bequest 1903

1018 ORCHARDSON, W. Q.: *The queen of the swords* $18\frac{5}{8} \times 31\frac{3}{4}$ (47·3 × 80·6) Bt 1910

***1138** ORCHARDSON, W. Q.: *Master Baby* $42\frac{1}{4} \times 65\frac{1}{2}$ (108 × 166) Bt 1913

1207 ORCHARDSON, W. Q.: *The artist's wife* 75×47 (191 × 119·5) Lady Orchardson bequest 1917

1229 ORCHARDSON, W. Q.: *Miss Joanna Isabella Dick* (oval) $10 \times 8\frac{5}{8}$ (25·4 × 21·9) A. B. Dick gift 1919

1658 ORCHARDSON, W. Q.: *Voltaire* 56×78 (142 × 198) Anonymous gift 1925

2184 ORCHARDSON, W. Q.: *The rivals* $33\frac{1}{8} \times 46\frac{1}{8}$ (84 × 117) Elspeth, Lady Invernairn of Strathnairn gift 1956.

2215 ORCHARDSON, W. Q.: *Lady Orchardson* $11\frac{5}{8} \times 11\frac{5}{8}$ (29·5 × 29·5) Sir James and Lady Caw bequest 1951

***995** ORLEY, Bernard van: *Before the Crucifixion* W: $26\frac{1}{2} \times 33\frac{3}{4}$ (67·3 × 85·7) Bt 1909

***1895** ORLEY, Bernard van: *Marie Haneton* W: $29\frac{5}{8} \times 22\frac{1}{8}$ (75·2 × 56·1) Sir Hugh Hume Campbell bequest 1894

54 OSTADE, Adriaen van (attr): *Interior with a pig's carcase* W: $18\frac{1}{4} \times 22\frac{3}{4}$ (46·3 × 57·8) W. Shiels gift (RSA) 1851

***951** OSTADE, Isack van: *Sportsmen halting at an inn* W: $21 \times 23\frac{1}{2}$ (53·4 × 59·7) H. C. Brunning bequest 1908

1743 OWEN, Samuel (attr): *Homeward bound* $39\frac{1}{2} \times 31\frac{1}{2}$ (100·3 × 80) Gerald Craig Sellar bequest 1930

***55** PAGGI, G. B.: *Rest on the Flight into Egypt* $34\frac{1}{8} \times 26\frac{3}{4}$ (86·7 × 68) Bt (RI) 1830

2070 PAILLOU, P.: *Adam Crooks of Leven* Miniature Capt J. C. Peebles Chaplin gift 1946

2093a PAILLOU, P.: *Portrait of a gentleman* Miniature Mrs Ethel M. Pearse gift 1947

2155 PAILLOU, P.: *Portrait of a young man* Miniature Sir John D. Don-Wauchope bequest 1951

296 PARK, Patric: *Scotch lassie* Marble: ht $27\frac{1}{2}$ (69·8) Commissioned by the RSA 1856

***441** PATER, J. B.: *Ladies bathing* 23×28 (58·4 × 71·1) Lady Murray of Henderland bequest 1861

1952 PATERSON, James: *Lady Charles Guthrie* Pastel: $20\frac{3}{8} \times 13\frac{3}{8}$ (51·8 × 34) Thomas Gascoigne gift 1941

***2023** PATERSON, James: *Edinburgh from Craigleith* $26\frac{1}{2} \times 45$ (67·4 × 114·3) Bt 1944

2357 PATERSON, James: *The estuary* B: 7×10 (17·7 × 25·3) Robert A. Lillie bequest 1977

***293** PATON, Noel: *The quarrel of Oberon and Titania* 39×60 (99 × 152) Bt (RAPFA) 1850

***294** PATON, Noel: *The reconciliation of Oberon and Titania* $30 \times 48\frac{1}{4}$ (76·2 × 122·6) Bt (RSA) 1848

*1230 P A T O N, Noel: *Dawn: Luther at Erfurt* 36½ × 27⅛ (92·7 × 69) Bt 1919

 1953 P A T O N, W. H.: *Victory* Bronze: ht 22½ (57) Gift of the artist's family 1941

*1021 P É R E Z, Gonzalo: *St Michael* W: 71½ × 36¼ (182 × 92) Bt 1910

 1874 P E R I G A L, Arthur: *Strowan bridge* 20½ × 29¼ (52 × 74·3) Bt 1937

*1805 P E R U G I N O, Pietro: *A fragment: four male nude figures* 29 × 21¾ (73·5 × 55·5)
 N A - C F gift 1934

 1250 P E S E L L I N O (imitator): *Madonna and Child with St John* W: 27¼ × 16⅜
 (69·3 × 41·7) Bt 1919

 1131 P E T T I E, John: *Who goes?* 30 × 22 (76·2 × 55·9) Bt 1913

*1187 P E T T I E, John: *Cromwell's Saints* 16¾ × 20½ (42·5 × 52) John Jordan bequest 1914

 534 P H I L L I P, John: *Spanish boys playing at bull-fighting* 53½ × 84¼ (136 × 214)
 Bt (R A P F A) 1867

 565 P H I L L I P, John: *W. B. Johnstone* transferred: S N P G no. 2040

 566 P H I L L I P, John: *Mrs W. B. Johnstone* 19⅝ × 23¾ (49·8 × 60·3) Mrs W. B.
 Johnstone gift 1868

*836 P H I L L I P, John: *La Gloria* 56½ × 85½ (144 × 217) Bt 1897

 1004 P H I L L I P, John: *W. B. Johnstone* 29½ × 24½ (75 × 62·2) Artist's gift (R S A) 1865

 1155 P H I L L I P, John: *Presbyterian catechising* 39⅝ × 61¼ (100·6 × 156) John Jordan
 bequest 1914

 1663 P H I L L I P, John: *Self-portrait* 23½ × 19½ (59·7 × 49·5) James Mackinlay bequest
 1926

 2028 P H I L L I P, John: *Mrs Mary McKay Glen* 41½ × 31½ (105·4 × 80) Miss E. T. C.
 Glen bequest 1945

 675 P I C K E R S G I L L, William: *Portrait of a gentleman* 24½ × 21½ (62·2 × 54·6)
 G. Woodburn gift 1852

 1633 P I E R O D I C O S I M O (style of): *Two censing angels* W (arched): 35 × 71½ (88·9 × 182)
 Sir Claude Phillips bequest 1924

 P I E R O D I C O S I M O (attr): *Madonna and Child with St John* see under I T A L I A N,
 16th cent no. 645

 109 P I E T R O D A C O R T O N A (after, or by a follower of): *Portrait of a prelate* 48 × 37
 (122 × 94) Robert Clouston gift (R I) 1850

*2098 P I S S A R R O, Camille: *The Marne at Chennevières* 36 × 57¼ (91·5 × 145·5) Bt 1947

*2238 P I T T O N I, G. B.: *St Jerome with St Peter of Alcantara* 108 × 56 (275 × 143) Bt 1960

 105 P O L I D O R O D A L A N C I A N O: *Holy Family* 16¾ × 20½ (42·5 × 52) Bt (R I) (1852

*1931 P O L I D O R O D A L A N C I A N O: *Madonna and sleeping Child* 20¾ × 26½ (52·7 × 67·8)
 Marquess of Lothian bequest 1941

*2268 P O P P I, Il: *The Golden Age* W: 16⅞ × 12½ (43 × 31·8) Bt 1964

*2275 P O U R B U S, Frans (attr): *5th Lord Seton and family* 42⅞ × 31 (109 × 79)
 Sir Theophilus Biddulph bequest 1965

 991 P O U R B U S, Pieter: *A married lady of Bruges, aged 26* W: 19¼ × 15½ (49 × 39·4)
 Bt 1909

 P O U S S I N, Gaspard see under D U G H E T

*2319 P O U S S I N N.: *Mystic Marriage of St Catherine* W: 49⅝ × 66¼ (126 × 168)
 Sir John Heathcoat Amory bequest, 1973

 * P O U S S I N, N.: *Moses striking the rock* 38¾ × 53½ (98·5 × 136) Duke of Sutherland
 loan 1946

 * P O U S S I N, N.: *Baptism* 46¼ × 69½ (117·5 × 177) Duke of Sutherland loan 1946

 * P O U S S I N, N.: *Confirmation* 46¼ × 69½ (117·5 × 177) Duke of Sutherland loan 1946

* POUSSIN, N.: *Marriage* $46\frac{1}{4} \times 69\frac{1}{2}$ (117·5 × 177) Duke of Sutherland loan 1946

* POUSSIN, N.: *Penance* $46\frac{1}{4} \times 69\frac{1}{2}$ (117·5 × 177) Duke of Sutherland loan 1946

* POUSSIN, N.: *Ordination* $46\frac{1}{4} \times 69\frac{1}{2}$ (117·5 × 177) Duke of Sutherland loan 1946

* POUSSIN, N.: *Holy Eucharist* $46\frac{1}{4} \times 69\frac{1}{2}$ (117·5 × 177) Duke of Sutherland loan 1946

* POUSSIN, N.: *Extreme Unction* $46\frac{1}{4} \times 69\frac{1}{2}$ (117·5 × 177) Duke of Sutherland loan 1946

***458** POUSSIN, N. (formerly attr): *Feast of the Gods* (after Bellini) $68\frac{1}{2} \times 75\frac{3}{4}$ (174 × 192·4) Sir Charles Eastlake gift 1862/3

2298 POWELL, John: *Stephen Henry Hough* $25\frac{1}{8} \times 18$ (63·8 × 45·7) J. A. F. Hamilton gift 1967

63 PROCACCINI, G. C.: *Cupid* $28\frac{1}{2} \times 38\frac{3}{4}$ (72·4 × 98·4) Bt (RI) 1830

***2276** PROCACCINI, G. C.: *Raising of the Cross* $86 \times 58\frac{1}{2}$ (218 × 148·6) Bt 1965

***1537** PROVOST, Jan: *Virgin and Child* W: $14 \times 8\frac{3}{8}$ (35·6 × 21·3) Bt 1921

1739 PUVIS DE CHAVANNES: *La Vigilance* $41\frac{3}{4} \times 21\frac{3}{4}$ (106 × 55·2) Bt 1929

2317 QUESNEL, François (attr): *René de Beaune, Bishop of Bourges* $14\frac{1}{4} \times 10\frac{1}{4}$ (36·2 × 26) Given by the NA-CF from the Alexander bequest 1972

***302** RAEBURN: *Mrs Scott Moncrieff* $29\frac{1}{2} \times 24\frac{1}{2}$ (75 × 62·3) Robert Scott Moncrieff Wellwood bequest (RSA) 1854

335 RAEBURN: *Alexander Adam* transferred: SNPG no. 2038

***420** RAEBURN: *Macdonell of Glengarry* 95×59 (241 × 150) Bt 1917

522 RAEBURN: *Lord Newton* $29\frac{1}{4} \times 24$ (74·3 × 61) Mrs Malcolm Laing bequest 1864

***623** RAEBURN: *Mrs Hamilton of Kames* $93 \times 58\frac{1}{2}$ (236 × 148·6) Sir William Stirling Maxwell gift 1877

626 RAEBURN: *Mrs Kennedy of Dunure* $49\frac{1}{4} \times 39\frac{1}{2}$ (125 × 100·3) John Heugh gift (RSA) 1877

681 RAEBURN: *John Wauchope* 30×25 (76·2 × 63·5) Rev H. B. Sands gift 1884

831 RAEBURN: *Lady Hume Campbell of Marchmont and child* $77\frac{1}{2} \times 59\frac{1}{4}$ (197 × 151) Sir Hugh Hume Campbell Bart bequest 1894

***837** RAEBURN: *Mrs Campbell of Ballimore* $48\frac{1}{4} \times 38\frac{1}{2}$ (122·6 × 97·8) Lady Riddell bequest 1897

845 RAEBURN: *Alexander Bonar* 30×25 (76·2 × 63·5) Miss S. A. Fleming gift 1900

846 RAEBURN: *Mrs Bonar* 30×25 (76·2 × 63·5) Miss S. A. Fleming gift 1900

***903** RAEBURN: *Major William Clunes* 93×59 (236 × 150) Lady Siemens bequest (RSA) 1902

***930** RAEBURN: *Self-portrait* $35\frac{1}{4} \times 27\frac{1}{2}$ (89·5 × 69·9) Bt 1905

***1026** RAEBURN: *Henry Raeburn on a grey pony* $13\frac{7}{8} \times 9\frac{1}{4}$ (35·3 × 23·5) Bt 1911

***1027** RAEBURN: *John Smith of Craigend* $29\frac{1}{4} \times 24\frac{3}{4}$ (74·3 × 62·9) Bt 1911

1192 RAEBURN: *Mrs Alexander Finlay* $86\frac{5}{8} \times 59\frac{1}{8}$ (221 × 150) Mrs Glassford Bell bequest 1915

1199 RAEBURN: *William Beveridge* $35\frac{1}{2} \times 26\frac{3}{4}$ (90·2 × 68) Mrs Lake Gloag bequest 1917

1222 RAEBURN: *George Kinnear* $34\frac{1}{2} \times 26\frac{3}{4}$ (87·6 × 68) Miss Kinnear bequest 1919

1223 RAEBURN: *Mrs George Kinnear* $34\frac{1}{2} \times 26\frac{3}{4}$ (87·6 × 68) Miss Kinnear bequest 1919

***1224** RAEBURN: *Lieutenant-Colonel Lyon* $35\frac{1}{2} \times 27$ (90·2 × 68·6) Miss Kinnear bequest 1919

1225 RAEBURN: *Dr Gardiner* 35 × 26⅝ (89 × 67·5) Miss Kinnear bequest 1919

1236 RAEBURN: *A dog* 27½ × 35½ (69·8 × 90·2) Bt 1919

1762 RAEBURN: *David Deuchar* Miniature Bt 1931

1816 RAEBURN: *Lady in lace cap* (oval) 29⅛ × 24½ (74 × 62·2) Miss Alice Leslie Inglis
bequest 1934

***1878** RAEBURN: *Miss Lamont of Greenock* 29¾ × 24½ (75·6 × 62·3) Robert Miller
gift 1937

1923 RAEBURN: *James Thomson of Bogie* 48¼ × 38¾ (122·5 × 98·4) Mrs Florence
Davidson gift 1940

***1959** RAEBURN: *Self-portrait* Medallion 3⅞ × 2¾ (9·5 × 7) Bt 1942

2034 RAEBURN: *Mrs Veitch of Eliock* 48½ × 38¾ (123 × 98·4) Francis Neilson gift
through the NA-CF in memory of his mother 1946

2108 RAEBURN: *Portrait of a Jew* 30 × 25 (76·2 × 63·5) Mrs F. C. Holland gift 1948

***2112** RAEBURN: *Rev Robert Walker skating* 30 × 25 (76·2 × 63·5) Bt 1949

***2147** RAEBURN: *Sir Patrick Inglis Bart* 49½ × 39½ (125·7 × 100·3) Sir John D.
Don-Wauchope bequest 1951

***2148** RAEBURN: *James Wauchope* 35½ × 27¼ (90·2 × 69·3) Sir John D. Don-Wauchope
bequest 1951

***2149** RAEBURN: *John Wauchope* 29¾ × 24¾ (75·6 × 62·9) Sir John D. Don-Wauchope
bequest 1951

***2150** RAEBURN: *Anne Erskine* 29¾ × 24¾ (75·6 × 62·9) Sir John D. Don-Wauchope
bequest 1951

***2181** RAEBURN: *Thomas Kennedy of Dunure* 50 × 40 (127 × 101·6) Lady Invernairn
bequest 1956

***2182** RAEBURN: *Mrs Kennedy of Dunure* 50 × 40 (127 × 101·6) Lady Invernairn
bequest 1956

2296 RAEBURN: *Mrs Colin Mackenzie* 49¾ × 39½ (126·5 × 100·4) Lieut Colonel J. C.
Dundas bequest 1967

***2301** RAEBURN: *Sir John Sinclair Bt* 93½ × 60½ (238 × 154) Bt 1967

***430** RAMSAY, Allan: *The painter's wife* 30 × 25 (76·2 × 63·5) Lady Murray of
Henderland bequest 1861

***820** RAMSAY, Allan: *Jean-Jacques Rousseau* 29½ × 25½ (75 × 64·8) Bt 1890/1

***946** RAMSAY, Allan: *Mrs Bruce of Arnot* 29 × 24 (73·7 × 61) Bt 1907

***1523** RAMSAY, Allan: *Lady Robert Manners* (oval) 29¼ × 24¼ (74·3 × 61·6) Mrs Nisbet
Hamilton Ogilvy bequest 1921

1524 RAMSAY, Allan: *Lady Lucy Manners* 29⅛ × 24¼ (74 × 61·6) Mrs Nisbet
Hamilton Ogilvy bequest 1921

1884 RAMSAY, Allan: *Portrait known as Flora Macdonald* 29½ × 24½ (74·9 × 62·2)
Mrs Morag Macdonald bequest 1937

1889 RAMSAY, Allan: *James Kerr* 29½ × 24½ (74·9 × 62·2) Mrs F. G. Kerr gift 1937

***1960** RAMSAY, Allan: *Sir Peter Halkett Wedderburn Bart* 29¼ × 24¼ (74·3 × 61·6)
C. J. G. Paterson bequest 1942

2119 RAMSAY, Allan: *George Bristow* 50 × 40 (127 × 101·6) Bt 1949

2133 RAMSAY, Allan: *Mrs Daniel Cunyngham* 93 × 57½ (238 × 146) Bt 1951

***2151** RAMSAY, Allan: *Sir John Inglis Bt* 30 × 25 (76·2 × 63·5) Sir John D.
Don-Wauchope bequest 1951

***2152** RAMSAY, Allan: *Lady Inglis* 30 × 25 (76·2 × 63·5) Sir John D. Don-Wauchope
bequest 1951

2295 RAMSAY, Allan: *Sketch of a dead child* $12\frac{5}{8} \times 10\frac{3}{4}$ (32 × 27·3) Lady Murray of Henderland bequest 1861

1935 RAMSAY, Allan (attr): *Caroline D'Arcy 4th Marchioness of Lothian* 93 × 58 (238 × 147) Marquess of Lothian bequest 1941

* RAPHAEL: *Holy Family with a palm tree* (circular) 40 (101·5) Duke of Sutherland loan 1946

* RAPHAEL: *Madonna with the veil* W: $27 \times 18\frac{7}{8}$ (68·5 × 48) Duke of Sutherland loan 1946

* RAPHAEL: *Madonna del Passeggio* W: $35\frac{1}{2} \times 25$ (90 × 63·3) Duke of Sutherland loan 1946

* RAPHAEL: *Bridgewater Madonna* 32 × 22 (81 × 56) Duke of Sutherland loan 1946

RAPHAEL (studio): *Two heads* see under GIULIO ROMANO no. 638.

110 RAPHAEL (after): *St Peter* $32\frac{5}{8} \times 26\frac{1}{4}$ (82·8 × 67·3) Acquired (RI) 1830

1854 RAPHAEL (after): *Copy of the Garvagh Madonna* W: $10\frac{7}{8} \times 8\frac{5}{8}$ (27·6 × 21·9) Mr and Mrs J. Percy Callard gift 1936

RAPHAEL (after): *The Transfiguration* see under URQUHART no. 66

1740 REID, George: *Norham Castle* $23\frac{1}{2} \times 35\frac{1}{2}$ (59·7 × 90·2) Bt 1929

***827** REMBRANDT: *Woman in bed* $32 \times 26\frac{3}{4}$ (81·3 × 68) Rt Hon William McEwan gift 1892

* REMBRANDT: *Study of a man's head* $8\frac{1}{4} \times 6\frac{3}{4}$ (21 × 17·2) Duke of Sutherland loan 1946

* REMBRANDT: *Hannah and Samuel* (?) W: $16 \times 12\frac{1}{2}$ (40·6 × 31·8) Duke of Sutherland loan 1946

* REMBRANDT: *Self-portrait* $21 \times 17\frac{3}{4}$ (53·3 × 44) Duke of Sutherland loan 1946

* REMBRANDT: *Young woman with flowers in her hair* W: (oval): 28 × 21 (71 × 53·2) Duke of Sutherland loan 1946

RENI, Guido (attr): *Holy Trinity* see under CANTARINI no. 42

RENI, Guido (after): *SS Peter and Paul* see under WILLIAMS, S. no. 43

***2230** RENOIR: *Mother and Child* $16\frac{1}{4} \times 13$ (41·3 × 33) Sir Alexander Maitland gift 1960

***70** RESCHI, Pandolfo: *A battle* $37\frac{1}{2} \times 58$ (95 × 147·3) Bt (RI) 1831

338 REYNOLDS: *James Coutts* W: $20\frac{3}{4} \times 17$ (52·7 × 43·2) Lord Elcho (Earl of Wemyss) gift 1858

427 REYNOLDS: *Sir David Lindsay Bart of Evelick* 30 × 24 (76·2 × 61) Lady Murray of Henderland bequest 1861

***1215** REYNOLDS: *Captain Duncan* $50 \times 39\frac{3}{4}$ (127 × 101) Earl of Camperdown bequest 1918

***1666** REYNOLDS: *A little girl (Lady Frances Scott?)* $29\frac{1}{4} \times 24\frac{1}{4}$ (74·3 × 61·6) Bt 1926

***2171** REYNOLDS: *The Ladies Waldegrave* $56\frac{1}{2} \times 66$ (143·5 × 168) Bt 1952

***2183** REYNOLDS: *Alexander, later 10th Duke of Hamilton* $27 \times 21\frac{5}{8}$ (68·5 × 55) Lady Invernairn bequest 1956

1077 RHIND, John: *Athenian youth* Marble: ht $30\frac{1}{2}$ (77·5) Bt 1912

RIBERA (attr): *Martyrdom of St Sebastian* see under NEAPOLITAN, 17th cent no. 84

RIBERA (attr): *A hermit saint doing penance* see under ITALIAN c 1630 no. 812

RIBERA (follower): *'A mathematician'* see under NOVELLI no. 83*

***7** RICCI, Marco (attr): *Landscape with monks* $37 \times 49\frac{1}{2}$ (94 × 126) Bt (RI) 1831

304 ROBERTS, David: *View of Rome* 84 × 168 (213 × 427) Artist's gift (RSA) 1857

***2261** ROBERTS, David: *View of Rome* W: $8\frac{1}{2}$ × $16\frac{1}{8}$ (21·6 × 41) Bt 1963

1741 ROBERTSON, Andrew: *Portrait of a man* Miniature Kenneth Sanderson
bequest 1943

1992 ROBERTSON, Andrew: *Lord Medwyn* Miniature Kenneth Sanderson bequest 1943

1993 ROBERTSON, Andrew (after): *Copy of no. 1992* Kenneth Sanderson bequest 1943

1994 ROBERTSON, Andrew: *Mary Robertson* Miniature Kenneth Sanderson bequest
1943

1995 ROBERTSON, Andrew: *Portrait of a lady* Miniature Kenneth Sanderson bequest
1943

2012 ROBERTSON, Andrew: *Lady in white dress* Miniature Sir St Clair Thomson
bequest 1944

1733 ROCHE, Alexander: *Nell* $18\frac{7}{8}$ × $16\frac{1}{4}$ (48 × 41·3). A. F. Roberts bequest 1929

2143 ROCHE, Alexander: *Afternoon sunshine, St Monans* W: $10\frac{1}{2}$ × $13\frac{3}{4}$ (26·7 × 35)
Sir James and Lady Caw bequest 1951

2360 ROCHE, Alexander: *Roses* W: $10\frac{5}{8}$ × $11\frac{3}{4}$ (27 × 30) Robert A. Lillie bequest 1977

***1747** RODIN: *La Défense* Bronze: ht 45 (114·3) J. J. Cowan gift 1930

***2054** RODIN: *Le lion qui pleure* Bronze: ht $10\frac{1}{2}$ (26·7) Sir D. Y. Cameron bequest 1945

***2290** RODIN: *The young mother* Marble: ht $23\frac{1}{2}$ (59·7) Sir Alexander Maitland
bequest 1965

1937 ROESTRAETEN, Pieter: *Still-life with musical instruments* M: $15\frac{1}{4}$ × $22\frac{1}{4}$
(38·7 × 56·5) Marquess of Lothian bequest 1941

ROMAN: *Antonia Augusta* see p. 158 (no. 935).

***1674** ROMNEY, George: *Mrs Wilbraham Bootle* $48\frac{3}{4}$ × $39\frac{1}{4}$ (123·9 × 99·7) Bt 1927

600 ROSA, Salvator (after): *Figure in armour* $33\frac{3}{4}$ × $23\frac{1}{4}$ (85·7 × 59) Lady Belhaven
bequest 1873

600a ROSA, Salvator (after): *Figure in armour* $33\frac{3}{4}$ × $23\frac{1}{4}$ (85·7 × 59) Lady Belhaven
bequest 1873

622 ROSA, Salvator (after): *River scene* $14\frac{1}{8}$ × $34\frac{1}{4}$ (35·9 × 87) Mrs Mary Veitch
bequest (RSA) 1875

920 ROSS, Joseph Thorburn: *The Bass Rock* (circular) 57 (145) Presented 1904

632 ROSS, Robert Thorburn: *Sunshine* $33\frac{5}{8}$ × $43\frac{5}{8}$ (85·5 × 111) John Scott bequest 1878

2002 ROSS, William: *Portrait of a lady* Miniature Kenneth Sanderson bequest 1943

2241 ROSS, William: *Harriet E. Simson* Miniature Mrs Charles Knox gift 1960

***1030** ROSSELLI, Cosimo: *St Catherine of Siena* W: $61\frac{1}{2}$ × $62\frac{1}{2}$ (156 × 159) Bt 1911

ROSSELLO DI JACOPO FRANCHI: *Cassone* see under TOSCANI (workshop)
no. 1738*

1721 ROSSETTI, D. G.: *Beata Beatrix* $33\frac{1}{2}$ × $25\frac{3}{4}$ (85 × 65·4) A. E. Anderson gift 1928

***2097** RUBENS: *St Ambrose* W: $19\frac{1}{2}$ × 15 (49·6 × 38·1) Bt 1947

***2193** RUBENS: *Feast of Herod* 82 × 104 (208 × 264) Bt 1958

***2311** RUBENS: *Adoration of the Shepherds* W: 29 × $36\frac{3}{8}$ (73·8 × 92·4) Bt 1970

***75** RUISDAEL, Jacob: *The banks of a river* $52\frac{3}{4}$ × 76 (134 × 193) Torrie collection

***** RUISDAEL, Jacob: *Ruins beside a river* $20\frac{3}{4}$ × 25 (52·7 × 63·5) Earl of Wemyss
and March loan 1957

***790** RUNCIMAN, Alexander: *Italian river landscape* W: $11\frac{1}{4}$ × $14\frac{1}{2}$ (28·6 × 36·8) Bt
1887

2189 RUNCIMAN, Alexander: *Hubert and Arthur* $22\frac{1}{4}$ × 31 (56·5 × 78·7) Sir Alec and
Lady Martin gift through the NA-CF 1957

305 RUNCIMAN, John: *Portrait of a young man* $30\frac{1}{4} \times 25$ (77×63.5) Robert Chambers gift 1845-59

***570** RUNCIMAN, John: *King Lear in the storm* W: $17\frac{1}{2} \times 24$ (44.4×61) David Laing bequest 1879

***648** RUNCIMAN, John: *The Flight into Egypt* W: $11\frac{3}{4} \times 8\frac{3}{4}$ (29.9×22.3) David Laing bequest 1879

792 RUNCIMAN, John: *The Temptation of Our Lord* W: $7\frac{1}{4} \times 11\frac{1}{4}$ (18.4×28.6) Bt 1887

***793** RUNCIMAN, John: *The Road to Emmaus* M: $6\frac{1}{2} \times 8\frac{1}{2}$ (16.5×21.6) Bt 1887

1005 RUNCIMAN, John: *Salome receiving the Baptist's head* W: $7\frac{1}{4} \times 5\frac{1}{4}$ (18.4×13.3) William Nelson gift (RSA) 1887

***2116** RUNCIMAN, John: *The Good Samaritan* W: $7\frac{7}{8} \times 11\frac{1}{8}$ (22.6×28.3) Bt 1949

1525 RUSSELL, John: *Mrs Gumley* Pastel: $33\frac{3}{4} \times 29$ (85.7×73.7) Mrs Nisbet Hamilton Ogilvy bequest 1921

***1508** SAFTLEVEN, Herman: *Christ preaching from a boat* W: $29\frac{1}{2} \times 42\frac{1}{2}$ (75×108) Mrs Nisbet Hamilton Ogilvy bequest 1921

387 SANDERS, George: *Portrait of a lady* Miniature William Tassie bequest 1860

1010 SANDERS, George: *Oswald Hunter* Miniature Dr J. Dickson Hunter bequest (RSA) 1890

1565 SANO DI PIETRO (workshop): *Coronation of the Virgin* W: $27\frac{1}{2} \times 16$ (70×40.6) Bt 1922

663 SANTVOORT, Dirk: *'The young housekeeper'* W: $47\frac{1}{2} \times 35\frac{5}{8}$ (120.7×90.5) William Wright gift 1881

1656 SARGENT, John Singer: *Lady Agnew of Lochnaw* $49 \times 39\frac{1}{4}$ (124.5×99.7) Bt 1925

1787 SARGENT, John Singer: *Mrs Ernest Hills of Redleaf* $61\frac{1}{2} \times 40\frac{1}{4}$ (156×102) Mrs Ernest Hills bequest 1933

***2297** SARTO, Andrea del: *Self-portrait* W: $33\frac{7}{8} \times 26\frac{1}{4}$ (86×66.6) Bt 1967

SCALETTI, L. (attr): *Madonna and Child with Saints* see under EMILIAN, 15th cent no. 1634

786 SCHETKY, John: *Sea piece* 36×50 (91.5×127) The Misses Schetky gift 1886

428 SCHMIDT, Johann: *Prince Ftalsky, Count Suvarov* Pastel (octagonal): 11×9 (27.9×22.8) Lady Murray of Henderland bequest 1861

SCHÖNFELD, J. (attr): *Battlefield* see under ITALIAN, 17th cent no. 85

***76** SCORZA, Sinibaldo: *Philemon and Baucis* $19 \times 28\frac{1}{2}$ (48.3×72.5) Bt (RI) 1830

***77** SCORZA, Sinibaldo: *Latona and the peasants* $19 \times 28\frac{1}{2}$ (48.3×72.5) Bt (RI) 1830

***342** SCOTT, David: *Vintager* $46 \times 38\frac{1}{4}$ (116.9×97.2) Andrew Coventry gift 1859

796 SCOTT, David: *Paracelsus lecturing on the Elixir Vitae* $58\frac{1}{2} \times 73$ (149×186) Bt (RAPFA) 1887

***825** SCOTT, David: *Philoctetes* $39\frac{3}{4} \times 47$ (101×119.4) J. W. Cousin gift 1890

***843** SCOTT, David: *The Traitor's Gate* W: 54×72 (137.2×183) Robert Carfrae gift 1899

***992** SCOTT, David: *Puck fleeing from the dawn* $37\frac{1}{2} \times 57\frac{1}{2}$ (95.3×146) Bt 1909

1006 SCOTT, David: *Ariel and Caliban* $46 \times 38\frac{3}{4}$ (116.8×98.5) Bt (RSA) 1849

1147 SCOTT, David: *The giants* Fresco: $39 \times 29\frac{1}{4}$ (99×74.3) Miss Fairbairn bequest 1914

1647 SCOTT, David: *The fire of London* $37\frac{3}{4} \times 20\frac{1}{2}$ (96×52) Arthur Kay gift 1924

1676 SCOTT, David: *The Descent from the Cross* $18\frac{1}{2} \times 15\frac{1}{2}$ (47×39.3) Bt 1927

1751 SCOTT, David: *The dead Sarpedon* $70\frac{1}{2} \times 55\frac{1}{2}$ (179 × 141) Miss Isabella Spring Brown gift 1930

1876 SCOTT, David: *Children pursuing fortune* $20 \times 36\frac{3}{4}$ (50·8 × 93·4) Miss Isabella Spring Brown bequest 1937

1877 SCOTT, David: *Dr Samuel Brown* $30\frac{1}{2} \times 25\frac{1}{2}$ (77·5 × 64·8) Miss Isabella Spring Brown bequest 1937

2072 SCOTT, David: *'The belated peasant'* 29×36 (73·6 × 71·5) Bt 1946

2073 SCOTT, David: *John Stirling* 30×25 (76·2 × 63·5) Bt 1946

2118 SCOTT, David: *William Bell Scott* $29\frac{7}{8} \times 24\frac{3}{4}$ (76 × 63) Miss Courtney-Boyd gift 1949

***969** SCOTT, W. B.: *Albrecht Dürer in Nürnberg* $23\frac{3}{4} \times 28\frac{3}{4}$ (60·4 × 73) Bt 1909

2299 SCOTTISH, 19th cent: *Interior of the National Gallery of Scotland c 1867-77* $19\frac{7}{8} \times 24$ (50·5 × 61) Bt 1967

***2032** SCOUGALL, John (attr): *Self-portrait* $24\frac{1}{2} \times 19\frac{3}{4}$ (62·3 × 50·2) Bt 1945

2010 SCOULAR, James: *William Ridding* Miniature Kenneth Sanderson bequest 1943

2011 SCOULAR, James: *Ellen Ridding* Miniature Kenneth Sanderson bequest 1943

***1941** SELLAIO, Jacopo del: *Man of Sorrows:* W: $12\frac{1}{2} \times 18\frac{1}{8}$ (31·8 × 46) Marquess of Lothian bequest 1941

***1538** SELLAIO, Jacopo del (attr): *Triumphal procession* W: $16\frac{3}{8} \times 65\frac{3}{8}$ (41·5 × 166) Bt 1921

***1513** SERODINE, Giovanni: *The Tribute Money* $57 \times 89\frac{1}{2}$ (145 × 227) Mrs Nisbet Hamilton Ogilvy bequest 1921

***1837** SETON, J. T.: *William Fullerton and Ninian Lowis* $29\frac{1}{4} \times 24\frac{1}{4}$ (74·3 × 61·6) Miss W. M. Fullerton bequest 1936

***1840** SETON, J. T.: *Lady Barrowfield* 30×25 (76·2 × 63·5) Bt 1936

1841 SETON, J. T.: *Mrs Smith (Lady Barrowfield's sister)* $29\frac{1}{2} \times 24\frac{1}{2}$ (75 × 62·2) Bt 1936

***2222** SEURAT: *Study for 'Une Baignade'* W: $6\frac{1}{4} \times 9\frac{3}{4}$ (15·9 × 24·8) Sir Alexander Maitland gift 1960

***2324** SEURAT: *La luzerne, St Denis* $25\frac{1}{4} \times 32$ (64 × 81) Bt 1973

2255 SHIRREFF, William: *Mary Queen of Scots escaping from Loch Leven Castle* $30\frac{3}{8} \times 36\frac{3}{8}$ (77·2 × 92·4) Mrs Fairgrieve gift 1963

308 SIMSON, William: *Solway Moss* $26\frac{1}{4} \times 37$ (66·7 × 94) Bt (RSA) 1853

368 SIMSON, William: *Scene in Holland* W: $9\frac{1}{2} \times 15\frac{1}{2}$ (24·1 × 39·4) Mrs Williams gift 1860

***369** SIMSON, William: *Twelfth of August* W: $9\frac{1}{2} \times 15\frac{1}{2}$ (24·1 × 39·4) Mrs Williams gift 1860

533 SIMSON, William: *Passage boats on the Maas at Dort* W: $11\frac{1}{2} \times 16\frac{3}{4}$ (29·2 × 42·5) Bt (RI) 1867

609 SIMSON, William: *Goatherd's cottage* W: $19\frac{1}{2} \times 26\frac{1}{2}$ (49·2 × 67·3) Acquired (RSA) by 1883

708 SIMSON, William: *Dog's head* $24\frac{1}{2} \times 21$ (62·2 × 53·3) Mary, Lady Ruthven bequest 1885

2175 SINCLAIR, A. G.: *Horses harrowing* $15\frac{3}{4} \times 19\frac{3}{4}$ (40 × 50·2) Mrs L. H. Sinclair bequest 1954

***79** SIRANI, Elisabetta: *St John in the wilderness* $29\frac{3}{4} \times 24\frac{1}{4}$ (75·5 × 61·6) Bt (RI) 1831

1775 SISLEY, Alfred: *Effet de neige* Pastel: $18 \times 21\frac{1}{2}$ (45·7 × 54·6) Bt 1932

***2235** SISLEY, Alfred: *Molesey Weir* $20\frac{1}{4} \times 27$ (51·5 × 68·6) Sir Alexander Maitland gift 1960

659 SKIRVING: Archibald: *Portrait* Pastel and gouache: $24\frac{1}{2} \times 21\frac{1}{8}$ (62·2 × 53·6)
W. M. Bryce gift 1879

849 SKIRVING, Archibald: *Mrs Carnegie* Pastel: $23\frac{3}{4} \times 17\frac{3}{4}$ (60·3 × 45) James
Carnegie bequest 1899

1914 SKIRVING, Archibald: *Portrait head* Pastel: $24\frac{1}{4} \times 19\frac{1}{4}$ (61·6 × 48·9) Miss
E. K. H. Scott bequest 1939

2212 SMIBERT, John: *Colonel Douglas* 30 × 25 (76·2 × 63·5) Bt 1959

532 SNYDERS, Frans: *Mischievous monkeys* $38\frac{1}{8} \times 45\frac{1}{4}$ (96·8 × 115) Bt (RI) 1867

80 SNYDERS, Frans (attr): *Bear hunt* $61\frac{3}{4} \times 79\frac{3}{4}$ (157 × 203) Bt (RI) 1840

795 SOLDI, Andrea: *Portrait of a gentleman* $43\frac{1}{2} \times 34\frac{1}{2}$ (110·5 × 87·6) Bt 1887

805 SOMERVILLE, Andrew: *Cottage children* 14 × $11\frac{7}{8}$ (35·5 × 30·2) William Nelson
gift (RSA) 1887

SPANISH, 15th century: *St Michael* see under PÉREZ no. 1021*

1970 STAPPEN, Charles van der: *The gleaner* Bronze: ht 18 (45·7) Bt 1942

311 STARK, James: *Gowbarrow Park* W: $8\frac{1}{2} \times 10\frac{7}{8}$ (21·6 × 27·6) Bt (RI) 1827

524 STEELL, John: *H. W. Williams* Marble: $15\frac{1}{2} \times 13\frac{1}{4}$ (39·3 × 33·6) Mrs Williams
gift 1866

557 STEELL, John: *Katherine, Lady Stuart of Allanbank* Marble: ht $23\frac{1}{4}$ (59) Lady
Stuart bequest 1867

***86** STEEN, Jan: *The doctor's visit* 28 × $22\frac{1}{2}$ (71·1 × 57·2) Torrie collection

***** STEEN, Jan: *A school for boys and girls* 33 × 43 (83·8 × 109·2) Duke of
Sutherland loan 1946

1696 STEVENS, Alfred: *Original models for metal work* Mr and Mrs Frank Rinder
to gift 1928
1713

2055 STEVENS, Alfred: *Lion sejant* Bronze: ht 13 (33) Sir D. Y. Cameron bequest
1945

2057 STEVENS, Alfred: *Truth and Falsehood* Bronze: ht $23\frac{1}{4}$ (59) Sir D. Y. Cameron
bequest 1945

2058 STEVENS, Alfred: *Valour spurning Cowardice* Bronze: ht $25\frac{1}{2}$ (64·8) Sir D. Y.
Cameron bequest 1945

1987 STEWART, Anthony: *Sir Hew Whiteford Dalrymple Bart* Miniature Kenneth
Sanderson bequest 1943

1988 STEWART, Anthony: *Colonel A. J. Dalrymple* Miniature Kenneth Sanderson
bequest 1943

1989 STEWART, Anthony: *Major Edward Fanshawe* Miniature Kenneth Sanderson
bequest 1943

1990 STEWART, Anthony: *Frances Mary Fanshawe* Miniature Kenneth Sanderson
bequest 1943

1991 STEWART, Anthony: *Edward G. Fanshawe* Miniature Kenneth Sanderson
bequest 1943

1446 STOMER, Matthias (attr): *Man with jug and girl with viol* 36 × 31 (91·4 × 78·7)
Bt 1920

900 STOTHARD, Thomas: *7 illustrations to Burns' poems* Henry Vaughan bequest 1900

901 STOTHARD, Thomas: *9 illustrations to Burns' poems* Henry Vaughan bequest 1900

1692 STOTT, William: *T. Millie Dow* 41 × $37\frac{7}{8}$ (104·2 × 81) Allan McLean bequest
1928

1693 STOTT, William: *The Fischerhorn glacier* Pastel: $9\frac{3}{4} \times 12\frac{3}{4}$ (24·8 × 32·4) Allan McLean bequest 1928

1951 SWAN, J. M.: *Matthew Maris* $20\frac{1}{2} \times 16\frac{1}{4}$ (52 × 41·3) Mrs and Miss Swan gift 1941

2060 SWAN, J. M.: *Panther stalking* Bronze: length $15\frac{1}{2}$ (39·4) Sir D. Y. Cameron bequest 1945

2063 SWAN, J. M.: *Lioness drinking* Bronze: length $10\frac{3}{4}$ (27·3) Sir D. Y. Cameron bequest 1945

721 SYME, John: *Rev John Barclay M.D.* transferred: SNPG no. 1830

2124 SYME, John: *The artist's brothers* $35\frac{3}{4} \times 27\frac{1}{4}$ (90·8 × 69·8) Miss Ella S. Boswell gift 1950

2125 SYME, John: *Maria Syme* $29\frac{1}{2} \times 25$ (75 × 63·5) Miss Ella S. Boswell gift 1950

386 TASSIE, James: *12 portrait medallions* transferred: SNPG nos. 1957-68

TAVELLA: *Landscape* see under DUGHET no. 88*

***90** TENIERS, David: *Peasants playing bowls* W: $13\frac{3}{4} \times 22\frac{1}{2}$ (35 × 57·2) Torrie collection

823 TENIERS, David: *Dutch boors drinking* W: $14\frac{7}{4} \times 10\frac{5}{8}$ (37·5 × 27) Bt 1891

***** TERBORG see under BORCH

***28** TERBRUGGHEN, H. (attr): *Beheading of St John Baptist* $66 \times 85\frac{3}{4}$ (168 × 218) James S. Wardrop gift 1850

***2325** TESTA, Pietro: *Adoration of the Shepherds* $34\frac{3}{4} \times 49\frac{1}{4}$ (88·3 × 125·5) Bt 1973

2326 TESTA, Pietro (after): *Triumph of painting* $33\frac{1}{2} \times 42\frac{1}{8}$ (85 × 106·8) Miss Armide Oppé gift through the NA-CF 1973

1615 THOMAS, J. Havard: *Castanets* Bronze: ht $13\frac{3}{4}$ (34·9) Bt 1922

2062 THOMAS, J. Havard: *Head of a young girl* Bronze: ht $5\frac{1}{2}$ (14) Sir D. Y. Cameron bequest 1945

316 THOMSON, Rev John: *Robert the Bruce's castle of Turnberry* $31\frac{3}{4} \times 48$ (80·7 × 121·9) Commissioned (RI) 1828

372 THOMSON, Rev John: *Landscape composition* 20×30 (50·8 × 76·2) Mrs Williams gift 1860

461 THOMSON, Rev John: *On the Firth of Clyde* 25×38 (63·5 × 96·5) Professor James Pillans bequest 1863

462 THOMSON, Rev John: *Ravensheugh·Castle* $25\frac{1}{4} \times 38\frac{1}{2}$ (64·2 × 97·8) Professor James Pillans bequest 1863

463 THOMSON, Rev John: *The Trossachs* 38×50 (63·5 × 127) Professor James Pillans bequest 1863

464 THOMSON, Rev John: *Trees on the banks of a stream* $11 \times 8\frac{3}{4}$ (28 × 22·2) Professor James Pillans bequest 1863

***556** THOMSON, Rev John: *Aberlady Bay* $25\frac{1}{4} \times 37\frac{1}{4}$ (64·2 × 94·6) Katherine, Lady Stuart bequest 1867

929 THOMSON, Rev John: *Wooded landscape* W: $11\frac{7}{8} \times 9\frac{1}{2}$ (30·2 × 24·1) Bt 1905

1228 THOMSON, Rev John: *The castle on the rock* 14×19 (35·6 × 48·3) A. W. Inglis gift 1919

1727 THOMSON, Rev John: *Fast Castle* W: $19\frac{3}{4} \times 30$ (50·2 × 76·2) A. W. Inglis bequest 1929

1864 THOMSON, Rev John: *Cliff scene* $16\frac{3}{8} \times 19\frac{1}{2}$ (41·6 × 49·5) Bt 1936

***2039** THOMSON, Rev John: *Fast Castle from below* $30 \times 41\frac{1}{2}$ (76·2 × 105·4) Bt 1946

***2191** THOMSON, Rev John: *Landscape composition* W: $14\frac{1}{2} \times 19$ (36·8 × 48·3) Bt 1957

2249 THOMSON, Rev John: *The artist's son, Francis* B: 14 × 10 (35·6 × 25·5) Mrs L. D. Luard gift 1961

2263 THOMSON, Rev John: *Edinburgh from Corstorphine Hill* W: 13¾ × 19 (34·9 × 48·3) Bt 1963

2264 THOMSON, Rev John: *View south of Edinburgh* Paper on wood: 10½ × 12¾ (26·7 × 32·4) Bt 1963

2265 THOMSON, Rev John: *Glen Altrive, Selkirkshire* 17½ × 23½ (44·5 × 59·7) Bt 1963

1748 THOMSON, W. J.: *Portrait of a young man* Miniature Bt 1930

1845-9 THORBURN, Robert: *5 miniatures* Edward Thorburn bequest 1936

*91 TIEPOLO, G. B.: *The meeting of Antony and Cleopatra* 26¼ × 15 (66·7 × 38·1) Bt (RI) 1845

*92 TIEPOLO, G. B.: *The finding of Moses* 79 × 134 (202 × 342) Robert Clouston gift (RI) 1845

1515 TILBORCH, Egidius II (attr): *Boors carousing* 9½ × 11¼ (24·1 × 28·6) Mrs Nisbet Hamilton Ogilvy bequest 1921

689 TINTORETTO, Jacopo: *Male head* 13 × 9¾ (33 × 24·8) Mary, Lady Ruthven bequest 1885

2161 TINTORETTO, Jacopo: *A Venetian family presented to the Madonna* 92¾ × 69 (236 × 175) Bt 1952

* TINTORETTO, Jacopo: *Portrait of a Venetian* 29¼ × 24½ (74·5 × 62) Duke of Sutherland loan 1946

* TINTORETTO, Jacopo: *The Deposition* 80 × 59 (203 × 150) Duke of Sutherland loan 1946.

99 TINTORETTO, Jacopo (studio): *Portrait of a man* 32 × 28 (81·3 × 71·1) Bt (RI) 1845

96 TINTORETTO, Jacopo (follower): *Summer* 45½ × 37½ (115·1 × 95·3) Bt (RI) 1830

97 TINTORETTO, Jacopo (follower): *Spring* 45½ × 37½ (115·1 × 95·3) Bt (RI) 1830

98 TINTORETTO, Jacopo (follower): *Winter* 45½ × 37½ (115·1 × 95·3) Bt (RI) 1830

* TITIAN: *Diana and Actaeon* 74 × 80 (188 × 203) Duke of Sutherland loan 1946

* TITIAN: *Diana and Calisto* 74 × 81 (118 × 206) Duke of Sutherland loan 1946

* TITIAN: *Venus Anadyomene* 29⅞ × 22½ (76 × 57·3) Duke of Sutherland loan 1946

* TITIAN: *Holy Family with St John the Baptist* 24¼ × 36 (61·5 × 91·5) Duke of Sutherland loan 1946

* TITIAN: *Three Ages of Man* 35½ × 59½ (90 × 151) Duke of Sutherland loan 1946

103 TITIAN (after): *Bacchanal: the Andrians* 66 × 85¾ (167·6 × 217·8) Bt (RSA) 1853

104 TITIAN (imitator): *Portrait of a man* 28¼ × 23 (71·8 × 58·4) Bt (RI) 1830

1206 TORRANCE, James: *The pet pigeon* 18 × 15¼ (45·7 × 38·7) Mrs Torrance gift 1917

2146 TORRANCE, James: *Dimples* 12 × 10 (30·5 × 25·5) Sir James L. Caw bequest 1951

*1738 TOSCANI, Giovanni (workshop): *Cassone* Dr John Warrack gift 1929

1865 TRAQUAIR, Phoebe: *4 embroidered panels* each c 72 × 29 (183 × 73·7) Artist's bequest 1936

1866 TRAQUAIR, Phoebe: *Pan* W: 69 × 32½ (175·3 × 82·6) Artist's bequest 1936

1867 TRAQUAIR, Phoebe: *3 studies for a decoration* each c 9¾ × 8 (24·8 × 20·4) Artist's bequest 1936

1868 TRAQUAIR, Phoebe: *'For so He giveth His beloved Sleep'* Oil on plaster: 16¼ × 13 (41·3 × 33) Artist's bequest 1936

1869 TRAQUAIR, Phoebe: *The shepherd boy* Oil on plaster: 7¾ × 9⅝ (19·8 × 24·5) Artist's bequest 1936

1871 TRAQUAIR, Phoebe: *Triptych* W: $8\frac{3}{4} \times 7\frac{1}{8}$ (22·3 × 18·2); wings $8\frac{3}{4} \times 3\frac{5}{8}$
(22·3 × 9·3) Artist's bequest 1936

1033 TROYON, Constant: *Pâturage en Touraine* 31 × $45\frac{1}{2}$ (78·8 × 115·6) Hugh A. Laird
bequest 1911

1034 TROYON, Constant: *Retour du travail* $25\frac{1}{2}$ × 32 (64·8 × 81·3) Hugh A. Laird
bequest 1911

1466 TROYON, Constant: *Sheep and shepherd* W: $13\frac{1}{2} \times 10\frac{1}{4}$ (34·3 × 26) Dr John
Kirkhope bequest 1920

*1614 TURNER, J. M. W.: *Somer Hill, Tonbridge* 36 × $48\frac{1}{8}$ (91·5 × 122·3) Bt 1922

1958 TUSCAN, 14th cent: *Triptych* W: $28\frac{1}{4} \times 10\frac{1}{2}$ (71·7 × 26·7); wings 22 × $6\frac{1}{4}$
(55·8 × 15·9) Bt 1942

 TUSCAN, 15th cent: *The burial of St Ephraim* see under AMEDEI no. 1528*

66 URQUHART, G. (after Raphael): *The Transfiguration* 160 × 110 (406·5 × 279·5)
Bt (RI) 1827

*2180 VELÁZQUEZ: *Old woman cooking eggs* 39 × 46 (99 × 117) Bt 1955

1625 VELÁZQUEZ (after): *King Philip IV of Spain* 20 × 18 (50·8 × 45·7) Bt 1923

*114 VELDE, W. van de, II: *Fishing boats in a calm* $16\frac{1}{2} \times 22\frac{1}{8}$ (41·9 × 56·2) Torrie
collection

376 VELDE, W. van de (attr): *Engagement between the English and Dutch fleets*
$27\frac{3}{4} \times 48\frac{3}{4}$ (70·5 × 123·8) George H. Girle gift 1860

1947 VELDE, W. van de (attr): *Ships in a calm* W: $14\frac{1}{2} \times 19\frac{5}{8}$ (36·8 × 49·9) Miss Alice
Anne White bequest 1941

*690 VENETIAN, 16th cent: *An archer* W: $21\frac{1}{4} \times 16\frac{1}{4}$ (54 × 41·3) Mary, Lady Ruthven
bequest 1885

704 VENETIAN, 16th cent: *Scholar with inkstand* $34\frac{1}{2} \times 42\frac{1}{2}$ (87·6 × 108) Mary, Lady
Ruthven bequest 1885

 VENETIAN, 18th cent: *Venetian scene* see under ITALIAN, 18th or 19th cent
no. 910

 VENETIAN, 18th cent: *View in Venice* see under CANALETTO (follower)
no. 2014

 VENETIAN, 18th cent: *Rebecca at the well* see under MONTI no. 2120

1516 VERBRUGGEN, Gaspar: *Fruit and flower piece* $15\frac{1}{2} \times 12\frac{1}{2}$ (39·4 × 31·8) Mrs
Nisbet Hamilton Ogilvy bequest 1921

1517 VERBRUGGEN, Gaspar: *Fruit and flower piece* $15\frac{3}{4} \times 12\frac{1}{2}$ (40 × 31·8) Mrs Nisbet
Hamilton Ogilvy bequest 1921

*1670 VERMEER, Johannes: *Christ in the house of Martha and Mary* 63 × $55\frac{3}{4}$ (160 × 142)
Gift of the sons of W. A. Coats 1927

1637 VERNET, C. J. (after): *The Italian gondola* 29 × $38\frac{1}{2}$ (73·7 × 97·8) Sir Claude
Phillips bequest 1924

339 VERONESE, Paolo: *Mars and Venus* 65 × $49\frac{3}{4}$ (165 × 126·4) Bt (RI) 1859

*1139 VERONESE, Paolo: *St Anthony Abbot and a donor* 78 × $46\frac{1}{4}$ (198·5 × 117·8) Bt 1913

*2338 VERROCCHIO, Andrea del: *Madonna and Child* 42 × 30 (106·7 × 76·3) Bt 1975

*952 VITALE DA BOLOGNA: *Adoration of the Kings* W: $23\frac{3}{4} \times 15\frac{1}{4}$ (60·4 × 39)
Bt 1908

1467 VOLLON, Antoine: *The silver vase* W: $9\frac{1}{2}$ × 7 (24·1 × 17·8) Dr John Kirkhope
bequest 1920

*2228 VUILLARD, E.: *The open window* B: $21\frac{1}{2}$ × 17 (54·6 × 43·2) Sir Alexander
Maitland gift 1960

***2229** VUILLARD, E.: *La causette* $12\frac{3}{4} \times 16\frac{1}{4}$ (32·4 × 41·3) Sir Alexander Maitland gift 1960

2366 WAITT, Richard: *Still-life* $23\frac{1}{4} \times 30\frac{7}{8}$ (59·3 × 78·5) Bt 1978

1982 WALLS, William: *The artist's mother* $35\frac{3}{4} \times 28\frac{3}{4}$ (90·8 × 73) Mrs William Walls gift 1944

1655 WALTON, Edward: *The ford, New Abbey* $30\frac{5}{8} \times 39\frac{3}{4}$ (77·8 × 101) H. Ballantyne gift 1925

2348 WALTON, Edward: *Portrait of his mother* $50\frac{3}{4} \times 40\frac{3}{4}$ (129 × 103·5) Mrs Dorothy Walton gift 1977

***2306** WARD, James: *The Eildon Hills and the Tweed* W: $40\frac{1}{2} \times 68$ (103 × 173) Sir Theophilus Biddulph bequest, received 1969

***2307** WARD, James: *Melrose Abbey, The Pavilion in the distance* $40\frac{1}{2} \times 68$ (103 × 173) Sir Theophilus Biddulph bequest, received 1969

319 WATSON, George: *Benjamin West* $35\frac{1}{2} \times 28$ (90·2 × 71·1) J. Smellie Watson gift (RSA) 1859

720 WATSON, George: *Mary Augusta Riddle* $56\frac{1}{4} \times 45$ (143 × 114·3) Rev Henry Cunliffe gift 1886

926 WATSON, George: *Self-portrait* $35\frac{1}{2} \times 28$ (90·2 × 71·1) Arthur Sanderson gift 1905

927 WATSON, George: *The artist's wife* $35\frac{1}{2} \times 28$ (90·2 × 71·1) Arthur Sanderson gift 1905

1885 WATSON, George: *Zoe de Bellecourt* $50\frac{3}{4} \times 38\frac{3}{4}$ (129 × 98·4) Major General Sir Theodore Fraser gift 1937

2170 WATSON, George: *Mr Kippen* $35\frac{1}{2} \times 29$ (90·2 × 73·7) Bt 1952

322 WATSON, Stewart: *Don Quixote tilting at a windmill* $27 \times 36\frac{1}{4}$ (68·6 × 92·1) Artist's gift (RI) 1832

***370** WATTEAU, Antoine: *Le dénicheur de moineaux* Paper on canvas: $9\frac{1}{8} \times 7\frac{3}{8}$ (23·2 × 18·8) Mrs Williams gift 1860

***439** WATTEAU, Antoine: *Fêtes Vénitiennes* 22×18 (55·9 × 45·7) Lady Murray of Henderland bequest 1861

932 WATTS, G. F.: *Mischief* W: 78×40 (198 × 101·6) Gift of the artist's executors 1906

1788 WATTS, G. F.: *Caroline Muriel Callander, later Mrs Baird* 24×20 (61 × 50·8) Mrs C. M. Baird gift 1933

2041 WATTS, G. F.: *Theophilos Kairis* 30×25 (76·2 × 63·5) Miss Daphne Ionides gift 1946

***51** WEENIX, J. B.: *Figures near a seaport* $26\frac{1}{4} \times 28\frac{1}{2}$ (66·7 × 72·4) Bt (RI) 1831

1062 WEISSENBRUCH, Johannes: *Near Dordrecht* W: $9\frac{1}{8} \times 16\frac{1}{4}$ (23·2 × 41·3) Hugh A. Laird bequest 1911

2272 WHEATLEY (attr): *John Cumming* $15 \times 11\frac{7}{8}$ (38·1 × 30·2) Mrs I. M. Cumming bequest 1965

1744 WHISTLER, James: *Arrangement in grey and green (portrait of J. J. Cowan)* $37 \times 19\frac{3}{4}$ (94 × 50·2) Miss Birnie Philip gift, associating Mr Cowan's name with the gift, 1930

***1945** WIJNANTS, Jan: *Landscape with figures* $24\frac{5}{8} \times 29$ (62·6 × 73·7) Miss Alice Anne White bequest 1941

323 WILKIE: *John Knox dispensing the sacrament at Calder House* W: $48\frac{1}{2} \times 65$ (123·2 × 165) Bt (RSA) 1842

585 WILKIE: *The artist's sister* W: $10\frac{3}{4} \times 8\frac{1}{2}$ (27·3 × 21·6) Dr Hunter, Largs, bequest 1871

839 WILKIE: *Scene from 'The Gentle Shepherd'* W: $12 \times 16\frac{1}{4}$ (30·5 × 41·3) Bt 1898

950 WILKIE: *Preaching of John Knox before the Lords of Congregation 10 June 1559* $18 \times 21\frac{1}{4}$ (45·7 × 54) Bt 1907

***1032** WILKIE: *Sheepwashing* W: 35 × 53 (88·9 × 134·6) Hugh A. Laird bequest 1911

***1445** WILKIE, *The bride at her toilet* $38\frac{1}{4} \times 48\frac{1}{4}$ (97·2 × 122·6) Bt 1920

***1527** WILKIE, *Pitlessie Fair* 23 × 42 (58·5 × 106·7) Bt 1921

1720 WILKIE: *Duncan Gray* W: $14\frac{1}{2} \times 12\frac{5}{8}$ (36·8 × 32·1) Bt 1928

***1890** WILKIE: *The letter of introduction* W: $24 \times 19\frac{3}{4}$ (61 × 50·2) Bt 1938

2103 WILKIE: *The painter's niece, Sophia* 24 × 18 (61 × 45·8) Miss M. Florence Nightingale gift 1948

***2114** WILKIE: *Josephine and the fortune-teller* 83 × 62 (211 × 158) Bt 1949

***2130** WILKIE: *The Irish whiskey still* W: 47 × 62 (119·4 × 158) Bt 1950

2172 WILKIE: *John Knox dispensing the sacrament at Calder House (study)* W: $17\frac{3}{4} \times 24$ (45·1 × 61) John M. Naylor gift 1953

***2173** WILKIE: *The artist's parents* W: 10 × 8 (25·5 × 20·3) Bt 1953

2196 WILKIE: *Dog facing right* $3 \times 4\frac{1}{8}$ (7·6 × 10·5) Lord Leven gift 1949

2197 WILKIE: *Dog facing left* $3 \times 4\frac{3}{8}$ (7·6 × 11·1) Lord Leven gift 1949

2198 WILKIE: *Sheep* $2\frac{1}{8} \times 3\frac{3}{8}$ (5·4 × 8·6) Lord Leven gift 1949

2302 WILKIE: *Sketch for 'Duncan Gray'* W: $5\frac{1}{8} \times 3\frac{7}{8}$ (13 × 9·9) Ian Hutchison gift 1968

***2315** WILKIE: *The confessional* $18\frac{3}{8} \times 14\frac{5}{16}$ (46·7 × 36·3) Bt 1972

***2337** WILKIE: *Distraining for rent* W: $32 \times 48\frac{7}{16}$ (81·3 × 123) Bt 1975

***** WILKIE: *Self-portrait* $29\frac{1}{4} \times 24$ (74·3 × 61) John Rankin gift (SNPG) 1898; loan from SNPG (no. 573)

1725 WILKIE (after): *The blind fiddler* $10\frac{1}{8} \times 14\frac{3}{4}$ (25·7 × 37·5) Bt 1929

1842 WILKIE (after): *The Jew's harp* W: $9\frac{1}{2} \times 6\frac{1}{2}$ (24·1 × 16·5) Bt 1936

371 WILLIAMS, H. W.: *Castle Urquhart, Loch Ness* $38\frac{3}{8} \times 51\frac{1}{2}$ (97·5 × 131) Mrs Williams gift 1860

43 WILLIAMS, S. (after Reni): *SS Peter and Paul* 79 × 54 (201 × 137) Henry Drummond gift 1856

***326** WILSON, Andrew: *View of Tivoli* $11\frac{1}{4} \times 17\frac{1}{4}$ (28·6 × 43·8) Bt (RSA) 1851

605 WILSON, Andrew: *View of Burntisland* $30\frac{3}{4} \times 46\frac{1}{2}$ (78·1 × 118·1) Rt Hon Lord Colonsay bequest 1874

1924 WILSON, Andrew: *Off Porto Fino* W: $10\frac{7}{8} \times 16$ (27·6 × 40·6) Bt 1940

328 WILSON, John: *Coast scene* W: $10\frac{5}{8} \times 14\frac{5}{8}$ (27 × 37·1) Bt (RSA) 1856

329 WILSON, John: *Ferry boat on the Maas* $29\frac{1}{2} \times 41\frac{3}{8}$ (74·9 × 105·1) Acquired (RSA) before 1860

902 WILSON, John: *A sea piece* $20\frac{1}{4} \times 41\frac{1}{8}$ (51·5 × 104·5) George R. MacDougall gift 1902

1910 WILSON, Mary: *An old high road* $20\frac{1}{4} \times 41\frac{1}{8}$ (51·5 × 104·5) George R. MacDougall gift 1902

***331** WILSON, Richard: *An Italian landscape* $20\frac{1}{4} \times 28\frac{3}{4}$ (51·5 × 73) Torrie collection

620 WILSON, Richard: *River scene with castle and figures* $33\frac{1}{2} \times 50$ (85·1 × 127) Mrs Mary Veitch bequest (RSA) 1875

1714 WILSON, Richard (imitator): *Lake of Albano* 12 × 17 (31 × 43·2) Bt 1928

1487 WINGATE, J. Lawton: *Sundown, Arran* $16\frac{3}{8} \times 18\frac{3}{4}$ (41·6 × 47·6) Dr John Kirkhope bequest 1920

***1488** W INGATE, J. Lawton: *Ash trees in spring* 17 × 12¼ (43·2 × 31·1) Dr John Kirkhope bequest 1920

***1649** W INGATE, J. Lawton: *A summer's evening* 21½ × 29¼ (54·5 × 74·3) Mrs T. H. Cooper bequest 1925

1734 W INGATE, J. Lawton: *Golden sunset* 11⅝ × 15⅝ (29·5 × 39·7) A. F. Roberts bequest 1929

2111 W INGATE, J. Lawton: *Sheepshearing* 35¼ × 45½ (89·5 × 115·6) Mrs T. H. Wingate Thornton gift 1949

2123 W INGATE, J. Lawton: *Harvest in Arran* 10¼ × 14¼ (26 × 36·2) Lady Caw bequest 1950

2358 W INGATE, J. Lawton: *Stormcloud, Muthill* B: 8$\frac{1}{16}$ × 11⅞ (20·5 × 30·3) Robert A. Lillie bequest 1977

2359 W INGATE, J. Lawton: *Kilbrannon Sound* 13⅞ × 18 (35·3 × 45·6) Robert A. Lillie bequest 1977

1776 W INT, Peter de: *Distant view of Lincoln Cathedral* 42½ × 64 (108 × 163) Messrs Davidson and Syme gift 1932

1218 W INTOUR, J. C.: *A Border castle* 39½ × 49½ (100·3 × 125·8) Archibald Smith bequest 1919

1489 W INTOUR, J. C.: *Riverside landscape* 16½ × 23½ (41·9 × 59·7) Dr John Kirkhope bequest 1920

1490 W INTOUR, J. C.: *On the Water of Leith near Livingston* W: 9¾ × 13⅜ (24·8 × 34) Dr John Kirkhope bequest 1920

2141 W INTOUR, J. C.: *Moonlight, Blairlogie* B: 14 × 20⅛ (35·5 × 51·1) Sir James L. Caw bequest 1951

***990** W ITTE, Emanuel de: *Church interior* 74¾ × 63¾ (190 × 162) Bt 1909

2257 Y ELLOWLEES, William: *The artist's father* 9⅝ × 7⅝ (24·5 × 19·4) Mr and Mrs Foley gift 1963

2258 Y ELLOWLEES, William: *The artist's mother* 9¾ × 7¾ (24·8 × 19·7) Mr and Mrs Foley gift 1963

1719 Z OPPO, Marco (attr): *Noli me tangere* W: 12¾ × 9¼ (32·4 × 23·5) Bt 1928

***340** Z URBARÁN: *The Immaculate Conception* 100 × 69¾ (255·5 × 177) Bt (RI) 1859

166 *Fragment of Psyche* (copy by Theed) Marble: 35 (88·9) Rt Hon Lord Rutherford bequest (RSA) 1854

373 *Model of the Parthenon* Bronze: length 30 (76·2) Mrs Williams gift 1860

802 *Fragment of an arm* (antique) Bronze: length 19 (48·3) A. W. Inglis gift c 1887

803 *Head of a man* Marble: ht 12¼ (31·1) A. W. Inglis gift c 1887

935 *Antonia Augusta* (Roman) Marble: ht 24¾ (62·9) Major-General D. M. Crichton Maitland gift 1906

NUMERICAL INDEX

Works are listed in the order of their accession numbers with the names under which they appear in the COMPLETE LIST (pp. 120–58) and, if they are asterisked, in the catalogue of PRINCIPAL WORKS (pp. 1–119).

323	Wilkie	463	Thomson, J.	*630	Geddes	
*326	Wilson, A.	464	Thomson, J.	*631	Geddes	
328	Wilson, J.	466	Duncan	632	Ross, R. T.	
329	Wilson, J.	521	Dyce	638	Giulio Romano	
*331	Wilson, R.	522	Raeburn	642	Bonnar	
*332	Gainsborough	524	Steell	645	Italian	
335	Raeburn	526	Michelangelo	646	Lorenzo di Credi	
338	Reynolds	527	Michelangelo	*647	Avercamp	
339	Veronese	528	Michelangelo	*648	Runciman, J.	
*340	Zurbarán	529	Fyt	649	Gordon, Watson	
*342	Scott, D.	530	Fyt	650	Gordon, Watson	
368	Simson	532	Snyders	*651	Kauffmann	
*369	Simson	533	Simson	*652	Cameron	
*370	Watteau	534	Phillip	*657	Chalmers, G. P.	
371	Williams, H.	554	Medina	659	Skirving	
372	Thomson, J.	*556	Thomson, J.	660	Bone	
373	see p. 158	557	Steell	661	Bone	
376	Velde, van de	565	Phillip	663	Santvoort	
386	Tassie	566	Phillip	664	Grimoux	
387	Sanders	*569	Martin, D.	669	Douglas, Fettes	
*415	Allan, D.	*570	Runciman, J.	672	Ewbank	
416	Geddes	571	Hutchison	675	Pickersgill	
*420	Raeburn	572	Lawson, G.	681	Raeburn	
421	Crawford	578	Christie, A.	689	Tintoretto	
*423	Lizars	579	Jordaens	*690	Venetian	
*424	Lizars	585	Wilkie	*691	Hals	
427	Reynolds	586	Landseer	*692	Hals	
428	Schmidt	587	McCulloch	693	Michelangelo	
*429	Boucher	589	Nasmyth, P.	704	Venetian	
*430	Ramsay	599	Herdman	707	Duncan	
431	Marlow	600	Rosa, S.	708	Simson	
432	Murillo	600a	Rosa, S.	720	Watson, G.	
433	Mercier	604	Duncan	721	Syme	
434	Mercier	605	Wilson, A.	779	Douglas, Fettes	
*435	Greuze	608	Harvey	*780	Carse	
*436	Greuze	609	Simson	786	Schetky	
437	Greuze	610	Macnee	789	Morland	
438	Greuze	*612	Allan, D.	*790	Runciman, A.	
*439	Watteau	619	Dutch	792	Runciman, J.	
*440	Lancret	620	Wilson, R.	*793	Runciman, J.	
*441	Pater	621	Courtois	794	Dutch	
447	Marshall	622	Rosa, S.	795	Soldi	
448	Duncan	*623	Raeburn	796	Scott, D.	
*458	Poussin	624	Drummond	*799	Church	
*459	Carducho	625	Drummond	801	Bough	
*460	Dyce	626	Raeburn	802	see p. 158	
461	Thomson, J.	627	Mercier	803	see p. 158	
462	Thomson, J.	628	Mercier	805	Somerville	

811	Burnett, T. S.	932	Watts	1015	Burnett, T. S.
812	Italian	934	Herdman	1016	Florentine
819	Bough	935	see p. 158	*1017	Bonington
*820	Ramsay	938	Brough	1018	Orchardson
823	Teniers	942	Charles	1019	Moore
*824	Cuyp, J. G.	944	Crome	1020	Douglas, Fettes
*825	Scott, D.	945	Lockhart	*1021	Pérez
826	French	*946	Ramsay	*1022	Monticelli
*827	Rembrandt	948	Melville	*1023	Matteo di
828	Guardi	949	Harvey		Giovanni
829	Guardi	950	Wilkie	*1024	Moreelse
830	Lauder, R. S.	*951	Ostade, I. van	*1026	Raeburn
831	Raeburn	*952	Vitale	*1027	Raeburn
*833	Italian	953	Gozzoli	*1028	Michel
*836	Phillip	957	Graham, T.	1029	Ferguson, W. G.
*837	Raeburn	*958	Jamesone	*1030	Rosselli
*838	Hogarth	*959	Chardin	*1032	Wilkie
839	Wilkie	*960	Cotman	1033	Troyon
*843	Scott, D.	*961	Monticelli	1034	Troyon
844	Crome	962	Claude	*1035	Daubigny
845	Raeburn	966	Lawson, C.	1036	Daubigny
846	Raeburn	*969	Scott, W. B.	1037	Corot
*847	Geddes	970	Ferguson, W. G.	1038	Corot
848	Geddes	980	Holland	1039	Corot
849	Skirving	*981	Douglas, Fettes	1040	Dupré
900	Stothard	*982	Fraser	1041	Dupré
901	Stothard	*987	Donald	1042	Diaz
902	Wilson, J.	989	Dutch	*1043	Diaz
*903	Raeburn	*990	Witte, de	*1044	Diaz
904	Brodie	991	Pourbus, P.	1045	Decamps
908	Dalou	*992	Scott, D.	1046	Jacque
909	Moucheron	993	Morland	*1047	Lépine
910	Italian	994	Morland	1048	Harpignies
911	Opie	*995	Orley, van	1049	Maris, J.
912	Both	998	German	1050	Maris, J.
913	Both	999	German	1051	Maris, J.
914	Houston	*1000	Burr, A. H.	1052	Maris, J.
*915	Lauder, J. E.	*1001	Burr, J.	1053	Maris, W.
916	Lenbach	1002	Douglas, Fettes	1054	Marcke, van
*919	Harvey	*1003	Lauder, R. S.	1055	Marcke, van
920	Ross, J. T.	1004	Phillip	*1056	Mauve
924	Chalmers, G. P.	1005	Runciman, J.	1057	Mauve
925	Nicol	1006	Scott, D.	1058	Mauve
926	Watson, G.	1007	Ewbank	1059	Israels
927	Watson, G.	1009	MacLeay	1060	Israels
929	Thomson, J.	1010	Sanders	1061	Israels
*930	Raeburn	*1013	Goyen, van	1062	Weissenbruch
*931	Cotman	1014	Asselijn	1063	Farquharson

*1071	McTaggart	*1254	Flemish	1497	Goyen, van
*1072	Boudin	1372	Lawson, C.	*1498	Guardi
1073	Geddes	*1383	Nasmyth, A.	*1499	Guardi
1074	Crosse	1444	Cameron	*1500	Bray, de
1076	Daubigny	*1445	Wilkie	*1501	Bray, de
1077	Rhind	1446	Stomer	*1502	Bray, de
1130	Desboutins	*1447	Corot	*1503	Bray, de
1131	Pettie	*1448	Corot	1504	Luttichuys
*1133	Bastien-Lepage	*1449	Corot	*1505	Heem, de
1135	Cotman	1450	Corot	*1506	Hobbema
*1138	Orchardson	1451	Corot	1507	Lely
*1139	Veronese	1452	Corot	*1508	Saftleven
*1142	Faed, J.	*1453	Daubigny	*1509	Maes
1146	Noble, J. C.	1454	Diaz	1510	Dutch
1147	Scott, D.	*1455	Fantin-Latour	1511	Bassano
1155	Phillip	1456	Fantin-Latour	1512	Dughet
*1187	Pettie	1457	Jacque	*1513	Serodine
1188	Fraser (1827–99)	1458	Lépine	1515	Tilborch
1189	Fortuny	1459	Lépine	1516	Verbruggen
*1190	Cima	1460	Lhermitte	1517	Verbruggen
1192	Raeburn	1461	Michel	*1521	Gainsborougl
1193	Harvey	1462	Monticelli	*1522	Lawrence
1199	Raeburn	1463	Monticelli	*1523	Ramsay
*1200	Hals	*1464	Monticelli	1524	Ramsay
1201	McTaggart	1465	Monticelli	1525	Russell
1202	Couture	1466	Troyon	1526	Ford
1206	Torrance	1467	Vollon	*1527	Wilkie
1207	Orchardson	1468	Bosboom	*1528	Amedei
1208	Noble, R.	1469	Bosboom	*1535	Ferrarese
*1210	Castagno	1471	Maris, J.	*1536	Botticelli
1211	Crayer, de	1473	Neuhuijs	*1537	Provost
*1215	Reynolds	1474	Neuhuijs	*1538	Sellaio
*1216	Hoppner	1475	Bough	*1539a	Master, S. Lucchese
1218	Wintour	1476	Bough		
*1219	Constable	1477	Chalmers, G. P.	*1539b	Master, S. Lucchese
1222	Raeburn	1478	Chalmers, G. P.		
1223	Raeburn	*1479	Douglas, Fettes	*1540a	Master of 1419
*1224	Raeburn	1480	Fraser (1827–99)	*1540b	Master of 1419
1225	Raeburn	1481	Fraser (1827–99)	*1541	Flemish
*1226	Emms	*1482	McTaggart	1543	Bartholomé
1228	Thomson, J.	1483	McTaggart	1544	Flemish
1229	Orchardson	1487	Wingate	*1564	Lievens
*1230	Paton, Noel	*1488	Wingate	1565	Sano
1231	Christie, J. E.	1489	Wintour	*1579	Harvey
1236	Raeburn	1490	Wintour	*1614	Turner
1250	Pesellino	*1492	Bril	1615	Thomas
*1252	Joos van Cleve	1493	Calraet	*1616	Daumier
*1253	Geertgen	1496	Gérard	1623	Legros

162

*1624	Degas	1720	Wilkie	*1805	Perugino	
1625	Velázquez	1721	Rossetti	1816	Raeburn	
1626	Barye	1725	Wilkie	1817		
*1628	Goya	1727	Thomson, J.	to	Macnee	
1629	Chalmers, G. P.	1728	Flemish	1822		
1633	Piero di Cosimo	1729	Archer	1824	British	
1634	Emilian	1730	Cameron	*1825	Geikie	
*1635	Bassano	1731	Douglas, Fettes	1828	Carse	
1636	Bassano	1732	Mackie	1829	Hamilton, G.	
1637	Vernet	1733	Roche	1832	Dutch	
1638	Italian	1734	Wingate	*1833	Hamilton, J.	
1641	Crawhall	*1738	Toscani	*1834	McTaggart	
*1642	Flemish	1739	Puvis	*1835	Morland	
*1643	Gauguin	1740	Reid	*1836	Morland	
1647	Scott, D.	1741	Robertson, A.	*1837	Seton	
1648	Alexander, R.	1743	Owen	1839	Duguid	
*1649	Wingate	1744	Whistler	*1840	Seton	
*1651	Monet	1745	Ferrarese	1841	Seton	
1655	Walton	*1746	Butinone	1842	Wilkie	
1656	Sargent	*1747	Rodin	1843	Crawhall	
1657	Hogarth	1748	Thomson, W. J.	1845		
1658	Orchardson	1749	Johnstone	to	Thorburn	
1659	McTaggart	1751	Scott, D.	1849		
1663	Phillip	1752	Mosman	*1852	Corot	
1664	French	*1757	McTaggart	1853	Ford	
1665	Italian	*1758	Lippi	1854	Raphael	
*1666	Reynolds	*1759	Burnet, J.	1864	Thomson, J.	
1669	McKay	1762	Raeburn	1865	Traquair	
*1670	Vermeer	1763	Cameron	1866	Traquair	
*1673	Marmitta	1764	Cameron	1867	Traquair	
*1674	Romney	*1768	Norie	1868	Traquair	
1675	Catena	*1769	Norie	1869	Traquair	
1676	Scott, D.	1770	Macgregor	1871	Traquair	
1677	Allan, W.	1775	Sisley	*1873	Greco, El	
1678	Joos van Cleve	1776	Wint, de	1874	Perigal	
*1679	Macnee	*1784	Alexander, J.	1875	Ford	
*1681	Corot	*1785	Degas	1876	Scott, D.	
1683	Italian	1786	Fielding	1877	Scott, D.	
1686	Dutch	1787	Sargent	*1878	Raeburn	
1692	Stott	1788	Watts	*1879	Lorimer	
1693	Stott	1792	Botticelli	*1882	Alexander, C.	
1696		1793	Bogle	*1883	Chardin	
to	Stevens	1798	Alexander, J.	1884	Ramsay	
1713		1799	McKay	1885	Watson, G.	
1714	Wilson, R.	1800	McKay	1886	Murray	
1717	Cameron	1802	Millar	1887	Fraser (1786–1865)	
1718	Martin, D.	*1803	Gogh, van	1888	Fraser (1786–1865)	
1719	Zoppo	1804	McInnes	1889	Ramsay	
				*1890	Wilkie	

163

1891	Chalmers, G. P.	1952	Paterson	2008	Ferguson, J.
1892	McLachlan	1953	Paton, W. H.	2009	Galloway
1893	Nasmyth, C.	1957	Macgregor	2010	Scoular
1894	Nasmyth, P.	1958	Tuscan	2011	Scoular
*1895	Orley, van	*1959	Raeburn	2012	Robertson, A.
1896	Douglas, Fettes	*1960	Ramsay	2014	Canaletto
*1897	More	1961	Mercier	*2015	Morland
*1904	Daddi	1962	Mercier	*2016	Constable
1905	Herald	1964	Hill, D. O.	*2017	Guthrie
1906	McTaggart	1966	Denune	2018	Guthrie
1907	McTaggart	1967	Geddes	2022	Alexander, C.
1908	Brodie	1968	Nasmyth, P.	*2023	Paterson
1910	Wilson, M.	1969	Lépine	*2024	Benson
1912	Nasmyth, E.	1970	Stappen	2028	Phillip
1913	Nicholson	1973	Jamesone	*2032	Scougall
1914	Skirving	1974	Apollonio di	2034	Raeburn
*1915	Macgregor		Giovanni	2036	Forbes
1919	Douglas, W.	1975	Master of the	2037	Denune
1920	Douglas, W.		Adimari Cassone	2038	Mackie
1921	Macnee	1977	McKenzie	*2039	Thomson, J.
1923	Raeburn	1978	McKenzie	2040	Grimmer
1924	Wilson, A.	1979	McKenzie	2041	Watts
1926	Martin, D.	1980	Fraser (1827–99)	2044	Mackie
1927	Asper	1981	Nasmyth,.P.	2045	Harvey
1928	German	1982	Walls	2046	Clausen
*1929	Flemish	1984	Faed, J.	2050	Legros
*1930	Clouet	1986	Graham, P.	2053	Barye
*1931	Polidoro	1987	Stewart	*2054	Rodin
1932	Dutch	1988	Stewart	2055	Stevens
*1933	Flicke	1989	Stewart	2057	Stevens
1934	Flicke	1990	Stewart	2058	Stevens
1935	Ramsay	1991	Stewart	2059	Barye
1936	Gardner	1992	Robertson, A.	2060	Swan
1937	Roestraeten	1993	Robertson, A.	2062	Thomas
*1938	Key	1994	Robertson, A.	2063	Swan
*1939	Key	1995	Robertson, A.	2064	Gilbert
*1940	Apollonio di	1996	Bogle	2067	Millais
	Giovanni	1997	Bogle	2070	Paillou
*1941	Sellaio	1998	Bogle	2071	British
*1942	Cranach	1999	Bogle	2072	Scott, D.
1943	Bronzino	2000	Donaldson	2073	Scott, D.
1944	Dyck, van	2001	British	2074	Flemish
1945	Wijnants	2002	Ross, W.	*2086	Macgregor
1946	Backhuyzen	2003	Miers	*2087	Guthrie
1947	Velde, van de	2004	Miers	2088	Guthrie
1948	Nasmyth, P.	2005	Miers	2089	Harvey
*1950	Fantin-Latour	2006	Miers	2090	Harvey
1951	Swan	2007	Miers	2091	Harvey

2092	Harvey	*2142	Guthrie	2197	Wilkie
2093a	Paillou	2143	Roche	2198	Wilkie
2093b	British	2144	Melville	*2199	Dyce
2093c	British	2146	Torrance	*2200	Macgregor
2093d	British	*2147	Raeburn	2201	Macnee
2093e	British	*2148	Raeburn	2202	Macnee
2094	British	*2149	Raeburn	2203	Lauder, R. S.
2096	Ferguson, W. G.	*2150	Raeburn	2212	Smibert
*2097	Rubens	*2151	Ramsay	*2213	David, G.
*2098	Pissarro	*2152	Ramsay	2214	McTaggart
2099	Lippi	2153	Ferrière	2215	Orchardson
2100	Nasmyth, A.	2154	Bogle	*2216	Gogh, van
*2101	Nasmyth, P.	2155	Paillou	*2217	Gogh, van
2102	Nasmyth, P.	2156	Geddes	*2220	Gauguin
2103	Wilkie	*2157	Allan, D.	*2221	Gauguin
2104	Nasmyth, A.	*2158	McTaggart	*2222	Seurat
2106	Cadenhead	2159	Hysing	*2223	Bonnard
2107	Fantin-Latour	*2160	Greco, El	*2224	Degas
2108	Raeburn	2161	Tintoretto	*2225	Degas
2109	Hone	2162	Cameron	*2226	Degas
2110	Hone	2163	Constable	*2227	Degas
2111	Wingate	*2164	Bonington	*2228	Vuillard
*2112	Raeburn	*2165	Bonington	*2229	Vuillard
2113	Chalmers, G.	2166	Müller	*2230	Renoir
*2114	Wilkie	2170	Watson, G.	2232	Courbet
*2115	Martin, J.	*2171	Reynolds	*2233	Courbet
*2116	Runciman, J.	2172	Wilkie	*2234	Courbet
2118	Scott, D.	*2173	Wilkie	*2235	Sisley
2119	Ramsay	*2174	Gainsborough	*2236	Cézanne
*2120	Monti	2175	Sinclair	*2238	Pittoni
*2121	Bough	2176	Guthrie	*2240	Claude
2123	Wingate	2177	Gordon, Watson	2241	Ross, W.
2124	Syme	*2178	Maillol	*2245	Bonnard
2125	Syme	2179	French	2249	Thomson, J.
2126	Allan, D.	*2180	Velázquez	*2253	Gainsborough
2127	Geddes	*2181	Raeburn	2254	Macnee
2128	Bogle	*2182	Raeburn	2255	Shirreff
2129	Crespi	*2183	Reynolds	2256	Allan, D.
*2130	Wilkie	2184	Orchardson	2257	Yellowlees
2131	Hudson	*2185	McTaggart	2258	Yellowlees
2133	Ramsay	2186	McTaggart	*2259	Cuyp, J. G.
2134	Fraser (1786–1865)	2189	Runciman, A.	*2260	Allan, D.
*2136	Herdman	*2190	Delacroix	*2261	Roberts
*2137	McTaggart	*2191	Thomson, J.	2263	Thomson, J.
2138	McTaggart	*2193	Rubens	2264	Thomson, J.
*2139	McTaggart	2194	Gibb	2265	Thomson, J.
2140	McTaggart	2195	Gibb	2266	Forain
2141	Wintour	2196	Wilkie	*2267	Dyce

*2268	Poppi	*2297	Sarto	2333	Hutchison	
*2269	Morisot	2298	Powell	2334	MacGeorge	
2270	Leonardo	2299	Scottish	2335	Geikie	
*2271	Lorenzo Monaco	*2301	Raeburn	*2337	Wilkie	
2272	Wheatley	2302	Wilkie	*2338	Verrocchio	
*2273	Massys	2303	Chinnery	*2339	Hamilton	
*2274	French	*2306	Ward	2340	Clausen	
*2275	Pourbus, F.	*2307	Ward	*2347	Moroni	
*2276	Procaccini	2308	Harvey	2348	Walton	
*2281	Elsheimer	*2309	Crome	*2349	Boudin	
*2283	Monet	2310	German	*2350	Boudin	
2284	Guthrie	*2311	Rubens	*2351	Boudin	
*2285	Degas	*2312	Elsheimer	2352	Fraser (1827–99)	
*2286	Degas	*2313	Domenichino	2353	Guthrie	
2287	Gilbert	*2314	Cuyp	2354	Guthrie	
2288	Gilbert	*2315	Wilkie	2355	McTaggart	
2289	Legros	2316	Lauder	2356	McTaggart	
*2290	Rodin	2317	Quesnel	2357	Paterson	
*2291	Bacchiacca	*2318	Dughet	2358	Wingate	
2292	Allan, D.	*2319	Poussin	2359	Wingate	
2293	Geddes	2320	Geddes	2360	Roche	
2294	Cotes	*2324	Seurat	2361	Henry	
2295	Ramsay	*2325	Testa	2366	Waitt	
2296	Raeburn	2326	Testa			

ABBREVIATED REFERENCES

ADHÉMAR H. Adhémar: *Watteau sa vie—son oeuvre* Paris 1950.

ANTWERP INV. Inventory made in May 1656 of Queen Christina's possessions going to Rome, published in J. Denucé: *The Antwerp art galleries . . . in the 16th and 17th centuries* Antwerp 1932 p. 176.

ARSLAN 1931 W. Arslan: *I Bassano* Bologna 1931.

ARSLAN 1960 E. Arslan: *I Bassano* Milan 1960.

BARTSCH A. Bartsch: *Le Peintre Graveur* Vienna 1803—.

BERENSON 1909–1968 B. Berenson: *Florentine Painters*, London 1909; *Italian Pictures of the Renaissance* Oxford 1932; *idem* London (Venetian School) 1957, (Florentine School) 1963 (Central and North Italian Schools) 1968.

BILLE Clara Bille: *De tempel der kunst—het kabinet van den heer Braamcamp* Amsterdam 1961.

BLUNT A. Blunt: *The Paintings of Nicolas Poussin* London 1966.

BM British Museum, London.

BREDIUS A. Bredius: *The Paintings of Rembrandt* Vienna 1935, London 1937; see also Gerson 1969.

BRIDGEWATER HOUSE Catalogues published London 1851 and 1926: see under relevant Bridgewater House numbers.

BRITTON J. Britton: *Catalogue raisonné of the pictures belonging to the Marquis of Stafford* London 1808.

BROULHIET G. Broulhiet: *Meindert Hobbema* Paris 1938.

BRUSCO G. Brusco: *Description des beautés de Gênes*. Genoa (2nd ed) 1788.

BURL. MAG. Burlington Magazine.

CAW 1917 J. L. Caw: *William McTaggart* Glasgow 1917.

COUCHÉ J. Couché et al: *Galerie du Palais-Royal, gravée . . . par J. Couché* Paris 1786–1808.

CROZAT J. A. Crozat: *Recueil d'Estampes après les Plus Beaux Tableaux . . . en France* 1729–42.

CUNNINGHAM A. Cunningham: *Life of Sir David Wilkie* London 1843.

CUST W. L. Bourke and L. Cust: *The Bridgewater Gallery* London 1903.

DACIER and VUAFLART E. Dacier and A. Vuaflart: *Jean de Jullienne et les graveurs de Watteau* Paris 1921–1929.

DAVIES 1961 M. Davies: *The Earlier Italian Schools* (National Gallery Catalogue) London 1961.

DEGAS SALES Atelier Edgar Degas sales at Galerie Georges Petit, Paris (I) 6–8 May 1918, (II) 11–13 Dec 1918, (III) 7–9 Apr 1919, (IV) 2–4 July 1919.

DUBOIS L. F. Dubois de Saint Gelais: *Description des tableaux du Palais-Royal* Paris 1727.

DE LA FAILLE J. B. de la Faille: *L'Oeuvre de Vincent van Gogh* Paris/Brussels 1928.

FARR D. Farr: *William Etty* London 1958.

FISCHEL O. Fischel: *Raphaels Zeichnungen* Berlin 1913—.

FRIEDLÄNDER M. J. Friedländer: *Die altniederländische Malerei* Berlin 1924–37.

GERSON 1968 H. Gerson: *Rembrandt* Amsterdam 1968.

GERSON 1969 Revision of Bredius (qv), published London 1969.

GRANBERG O. Granberg: *La Galerie de Tableaux de la Reine Christine de Suède* Stockholm 1897.

HDG (and see following entry) C. Hofstede de Groot: *Beschreibendes und kritisches Verzeichnis der Werke der hervorragendsten holländischen Maler des 17 Jahrh.* Esslingen a N. 1907–28 (Vols 1–8 translated, London 1908–27).

H. DE GROOT 1893 C. Hofstede de Groot: *Hollandsche Kunst in Schotland* in *Oud Holland* 1893 XI, 3 p. 129 and 4 p. 211.

HIND A. M. Hind: *Catalogue of drawings by Dutch and Flemish Artists . . . in the British Museum* (vol II Rubens) London 1923.

HOET G. Hoet: *Catalogue of Naamlyst van Schilderyen* The Hague 1752 and 1770 (continuation by P. Terwesten).

KDK Klassiker der Kunst edition.

KAFTAL 1952 G. Kaftal: *Iconography of the Saints in Tuscan painting* Florence 1952.

LEMOISNE P. A. Lemoisne: *Degas et son oeuvre* Paris 1947–49.

LONGHI 1934 R. Longhi: *Officina Ferrarese* (1934) Florence 1956 ed.

MÂLE E. Mâle: *L'Art Religieux de la Fin du Moyen-Age* Paris 1931

VAN MARLE R. van Marle: *The Development of the Italian Schools of Painting* The Hague 1923–38.

MORASSI A. Morassi: *G. B. Tiepolo* London 1962.

NA-CF National Art-Collections Fund.

NG LONDON National Gallery, London.

NICOLSON B. Nicolson: *Hendrick Terbrugghen* London 1958.

OFFNER R. Offner: *A Critical Corpus of Florentine Painting* New York 1930—.

PALAZZO RIARIO INV. Inventory of Queen Christina's possessions unpacked in Rome 1662 (see *Christina Exh.* Stockholm 1966 catalogue 1,045).

PASSAVANT 1836 Passavant: *Tour of a German Artist in England* London 1836.

PASSAVANT 1860 Passavant: *Raphael d'Urbin* Paris 1860.

RA Royal Academy, London.

RAPFA Royal Association for the Promotion of the Fine Arts in Scotland.

RATTI G. Ratti: *Istruzione di quanto può vedersi di più bello in Genova* Genoa 1766 and 2nd ed. Genoa 1780.

REWALD 1944 J. Rewald: *Degas, works in sculpture* New York-London 1944, London 1957.

RI Royal Institution.

RIDOLFI C. Ridolfi: *Le Maraviglie dell' Arte 1648* (von Hadeln ed.) Berlin 1914–24.

ROBAUT A. Robaut: *L'Oeuvre de Corot* Paris 1904–6.

RSA Royal Scottish Academy.

RSA LIST *Art property in the possession of the Royal Scottish Academy* Edinburgh 1883 (privately printed).

168

SANDRART J. von Sandrart: *Academie der Bau-, Bild- und Mahlerey-Künste von 1675* (Peltzer ed.) Munich 1925.

SCHMIT R. Schmit: *Eugène Boudin* Paris 1973.

SCOTT W. B. Scott: *Memoir of David Scott RSA* Edinburgh 1850.

SHIRLEY A. Shirley: *Bonington* London 1940.

SLIVE S. Slive: *Frans Hals* London 1970–74.

SMITH J. Smith: *Catalogue raisonné of . . . the most eminent Dutch, Flemish and French painters* London 1829–37 (supplement 1842).

SNPG Scottish National Portrait Gallery, Edinburgh.

STAFFORD GALLERY 1818 W. Y. Ottley and P. W. Tomkins: *Engravings of the Marquis of Stafford's collection* London 1818.

STRYIENSKI C. Stryienski: *Galerie du Régent Philippe Duc d'Orléans* Paris 1913.

TIETZE H. Tietze: *Tizian* Vienna 1936.

V & A LONDON Victoria and Albert Museum, London.

VASARI G. Vasari: *Le Vite de'più Eccellenti Pittori Scultori ed Architettori* (G. Milanesi ed.) Florence 1878–85.

WAAGEN G. F. Waagen: *Treasures of art in Great Britain* London 1854, and Supplement: *Galleries and Cabinets of Art in Great Britain* London 1857

WATERHOUSE 1941 E. K. Waterhouse: *Reynolds* London 1941.

WATERHOUSE 1953 E. K. Waterhouse: *Painting in Britain 1530 to 1790* London 1953.

WATERHOUSE 1958 E. K. Waterhouse: *Gainsborough* London 1958.

WETHEY H. Wethey: *El Greco and his School* Princeton 1962.

WILDENSTEIN 1963 G. Wildenstein: *Chardin* Zurich 1963.

WILDENSTEIN 1964 G. Wildenstein: *Gauguin* Paris 1964.

ZANETTI A. M. Zanetti: *Descrizione di tutte le pubbliche pitture di Venezia . . . di Marco Boschini* Venice 1733 ed. with supplement.

Printed in Scotland for Her Majesty's Stationery Office
by McCorquodale (Scotland) Ltd., Glasgow
Dd 591281/3827 K48 8/78

Pieter Ter Meulen ?